Russia

Engages the World, 1453–1825

Published in cooperation with
The New York Public Library

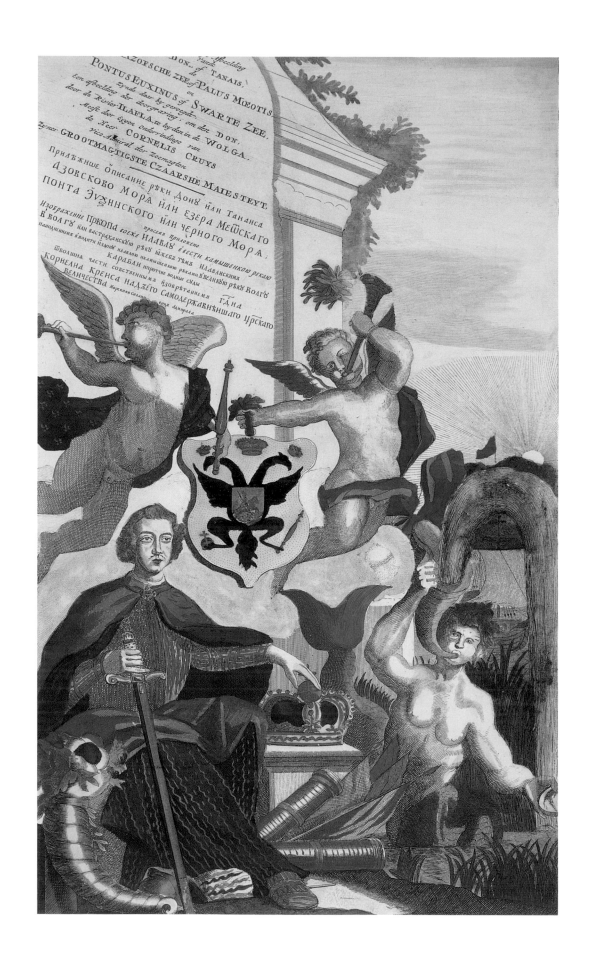

Russia

ENGAGES THE WORLD, 1453–1825

Edited by Cynthia Hyla Whittaker

With Edward Kasinec and Robert H. Davis, Jr.

Harvard University Press

Cambridge, Massachusetts
London, England
2003

Copyright © 2003 by The New York Public Library,
Astor, Lenox and Tilden Foundations

Printed in Italy

Karen Van Westering, Manager of Publications
Anne Skillion, Project Editor
Barbara Bergeron, Editor
Photography by Bob Lorenzson

Designed by Kara Van Woerden

Cataloging-in-Publication Data available from the
Library of Congress

ISBN 0–674–01193–7 (cl.: alk. paper)
ISBN 0–674–01278–X (pbk: alk. paper)

www.nypl.org www.hup.harvard.edu

Contents

From the underwriter of the exhibition *Russia Engages the World, 1453–1825*

FOLLOWING A PROTRACTED PERIOD of political confrontation that was finally broken with the fundamental political changes of the early 1990s, scientific and cultural exchanges between the United States and Russia have increased at a breathtaking pace. After seventy-five years of communism, Russia finally returned to the global community, accepting the principles of democracy and an open society. In this sense, the title of the exhibition is most apt.

Our support of *Russia Engages the World* is in no small sense related to the importance that we attach to Russia's return to the international community. Exposing a wider audience in the United States to Russia's history and culture is particularly important at this moment. The deeper our understanding of the histories of our two countries, the better we will understand each other and the sooner we will reach a common language. We must work together if we are to solve the problems that face us and move forward on the road of progress and peace.

For the Jordan family, this exhibition is an extension of our commitments in support of culture and science and the restoration of historical monuments in Russia. We provide financing for the publication of books in Russian on Russian history and culture and for the organization of museum exhibits, in addition to supporting the revival of the Cadet Corps, a pre-1917 institution that now provides schooling and other assistance to sons of those who lost their lives on military duty.

Russia Engages the World is an important cultural event not just for New York, but for all Americans. The high professional standards of the curators and Library staff involved in the project, together with the quality of the materials on view and their presentation, ensure its success. It is with great pride that we support this exhibition, and we are pleased that Harvard University Press is publishing this book. We hope visitors to the exhibition, as well as the readers of this volume, will be stimulated to undertake further exploration of Russia's rich culture and history.

Boris Jordan

From the Director of the State Hermitage Museum

IN THE SPRING OF 2003, the peoples of Russia and the many admirers of their culture around the world began to mark the 300th anniversary of the founding of a Russian city on the site of the present-day St. Petersburg. As one of the organizers of festivities here in St. Petersburg, and the head of the city's major cultural institution, The State Hermitage Museum, founded in 1764, I take particular pleasure in saluting The New York Public Library, which has marked this anniversary in a unique way, through the extraordinary exhibition *Russia Engages the World, 1453–1825* and this beautiful companion volume.

This year, as on previous anniversaries of the city celebrated in 1753, 1803, and 1957, the city of St. Petersburg will present within its borders numerous performances, exhibitions, and publications marking the occasion; dozens of similar events will take place beyond the borders of Russia. In some respects, these latter events take on a special significance, and even poignancy, at this historical juncture in both Russian and world culture.

With the increasing interest in the phenomena of westernization and globalization, scholars and writers outside of Russia have begun to explore and rediscover the historic, long-standing ties of Muscovy, and later the Russian Empire, with other cultures of the world. St. Petersburg, of course, offers a natural prism through which to trace these historic relations. As a specialist in the art and archaeology of the Muslim world, I was especially pleased to see that this exhibition sets the Library's Rossica collections in the broader context of the book cultures of Asia, Northern and Western Europe, and the cultures of Islam. Much as the Hermitage reflects the passionate acquisition, over a long period, of artistic achievements of many cultures in many media, so too does The New York Public Library's collection today reflect the farsighted work of librarians who have collected books from all the great universal cultures, including Russia. The myriad threads that bind the cultures of the world—including Russia and the Americas—merit continuous exploration, analysis, and appreciation. That is the message of *Russia Engages the World*, and I am proud to have had an active role in affirming it on these pages, as well as by my personal participation in the opening day of the symposium.

Mikhail B. Piotrovski

Foreword

FROM THEIR INCEPTION in the nineteenth century, the Astor and Lenox libraries, which would consolidate at century's end as The New York Public Library, assembled a rich collection of western-language materials about Russia. The new Library's continuation of this program of acquisitions took on new meaning after the Bolshevik Revolution of 1917. Soviet officials, especially in their first two or three decades in power, seemed intent on eradicating evidence of Russia's tsarist, pre-Soviet past. Anticipating interest in Russian history and culture of both the old and new regimes, curators from the Library traveled in the winter of 1923–1924 to Russia, where they acquired large numbers of prerevolutionary books, including some of the great monuments of Russian culture. After a century of amassing materials, the Library now boasts one of the premier collections of Russian materials in the western world.

The abundance of the Library's holdings has made possible the mounting of a major exhibition, *Russia Engages the World, 1453–1825*. Besides the Slavic and Baltic Division, more than a dozen other divisions of the Library contributed books, maps, manuscripts, and works of art for display. Almost every one of the more than 250 objects on view (and every image in this book) is drawn from the Library's own collections; few independent research libraries outside Russia could match this feat.

This collection of essays acts as a companion volume for the exhibition, with eminent scholars of Russian culture placing the items in a rich historical context. They deserve our congratulations for their contribution to broadening public awareness of the wealth and significance of Russian culture, and of the holdings of this great library and its sister cultural institutions in New York. The Library is also grateful to the two dozen other scholars from around the world who joined the writers of these essays at a symposium—co-sponsored by the Harriman Institute of Columbia University, the Trust for Mutual Understanding, and The New York Public Library— that elucidated topics in Russian history and literature that the exhibition could not address.

The exhibition curators reviewed the thousands of items in the collections, selected those for display, and provided the intellectual links that bind them together for the public. We thank them, and all of the academic contributors to the exhibition, for their masterful achievement. Our gratitude goes as well to the editorial and production staffs of the Library and the Harvard University Press, who brought to completion an intelligent and handsome book.

The exhibition and its companion volume could not have come at a more propitious time. After more than seven decades of Soviet power, the Russian people are recapturing and celebrating their past and, in the process, reaching out for cultural partners around the globe. We are delighted that this book and exhibit coincide with the worldwide festivities surrounding the tercentenary of St. Petersburg and that they represent another joint undertaking with our partner institution, the Russian National Library in St. Petersburg. Boris Jordan is perhaps the best personification of this new spirit: a native New Yorker of Russian extraction and now resident in the land of his forebears, he became the leading sponsor of *Russia Engages the World*.

Paul LeClerc
PRESIDENT,
THE NEW YORK PUBLIC LIBRARY

Editor's Introduction

In one significant respect, Russia in 2003 resembles Russia in 1703. At the beginning of this century, the country is struggling to become "normal," to emerge from over seven decades of hostile aloofness to most global trends and from what came to be called a Cold War mentality. Similarly, at the beginning of the eighteenth century, Russia resolved to become "modern," to shrug off five hundred years of insularity caused first by Mongolian overlordship and then by the isolating belief that the country constituted the only true Christian realm in the universe. Then, as now, the conversation revolved around Russia's essential identity and what its culture might gain or lose through exposure to and interaction with a larger, more diverse world. The exhibition *Russia Engages the World, 1453–1825* and this companion volume hope to present to viewers and readers the historical stage upon which these issues have been and are being played out.

St. Petersburg was founded in 1703, and the coming tercentenary inspired The New York Public Library to put on display those holdings that record Russia's transformation from religious isolation into secular empire. Tsar Peter I—who reigned from 1682 to 1725 and would earn the title of emperor and the epithet "the Great"—envisioned his new capital as a "window on Europe," a forceful symbol of his policy of westernization. Most of the essays in this book and the items on display relate to the eighteenth century, when Peter and Empress Catherine II, also "the Great" (r. 1762–1796), made their country an integral part and leading member of the European family of nations at a time when that continent was achieving global hegemony. These monarchs aimed to create a population of Russian Europeans, actively engaged in the destinies of their own continent and those of the rest of the world.

The beginning date for the book and exhibit, 1453, recognizes a watershed in world and Russian history. By that year, "Russia" had already been in existence for six centuries. Kievan Rus' (ninth–thirteenth centuries) had a dual identity, both western and eastern: it possessed a political, economic, and social structure that was the equal of, or perhaps even superior to that of, any other European state, while it received its religion and cultural moorings from the East, the Greek Orthodox Byzantine Empire centered in the glorious metropolis of Constantinople. In addition, a constant stream of nomadic tribes from Asia offered a constant threat but often resulted in cultural exchange. The fiercest of these raiders, the Mongolians, in the early thirteenth century began to invade and dominate Russian territory. The resulting devastation and isolation from other civilizations retarded development in every area for about 150 years, with Orthodox prelates and the northernmost Russian city of Novgorod preserving what remained of culture and tradition.

Eventually, the grand princes of Moscow succeeded in establishing control over central European Russia and founded the second Russian state, Muscovy (fourteenth–seventeenth centuries). It grew rapidly and maintained an Orthodox, eastern, tradition-bound mentality, with strong ties to Constantinople. However, in 1453, the Ottomans captured the Christian capital, changed its name to Istanbul, and made it a seat of Islam. In reaction, Muscovy identified itself as the only remaining independent Orthodox realm, superior to all other religions, treating its Islamic or other Christian neighbors with disdain.

Marshall Poe's essay, "A Distant World," sets this early Russian history in a broad Eurasian context. He traces the settlement of the land from the Baltic to the Black Sea, showing the geographical connections of Muscovy with the other peoples of this land mass. Poe concentrates on the travel literature written by European political tourists, who, with some ignorance and exagger-

ation, portrayed Muscovy as an Asiatic despotism, its people as brutal and servile, its history as violent and foreign.

In contrast, James Cracraft's essay on St. Petersburg at the beginning of the eighteenth century provides a picture of a tsar reformer borrowing western ideas and personnel to usher in a new and modern age; a population becoming both cosmopolitan and civilized; and a history that was catapulting Russia into the middle of the European stage. Such was the revolution wrought by Peter the Great that travel accounts began speaking not of a "distant world" but of an "imperial colossus." His new capital became not only the architectural embodiment of the empire's power but also the site of a monumental cultural revolution that was transforming Russians into Europeans.

During Peter's reign, Russians began to absorb and adapt European literary ideas, as Irina Reyfman points out, but it was Catherine the Great, herself a prolific author, whose patronage and policies led to the flowering of original creations in all the genres. Furthermore, by attracting Enlightenment figures to her glittering court, the empress brought European renown to the fledgling Russian literature. Attracted by the novelty, a phalanx of artists from all over Europe came to visit Russia and "this newly appeared city" of St. Petersburg. Elena Barkhatova explains how they portrayed the empire's peasants and peddlers, recorded amusements and oddities both urban and rural, drew the constructs that resulted from Catherine's "passion for building," and, upon their return, inaugurated the Russian theme in eighteenth-century European art.

In the eighteenth century, an involvement not just with the arts but also with world exploration and scientific pursuits was essential to a European identity and to being numbered among educated peoples. Richard Wortman's essay depicts the Russians' eagerness to sponsor the documentation of the flora, fauna, and multitude of ethnic groups inhabiting their empire; it also shows their drive to explore beyond Siberia to America, the North Pacific, and indeed to much of the globe, seeking trade, territory, and the expansion of scientific knowledge in a manner that was acceptably "European."

Marc Raeff examines the many avenues that led to the formation of a europeanized elite: schooling, publications, travel, civil and military service, membership in intellectual, spiritual, or philanthropic societies. By the beginning of the nineteenth century, a distinct "western" identity had been forged. However, as Edward Allworth points out, there long coexisted a fascination with the East as a land of splendor and mystery. Through conquest, Russians extended their territory to the Pacific, and, given that they occupied a Eurasian land mass, some considered their culture more properly a combination of eastern and western influences or a bridge that could link the two civilizations. Others rued the loss of their Slavic or Muscovite heritage in the quest for europeanization. Cultural identity, then, was not as simply resolved as it seemed to Peter and Catherine.

The apogee in the drive to integrate Russia into the European family of nations occurred during the reign of Catherine's grandson, Alexander I (r. 1801–1825). The emperor led the coalition of European states that overthrew "the usurper" Napoleon Bonaparte, and thousands of Russian soldiers experienced life to the west of their country's borders. Many returned eager to take fuller participation in public life, but the government balked at this further europeanization. At Alexander's death, young officers in St. Petersburg and Ukraine rebelled in dissatisfaction. While the Decembrist Revolt was easily put down, it demonstrated to the tsars that the project of their forebears, the creation of Russian Europeans, was a mixed blessing.

After 1825, Russia remained an integral part of Europe, and strides forward in the sciences and golden ages of poetry and prose confirmed a remarkable coming of age. However, a new spirit hovered. The government and many of the elite debated the value of using foreign cultural and

political models; they searched, in Romantic fashion, for signs of uniqueness in the Slavic, pre-Petrine past with its eastern overtones. The now classic controversy between westernizers and Slavophiles began in the very early years of the nineteenth century and still dominates the intellectual scene in post-Soviet Russia. The New York Public Library's exhibition and these essays have aimed to set this debate in its historical context.

This book appropriately ends with an afterword by Edward Kasinec and Robert Davis. Kasinec, the visionary curator of the Slavic and Baltic Division of The New York Public Library since 1984, gave birth to the idea both of the exhibition and this companion volume. He and Davis, his second-in-command, won the cooperation of the contributing scholars, raised external funding, ferreted out treasures from the many divisions of the Library, provided information for the items displayed, and, in general, worked tirelessly to bring this project to fruition.

The New York Public Library's holdings of materials on Russia represent over 150 years of intelligent collection. To choose the more than 250 items for display, the curators examined roughly 3,500 Library entries from the fifteenth to the nineteenth centuries. The holdings dictated an emphasis on elite and Great Russian culture, and the authors of the essays were asked to work their themes around the objects that would be used as illustrations. While this book and exhibition thus present just one aspect of the panorama of Russian history, we hope that they will encourage readers and viewers to explore further the riches of an extraordinary people and culture.

The elegance and beauty of this book may be attributed directly to the very talented publications staff of The New York Public Library, who are also a joy with whom to work: Anne Skillion possesses a remarkable sense of the art of the book, both in prose and layout; Barbara Bergeron brings real brilliance to her work as copyeditor; Kara Van Woerden's gift for design is evident on every page of this book; and Karen Van Westering's managerial skills create an atmosphere of efficiency, trust, and friendship.

It has been a special personal pleasure and deeply felt honor to participate so closely in a public event sponsored by the Library, my intellectual home since I researched my first paper in my freshman year at college. Over the decades, I have remained awestruck by the majesty of the building, the wealth of the holdings, and the unmatched quality of the staff.

Cynthia Hyla Whittaker
NEW YORK CITY, FEBRUARY 2003

A Timeline of Related Events

1425 **Vasilii II, "the Blind" (r. 1425–1462), becomes Grand Prince of Muscovy.**

CA. 1450 Florence under the Medici becomes a center of the Renaissance and of Humanism.

Beginnings of the European Age of Exploration.

1453 Ottomans capture Constantinople and end the Byzantine Empire; Islamic Istanbul becomes the political and religious center of Eastern Christendom.

1462 **Ivan III, "the Great" (r. 1462–1505), becomes Grand Prince of Muscovy.**

1472 Ivan III marries Sophia Palaeologus, niece of the last Byzantine emperor.

1478 Ivan III annexes Novgorod and the vast territories surrounding it.

1480 The Stand on the Ugra River marks the end of Mongol rule.

1485–1516 Building of the new Kremlin in Moscow.

1505 **Vasilii III (r. 1505–1533) becomes Grand Prince of Muscovy.**

1520 Süleyman I, "the Magnificent" (r. 1520–1566), becomes the Ottoman Sultan.

1529 Ottoman siege of Vienna; another siege will occur in 1683.

1533 **Ivan IV, "the Terrible" (r. 1533–1584), becomes Grand Prince of Muscovy; in 1547, he will proclaim himself Tsar of Muscovy.**

1552 Opening of the northern sea route to Russia by the Englishman Richard Chancellor.

1552–1556 Annexation of the Khanates of Kazan and Astrakhan, beginning Russia's expansion east through Siberia and to the Pacific.

1556 Beginning of the reign of Akbar I, "the Great" (r. 1556–1605), of India, apogee of the Mughal Empire centered at Delhi and later Agra.

1558 Elizabeth I (r. 1558–1603) becomes Queen of England.

1564 The first book is printed in Moscow by Ivan Fedorov.

At roughly this time, rudimentary maps become accessible to the Muscovite court.

1577 Russia establishes commercial ties with Holland.

1584 **Fedor I (r. 1584–1598) becomes the last of the Riurikid dynasty, which has ruled Russia since 862.**

1587 Beginning of the reign of Shah 'Abbas I, "the Great" (r. 1587–1628), apogee of the Safavid state in Persia, centered in Isfahan, which willl last until 1722.

1598 **Boris Godunov (r. 1598–1605) becomes Tsar.**

1598—1613 A succession crisis in Russia precipitates economic dislocation and political disarray, leading to a period marked by famine, foreign invasion, and popular revolt known as the "Time of Troubles."

CA. 1600 Beginning of the Scientific Revolution in Europe.

1603 Tokugawa Ieyasu becomes Shogun in Japan; Tokugawas rule until 1867.

1605 **Fedor II Godunov (r. 1605) becomes Tsar.**

The First Pretender, Dmitrii (r. 1605–1606), becomes Tsar.

1606 **Vasilii Shuiskii (r. 1606–1610) becomes Tsar.**

1610—1612 The Poles occupy Moscow; the Swedes invade Russian territory.

1613 **The Assembly of the Land elects Mikhail Romanov (r. 1613–1645) to become Tsar, beginning the dynasty that rules until 1917.**

1626 Manhattan Island is purchased from the Native Americans by the Dutch West Indian Company.

1628 Shah Jahan (r. 1628–1658), builder of the Taj Mahal, becomes Mughal Emperor.

1631 Founding of the Kiev Academy, through which western knowledge first penetrates Muscovite culture.

1643 Louis XIV, the "Sun King" (r. 1643–1715), becomes King of France.

1644 Manchus found the Qing dynasty and rule until 1911.

1645 **Aleksei (r. 1645–1676) becomes Tsar.**

1666 Beginning of the Old Ritualist Schism in the Russian Orthodox Church.

1667 Russia acquires Kiev and large areas of Poland-Lithuania through the Treaty of Andrusovo.

1669—1671 The revolt of Stepan Razin reflects popular discontent with an increasingly bureaucratic, highly regulated sociopolitical and military system.

1672 Russians send embassies to all the major European states.

1676 **Fedor III (r. 1676–1682) becomes Tsar.**

CA. 1680—1790 Growth of absolutism in central and eastern Europe.

The Petrine Era

1682 **Ivan V and Peter I become co-Tsars (1682–1696), under the regency of their older sister, Sofiia (regent 1682–1689). Peter continues as sole ruler through 1725.**

1688—1689 The Glorious Revolution in England ends absolutism there.

1689 The Treaty of Nerchinsk between Russia and China establishes recognized borders between the Muscovite State and the Qing dynasty in China.

1695—1696 Successful campaigns to acquire Azov expand Russia's southern border.

1697 Charles XII (r. 1697–1718) becomes King of Sweden.

1697—1698 Peter's Grand Embassy to western Europe.

1700 Defeat of the Russian army at Narva and beginning of the Great Northern War with Sweden.

CA. 1700—1800 The Age of the Enlightenment, a dominant force in the europeanization of Russia.

1703 On May 16, the Russian city of St. Petersburg is founded. By opening this "window onto Europe," Peter the Great sets in motion the complex process of bringing about a nation of "Russian Europeans."

Russia's first newspaper, *Moskovskie vedomosti* [*The Moscow Times*], begins publication.

1721 End of the Great Northern War and Russia's acquisition of Baltic territories, with Russia replacing Sweden as the dominant power in "the North." The formerly isolated kingdom of Muscovy, now known as the Russian Empire, becomes an integral part of the European state system just as Europe is coming to dominate the world.

Peter accepts the title of Emperor.

1724 The Russian Academy of Sciences, Russia's first center of higher learning and scientific research, is founded.

1725 **Peter's second wife, Catherine I (r. 1725–1727), becomes Empress.**

1727 **Peter II (r. 1727–1730), Peter's grandson, becomes Emperor.**

1730 **Anna Ioannovna (r. 1730–1740), Peter's niece, becomes Empress.**

1740 **Ivan VI (r. 1740–1741), Anna's grandnephew, becomes Emperor.**

Reign of Frederick II, "the Great" (r. 1740–1786), of Prussia begins.

Maria Theresa (r. 1740–1780) becomes Empress of the Austro-Hungarian Empire.

1741 **Peter the Great's daughter, Elizabeth (r. 1741–1761), becomes Empress.**

Vitus Bering's expedition reaches the coast of Alaska.

1755 A university on the European model is founded in Moscow.

1756 Russia joins Austria and France against Great Britain and Prussia in the Seven Years War (1756–1763), which is fought on several continents.

1761 **Peter III (r. 1761–1762), Peter's grandson, becomes Emperor.**

1762 **Catherine II (r. 1762–1796) becomes Empress.**

1767—1773 A Legislative Commission is elected in Russia to draft a new law code.

1768—1774, 1787—1792 The First and Second Russo-Turkish Wars are fought.

1770 James Hargreaves patents the "spinning jenny," beginning the mechanization of industry and the path to the Industrial Revolution.

1773—1774 The Pugachev Revolt, led by the army deserter Emil'ian Pugachev, reflects popular discontent with serfdom and social inequalities between landlord and peasant.

1774 Louis XVI (r. 1774–1793) becomes King of France.

1776 Britain's American colonies adopt a Declaration of Independence.

The Alexandrine Era

1782 The statue called the Bronze Horseman is erected in Peter's honor by Catherine II and later immortalized in a long poem of that name by Aleksandr Pushkin, Russia's greatest poet.

1783 A decree by Catherine II permits the operation of private printing presses and publishing houses, which will lead to a growing reading public in Russia.

The Khanate of the Crimean Tatars is annexed by Russia.

1785 The Charter of the Nobility and the Charter of the Cities are issued.

1786 A program for a state system of education is published.

1789 The U.S. Constitution is ratified.

The Fall of the Bastille marks the beginning of the French Revolution.

1796 **Paul I (r. 1796–1801), Catherine's son, becomes Emperor.**

1799 Napoleon I becomes First Consul (1799–1804) of France.

1801 **Alexander I (r. 1801–1825), Catherine's grandson, becomes Emperor.**

The Kingdom of Georgia is annexed by Russia.

1802 Modern governmental ministries are created in Russia.

During the first decade of Alexander's rule, he introduces liberal censorship regulations, which spur the rapid expansion of publishing in all fields.

1804 A system of universities and secondary schools is created in the Russian Empire.

Napoleon I (r. 1804–1814/15) becomes Emperor of France.

1806–1825 Latin American wars of independence are fought.

1807 Slavery is abolished in the British Empire.

1808–1809 Russia annexes Finland, which becomes a Grand Duchy.

1812 Fort Ross, established along the coast of Northern California, represents the Russian Empire's easternmost reach.

Napoleon I invades Russia.

1815 The Congress of Vienna ends the Napoleonic Wars.

1818 Karl Marx is born.

1819 St. Petersburg University opens.

1825 The Decembrist Revolt occurs when Alexander I dies in December; young officers in St. Petersburg demand a constitutional monarchy for Russia and those in Ukraine demand a republic; both groups seek the abolition of serfdom.

A Distant World

Russian Relations with Europe Before Peter the Great

by Marshall Poe

Shortly after the fall of the western Roman Empire in the fifth century, a number of previously unknown groups—the Veneti, the Sclaveni, and the Antes—rather suddenly appeared in the writings of European annalists. Although their exact identity is the subject of some dispute, most historians agree that they were probably Slavs. The early history of this group is shrouded in mystery. We do not know where they came from, who they were, or even what they called themselves. One thing, however, is certain: they were on the move. Under pressure from the Avars, a group of nomadic pastoralists from the western Eurasian Steppe, the Slavs migrated out of their homeland above the Danube to the north and east and settled regions so inhospitable that no agriculturalist had ever attempted to scratch out a living there. Indeed, the only inhabitants of this corner of northeastern Europe at the time were Uralic-speaking hunter-gatherers, the ancestors of today's Finns. Over the course of five centuries, the Slavic plowmen progressed into the seemingly endless forested zone, pushing the proto-Finns before them into a smaller and smaller corner of the continent. As they did so, their Common Slavic language evolved into East Slavic, and the resulting linguistic divisions laid the earliest foundations for what would become Belarusian, Ukrainian, and Russian culture, though hardly in recognizable form.[1]

The peopling of the distant and barren northeastern expanse was a remarkable achievement, but one with two serious consequences. First, the geographic position of the East Slavs meant that they, and particularly that cohort which came to reside north of the Oka River, would be relatively isolated from the great civilizations of medieval western Eurasia: the Carolingian Empire, the Byzantine Empire, the Abbasid Caliphate, and Transoxiana. The East Slavs were pioneers rather than successors. They opened to the axe, plow, and scythe a territory that had hosted no ancient civilization, was not on any major trade route, and was, all things considered, a long way

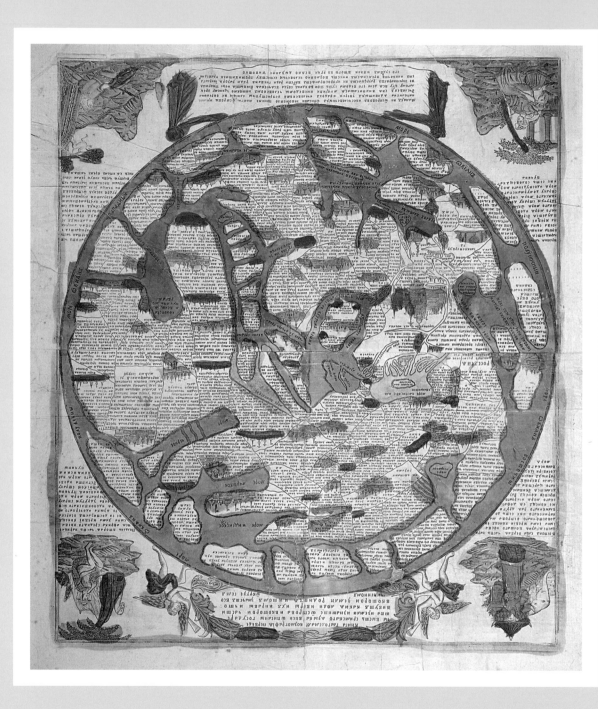

from anywhere. This is not to say that the East Slavs were completely isolated from the ancient centers of Eurasian culture, for they were not. The point is that they did not have very frequent or sustained contact with these cultural loci for a period of approximately half a millennium.

The second consequence resulting from the settlement of the Slavs in the northeast, an area that later became the Russian heartland, was poverty. The territory was ill-suited to agriculture: it was largely covered with pine trees that, while they made excellent building material and provided ready fuel, shed acid-rich needles. This arboreal detritus impoverished the already sandy soil. Being in a northern clime, growing seasons in the East Slavic lands were short. A peasant could hope to harvest only one crop before the fall brought darkness and cold for the next seven or eight months. Finally, it must be said that for all their dogged determination, the East Slavic agriculturalists practiced a rather primitive kind of agriculture. They cleared the forest, scratched the earth with wooden plows until the soil was exhausted, and then they moved on. Yields were low, hunger probably common.

Despite their isolation and poverty, the Slavic plowmen succeeded in settling this unforgiving region, expanding their numbers, and, most importantly, creating the beginnings of a trading network along the many rivers of the region—the western Dvina, the Volkhov, the northern Dvina, and the Dniepr and its tributaries. The dimensions and geography of East Slavic commerce are largely unknown to us, but we can infer that the routes must have been sizable and extensive from the fact that they soon attracted predators. These were the Volga Bulgars, the Khazars of the lower Volga, the Pechenegs and Polovtsy of the Great Steppe, and, most famously, the Vikings or Norsemen of the Baltic. All of these groups proved aggressive and acquisitive, but only the Vikings succeeded in conquering the Slavs.

[1]

AN EARLY RUSSIAN MAP OF THE WORLD

after Cosmas Indicopleustes
Kniga glagolemaia Kosmografiia
Russia, first third of the 18th century

This engraved map is modeled after seventeenth-century Russian monastic translations of world maps based on Byzantine sources, and encountered in medieval universal history books or cosmographies. Based on examples dating back to the second-century astronomer and geographer Ptolemy, this "circular" style was out of favor in western Europe by the late fifteenth century. In the corners are allegorical figures indicating that the sun's rays begin the day in Asia, proceed to Africa, then Europe, and end the day in "New America." Text identifies the geographical location of Muscovy, noting that its cities are built in stone and wood. Moscow is represented by the Kremlin, recognizable by the "splendor of its numerous cupolas." In spite of the advancements of learning in Russia, for some eighteenth-century Russians this map reflected their conceptualization of the world, both symbolically and philosophically.

By the standards of pre-modern warriors, the Vikings were rather sophisticated. Unlike their competitors in northern Eurasia, they did not employ horses as a mode of travel and conquest. Rather, they relied on a very specific and highly advanced form of nautical technology. Their longships were remarkable because they were highly durable, relatively light, and, most significant, capable of traveling with great efficiency both in open seas and tiny rivers. By a peculiar geographic accident, the longship proved to be perfectly suited for travel around the European peninsula of Eurasia, which was surrounded by reasonably mild seas and crisscrossed with large, slow-flowing rivers. Whereas footborne or horseborne warriors had to trudge across the rough and inhospitable terrain of western Eurasia in search of booty, the Vikings could use the sail to travel around it and oars to move within it.

Sometime near the end of the first

millennium C.E., a group of Vikings—the Rus'—took control of the riparian trade route from the Baltic to the Black Sea.[2] Just how they accomplished this, we do not know. As a creation of the Vikings, Kievan Rus' (as historians sometimes call this medieval jurisdiction, whose capital was located in Kiev) shared a common heritage with other early western Eurasian states created or conquered by Norsemen, including regions in England, Ireland, northern and western France, and southern Italy. Indeed, the histories of the western and eastern Viking enterprises are quite similar, as the parallel histories of Normandy and Rus' demonstrate. Once the Vikings became sufficiently established in these areas, they gave up their wandering ways and settled down to rule and tax the natives. In essence, they traded the hard life of nomadic banditry for the easier life of sedentary banditry. Yet neither the Norman nor Rus' enterprise existed in a vacuum. Rather the opposite: both had to deal with the great powers of the day, Rome and Constantinople. After some violent negotiation, a compromise was reached: the new Viking kingdoms would be recognized as legitimate if their subjects would accept Christianity. And so it was, though in truth only a tiny portion of the native populations had any understanding of the Gospel or, for that matter, of the existence of Rome and Constantinople. There were also local politics with which to contend. Being outnumbered by the natives, the Normans and Rus' had to be careful not to push their Frankish and Slavic underlings into rebellion. In any case, they needed native allies and proceeded to marry the native daughters, a process that ended in the Vikings' complete cultural assimilation by the locals. Within a few generations, neither the Normans nor Rus' spoke Scandinavian tongues.[3]

Although they were similar in origin and early development, careful examination reveals a number of crucial differences between Kievan Rus' and the other Viking states. Culturally, the western Vikings were, like the East Slavs they conquered, pioneers. The Norman kingdom inherited the cultural legacy of the older Roman and Carolingian empires. In stark contrast, the eastern Vikings were founders. When the Rus' arrived in the northeast, the Finno-Slavic cultural world they found was functional but comparatively unsophisticated. It contained no hint of the accumulated techniques of classical Greco-Roman culture. The Rus' did receive classical culture through

[2, *opposite, left*]
AN ASCENT TO PARADISE

St. John Climacus
Lestnitsa
Russia, 16th century

Hand-copied books prevailed in Russia far longer than in the rest of Europe, with printing arriving in the Muscovite tsardom a full century after Gutenberg's innovation of moveable type. This manuscript illumination depicts the Scala Paradisi as described in the writings of the sixth-century mystic St. John Climacus. Souls of the earth struggle to hold on to the ladder, tempted by Beelzebub and his cohort. The righteous, assisted by monks in black cowls, resist such temptations and are welcomed into the heavenly city by Christ enthroned; those who fail fall into the maw of the beast.

[3, *opposite, right*]
AN ILLUSTRATED GOSPELS

Evangelie
Moscow, 1606

Despite its appearance, this Church Slavic New Testament is actually a printed book, the work of Ukrainian typographer Anisim Radishevskii. The ornamentation and coloration of this leaf, showing the evangelist John dictating his Gospel to Saint Prochoros, suggest the prevailing stylistic "Orientalism" of Muscovite design in the seventeenth century. Although other copies of this printing exist, few if any have the brilliant hand-coloring of the NYPL volume, suggesting that this one may originally have belonged to the Moscow Patriarch (later Saint) Germogen.

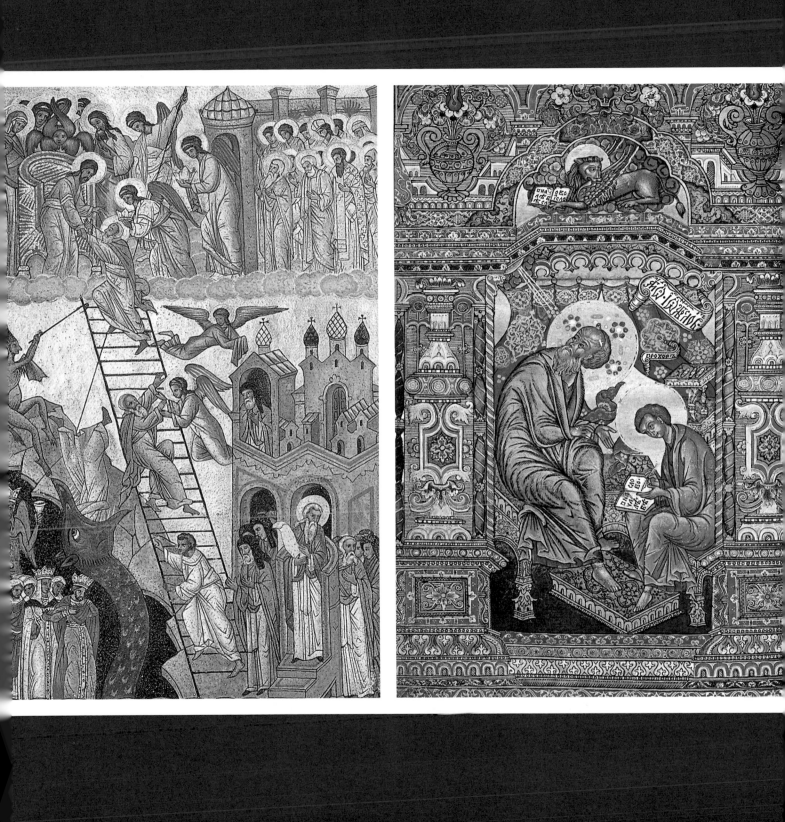

contact with Byzantium, but quite little of it. Christianity was the most important export, yet it took some time to penetrate East Slavic life. Economically, the western Vikings built their operations on the decayed remnants of older imperial infrastructures, while the eastern Vikings had to start almost from scratch. In Gaul, the Romans had constructed a vast system of fortified towns linked together by well-traveled trade routes. In the land of the Rus', the Finns and Slavs had not lived in large settlements, nor was their international trade comparatively lively. Militarily, the eastern Vikings were at war much more often than their western counterparts. Certainly the Normans and their western brothers were involved in their share of violent scrapes. But in one important respect, western Eurasia across the Elbe was pacified after the turn of the millennium: the flow of Eurasian nomads—Huns, Avars, and the others—that had flooded Central Europe over the preceding centuries ceased. The Magyars were the last to come and settle. The story was rather different in Rus'. Here, the nomads continued to arrive and remained very powerful. The early Rus' chronicles overflow with stories of Orthodox princes fighting a host of usually nomadic, usually Turkic-speaking enemies.

Despite these comparative disadvantages, the Rus' were more than reasonably successful. From the tenth century, at the time of the Viking takeover, to the beginning of the thirteenth century, Rus' progressed from a distant, marginally profitable Norse enterprise to an established western Eurasian empire. The writ of the grand prince, as the Kievan ruler was called, ran from the Baltic to the edge of the steppe and from the Vistula to the Upper Volga. Kiev was a considerable metropolis, and smaller towns dotted the landscape. International trade flowed along the region's many rivers. The beginnings of high culture were flowering. True, there were problems: the Kievan realm demonstrated a tendency for periodic breakdown, causing in turn a tendency toward political fragmentation. By the mid-twelfth century, Rus' was already divided into semi-autonomous principalities.[4] Yet it was not some internal mechanism that finally laid the Kievan

[4, *opposite, above*]
NORTHERN MUSCOVY

================================

Guillaume de L'Isle; engraved by Matthaeus Seutter
Mappae Imperii Moscovitici
Augsburg?, 18th century

--

Over the course of the sixteenth and seventeenth centuries, European interest in Russian geography grew rapidly, particularly in the northern part of the state. Muscovy had no stable outlet to the Baltic, so most maritime traffic came over the Scandinavian peninsula and into the White Sea. The Muscovites designated the port of Archangel, on the Northern Dvina River, as the primary transit point for European traders. It was through this port that most Russian-European trade traveled before the Baltic littoral was captured in the eighteenth century. European traders not interested in trade with Russia itself viewed northern Russia as a transit point to the lucrative Persian and eastern markets.

[5, *opposite, below*]
MAP OF MUSCOVY

================================

Tabula Russiae
Amsterdam, 1614

--

In 1613, an assembly elected the first of the Romanovs to the Muscovite throne. At that time, in contrast to our conception of Russia as a part of "Eastern Europe," early modern Europeans understood Russia to be a "northern" country, as we can see in this early seventeenth-century map. Here Russia extends to the edge of the great steppe, where its borders meet "Northern Lithuania" (modern-day Ukraine) and "Crimea" or "Tartaria" (modern eastern Ukraine and southern Russia). Of note are the emphasis on shipping, and the apparently detailed knowledge of place names along the Northern Dvina River, the main route for Europeans into Russia. Embellishments to the map include an inset with a detailed plan of the city of Moscow.

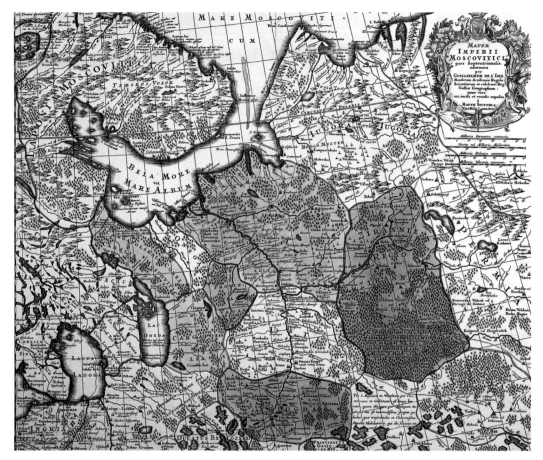

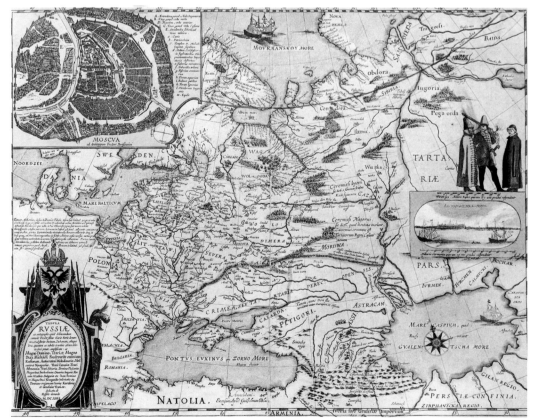

empire low. Rather, the mortal blow was struck by yet another group of Eurasian pastoral nomads—the Mongols.

The Mongols, like the Vikings before them, have been treated with scorn. In the Rus' chronicles they are godless Hagarites, the orphans of God; in more modern times, they become "Asiatic" barbarians, the orphans of civilization. The truth is that the Mongols were the largest, most advanced, and best-led nomadic force ever to cross the Great Steppe. They defeated the most sophisticated empires of Eurasia—Northern China, Southern China, Inner Asia, Safavid Persia. They also subordinated a host of minor, more primitive enterprises, among them the Rus' empire. The Mongols' initial thrust in the early thirteenth century was devastating. They razed entire cities, murdered and pillaged extensively, and desecrated sacred monuments. The nomads sent a message: submit or die. That message was duly received, and Rus' entered the Pax Mongolica. Shortly thereafter, the princes of Rus' were summoned to Sarai (the capital of the Mongol kingdom of the Golden Horde); tax collectors were sent to Rus'; and the Mongol army left Rus' hardly ever to return. For the next two or more centuries, the Mongols would be absentee landlords. As long as the rent arrived promptly, there was very little reason to meddle.[5]

Usually, the tribute did arrive promptly, largely thanks to the good offices of the princes of a tiny town called Moscow. Like all good imperialists, the Mongols worked through local proxies. They would summon a Rus' leader to Sarai, proclaim him grand prince, and dispatch him back to the wilderness to make sure the money kept flowing east. Among the princes so instructed, those in the Muscovite line proved the most able, and their realm of Muscovy grew rich and powerful. Over the course of the fourteenth and fifteenth centuries, they brought the other Rus' principalities (Vladimir, Suzdal, Tver, among them) to heel. During this slow campaign, as they became stronger and stronger, they even managed to adjust the terms of trade with their Mongol masters. In 1380, at the Battle of Kulikovo Field, the Muscovites and their allies faced down the Tatars. The Muscovites still paid, but clearly Mongol power in the northern region was waning. After the Stand on the Ugra River in 1480, the Mongol yoke finally ended.

Into the imperial void stepped a series of remarkable Muscovite leaders who ruled from 1462 to 1584: Ivan III, Vasilii III, and Ivan IV, often called "the Terrible." They expanded the kingdom's borders east beyond the Volga, south to the Caspian Sea, west to the Dniepr, and north to the White Sea (fig. 5). In so doing they came to rule peoples who had never been part of Kievan Rus'—Mordvinians, Chuvash, Mari, Samoyeds, Bashkirs, Tatars, Balts, Finns, Germans, Lithuanians, Poles, Cossacks, and Turks, among others. The once homogeneous Muscovite principality, located in the uniformly East Slavic Oka-Moscow mesopotamia, became a multiethnic empire. This imperial reach brought the warrior elite unprecedented wealth in the form of trading cities— Smolensk, Polotsk, Novgorod, Kazan, Astrakhan (fig. 6). It also brought the Muscovites into contact with other major states in Eurasia. Prior to this period of expansion, the Muscovites lived in a world dominated by the Tatar Khanates, the Byzantine sphere of influence, and the powers of East Central Europe, which included Poland, Lithuania, and the Baltic German jurisdictions. After building their empire, the Muscovites found themselves in a much larger world. To the east was Ming China, to the south were the Safavids and the Ottomans, to the west were the kingdoms of Europe. Commercial, diplomatic, and military relations began with all these states in the later fifteenth and early sixteenth centuries (fig. 4).[6]

Of all these regions, Europe presented the Muscovites with the greatest opportunities. It was closest geographically. To get to China or Persia, the Russians had to cross vast distances and formidable terrain. To get to Turkey, the Muscovites had to fight their way across the Great Steppe. But to get to Europe, they merely had to cross the border with the Baltic German states

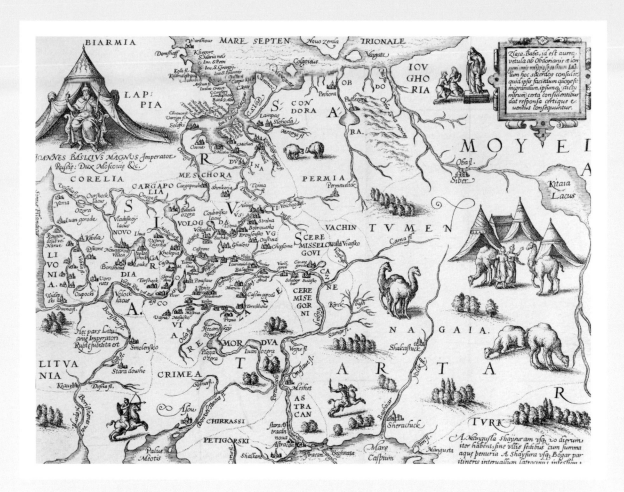

[6]

POSSEVINO'S MAP OF MUSCOVY

Antonio Possevino

Moscovia

Antwerp, 1587

Antonio Possevino of the Society of Jesus was sent by Pope Gregory XIII in the early 1580s to investigate the possibility of clerical and ecclesiastical union between the Catholic and Orthodox churches. His mission came to nothing, but he did use the opportunity of a lengthy stay at the court of Ivan IV ("the Terrible") to record his impressions of Russia. Upon his return to Rome, he drafted and published one of the best descriptions of Muscovy available at the time. Possevino had a keen eye for detail as well as a scholar's knowledge of world affairs. This combination made his *Moscovia* a classic of European intelligence on Russia. The book was referred to frequently by seventeenth-century travelers, and continues to be of value for historians today.

or Poland-Lithuania. Europe was also closest culturally. The eastern regions were Islamic, Hindu, Buddhist, Confucian, or animist. Europeans were Christians, even if of a heretical kind from the Russian perspective. Finally, Europe was the richest region, or at least its riches were the closest at hand, while Isfahan, Bukhara, and Beijing were largely inaccessible. As early as the fifteenth century, Novgorodians were trading in the great Baltic ports, and the commercial centers of northern Europe were almost in reach. It is little wonder, then, that by the early sixteenth century, the once isolated Muscovite regime had become drawn into the orbit of Europe. European diplomats began to travel to Moscow to negotiate Russian involvement in various central European affairs; the interaction between the western and eastern churches intensified, though it remained hostile; and European merchants began to deal directly with the Muscovite government for trading rights in Russian cities.

Western Europeans knew practically nothing about Russia, and most hardly knew that Muscovy existed. It is no surprise, then, that the first visitors recorded their impressions for the curious back home.[7] The first European account was written by an Italian, Ambrogio Contarini, a Venetian diplomat and merchant who was dispatched in 1474 to Persia with instructions to form an alliance for the purpose of attacking the Ottomans. On his return trip in 1475, he was forced north and found himself, quite unexpectedly, in Moscow. Upon returning to Venice, he wrote an account of his travels, focusing on the Persian mission. Muscovy, a place about which he knew little and cared less, was at best a sidelight. Contarini wrote that the grand prince controlled a large territory and could field a sizable army, although he believed the Russians to be worthless soldiers. The people, he reported, were handsome but "brutal" and inclined to while away the day in drink and feasting. He opined that the Russians were Christians, but not very good ones.[8]

Contarini's disdain for the Orthodox faith was typical, but this contempt did not stand in the way of European efforts to convince the Muscovites to help remove the Turks from the continent. In the early sixteenth century, the papacy and the Habsburgs made repeated overtures to Muscovy regarding a possible alliance against the Ottomans. These proposals led nowhere, but they did produce three little tracts on the realm, one each by Alberto Campensé, Paolo Giovio, and Johann Fabri.[9] None of these men had ever been to Muscovy; thus their accounts are full of fantasy, notably the odd idea that every Russian Orthodox believer was a nascent Roman Catholic. Other Europeans possessed less kindly opinions, primarily because they were at war with the Muscovites. Jacob Piso, an Italian in Polish service, wrote Latin verse condemning Russian aggression, and Christian Bomhover, a Livonian official, penned an inflammatory history of Russian atrocities in the Baltics.[10] Some took a more balanced view, as can be seen in the largely neutral Muscovite vignettes found in the contemporary cosmographies of Maciej z Miechowa and Sebastian Münster.[11]

[7]
Tsar Vasilii III

Sigmund von Herberstein
Comentari della Moscovia
Venice, 1550

Tsar Vasilii III, depicted here, was one of the hosts of Sigmund von Herberstein, without a doubt the best and most popular expert on Muscovy in sixteenth-century Europe. Herberstein was familiar with a Slavic language, so he could converse with the Russians after a fashion. As a senior diplomat for the Habsburgs, he was afforded audiences with the highest authorities, and possessed a sharp eye for ethnographic detail. His *Notes on the Muscovites* is a veritable encyclopedia of Rossica.

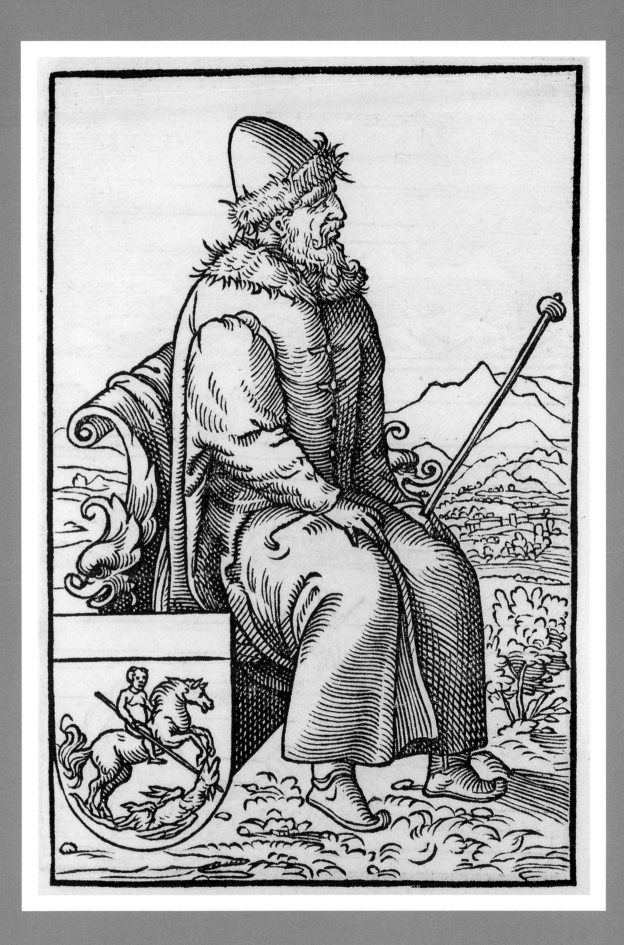

Sigmund von Herberstein's seminal *Notes on the Muscovites*, published first in 1549, was exact, sober, and astoundingly true to life (fig. 7).[12] Herberstein was an experienced Habsburg statesman and had traveled on diplomatic missions to Muscovy in both 1517 and 1527. Although the Muscovites did their best to limit what foreigners learned (diplomats commonly complained that they were being held prisoner), Herberstein succeeded in observing a remarkable amount of Russian life. He recorded it all in thick notebooks like an ethnographer. In stark contrast, earlier European descriptions of Muscovy were short on detail, long on wishful thinking, and often wildly inaccurate.

Some twenty years after his final journey, Herberstein apparently became exasperated with the misinformation being bandied about by supposed experts on Muscovy and decided to set the record straight. He described a vast range of topics: the existing literature on the state; its languages, name, geography, borders, economy, and religion; its ancient history; domestic life; the grand prince's army, mode of rule, titles, and coronation ceremonies; the administration of justice; the history of Muscovy's relations with Poland-Lithuania and the Holy Roman Empire; the condition of the Tatars on Russia's southern and eastern frontiers; the vast and little-known northern territories; the Russian court's treatment of ambassadors; and, finally, the course of Herberstein's own missions to Russia. *Notes on the Muscovites* proved to be the single most influential book on Russia published in the early modern period. Over the next fifty years it was pressed roughly two dozen times and translated into six languages. So impressive was Herberstein's portrait that many authors—including those who had been to Russia themselves—simply gave up and stole his vivid descriptions. More generally, Herberstein's image of Muscovy and its inhabitants was passed down to later generations.

And how did Herberstein depict Russia? In broad terms, he believed it was a tyranny, a polity in which a rogue prince illegally appropriates the commonwealth. In essence, a tyrant makes the *res publica* the *res privata*—he steals the state. The princes in question were Ivan III and Herberstein's own host, Ivan's son, Vasilii III. These men, according to Herberstein, had reduced Rus' to a state of servitude. Vasilii, Herberstein wrote, "uses his authority as much over ecclesiastics as laymen and holds unlimited control over the lives and property of all his subjects: not one of his counselors has sufficient authority to dare to oppose him, or even differ from him, on any subject." Herberstein explained that the Russians' servility before their prince arose out of religious conviction: "They openly confess that the will of the prince is the will of God; on this account they call him God's key-bearer and chamberlain, and in short they believe that he is the executor of the divine will."[13] If the grand prince acted with divine authority in all things, and if he owned the "lives and property" of all his subjects, could these subjects be anything but slaves? No, as was demonstrated by the fact that "all confess themselves to be the *chlopos*, that is, slaves of the prince."[14]

Shortly after the publication of *Notes on the Muscovites*, its author's interpretation of the Muscovite monarchy seemed to be confirmed by events. In the mid-1560s, after what had been by all accounts a very successful reign, Ivan IV earned his epithet "the Terrible" and began a merciless assault on his court and kingdom.[15] Just *why* this happened we do not know, but we do have a good understanding of *what* happened, thanks largely to the observations of several Europeans then in Moscow. Foreigners such as Raffaello Barberino, Heinrich von Staden, Jacob Ulfeldt (fig. 9), Daniel Printz von Buchau, Johann Taube, and Elbert Kruse witnessed acts of cruelty that nearly defied description.[16] Albert Schlichting provided a nightmarish account of one such episode:

Making a sign with his hand the tyrant [Ivan] cried: "Seize him." They stripped him [Ivan Viskovatyi]

naked, passed a rope under his arms, tied him to a traverse beam, and let him hang there. Maliuta went to the tyrant and asked who was to punish him. The tyrant replied: "Let the most loyal punish the traitor." Maliuta ran up to the man as he hung from the beam, cut off his nose, and rode away on his horse; another darted up and cut off one of Ivan's ears, and then everyone in turn approached and cut off various parts of his body. Finally Ivan Reutov, one of the tyrant's clerks, cut off the man's genitals and the poor wretch expired on the spot.... The body of Ivan Mikhailovich was cut down and laid on the ground; the retainers cut off the head, which had neither nose nor ears, and hacked the rest of it to pieces.[17]

Yet the Muscovite tsar hardly had a monopoly on terror. Such displays of violence and cruelty were not unusual in sixteenth-century Europe: think, for example, of the horrors of the Inquisition or the Wars of Religion.

Nonetheless, Ivan's bloody campaign remained somewhat unique. According to the dominant Aristotelian political theory of the day, tyranny was a temporary affair because abused subjects normally would not permit a rogue prince to oppress them forever and would, eventually, overthrow the tyrant. Yet Muscovites remained passive, and they did not rise up against their tormentor or his successor, Fedor. Giles Fletcher, a scholar and English ambassador to Muscovy, said, however, that it was only a matter of time before the entire enterprise imploded. In his famous *Of the Russe Common Wealth* (fig. 10), Fletcher predicted that Ivan's legacy would be civil war:

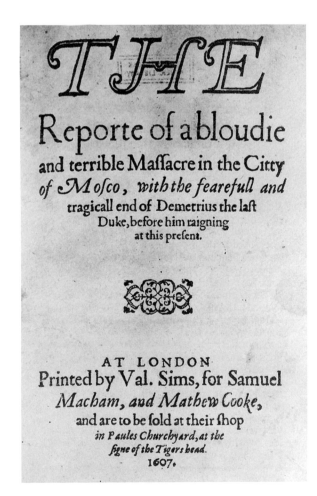

[8]
THE LEGEND OF THE FALSE TSAR

William Russell
The Reporte of a Bloudie and Terrible Massacre in the Citty of Mosco
London, 1607

Dynastic crisis, famine, and foreign invasion brought Muscovy low in the early sixteenth century, a time that quickly became known as the "Time of Troubles" (*Smutnoe vremia*). By this time, many Europeans were on hand in Moscow to witness the intrigue, mass starvation, and capture of the city by one or another faction. A number of such factions were led by men who pretended to be Dmitrii, the last son of Tsar Ivan IV. Tsarevich Dmitrii had actually died, but his legend proved very useful to the players in the civil war. This account of the coup that brought False Dmitrii I's rule to an end proved popular, and in fact an entire genre of "Dmitrii Tales" was produced in Europe in the seventeenth and eighteenth centuries.

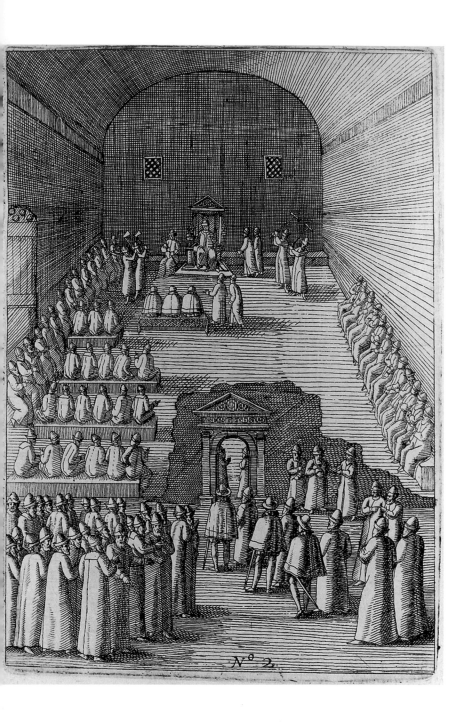

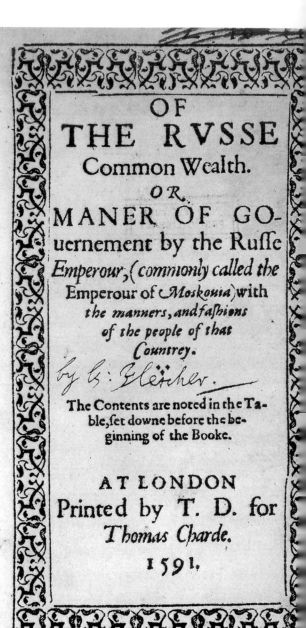

OF
THE RVSSE
Common Wealth.
OR
MANER OF GO-
uernement by the Ruſſe
Emperour, (commonly called the
Emperour of *Moskouia*) with
the manners, and faſhions
of the people of that
Countrey.

by *G: Fletcher.*

The Contents are noted in the Ta-
ble, ſet downe before the be-
ginning of the Booke.

AT LONDON
Printed by T. D. for
Thomas Charde.
1591.

"[His] wicked pollicy and tyrannous practise (though now it be ceassed) hath so troubleld that countrey, and filled it so full of grudge and mortall hatred ever since, that it wil not be quenched (as it seemeth now) till it burne againe into a civill flame."[18] According to Fletcher, Russia's condition was so dire after Ivan's passing that "the people of the most part … wishe for some forreine invasion, which they suppose to bee the onely meanes, to rid them of the heavy yoke of this tyrannous government."[19]

Fletcher was right on both counts, for the succeeding era of Russian history—the "Time of Troubles"—was marked by both civil war and foreign invasion.[20] The former was brought about by a series of unfortunate accidents. The first of these occurred in 1591, when Tsarevich Dmitrii, the son of Ivan IV and possible heir to the throne, died under mysterious circumstances. Although the evidence suggests that the boy stabbed himself during an epileptic seizure, rumor spread that Tsar Fedor's mentor, Boris Godunov, was behind the deed. The second fateful happenstance occurred in 1598, when Tsar Fedor died without an heir. Thus the dynasty that had ruled Rus' for over 700 years—the Riurikid—ended. Boris Godunov was "elected" tsar, but his legitimacy was challenged by a charismatic man claiming to be Dmitrii, who led a sizable army of Russians and Cossacks from the Polish frontier. In the midst of Godunov's battle with the impostor, the third unhappy accident occurred: the tsar himself died. In 1605, Russia had no dynasty, no tsar, and a man claiming to be Tsarevich Dmitrii at the gates of the capital. "Dmitrii" promptly took the city, but was overthrown a year later by Vasilii Shuiskii.

Fletcher's second prophecy was then fulfilled. Shuiskii invited the Swedes to assist him in maintaining the throne; his enemies (led by yet another False Dmitrii) turned to Poland; and both armies proceeded to invade Muscovy (fig. 8). In the subsequent rush of events, Shuiskii himself was ousted in a coup; the Second False Dmitrii was killed by one of his men; the Muscovite elite swore allegiance to the son of the Polish king; and the Poles occupied Moscow. In 1610, Muscovy was an occupied country awaiting the arrival of a new foreign ruler, and the Swedes still threatened. But then a remarkable thing occurred: provincial Russians of every class banded together to repel the foreign invaders and began a movement of national liberation, which, against all odds,

[9, *opposite, left*]
An Audience with Tsar Ivan IV

Jacob Ulfeldt
Hodoeporicon Ruthenicum
Frankfurt, 1608

--

This engraving depicts the audience of Jacob Ulfeldt, a Danish legate in the sixteenth century, with Tsar Ivan IV. Such an audience was one of the rituals typical of European embassies to Moscow. When foreign diplomats arrived in the capital, they were sequestered and allowed very limited contact until the audience. The tsar was to be the first, at least in an official sense, to greet them. Tsar Ivan IV is shown here surrounded by his ceremonial guard; his boyars, or aristocrats, sit silently along the walls and in front of him in rows.

[10, *opposite, right*]
An English Ambassador's Account of Russia

Giles Fletcher
Of the Russe Common Wealth
London, 1591

--

Westerners frequently complained of their treatment at the hands of the Russians, whom they found brutish by the refined standards of Europe. Judging by the severe tenor of Giles Fletcher's *Of the Russe Common Wealth*, the English ambassador seems to have been mistreated more than most. Fletcher describes the tsar's rule as a perfect tyranny, and his subjects as ignorant slaves. Such images were not at all uncommon among European visitors.

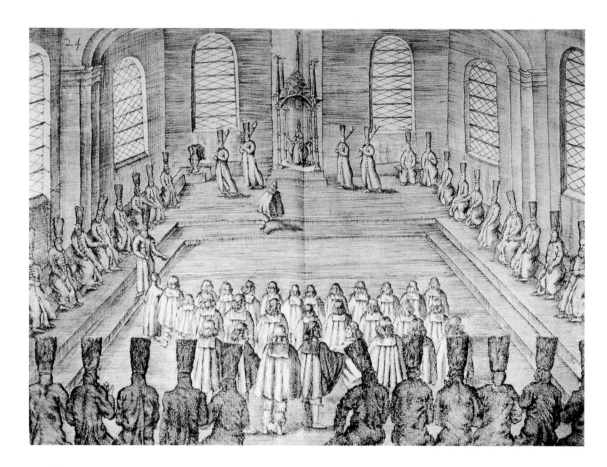

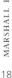

[11, *above*]

AN AUDIENCE WITH THE FIRST ROMANOV

═══════════════════════════════════

Adam Olearius

Viaggi di Moscovia de gli anni 1633, 1634, 1635, e 1636
Viterbo, 1658

- -

Muscovite customs were slow to change. In this
engraving, we see the ambassador of the Duchy
of Holstein, Adam Olearius, being presented to Tsar
Mikhail in the first half of the seventeenth century.
Note that the scene is almost identical to that depict-
ed in the engraving of Ulfeldt's audience of a century
earlier (see fig. 9). We see the same ceremonial
guards, the same boyars arrayed around the walls,
the same foreigners awaiting presentation (though
here they are, more accurately, bareheaded). By this
point in the century, the Romanovs had succeeded in
consolidating their power, largely copying the rituals
of their predecessors, the Riurikid dynasts who ruled
from the tenth through the sixteenth centuries.

[12, *opposite*]

TSAR ALEKSEI

═══════════════════════════════════

Samuel Collins

*The Present State of Russia, in a letter to a friend
at London; written by an eminent person residing at the
great Tzars court at Mosco for the space of nine years*
London, 1671

- -

Samuel Collins was one of the physicians imported
to treat the Russian elite. This frontispiece engraving
for Collins's book is of Tsar Aleksei; it may have been
taken from life and therefore may be among the
earliest depictions of a Russian head of state. The
tsars preferred European doctors to their own Russian
healers, but given the state of Western medicine it is
not certain that this was a wise choice. Collins con-
sidered himself something of a scientist (the friend in
the title was Sir Robert Boyle), but he wasn't a very
good one. His discourse on mushrooms is perhaps
the most interesting thing in his confused account.

succeeded. By 1613, the native forces had pushed back the Swedes and the Poles, and an elected assembly elected a new tsar, Mikhail Romanov, the founder of the second Russian dynasty, which lasted until 1917. All of these events were witnessed and recorded by Europeans who served on various sides in the civil conflict.[21]

After the Time of Troubles, in contrast to Fletcher's expectations, Muscovy remained a tyrannical state. Adam Olearius, a scholar and diplomat from Holstein who visited Russia in the 1630s, noted that Tsar Mikhail was not a tyrant, but rather a mild ruler who was greatly loved by his subjects (fig. 11). Nonetheless, his power was that of a tyrant, for his subjects themselves acknowledged that they were the tsar's slaves:

All subjects, whether of high or low condition, call themselves and must count themselves the tsar's *kholopi*, that is slaves and serfs. Just as the magnates and nobles have their own slaves, serfs and peasants, the princes and the magnate are obliged to acknowledge their slavery and their insignificance in relation to the tsar.[22]

Just as Herberstein had said over one hundred years before, the tsar was the owner of the "lives and property" of all his subjects. But how could Muscovy be a tyranny without a tyrant? Olearius proposed a novel explanation for this century-old paradox. The Aristotelian theory of monarchy assumed that the character of a regime was determined by the behavior of the prince: if he was good, he would be loved and his government stable; if he was a tyrant, then he would be loathed and his reign would be short-lived.

Yet Olearius, an astute reader of Aristotle, discovered in the *Politics* a type of polity that reversed this causality—despotism. In despotic monarchies, the character of the people determined that of the prince. Natural slaves required and rightfully received a despot as ruler. Since natural slavery was a permanent condition, despotisms were immobile. If it was assumed that the Russians were natural slaves, then the question of love or fear became moot; whether they respected the tsar or feared him was of no consequence because their very state of being necessitated complete submission. Or so it seemed to Olearius:

Their nature is such that, as the wise Aristotle said of the barbarians, "they cannot and shall not live other than in slavery." To them applies also what Aristotle said of the peoples of Asia Minor, who are called Ionians because they derived from the Greeks: "They are miserable in freedom and comfortable in Slavery."[23]

Later European commentators agreed with this judgment; the Russian tsar was a despot, and in despotism, seemingly absolute power is routinely afforded the ruler and passively accepted by his subjects.[24]

There can be little doubt that Olearius and other observers exaggerated the extent of the tsars' power and the submissiveness of those in their realm. The historical record clearly contradicts the notion of state omnipotence and subject servility. On several occasions—the urban riots of 1648, the Copper Revolt of 1662, Stenka Razin's rebellion in 1669–1671, the Solovetskii Monastery Uprising of 1668–1676, and the revolt of the *strel'tsy*, or elite guards, in 1682—disgruntled Russians rose up against what they perceived as tyrannical authority. A more accurate assessment is to say that seventeenth-century Muscovy was usually ruled by a coalition of forces, including the royal family, boyars, church hierarchs, and military servitors, who exercised direct control over the serfs.

Clearly, however accurate their accounts, west and central European observers saw Muscovite Russia as a world apart, a "rude and barbarous kingdom" distant from the mores of their own civilization. Russians, in turn, prided themselves on being the sole protectors of Orthodoxy—in their eyes, the only true religion—and maintained an aloofness toward peoples of other faiths with whom they came into contact. This sense of satisfied isolation and heavy religiosity began to weaken during the reign of the second Romanov, Aleksei (fig. 12). The tsar himself was very pious but developed and communicated a taste for west European ballet, theater, literature, snuff, asparagus, and roses—secular pleasures inimical to traditional practitioners of the Muscovite way of life. But it was Aleksei's son, Peter, who would cast aside tradition, forcibly pull Russians out of their isolation, and turn the Orthodox Muscovite state into a secular westernized empire that no longer stood apart from the rest of Europe as a distant world.

Notes

1 P. M. Barford, *The Early Slavs: Culture and Society in Early Medieval Eastern Europe* (Ithaca, N.Y.: Cornell University Press, 2001).

2 Thomas S. Noonan, "Why the Vikings First Came to Russia," *Jahrbücher für Geschichte Osteuropas*, 34 (1986): 321–348; Omeljan Pritsak, "The Origin of Rus'," *Russian Review*, 36 (1977): 249–273.

3 Simon Franklin and Jonathan Shepard, *The Emergence of Rus', 750–1200* (London: Longman, 1996).

4 John L. I. Fennell, *The Crisis of Medieval Russia, 1200–1304* (London: Longman, 1983).

5 Charles Halperin, *Russia and the Golden Horde: The Mongol Impact on Russian History* (Bloomington: Indiana University Press, 1985). A revisionist approach, stressing the importance of the Mongols on early Rus' and Muscovite history, is found in Donald G. Ostrowski, *Muscovy and the Mongols: Cross-cultural Influences on the Steppe Frontier, 1304–1589* (Cambridge, England: Cambridge University Press, 1998).

6 The rise and early history of Muscovy are ably treated in Robert Crummey, *The Formation of Muscovy, 1304–1613* (London: Longman, 1987).

7 Marshall Poe, *"A People Born to Slavery": Russia in Early Modern European Ethnography, 1476–1748* (Ithaca, N.Y.: Cornell University Press, 2000). For a complete bibliography of foreign accounts of Muscovy, see Marshall Poe, *Foreign Descriptions of Muscovy: An Analytic Bibliography of Primary and Secondary Sources* (Columbus, Ohio: Slavica Publishers, 1995).

8 Ambrogio Contarini, *Questo e el Viazo de misier Ambrosio Contarini* (Venice, 1487). See *Travels to Tana and Persia* by Josefa Barbaro and Ambrogio Contarini, trans. William Thomas and S. A. Roy, Esq. (London, 1873), pp. 161–163.

9 Alberto Campensé, *Lettera d'Alberto Campense che scrivo al beatissimo Padre Clemente VII intorno alle cose di Moscovia* (Venice, 1543); Paolo Giovio, *Pauli Iovii Novocomensis libellus de legatione Basilij magni principis Moscoviae ad Clementem VII* (Rome, 1525); Johann Fabri, *Ad serenissimum principem Ferdinandum archiducem Austriae, Moscovitarum iuxta mare glaciale religio, a D. Iaonne Fabri aedita* (Basel, 1526).

10 Jacob Piso, "Epistola Pisonis ad Ioannem Coritium, de conflictu Polonorum et Lituanorum cum Moscovitis," in *Ianus Damianus, Iani Damiani Senensis ad Leonem X. Pont. Max. de expeditione in Turcas Flegia* (Basel, 1515); Christian Bomhover, *Eynne schonne hystorie van vnderlyken gescheffthen der heren tho lyfflanth myth den Rüssen unde tataren* (Cologne?, 1508).

11 Maciej z Miechowa, *Tractatus de duabus Sarmatiis asiatiana et europiana et de contentis in eis* (Cracow, 1517); Sebastian Münster, *Cosmographia. Beschreibung aller Lender durch Sebastianum Munsterum in welcher Begriffen aller völker Herrschafften, Stetten, und namhafftiger Flecken herkommen* (Basel, 1544).

12 Sigmund von Herberstein, *Rerum moscoviticarum commentarii* (Vienna, 1549).

13 Sigmund von Herberstein, *Notes upon Russia*, trans. R. H. Major. 2 vols. (London, 1851–1852; reprint, New York: B. Franklin, 1963?), 1: 32.

14 Ibid., 1: 95. See also Marshall Poe, "What Did Russians Mean When They Called Themselves 'Slaves of the Tsar'?" *Slavic Review*, 57 (1998): 585–608.

15 On Ivan's reign, see R. G. Skrynnikov, *Ivan the Terrible*, trans. Hugh F. Graham (Gulf Breeze, Fla.: Academic International Press, 1981).

16 Raffaello Barberino, "Relazione di Moscovia," in *Viaggi di Moscovia de gli anni 1633, 1634, 1635 e 1636* (Viterbo, 1658); Heinrich von Staden, "Aufzeichnungen über den Moskauer Staat." See *Aufzeichnungen über den Moskauer Staat*, ed. Fritz T. Epstein (Hamburg: de Gruyter, 1964); Jacob Ulfeldt, *Hodoeporicon Ruthenicum in quo de moscovitarum regione, moribus, religione, gubernatione, & Aula Imperatoria quo potuit compendio & eleganter exequitur* (Frankfurt, 1608); Daniel Printz von Buchau, *Moscoviae et ortus progressus* (Neisse in Schlesian, 1668); Johann Taube and Elbert Kruse, *Erschreckliche / greuliche und unerhorte Tyranney Iwan Wasilowictz / jtzo regierenden Grossfürsten in der Muscow* (N.p., 1582).

17 Albert Schlichting, "De Moribus et Imperandi Crudelitate Basilij Moschoviae Tyranni Brevis Enarratio." Written 1571. Cited text: "'A Brief Account of the Character and Brutal Rule of Vasil'evich. Tyrant of Muscovy' (Albert Schlichting on Ivan Groznyi)," trans. Hugh Graham, *Canadian-American Slavic Studies*, 9 (1975): 259–260.

18 Giles Fletcher, *Of the Russe Common Wealth* (London, 1591). See "Of the Russe Common Wealth" in *The English Works of Giles Fletcher, the Elder*, ed. Lloyd E. Berry (Madison: University of Wisconsin Press, 1964), p. 201.

19 Fletcher, "Of the Russe Common Wealth," p. 210.

20 On the Time of Troubles, see Sergei F. Platonov, *The Time of Troubles*, trans. John T. Alexander (Lawrence: University of Kansas Press, 1970) and Chester S. L. Dunning, *Russia's First Civil War: The Time of Troubles and the Founding of the Romanov Dynasty* (University Park: Pennsylvania State University Press, 2001).

21 Konrad Bussow, *Verwirrter Zustand des Russischen Reichs*. See *The Disturbed State of the Russian Realm*, trans. G. Edward Orchard (Montreal: McGill-Queen's University Press, 1994); Jacques Margeret, *Estat de l'Empire de Russie et Grand Duché de Moscouie* (Paris, 1607). See *The Russian Empire and the Grand Duchy of Muscovy*, trans. and ed. Chester S. L. Dunning (Pittsburgh: University of Pittsburgh Press, 1983); Issac Massa, "Een coort verhael van beginn oospronck deser tegenwoordige troeblen in Moscovia, totten jare 1610 int cort overlopen ondert gouvernenment van diverse vorsten aldaer." See *A Short History of the Beginnings and Present Origins of These Present Wars in Moscow Under the Reign of Various Sovereigns down to the Year 1610*, trans. G. Edward Orchard (Toronto: University of Toronto Press, 1982).

22 Adam Olearius, *Austührliche Beschreibung der kundbaren Reyss nach Muscow und Persien* (Schleswig, 1647). See *The Travels of Olearius in Seventeenth-century Russia*, trans. and ed. Samuel H. Baron (Stanford, Calif.: Stanford University Press, 1967), p. 147.

23 Olearius, *Travels*, p. 151.

24 Samuel Collins, *The Present State of Russia* (London, 1667); Johann Georg Korb, *Diarium itineris in Moscoviam* (Vienna, 1700 or 1701). See *Diary of an Austrian Secretary of Legation at the Court of Czar Peter the Great*, trans. and ed. Count MacDonnell (London, 1863; reprint, London: Cass, 1968); Paul of Aleppo, *The Travels of Macarius Patriarch of Antioch. Written by his Attendant Archdeacon, Paul of Aleppo, in Arabic*, trans. Francis C. Belfour. 2 vols. (London, 1829–1836); Augustin Freiherr von Meyerberg, *Iter in Moschoviam ... ad Tsarem et Magnum Ducem Alexium Mihalowicz, Anno M.DC.LXI* (Cologne?, 1679?); Jacob Reutenfels, *De rebus Moschoviticis ad serenissimum Magnum Hetruriae Ducem Cosmum tertium* (Padua, 1680); Carl Valerius Wickhart, *Moscowittische Reiß-Beschreibung* (Vienna, 1677).

St. Petersburg

The Russian Cosmopolis

by James Cracraft

No major city of the modern world is more closely connected with its founder than St. Petersburg is with Peter the Great. Extant buildings dating directly from his life and reign (born 1672, ruled 1689–1725) include his *domik*, the little Dutch-style house that was his first home in the city; his Summer Palace, where his many-sided interests are memorialized in the numerous personal items on display; suburban Peterhof (Petrodvorets), the complex of palaces and parks overlooking the Finnish gulf that was his favorite retreat; and the central fortress with its church of Saints Peter and Paul, where he is buried. Many other buildings in today's St. Petersburg also date back to Peter's time: the Winter Palace, the Admiralty, the Academy of Sciences, the *Kunstkamera* or museum of natural history, and the building that housed his central administrative departments or "colleges" and is now, like Peterhof, part of St. Petersburg University (fig. 14). Countless other mementos of Russia's first emperor are to be found in the city as well: museum exhibits, historic sites, shop signs, street names, and monumental statues—most famously, the statue called the Bronze Horseman (fig. 15), which was erected in Peter's honor in 1782 by Catherine II and later immortalized in a long poem of that name by Aleksandr Pushkin, Russia's greatest poet. Not only is the city named after Peter's patron saint but its popular nickname in Russian, maintained throughout the Soviet era, is "Piter," the Dutch form of his name that he himself often used (he learned to speak Dutch, then the lingua franca of the Baltic maritime world). To call the city "Piter" in the Soviet era implied opposition to "Leningrad," its official designation from 1924 to 1991, when its citizens voted to restore its original name.

All these elements of St. Petersburg today constitute tangible connections with Peter; all are enduring reminders of his reign as Russia's tsar and first emperor, the title officially conferred on him in 1721 in recognition of his victory in the long war with Sweden for control of the

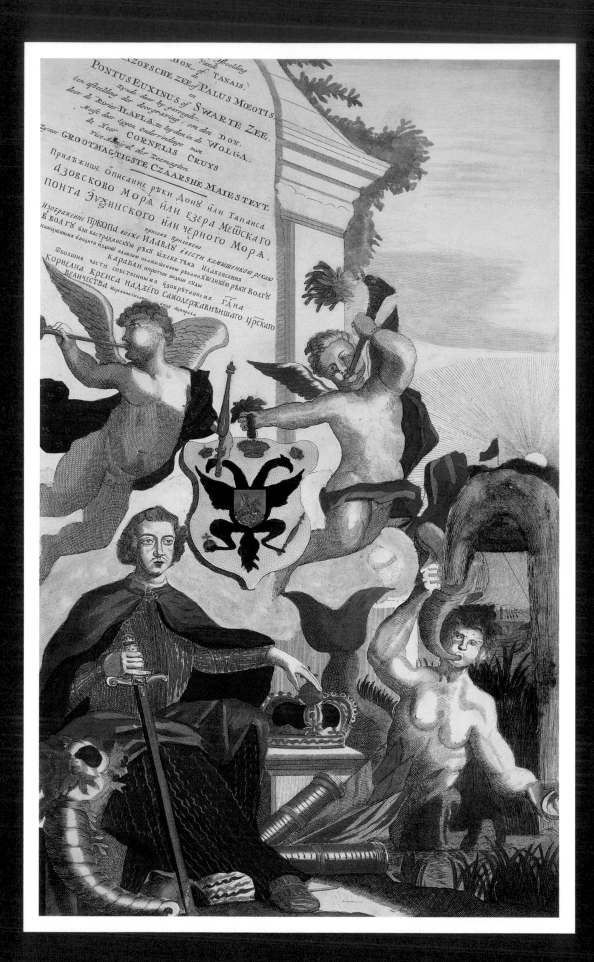

eastern Baltic. Successfully waging the war—known in history as the Great Northern War—had necessitated sweeping military and administrative reforms in Russia and the creation of a Russian navy. These achievements, stunning enough in their own right, had led in turn to the establishment of primary and specialized secondary schools for the training of naval and artillery officers, clergy, and government officials. They had also entailed an enormous expansion of printing facilities in Russia and the publication, in a newly streamlined "civil" alphabet, of a wholly unprecedented number of secular books. In time came Peter's foundation of the St. Petersburg Academy of Sciences, Russia's first university and center of scientific research. Still more, his victory in the Northern War occasioned a diplomatic revolution in Europe, with Russia replacing Sweden as the dominant power in "the North." The formerly isolated kingdom of Muscovy, now known as the Russian Empire, had become an integral part of the European state system just when Europe was coming to dominate the world.

St. Petersburg remains the principal site and architectural embodiment of the cultural revolution in Russia that issued from Peter's myriad victories, achievements, and projects. The whole city, in short, has an enduring historical importance that goes well beyond its many concrete connections with the person and reign of its founder. Never a purely Russian town in the narrowly ethnic or nationalist sense of the term, always a metropolis of indisputably cosmopolitan dimensions, St. Petersburg's history is the history of Russia's struggle to claim, and then to maintain, a leading role in Europe and the world. Even during the Soviet era, when Moscow again became Russia's political capital and the country retreated into economic and cultural autarky, St. Petersburg's classical architecture, its great poets, its imperial history, its very location, constituted potent reminders of that claim.

Investigations of St. Petersburg's history usually begin with its striking geographical site. Located in the low-lying marshy delta of the Neva River, where it empties into the Finnish gulf of the Baltic Sea, "Peter's creation" (as Pushkin called it) is the northernmost of any major city in the world. Its damp, raw climate is both meteorologically unsettled and psychologically unsettling: the sun never fully rises in the depths of winter, never fully sets in high summer, when its citizens enjoy the "white nights" of June and July. The Neva and its tributaries regularly overflow, for an average of nearly one serious flood a year since the city's founding. The soils of the immediate area are poor, its vegetation is sparse; under a natural economy it never supported more than a few fishing hamlets. Climate and location, with their recurrent mists and looming clouds, impart to St. Petersburg that eerie or magical atmosphere hauntingly evoked by generations of local writers, poets, and painters. But a less auspicious setting in which to locate the capital of a great empire is hard to imagine.[1]

There was no one act or date by or on which St. Petersburg was founded; it became the new capital by stages, as events and Peter's ever more ambitious plans unfolded. First came the war with Sweden, which was motivated by the long-standing

[13]
PETER I OF RUSSIA

Cornelius Cruys
Nieuw pas-kaart boek
Amsterdam, [1703–1704]

This striking, hand-colored depiction of a youthful Peter the Great is from the title page of *A New Book of Charts* by Cornelius Cruys, born Niles Olufson Olsen in Stavanger, Norway. Cruys rose in the Dutch maritime service to a senior position at the Admiralty in Amsterdam. There, in 1697, he met Peter the Great, who appointed him the first vice-admiral of the nascent Russian navy. An accomplished hydrographer, this is the only example of his work known to survive.

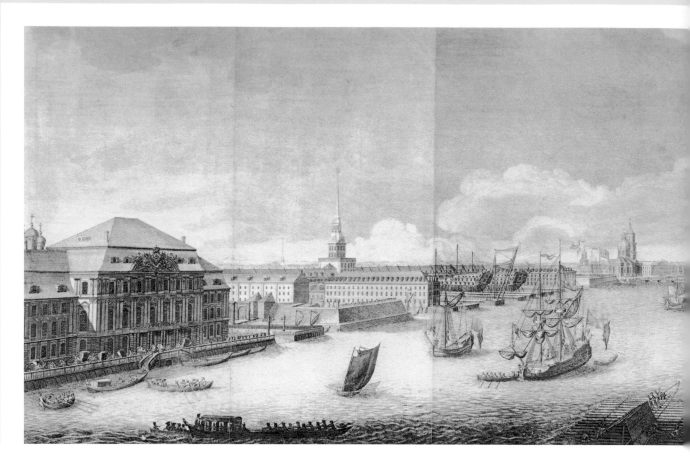

[14, *above*]
VIEW OF ST. PETERSBURG

Mikhail Ivanovich Makhaev
Plan stolichnago goroda Sanktpeterburga
St. Petersburg, 1753

--

This view from the Neva River is looking downstream, or west, toward the Gulf of Finland. The Winter Palace and the Admiralty are visible on the left, the *Kunstkamera* (the natural history museum and library, with tower) on the right. The engraving was made through a camera obscura—a device that reflects images onto a surface for the artist to draw. Mikhail Makhaev made many of his drawings from the perspective of the tower of the *Kunstkamera*. This engraving was published by the St. Petersburg Academy of Sciences after a drawing made in 1749.

[15, *opposite*]
THE BRONZE HORSEMAN

John Augustus Atkinson
Frontispiece (etching and aquatint) for the portfolio
Panoramic Views of St. Petersburg
London, [1805–1807]

--

The famous equestrian statue of Peter the Great was executed in bronze on a massive granite base by Étienne-Maurice Falconet assisted by Marie-Anne Collot and formally unveiled in St. Petersburg in 1782. Inscribed, in Russian and Latin, "To Peter the First from Catherine the Second," the monument became known as the Bronze Horseman from the celebrated 1833 poem of that title by Aleksandr Pushkin. The movement of the huge granite slab— the "Thunder Stone"—upon which the statue sits was itself a considerable achievement, engineered by Carburi de Ceffalonie (Marinos Charboarēs). The English artist John Augustus Atkinson traveled extensively in Russia in the 1780s and 1790s. For his other views of St. Petersburg, see fig. 51 on page 87, below.

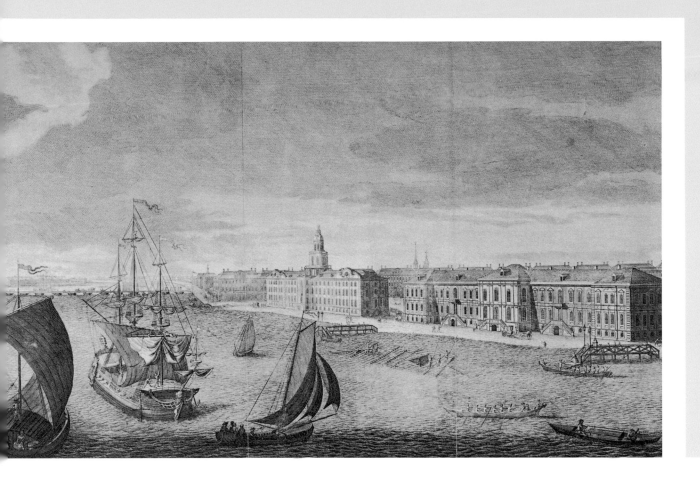

TO HIS IMPERIAL MAIESTY
ALEXANDER 1ST
THESE FOVR PANORAMIC VIEWS
OF ST PETERSBVRGH TAKEN A CENTVRY
AFTER ITS FIRST FOVNDATION BY
PETER THE GREAT,
ARE MOST HVMBLY DEDICATED BY HIS
MVCH OBLIGED AND DEVOTED SERVANT
JOHN A. ATKINSON.

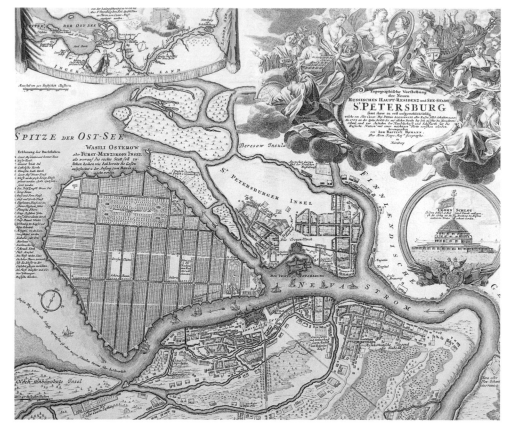

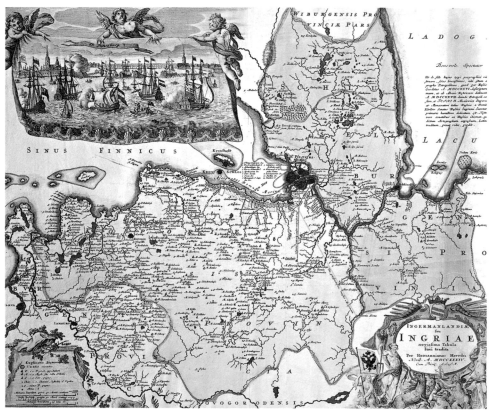

desire of Muscovy's rulers to gain, or regain, a foothold on the Baltic. The war began in the fall of 1700 with Peter's disastrous siege of Narva, a Swedish-held river port located near the Finnish gulf about 160 kilometers west of the site that became St. Petersburg. Quickly regrouping and reequipping his forces, he ordered small-scale attacks on other Swedish strongholds positioned along the Gulf and in 1702 launched a major campaign from the north and east. In the spring of 1703 Russian forces captured the trading settlement called Nyenskans in Swedish (Nevalinna in Finnish), which was situated just south of the last big bend in the Neva, where it turns west to flow rapidly into its delta. Peter renamed the settlement Shlotburg (from German *Schlot* or "neck," referring no doubt to the nearby neck of the Neva) and then sent a detachment of soldiers in search of a better place to fortify. They soon found a little island located about 4 kilometers down-river from Shlotburg, in the main channel of the Neva, roughly at the point where it separates into several branches, a spot accessible from the gulf to the largest vessels then afloat. There, on May 16, the foundations of a fortress were laid. It was christened St. Petersburg (Sant-Piterburkh, eventually Sankt-Peterburg), a typically Petrine Germanism (or Dutchism) chosen, apparently, to project a Baltic and European, rather than simply Russian, identity. And this date came to mark the foundation of the city.[2]

So the location of St. Petersburg was chosen for urgent tactical reasons, and the city began life as a fortress. But much more was to come. On June 29, 1703, the feast day of Saints Peter and Paul, a church was inaugurated within the fortress and dedicated to them (the name, Peter-Paul, was eventually applied to the fortress as a whole). In various documents of the time Peter and his officials were soon referring to the ensemble of fortress, church, and attached encampment of soldiers and builders as "Petropolis" or "Petropol" as well as "St. Petersburg," names that also suggested wider European pretensions. An issue of the *Moscow Gazette* published in August 1703 announced that "His Tsarist Majesty has ordered a fortified settlement to be built

[16, *opposite, above*]
AN EARLY MAP OF ST. PETERSBURG

Johann Baptist Homann
Topographische Vorstellung der neuen russischen Haupt-
Residenz und See-Stadt St. Petersburg
Nuremberg, [1718]

This plan of the infant St. Petersburg, printed by the famed map publisher Johann Baptist Homann, is one of the first published descriptions of St. Petersburg, "the new Russian royal residence and seaport." The hexagonal Peter-Paul fortress is depicted at the center; the similarly fortified Admiralty is across and downriver from it. Vasil'evskii Island (left), only just being settled at the time, shows the plan for its "regular" development drawn up for Peter the Great by the Swiss-Italian Domenico Trezzini, the first architect of St. Petersburg.

[17, *opposite, below*]
ST. PETERSBURG RISES ON TERRITORY CAPTURED FROM THE SWEDES

Ingermanlandiae seu Ingriae
Nuremberg, 1734

Ingria, a disputed territory for centuries, was annexed to Russia by Peter the Great in 1721 at the conclusion of the Great Northern War with Sweden. The region formed a protective land barrier around his new city of St. Petersburg, which we see in the tapestry at upper left, helpfully displayed by thoughtful *putti*. Warlike ships are on parade in this view, which was published by the mapmaker Homann's heirs. At the lower right, various sea nymphs pay homage to Neptune, God of the Sea, probably an allusion to St. Petersburg as the headquarters of the Russian Admiralty, and to its evolving importance as a center of trade and commerce.

not far from Shlotburg, by the sea, so that henceforth all goods arriving [from Europe] should find a haven there, as should Persian and Chinese goods." The announcement indicates that Peter now had it in mind to create a major port at the site, too. The first friendly foreign ship, a Dutch merchantman, arrived in November 1703 with a cargo of salt and wine; its captain was handsomely rewarded and similar rewards were promised to other shippers willing to help supply the new settlement. In 1704 Peter's forces finally captured Narva, giving him greater control of the approaches to St. Petersburg. That autumn construction began on an "Admiralty" or fortified shipyard situated on the left or southern bank of the Neva, just across and a little downriver from the Peter-Paul fortress. And in a letter of September 1704 Peter called the infant settlement *stolitsa*, a Russian word that can be translated "metropolis" but also "capital" or "capital city."

Within a year or so of founding the fortress, in other words, its site at the mouth of the Neva had been transformed in Peter's mind into a naval base as well as potential seaport and major city. Yet before he could seriously proceed with any such plans, the ongoing war with Sweden had to be resolved. Charles XII, the Swedish king, steadfastly refused to negotiate and in 1708 invaded Peter's realm with the aim of dethroning him, only to be roundly defeated by Russian forces at Poltava, in Ukraine, in 1709 (figs. 18, 19). Two years later, at the battle by the Pruth River, in Moldavia, Peter was obliged to capitulate to the larger army of the Turkish Grand Vizier, which meant the end of his Petropolis in the south. Peter interpreted these developments as providential proof that he should focus his energies on building his "paradise" on the Baltic, a project which so preoccupied him that in 1714 he ordered an indefinite halt to masonry construction anywhere else in his domains. That year his navy won an important victory over a Swedish squadron off Hangö Head, on the coast of Finland (fig. 20), and the St. Petersburg Naval Academy was founded.

CAROLUS XII.
SVECORUM GOTHORUM
ET VANDALORUM REX.

[18]

PORTRAIT OF CHARLES XII OF SWEDEN

Erik Jönsson Dahlbergh
Suecia antiqua et hodierna
[Stockholm, 1667–1716]

Charles XII, who ruled Sweden from 1697 (when he was fifteen) until his death on the battlefield in 1718, is shown here in an engraved portrait from Erik Jönsson Dahlbergh's *Ancient and Modern Sweden*. Before Peter could proceed with plans for the great city that he envisioned, the war with Sweden had to be resolved, but he underestimated the intelligence and political resolve of the young Swedish king. The Northern War between Russia and Sweden was not brought to an end until 1721. The French philosopher Voltaire, who wrote the classic biography *Histoire de Charles XII*, admired Charles for his courage and character, but was critical of many of his policies and his flawed military strategy.

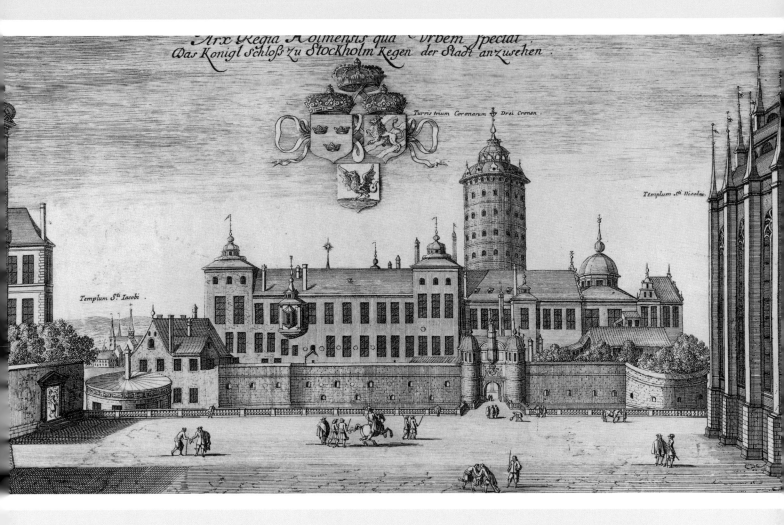

Arx Regia Holmensis qua Urbem Spectat.
Das Konigl Schloß zu Stockholm Kegen der Stadt anzusehen.

Turris trium Coronarum & Drei Cronen.

Templum Sti Nicolai.

Templum Sti Iacobi.

[19]
A SQUARE IN STOCKHOLM

Erik Jönsson Dahlbergh
Suecia antiqua et hodierna
[Stockholm, 1667–1716]

This engraving from Erik Jönsson Dahlbergh's collection of 353 plates, *Ancient and Modern Sweden*, appeared at the moment of the country's age of imperial greatness and was intended to demonstrate Sweden's hegemony in northeastern Europe. Dahlbergh was a fortifications expert, cartographer, engineer, architect, and accomplished draftsman as well as a military and governmental administrator. At the age of seventy-one, he was appointed governor-general of Sweden's most affluent province, Livland. Here Dahlbergh provides a view of the western facade of the royal castle Tre Kronor in Stockholm. Drafted by Dahlbergh and engraved by Jean Morot, it is of special importance since it is one of only a handful of extant depictions of the castle, which was destroyed by fire in 1697.

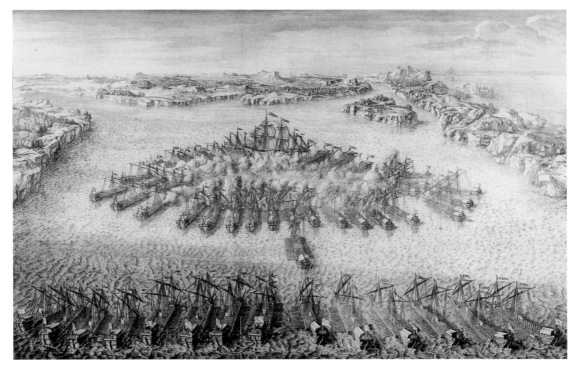

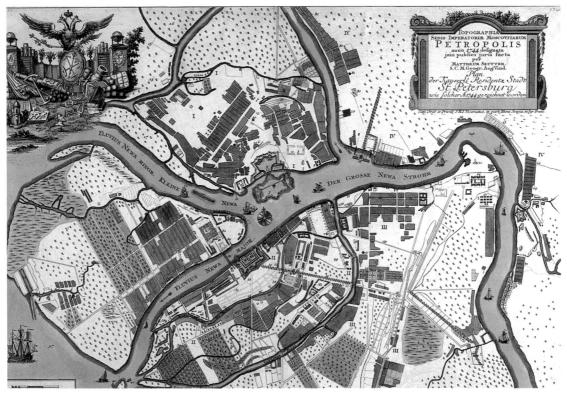

The Northern War between Russia and Sweden was not brought to an end until 1721, with the Peace of Nystad. But in the meantime Peter hastened the buildup of St. Petersburg and its protective Baltic fleet, sparing no expense, the scale of the project seeming to grow ever grander from year to year. Such figures as we have indicate that between 1703 and 1725 anywhere from 10,000 to 30,000 workers labored annually on the construction of the city, their efforts directed by the thousand or more architects, masons, and interior decorators recruited in Italy, Germany, Holland, and France. The first of the architects to arrive and in many ways the most important was Domenico Trezzini, a Swiss-Italian who was hired away from the Danish king's service in 1703. He built St. Petersburg's first permanent fortifications, laid out its streets and squares, designed and directed the construction of houses, and started the first architectural school ever known in Russia. Trezzini's surviving structures include the Peter-Paul fortress and church, the Summer Palace, the building housing Peter's new administrative offices (the Building of the Twelve Colleges), and the Church of the Annunciation at the Aleksandro-Nevskii Monastery, which was founded by Peter to shelter the remains of the medieval warrior-saint of that name. Trezzini also first laid out the famous Nevskii Prospekt, the great long avenue connecting the Admiralty and the monastery, which quickly became the city's main thoroughfare (fig. 21). His best pupil, Mikhail Zemtsov, went on to design still more buildings for St. Petersburg and to train dozens of other native builders, who in turn brought the new architecture to Moscow and beyond.

Jean-Baptiste-Alexandre Leblond, hired by Peter's agents in France in 1716, is generally considered the ablest of the first architects of St. Petersburg, where he worked from August of that year until his sudden death from smallpox in February 1719. Leblond designed parks and noble townhouses both in the city and at suburban Peterhof, the would-be Russian Versailles, which still retains strong evidence of his influence. Other architectural creators of the new capital, always

[20, *opposite, above*]
THE BATTLE OF HANGÖ

Aleksei Fedorovich Zubov
Etching depicting the Russian naval victory over Sweden at Hangö Head, July 27, 1714
Moscow, 1717

Aleksei Zubov, who is considered the first Russian printmaker, was trained by Dutch graphic artists hired by Peter the Great to work in Russia. Zubov executed numerous commissions for Peter, including maps, views of St. Petersburg, depictions of court celebrations, and illustrations for technical manuals. This etching depicts an important Russian naval victory.

[21, *opposite, below*]
THE TOPOGRAPHY OF ST. PETERSBURG

Tobias Conrad Lotter
Topographia sedis Imperatoriae Moscovitarum Petropolis anno 1744
Augsburg? 1744

The so-called Academy Map of St. Petersburg, designed by Matthaeus Seutter, was the first map published by the Russian Academy of Sciences, in 1737. In this later, hand-colored derivative, the map-maker has inserted the new Winter Palace (today's Hermitage Museum), as well as other new structures added between 1737 and 1744. The map is printed in both Latin, the language of scholarship, and German, the language of the mapmaker, and refers to St. Petersburg as "Petropolis, the seat of the Muscovite Empire." The decorative motif at the top includes the imperial coat of arms and symbolic representations of both military power and the arts.

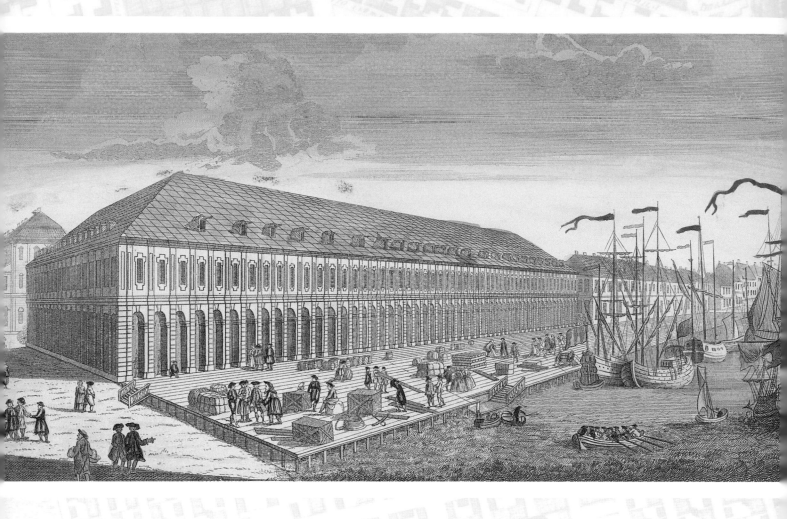

[22]
THE BOURSE

Hand–colored lithograph depicting the St. Petersburg
Exchange
N.p., ca. 1825

The St. Petersburg Exchange (*Birzha* or Bourse) was
founded by Peter the Great. Shown here is the first
Exchange building on the site, on Vasil'evskii Island,
dating to the 1730s. This lithograph was probably
based on a well-known engraving of ca. 1750, after
a drawing of 1749 by Mikhail Makhaev.

working under the close supervision of Peter and his designated officials, included Andreas Schlüter, a sculptor and architect well known for his work in Poland and Prussia whose decorative designs are still to be seen on the exterior of the Summer Palace; Schlüter's assistant Johann Friedrich Braunstein, active mostly at Peterhof; Georg-Johann Mattarnowy, Trezzini's Swiss-German collaborator on the first Winter Palace and at the Aleksandro-Nevskii Monastery and the architect, most famously, of the *Kunstkamera*; and Niccolò Michetti, recruited in Rome, who did extensive work at Peterhof and was the designer of a palace (still standing in Tallinn, Estonia) for Peter's wife, Catherine I. The list also includes Giovanni Maria Fontana, original architect of the Menshikov Palace, so-called after its first owner and the city's first governor, Aleksandr Menshikov; the palace, much augmented, later housed a distinguished military academy (1732–1918) and is now a museum of the Petrine period. Fontana was translator of the first Russian editions (1709, 1712, 1722) of Vignola's *Rule of the Five Orders of Architecture* (first published at Rome in 1562), one of the most popular architectural handbooks in early modern Europe and the first such work ever published in Russia, where it remained the single best-known book on architecture until the end of the eighteenth century. Working with these and other architects were the hundreds of painters and sculptors recruited in Europe to decorate the palaces of St. Petersburg and its suburbs, the most prominent of whom were Philippe Pillemont, Nicolas Pineau, François Pascal Wassoult, Bartolomeo Tarsia, and Hans Conradt Ossner.

These many architects and decorators, their pupils and assistants, made St. Petersburg the architectural center and trendsetter of the Russian Empire, a role it indisputably played once the St. Petersburg Academy of Fine Arts, projected under Peter on the model of similar institutions in Europe, was founded in 1757 by his daughter, Empress Elizabeth (fig. 23). Until late in the nineteenth century, when a neo-Muscovite movement, centered in the old capital, arose to dispute St.

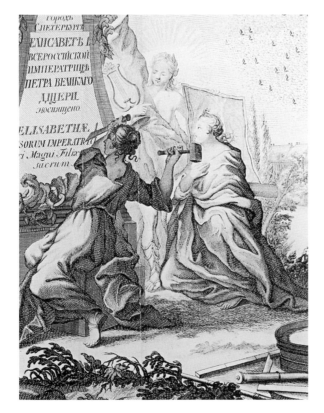

[23]

INSCRIBING IMMORTALITY

Mikhail Ivanovich Makhaev
Plan stolichnago goroda Sanktpeterburga
St. Petersburg, 1753

As part of the fiftieth anniversary celebrations of the city of St. Petersburg, Peter the Great's daughter, the Empress Elizabeth, commissioned a series of views and plans of the city her father founded. Under the direction of the Academy of Sciences, the project retained the services of the Venetian artist, stage designer, and innovative engraver Giuseppe Valeriani. Valeriani trained Makhaev and other Russians in the latest techniques for capturing and representing vast public spaces on paper. Here, in a detail from an engraving by Makhaev, engravers are at work on a cartouche for the ornamental pedestal bearing Elizabeth's name, surmounted by a statue of the empress herself.

Petersburg's supremacy, Russia's architectural history is essentially one of outward diffusion from the city on the Neva. Yet its architecture, much of it painstakingly restored after the destruction of World War II, is only the most conspicuous way in which St. Petersburg once embodied, and symbolizes still, Peter's revolution in Russia.

The new capital also rapidly became the most important base of the new Russian navy and modernized army with their respective offices, hospitals, barracks, schools, shipyards, and parade grounds: the center, in other words, of Peter's stupendous military and naval initiatives, which first made possible and then guaranteed Russia's status as a great power. St. Petersburg's economic importance was nearly as great. Its construction entailed the production of bricks, tiles, and glass in wholly unprecedented quantities and the manufacture for the first time in Russia of cement. The Admiralty's shipyards quickly became "the largest industrial complex in eighteenth-century Russia," as a leading economic historian has noted, just as the city itself "became in a short time the largest Russian port and the most significant center of Russian foreign trade"[3] (fig. 22). With the concentration within and around it of the empire's governing elite, St. Petersburg promptly established itself as Russia's center for the consumption of foreign goods and the place where fashions were set. By the middle of the eighteenth century thousands of merchants and craftsmen of a dozen different nationalities had established their shops and businesses in the city to cater to this elite trade, along with more than 3,000 drivers of coaches or carriages for hire. St. Petersburg would remain the capital of conspicuous consumption in the Russian Empire, its wealthiest and most fashionable city, "a place in which the cosmopolitan elite of Europe could feel at home and at ease," until the empire's collapse in 1917.[4]

Yet more, St. Petersburg was the principal site of Peter's governmental reforms in Russia and the chief beneficiary of the diplomatic revolution that his victories in battle precipitated in Europe. Starting in 1710, he ordered various governmental and commercial as well as military functions transferred to the new city from Moscow, Archangel (on the White Sea), Voronezh (on the Don River), and elsewhere in his realm, including the recently conquered Baltic towns of Riga and Reval. At the same time, he created new government offices in St. Petersburg, chiefly the Senate, the central administrative colleges, and the Holy Synod: the last move made the city, at the stroke of his pen, the headquarters of the Russian Orthodox church, displacing "Holy Moscow." Other measures ensured that the governors of his reorganized provinces, including that of Moscow, should report to officials in St. Petersburg. The new capital was also made the pilot, based on Swedish models, for a vastly expanded program of local government, one that concerned itself not just with tax-collecting and basic policing but with public health and hygiene, garbage collection, fire prevention, building regulation, street and bridge maintenance, and supervision of public morals.[5] St. Petersburg was to be the adminis-

[24]
Caviar Seller

Christian Gotthelf Schönberg and Christian Gottfried Heinrich Geissler
St. Petersburgische Hausierer: Crieurs publics de St. Pétersbourg
St. Petersburg, 1794

Russian "types" were a favorite subject of foreign artists who visited or resided in Moscow and St. Petersburg. This colored etching (from a collection of etchings of street peddlers in the capital) was the work of two such artists who lived and worked in St. Petersburg, Christian Schönberg and Christian Geissler. Geissler accompanied the expedition, sponsored by Catherine the Great and led by Peter Simon Pallas, to explore and document the empire's provinces, and his drawings appear in many of the ethnographic works subsequently published.

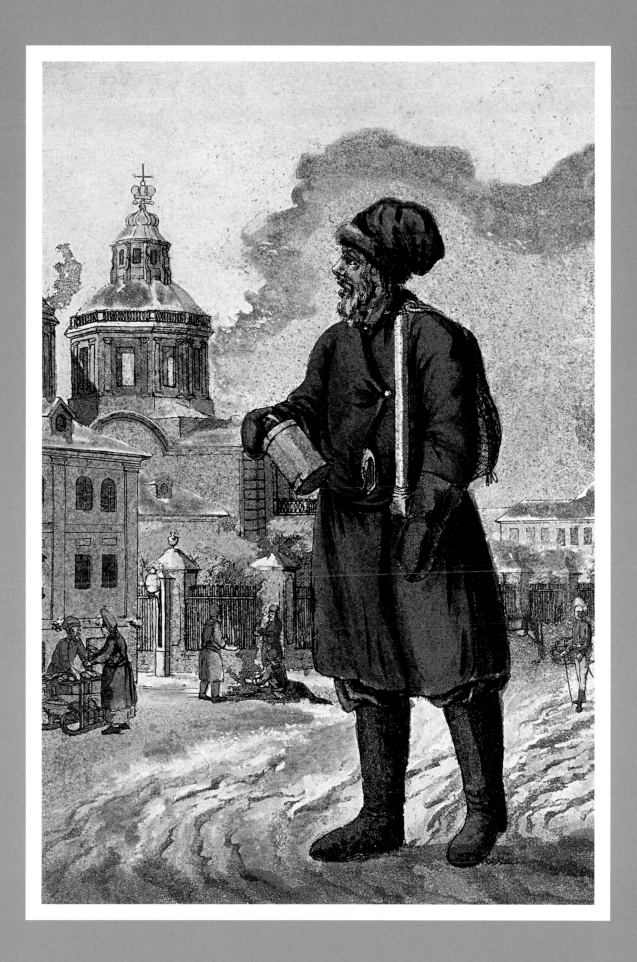

Commentarii Academiae Scientiarum Imperialis Petropolitanae ... ad annum 1726
St. Petersburg, 1728

The St. Petersburg Academy of Sciences was founded by Peter the Great in 1724. Its *Commentaries* (*Proceedings*) were published in Latin (then still the universal scientific language) by the Academy's press. This first volume contains contributions from such noted scientists of the day as Nicolaus and Daniel Bernoulli, Joseph Nicolas de L'Isle, Christian Goldbach, and Jakob Hermann, all of whom, recruited in Europe, were among the Academy's first members.

trative as well as the architectural model for Russia's other cities, in addition to its role as the political capital of the empire and the residence of all the foreign ambassadors assigned to it. These developments naturally added more layers of officials, clerks, workers, and servants to the city's permanent population, which by the 1760s was already second in size only to Moscow's and incomparably more diverse. From its very beginnings countless Finns, Swedes, and Germans as well as Russians and Ukrainians called St. Petersburg home, as did numerous British, Dutch, and other European craftsmen, merchants, scholars, and artists.[6]

But it was as the new cultural capital of Russia that St. Petersburg best embodied the Petrine revolution, "culture" to embrace not only architecture but also the other visual arts, literature and the sciences, education, theater, music, and manners. The first systematic training in Russia in architecture, in modern European painting (painting in the Renaissance tradition), and in the new graphic arts was instituted in St. Petersburg, a development that culminated in the foundation, as mentioned above, of the St. Petersburg Academy of Fine Arts. Similarly, after its founding in 1724 the St. Petersburg Academy of Sciences rapidly became the institutional hub for the development of modern mathematics and the natural sciences in Russia (fig. 25). With its subordinate university and other schools, its press and graphic arts shop, its museum and library, the Academy of Sciences also served for much of the eighteenth century as the institutional base for the inventors of modern Russian (as distinct from traditional Church Slavonic), or the language in Russia of modern literature, law, and philosophy as well as science and the fine arts. Virtually all the creators of modern Russian literature, most notably Vasilii Trediakovskii (1703–1769), Mikhail Lomonosov (1711–1765), and Aleksandr Sumarokov (1718–1777), spent much of their careers at the St. Petersburg Academy of Sciences, whose press was far and away the leading publisher of books of secular content in eighteenth-century Russia. The Academy was the

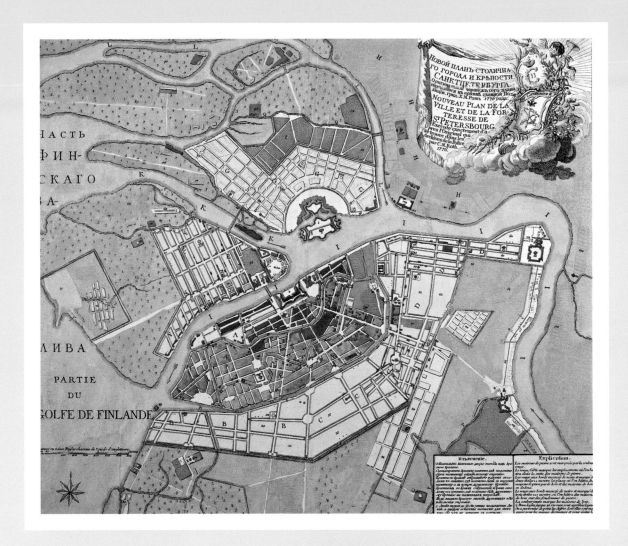

[26]

St. Petersburg in the Late Eighteenth Century

Christoph Melchior Roth
Novoi plan stolichnago goroda i kreposti Sanktpeterburga
St. Petersburg, 1776

This beautifully hand-colored map shows the built city (red) and planned expansion (yellow). Letters and numbers on the map refer to a key or legend that is not present. Catherine II's cipher shines through the clouds surrounding the coat of arms of the city of St. Petersburg, with its cross anchors. Here the mapmaker gives Catherine II credit for further beautifying and enhancing the city, "embellie par Catherine II."

home, too, of Russia's first law professors, historians, archaeologists, and ethnographers, some of whom were instrumental in creating the University of Moscow in 1755.[7]

Equally critical, St. Petersburg was the wellspring in Russia of modern European theater, music, dance, and etiquette. Although the first two had blossomed briefly in Moscow in the later seventeenth century, they flowered in St. Petersburg under Peter. Court, school, and public playhouses regularly produced dramas and the occasional comedy for increasingly appreciative local audiences. At the same time, Peter's court choir steadily superseded the leading church singers in the development of Russian choral music until, in the 1730s, the Imperial Court Choir came firmly under Italian direction, thus inaugurating grand opera in Russia as well as what soon became the dominant—some would say, the excessive—Italian influence on Russian church music. The 1730s also witnessed the birth in St. Petersburg of the Imperial Court Orchestra and the opening of the first Russian ballet school, events that were similarly rooted in Petrine undertakings. Meanwhile a "spreading reformation of manners," as a resident German diplomat observed about 1720, was Europeanizing court life.[8] Other evidence of this notable trend is found in an etiquette manual entitled *The Honorable Mirror of Youth, or A Guide to Social Conduct Gathered from Various Authors*, which was first published in St. Petersburg in February 1717 and reissued repeatedly thereafter. As its title indicates, the manual was compiled from various European sources translated into Russian and was printed for the guidance of young men and women aspiring to be "true nobles" and "true courtiers." We cannot of course know to what extent the standards of gentlemanly and maidenly behavior laid down in this manual ever took hold among the Russian elite—although readers of Russian literature of the later eighteenth and early nineteenth centuries will recognize in various characters their fictional embodiments. Elite memoirs of the period similarly suggest successful assimilation of the new etiquette.[9] It is also noteworthy that in a tract first published in St. Petersburg in 1717 defending the Russian cause in the Northern War, its author, Petr Shafirov, a leading Petrine diplomat, at one point remarks on how "we now see ... several thousand of His [Peter's] subjects of the Russian nation, male and female, skilled in various European languages ... and of such conduct moreover that they can be compared without shame to all other European peoples."[10]

In such many and varied ways—architectural, military, naval, commercial-industrial, governmental, diplomatic, and more generally cultural—did St. Petersburg embody the revolution of Peter the Great. Still, it would be wrong to represent its development from military outpost to cosmopolitan capital as some sort of uninterrupted triumphal progress, which the surviving visual depictions—stylized prints, drawings, and paintings—might seem to suggest (fig. 26). The successive verbal accounts of discriminating European visitors offer more telling testimony in this respect. For example, a special report to his government of the first regular British ambassador to Russia affords a chilly glimpse of St. Petersburg in 1710:

The foundations of this new town were laid in hopes it might one day prove a second Amsterdam or Venice. To people it the nobility have been ordered to remove hither from the farthest parts of the country, though with no small difficulty, since the climate is too cold and the ground too marshy to furnish the conveniences of life, which are all brought from the neighbouring countries. However the Tsar is charmed with his new production and would lose the best of his provinces sooner than this barren corner. The fortress is built on a separate island, with good stone bastions laid on piles, but of much too narrow an extent to make any considerable defense in case of attack. The floods in autumn are very inconvenient, sometimes rising in the night to the first floors, so that the cattle are often swept away and the inhabitants scarce saved by their upper story.... The river is seldom or never clear of ice before the middle of May, and the

ships cannot hold [back from] the sea any longer than the end of September without great danger.[11]

F. C. Weber, the long-resident German diplomat quoted earlier, left a description of the city as of 1720 that, while similarly negative, also praises the regulations introduced by Peter for extinguishing fires and "for keeping his new city in good order, the great encouragements given to architects, mechanics, and all other imaginable sorts of artificers," and "the improvements which the Tsar has made not merely calculated for profit, but for delight also." Thus,

He has built splendid pleasure houses, raised noble gardens and adorned them with greenhouses, aviaries and menageries, grottos, cascades, and all other sorts of water-works. He has placed in the steeple of the fortress a chime made in Holland. He has ordered assemblies [soirées] to be kept in the winter; operas, plays, and concerts of music are to be set up for the diversion of his court; and in order to engage foreigners to frequent it, drafts [architectural plans] have already been made and proper places marked out to build houses for those purposes.

The detailed diary kept by a German visitor to St. Petersburg in 1721–1725, Friedrich Wilhelm von Bergholtz, contains equally positive descriptions of the city. They begin with the recently built Nevskii Prospekt, "a long, wide avenue paved in stone" that was "extraordinarily beautiful by reason of its enormous extent and state of cleanliness.... It makes a more wonderful sight than any I have ever beheld anywhere." The Admiralty was "a huge and beautiful building," the park adjacent to the Summer Palace contained "everything that could be wanted in a pleasure garden," while the church in the Peter-Paul fortress was the "largest and most beautiful" in St. Petersburg. "Above it," Bergholtz continues,

rises a high steeple in the new style, covered in brightly gilded copper plates which look extraordinarily fine in the sunlight. The chimes in its steeple are as large and fine as those at the Admiralty.... This fine church is entirely of masonry construction, and not in the Byzantine but in the new taste, adorned with prominent arches and columns and, front and side, a splendid portico.

Bergholtz then describes the layout of the city, at one point noting: "They say that its rapid construction cost countless lives." He thereby cautiously invoked the allegation, repeated in other foreigners' accounts and acquiring thereafter the force of legend, that in its early years tens of thousands of workers—"60,000" in seven years, "100,000" in eight, "300,000" in its first decade or so—had died in the building of St. Petersburg, figures that are, on their face, preposterous (we note again that the city's total population in 1725 was only 40,000, and that no more than 30,000 workers labored on constructing it at any one time). This is not to deny that in these same years the death toll among workers seems to have been unusually high owing to the severity of the climate, rampant sickness, and the shortage of provisions, a situation not unknown elsewhere in the world when large-scale building projects have been undertaken in harsh and unfamiliar terrain and before mostly twentieth-century medical advances in the control of malaria ("swamp fever") and other such infectious diseases were available. In St. Petersburg's case, steps were promptly taken to improve conditions at the worksite including whatever medical measures were known at the time, and the total death toll between 1703 and Peter's death in 1725 was probably a few thousand. Bergholtz also recorded his impressions of the suburban palace-estates that were in various stages of construction in the early 1720s and especially of Peterhof, whose buildings and grounds were nearer completion than the others (fig. 27). Peter's favorite residence there, Monplaisir, was in

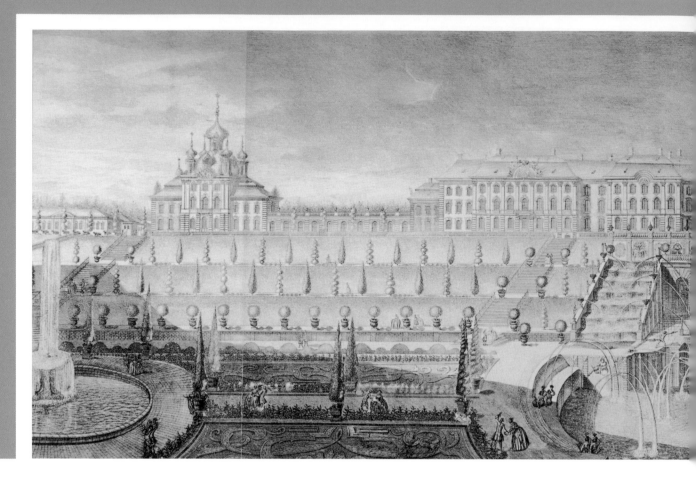

Bergholtz's view "a small but very nice house, decorated most notably with many choice Dutch paintings." The main palace on its hill comprised two stories, the lower containing

large and fine hallways with pretty columns; and above there is a splendid hall whence one has a wonderful view of the sea and, in the distance, of Petersburg.... The rooms in general are small but not bad, and are hung with fine paintings and provided with beautiful furniture. Especially remarkable is the cabinet [study] containing a small library belonging to the Tsar made up of various Dutch and Russian books; it was done by a French craftsman [Nicolas Pineau] and is distinguished by its excellent carved decoration.

The large garden behind the main palace was "very beautifully laid out" while before it Bergholtz discovered a "magnificent cascade, as wide as the palace itself, made of natural stone and decorated with gilded lead figures in relief against a green background." A fine canal connected the cascade to the Finnish gulf, where a small harbor had been built, thus permitting access to Peterhof by boat, "which is very agreeable and convenient." Finally, the Lower Park, spread out beneath the main palace on either side of the cascade and canal, was

intersected by many fine and pleasant alleys shaded by groves of trees. The two principal alleys lead from the two sides of the Park through a grove of trees to two pleasure houses located exactly the same distance from the palace and the Gulf. To the right is Monplaisir, in whose garden, also surrounded by trees, grow many beautiful bushes, plants, and flowers; here there are also a large pond with swans and other fowl swimming in it, a little house for them, and various other structures built for fun. At the oppo-

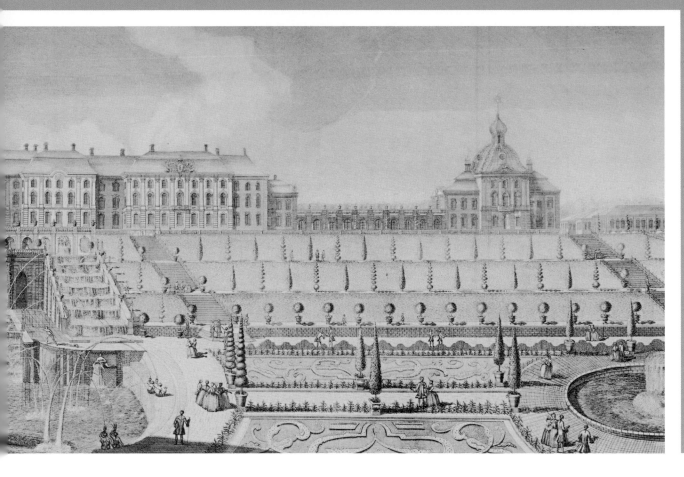

[27] A RUSSIAN FANTASY PALACE

[*Vidy S.-Petersburgskikh okrestnostei*]
St. Petersburg, 1761

Peterhof (Petrodvorets), Peter the Great's favorite
retreat west of St. Petersburg, was begun in 1714
under the French architect J.B.A. Leblond and
completed, much as shown here in this engraving,
in 1755 under the celebrated Italo-Russian architect
Bartolomeo Rastrelli.

site end of the alley from Monplaisir a similar garden and house [to be called Marly], already begun, will be completed.

The buildings and grounds of Peterhof, largely destroyed during World War II, have since been restored to something like their original condition, and are now among the most popular tourist attractions of greater St. Petersburg.

Following Peter the Great's death the city's development slowed to a standstill, and in 1727 the court moved back to Moscow. But once securely on the throne, Empress Anna, Peter's niece, returned it to St. Petersburg, and the city resumed its rapid growth. European grand tourists began to arrive, among them Count Francesco Algarotti, a well-known scientist and *littérateur* who paid a visit in 1739. In several subsequently published letters to his friends in European high society he provided a predictably witty account of what he saw.

Entering the Neva estuary, Algarotti was ostensibly shocked to find that the river, "this sacred way," was "not adorned with either arches or temples" but rather was "flanked by forest to both left and right—and that not of majestic oaks or tufted elms or evergreen laurels, but of the most wretched species of trees on which the sun shines." His first glimpse of St. Petersburg seemed to make up for its dreary approaches, for

all of a sudden the river bends; the scene instantly changes, as in an opera, and we behold before us the Imperial city. On either bank groups of sumptuous edifices, towers topped by gilded spires, ships with banners flying … such is the brilliant spectacle that greets us. Here, they tell us, is the Admiralty, there the Arsenal; here the fortress, there the Academy; ahead, the Winter Palace.

But when Algarotti and his party finally set foot in the city, "we no longer found it as superb as it appeared from a distance, perhaps because the gloominess of the forest no longer brightened our perspective." On the one hand, "the situation of a city located on the banks of a large river and made up of various islands, providing different vantage points and optical effects, could only be beautiful"; on the other, "the ground on which it is founded is low and marshy, the materials of which it is constructed are of little value, and the designs of the buildings are not by an Inigo Jones or a Palladio." Indeed, "there reigns in this capital a kind of bastard architecture, one which partakes of the Italian, the French, and the Dutch." The suburban villas of the grandees fared no better in this critic's eyes, as "one sees clearly that they were built more in obedience than by choice. Their walls are all cracked, out of plumb, and remain standing with difficulty." This provoked the witticism that "elsewhere ruins make themselves, while in St. Petersburg they are built." Yet Algarotti's most memorable remark applied to the metropolis as a whole, which he had come to see, he said, purely out of curiosity, to discover for himself "this new city" created by Peter the Great, "this great window recently opened in the north through which Russia looks on Europe." The metaphor would long outlive its author. Pushkin would refer to St. Petersburg as Russia's "window on Europe" in his famous poem of 1833, "The Bronze Horseman"; and countless other commentators have deployed it, sometimes distorted as "window on the west," ever since. But from the outset St. Petersburg was much more than a window through which Russians gazed westward. It was also a great channel through which countless Europeans, bearing their values and their ways, poured into Russia, there to help implement, in one way or another, the Petrine revolution.

A virtually continuous process of development—architectural, governmental, naval, commercial, industrial, demographic—followed Algarotti's famous visit. By the early nineteenth centu-

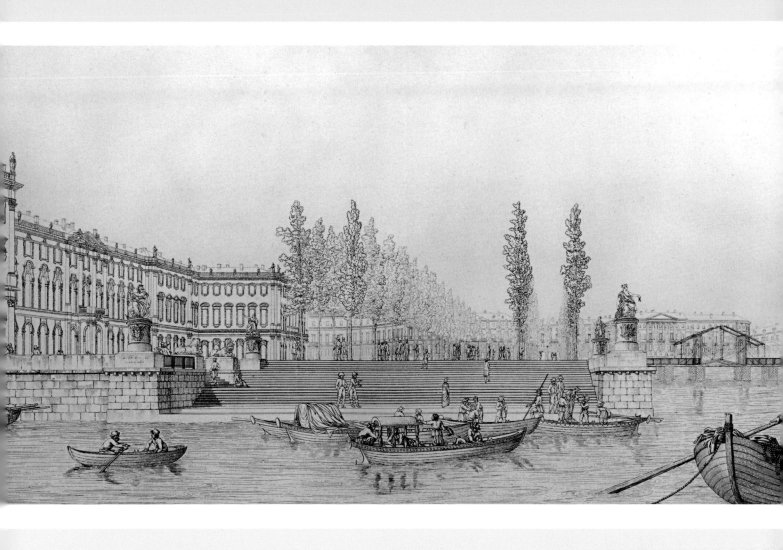

[28] THE QUAY OF THE WINTER PALACE AND ADMIRALTY

Luigi Rusca
Recueil des Dessins de différens bâtiments, construits
à Saint-Pétersbourg et dans l'intérieur de l'Empire Russie
St. Petersburg, 1810

Luigi (known in Russia as Aloizii Ivanovich) Rusca was a Swiss-born architect who spent more than three decades of his career in Russia in the employ of the Russian government and its servitors. For much of the first quarter of the nineteenth century, Rusca was one of the principal architects of the empire, designing a number of monumental Classical buildings in the capital and the provinces. This sketch shows the embankment of the Winter Palace, the present-day Hermitage Museum.

ry St. Petersburg was the most populous as well as the most important city of the Russian Empire, an "imperial colossus" from which more than one-sixth of the land surface of the earth was ultimately ruled.[12] In 1914, on the outbreak of war with Germany, its long-standing Germanic name was officially russified to Petrograd, "Peter's city" by another name. A few years later, in 1917, it became the crucible of the revolutions that toppled the monarchy and propelled the Bolsheviks under Lenin into power. Fearing for its own survival in the face of an imminent German invasion (World War I was still waging), the Bolshevik government, early in 1918, moved Russia's capital back to Moscow, which became the capital under Stalin of the Soviet Union. On Lenin's death in 1924 the city was renamed Leningrad in a transparent attempt to replace the aura of Peter and all it stood for with that of Lenin. It was not to last. The city survived Soviet rule, or misrule, as well as the horrific German siege of World War II by a mixture of pride and courage, wit and perseverance, a spirit best captured, perhaps, in the person and poetry of Anna Akhmatova. "A different time is drawing near," she wrote in 1919, prophetically: "The wind of death already chills the heart;/ But the holy city of Peter/ Will be our unintended monument."[13] In 1991 its citizens voted to restore the city's original name, and as St. Petersburg, again, it celebrates its tercentenary in 2003. It may be hoped that the vision of its founder—Peter's vision of Russia as an integral part of Europe and the modern world—will also be fully restored.

Notes

1 The best book in English on St. Petersburg, its history
 and cultural significance, is W. Bruce Lincoln, *Sunlight
 at Midnight: St. Petersburg and the Rise of Modern
 Russia* (New York: Basic Books, 2000), which is schol-
 arly but written for general readers.
2 Details of St. Petersburg's early history and architec-
 ture are taken from James Cracraft, *The Petrine
 Revolution in Russian Architecture* (Chicago: University
 of Chicago Press, 1988), chap. 6.
3 Arcadius Kahan, *The Plow, the Hammer, and the
 Knout: An Economic History of Eighteenth-century
 Russia* (Chicago: University of Chicago Press, 1985),
 pp. 87, 163, 247–248.
4 Lincoln, *Sunlight at Midnight*, p. 52.
5 Lindsey Hughes, *Russia in the Age of Peter the Great*
 (New Haven, Conn.: Yale University Press, 1998),
 pp. 117–119; this is the most comprehensive scholarly
 account of Peter's life and reign in English.
6 The British presence was notably strong, as recounted
 in Anthony Cross, *By the Banks of the Neva: Chapters
 from the Lives and Careers of the British in Eighteenth-
 century Russia* (Cambridge, England: Cambridge
 University Press, 1997).
7 See James Cracraft, *The Petrine Revolution in Russian
 Imagery* (Chicago: University of Chicago Press, 1997),
 and Cracraft, *The Petrine Revolution in Russian
 Culture* (Cambridge, Mass.: Harvard University Press,
 forthcoming), for details of these other aspects of
 Peter's revolution.
8 Friedrich Christian Weber, *The Present State of Russia*,
 authorized English translation from the original
 German, vol. 1 (London, 1723), p. 148.
9 See, for example, *Days of a Russian Noblewoman:
 The Memories of Anna Labzina, 1758–1821*, ed. and
 trans. Gary Marker and Rachel May (DeKalb: Northern
 Illinois University Press, 2001).
10 For Shafirov's tract, and the *Honorable Mirror of
 Youth*, see Cracraft, *Revolution in Culture*, chaps. 4, 5.
11 See Cracraft, *Revolution in Architecture*, chap. 7, for
 the source of this and all subsequent quotations from
 early European visitors to St. Petersburg.
12 See Lincoln, *Sunlight at Midnight*, part II.
13 *Selected Poems of Anna Akhmatova*, trans. Judith
 Hemschemeyer; ed. Roberta Reeder (Brookline, Mass.:
 Zephyr, 2000), p. 101.

CATHERINE II

As a Patron of Russian Literature

by Irina Reyfman

T he second third of the eighteenth century witnessed the birth of modern, or "new" (as Russians themselves referred to it), Russian literature, that is, literature understood as an aesthetic phenomenon and the product of a single, named individual. Seventeenth-century literary production had remained predominantly medieval—that is, for the most part anonymous and aimed at propagating religious, moral, or political values—despite the occasional appearance of poetry and prose under the name of an author, particularly during the reign of Tsar Aleksei. The Petrine era, which stretched from 1696 to 1725, was transitional in literary terms and produced little of significant value. One notable exception was the work of Feofan Prokopovich, a prominent clergyman, poet, and playwright and a firm supporter of Peter's policies (fig. 29). One of Prokopovich's first works, the tragicomedy *Vladimir*, staged at the Kiev Mohyla Academy in 1705, praised Peter's church reforms, and his sermons consistently offered support for all of the tsar's revolutionary changes.

Despite the paucity of great works of literature during Peter's years in power, the important process of absorbing and adapting European literary ideas nonetheless took place and proved yet another manifestation of the profound changes in Russian life that the emperor initiated. By the late 1720s and 1730s, modern European ideas of literature had firmly and permanently penetrated Russian literary consciousness and practice. The principal conductors of those ideas, in addition to Prokopovich, included Antiokh Kantemir, the creator of Russian satire; Vasilii Trediakovskii, a poet, translator, and reformer of Russian versification; and Aleksandr Sumarokov, the founder of Russian drama and a canonizer of love lyrics (fig. 30). Towering above the rest in the Russian national imagination, Mikhail Lomonosov stands as the acknowledged "father" of modern Russian literature; in addition to bringing the panegyric ode to its apex, he bequeathed to his literary descendants the "theory of three styles," a tripartite hierarchy whose influence is

still felt in contemporary Russian usage. Despite their quarrels and bitter rivalry, during the reigns of Empress Anna and Empress Elizabeth these writers succeeded in their collective effort to make Russians aware of and receptive to contemporary European forms of literary production.

By the time Catherine II succeeded to the throne in 1762, Russia could already boast significant achievements in a wide range of genres: drama was rapidly developing, with Sumarokov as the most successful author of both tragedies and comedies as well as director of the first Russian professional theater, established by Elizabeth in 1756; the tradition of the panegyric ode flourished, with Lomonosov as its most prominent practitioner; Sumarokov prolifically and successfully wrote love songs and elegies; both he and his disciple, Vasilii Maikov, excelled in the art of writing fables. The genre of the heroic epic developed more slowly, until Mikhail Kheraskov produced his *Rossiada* in 1779 and *Vladimir Reborn* in 1785.

By the early 1760s, Russians had also produced several literary journals, mostly private: Sumarokov published *The Industrious Bee* in 1759; in the same year, graduates of the Noble Infantry Cadet Corps, Sumarokov's alma mater, put out *Idle Time Well Employed*; and Kheraskov edited *Useful Amusement* from 1760 to 1762 and *Leisure Hours* in 1763. In addition, Russian writers were able to see their work in print in the more official *Monthly Compositions* (1755–1764), a journal published by the Academy of Sciences.

Many of modern Russian literature's early achievements were summarized in Nikolai Novikov's *Attempt at a Historical Dictionary of Russian Writers* (1772; fig. 31). It included entries on 317 Russian writers, mostly from the eighteenth century. Novikov's pride in his native literature is evident in this publication. As the historian Gary Marker said of the *Dictionary*: "a casual reader leafing through this volume would almost certainly have read it as a celebration of modernity. The message could not have been clearer: educated Russians were living amid a literary cornucopia, an unprecedented flowering of the pen and the press."[1]

Upon ascending the throne, Catherine enthusiastically took upon herself the role of patron of Russian culture and belles-lettres. The empress's active part in shaping Russia into a European nation—politically, administratively, and culturally—is well known and indisputable, and this well-read woman regarded literature as an important tool in fulfilling her goal. She financed a number of literary and publishing enterprises and promoted the further adoption of European literary models in Russia, both by encouragement and by example. Overall, Catherine the Great clearly strove to be perceived as a philosopher on the throne, who, like Frederick the Great, not only wrote herself but also sought to attract talent and wit to her court.

To a significant degree Catherine's effort was directed abroad, toward famous and influential Europeans. A great deal has been written about her ongoing correspondence with Voltaire, Friedrich Grimm, Denis Diderot, and Jean d'Alembert as well as about her attempts to persuade several *philosophes* to come to live in Russia. She invited d'Alembert, Cesare Beccaria, Diderot, and even Jean-Jacques Rousseau, with whom she disagreed on many points. Only Diderot accepted the invitation, arriving in October 1773 and staying for six months. Earlier, Catherine had offered to move the printing of his *Encyclopedia* to Russia, an invitation he declined, and she also bought his library, generously leaving it in his possession until his death in 1784 and even paying him a pension as her librarian. After Voltaire's death in 1778, she bought his library as well.

Catherine's efforts to maintain relations with the prominent Europeans of her time are often interpreted as pure propaganda—as an attempt to manipulate public opinion abroad by pretending to put the *philosophes*' ideas into practice. No doubt, this is in part true, but as Catherine's biographer, Isabel de Madariaga, points out, the Russian empress did not differ from her older contemporary and model, Frederick the Great, who was "never accused of hypocrisy, of attempting

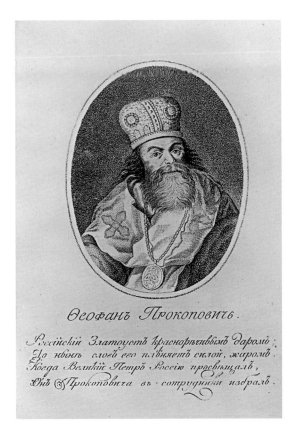

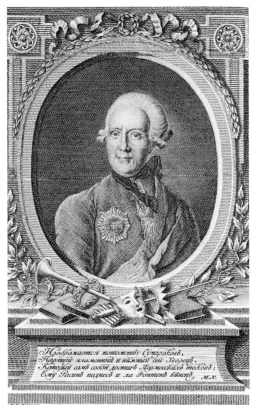

[29]

A PETRINE ERA PRELATE AND REFORMER

Platon Petrovich Beketov
Panteon rossiiskikh avtorov
Moscow, 1801

Feofan Prokopovich, an early eighteenth-century Orthodox hierarch, statesman, literary theorist, and poet, was an ardent supporter of Peter's reforms, particularly of his policies toward the secularization of the state; his "tragicomedy" *Vladimir* (1705) drew a parallel between Peter's church reforms and the Christianization of Rus' in 988. This portrait of Prokopovich is from Platon Beketov's *Pantheon of Russian Authors*, a collection of portraits of Russian writers with accompanying text by Nikolai Karamzin. Beketov was a minor poet and translator, best known as an amateur publisher of very elegant books, of which this may serve as an example.

[30]

A PIONEERING LITERARY FIGURE

Aleksandr Petrovich Sumarokov
Polnoe sobranie vsekh sochinenii, v stikhakh i proze
Moscow, 1781–1782

Poet, playwright, and director of the first Russian professional theater open to the public, Aleksandr Sumarokov was instrumental in introducing to Russia the European system of literary genres. He was also the first in Russia to publish a private magazine, *The Industrious Bee* [*Trudoliubivaia pchela*] (1759). Nikolai Novikov, the most active Russian publisher of the late eighteenth century, considered the writer his mentor, and published the posthumous *Complete Collection of All Works in Verse and Prose* by Sumarokov.

54

[31]

A First Dictionary of Russian Writers

Nikolai Ivanovich Novikov

Opyt istoricheskago slovaria o rossiiskikh pisateliakh

St. Petersburg, 1772

Nikolai Novikov's *Attempt at a Historical Dictionary of Russian Writers* was the first printed systematic account of modern Russian literature. Organized alphabetically, it includes sketches of all the major and many of the minor authors of the eighteenth century, even those who could boast no more than one published work. Only a handful of names from before the eighteenth century made their way into it. The dictionary thus virtually discarded the medieval Russian literary tradition and confirmed the widespread eighteenth-century opinion that Russian literature dated from the Petrine era, that is, from the time when it began to adopt European literary notions.

[32]

A Historian's Defense of Russia

Ivan Nikitich Boltin

Primechaniia na Istoriiu drevniia i nyneshniia Rossii g. Leklerka

[St. Petersburg], 1788

Ivan Boltin, whose main career was first in the military and then in the civil service, was a self-taught but serious and qualified historian. An admirer of Vasilii Tatishchev's works on Russian history, in the 1770s he devoted himself to the thorough study of historical documents. When Nicolas-Gabriel LeClerc's treatises, *A Physical, Moral, Civil, and Political History of Ancient Russia* (1783–1784) and *A Physical, Moral, Civil, and Political History of Modern Russia* (1783–1785), came out, Boltin was ready to respond. His *Notes on the History of Ancient and Modern Russia by Mr. LeClerc* in particular attacked LeClerc's portrayal of pre-Petrine Russia as backward and uncivilized.

[33]

THE FIRST RUSSIAN JOURNAL FOR WOMEN

Modnoe ezhemesiachnoe izdanie; ili, Biblioteka dlia damskago tualeta

Moscow, 1779

A Fashionable Monthly, or A Library for Lady's Dress, published as a supplement to Nikolai Novikov's newspaper *The Moscow News* [*Moskovskie vedomosti*], was the first Russian journal for women (the title page of an issue for 1779 is shown here). In addition to reports on the latest fashions, it featured a literary section, in which short stories in translation as well as Russian poetry appeared. Given the broad thematic variety of the journals that Novikov printed in the 1770s and 1780s (from Masonic, to historical, to publications on economics, to a journal for children), *A Fashionable Monthly* can be interpreted as yet another effort to build a Russian readership.

[34]

A LITERARY ANTHOLOGY FOR CATHERINE

Raznost' i priiatnost'

[Russia], late 18th century

Diversity and Pleasure is a rare manuscript collection of various works in verse and prose. Its opening page, shown here, bears a dedication in verse by Aleksandr Sumarokov, addressed to "Her Imperial Highness, Grand Duchess Ekaterina Alekseevna," that is, the empress-to-be, Catherine the Great, whose interest in reading was well known. The collection includes texts from different genres, with so-called low (entertaining) works predominating: fables, epigrams, riddles, satires (in verse and in prose), and novellas. More serious works—such as transpositions of psalms, translations of the "wisdom" of Solomon, and philosophical prose—are also included.

[35]

A FRENCH TRAVELER IN SIBERIA

Jean Chappe d'Auteroche
Voyage en Sibérie
Paris, 1768

Abbé Jean Chappe d'Auteroche, an astronomer and a member of the French Academy of Sciences, was sent to Siberia to observe the transit of Venus that occurred in June 1761. He spent several months in Tobolsk. After his return, he published his *Journey into Siberia*. Based on his diary and highly critical of Russia's social ills, this richly illustrated book offers a brief history of Russia, a description of its government, and ethnographic sketches of peoples of the empire, both Russian and some non-Russian. These sections from a multipart topographical chart show pieces of his route from Brest to Siberia. Chappe d'Auteroche died while in California to observe the second transit of Venus.

to buy himself a good press." Furthermore, de Madariaga suggests that Catherine was largely sincere in her determination to bring reforms to Russia and in her admiration for many of the *philosophes'* views. To be sure, she did not plan to go further than to establish Russia as an enlightened monarchy, the project supported by Voltaire. As for the more radical ideas of Rousseau, Guillaume Raynal, or Diderot, Catherine did not consider them practical. As de Madariaga rightly argues, most of these concepts were of a utopian nature, especially in relation to Russia, a country none of the *philosophes* knew well.[2]

One way to shape public opinion of Russia, both outside and within the country, was through historical accounts of its past. Vasilii Tatishchev became one of the first to compile a full history of Russia. He worked on his *Russian History from Earliest Times* for over thirty years but did not live to see it published. He died in 1750, and the first of five volumes of his treatise appeared only in 1768. Several other historical accounts were also published during Catherine's reign; the first volume of Lomonosov's *Ancient Russian History from the Origins of the Russian People Until the Death of Grand Prince Iaroslav the First, or up to the Year 1054* and Prince Andrei Khilkov's (actually, Aleksei Mankiev's) *The Kernel of Russian History* provide two of many possible examples.

Interpretations of the Russian past by foreigners inevitably had a political significance similar to that wielded by the observers of Muscovite Russia. Voltaire's *History of the Russian Empire During the Reign of Peter the Great* (1761–1763) suited Catherine, but Nicolas-Gabriel LeClerc's treatises, *A Physical, Moral, Civil, and Political History of Ancient Russia* (1783–1784) and *A Physical, Moral, Civil, and Political History of Modern Russia* (1783–1785), proved highly critical both of Russia's past and present, and Catherine ordered a riposte. Ivan Boltin responded with a two-volume critique, *Notes on the History of Ancient and Modern Russia by Mr. LeClerc* (1788; fig. 32), which pointed out the Frenchman's alleged factual mistakes, particularly those concerning pre-Petrine Russia, a period he presented in utterly dark colors.

Catherine herself replied to yet another critic of Russia's past and present, Abbé Jean Chappe d'Auteroche, who in 1768 published *A Journey into Siberia, Made by Order of the King of France* (fig. 35). Two years later, the empress, anonymously, published *The Antidote, or an Enquiry into the Merits of a Book, entitled A Journey into Siberia* and sharply disagreed with Chappe d'Auteroche's definition of the Russian political regime as despotic and backward and refuted his criticism by citing her own achievements as a legislator. Catherine also counteracted his claim that Russians were rude, immoral, and uncivilized by citing the achievements of writers such as Lomonosov and Sumarokov. In de Madariaga's opinion, Catherine was particularly vexed by Chappe d'Auteroche's book because it appeared just as a war with Turkey was beginning and derided Russia's military power.[3] The empress commented on every one of Chappe d'Auteroche's alleged mistakes, and this resulted, in de Madariaga's words, in "a tedious and long-winded work written in a niggling manner."[4]

Along with her efforts to make friends for Russia abroad, Catherine also tried to attract local talent to her court through her patronage of literature and journalism. Some of her support came in monetary form. For example, she subsidized the publication of Sumarokov's works from 1762 until his death in 1777 and continued her support even after disagreements had arisen between them. She also financed several of Novikov's projects, including the publication of ten volumes of *Russian Antiquities*, a collection of historical documents from state and private archives. In addition, Catherine initiated several major cultural enterprises, such as founding the Russian Academy in 1783.

More subtly, Catherine encouraged prominent writers to act as her interlocutors, both in the realm of literature, by engaging them in a literary dialogue, and in life, by making them part of

her inner circle. From the early days of her reign, she surrounded herself with literati. One of her secretaries, Ivan Elagin, was a poet and historian as well as a patron of theater and the head of a group of young playwrights that included Denis Fonvizin, whose plays are still produced. Her other secretaries and editorial assistants, Grigorii Kozitskii and Aleksandr Khrapovitskii, were likewise active in literary affairs. In 1768, she appointed a budding poet, Vasilii Petrov, as translator for her private affairs, and in 1791, she made Gavriil Derzhavin, the preeminent Russian poet of the eighteenth century, state secretary for her private affairs.

Following in the footsteps of the Empress Anna and Empress Elizabeth, Catherine gave special support to the dramatic arts. Her court theater put on plays by such foreign authors as Molière, Voltaire, Diderot, and Richard Brinsley Sheridan, as well as by Russian playwrights, such as the "father" of Russian drama, Sumarokov, and his younger colleagues Vladimir Lukin, Fonvizin, and Iakov Kniazhnin. From 1786 to 1794, the Academy of Sciences press published a periodical, *Russian Theater, or The Complete Collection of All Russian Theatrical Compositions* (fig. 36), which included about two hundred titles. Rarely since have the dramatic arts held such a prominent place in Russian cultural life.

Catherine herself wrote about two dozen plays, mostly comedies. (It is generally believed that her staff, including Kozitskii and Khrapovitskii, edited her dramas for grammar due to the German-born Catherine's non-native grasp of Russian.) The first group of comedies—written in the early 1770s and presented as "composed in Iaroslavl'," that is, by a provincial—had a moralistic tint and criticized corrupt clerks, fashionable *petit-maîtres*, and retrogrades and rumormongers among the Russian nobility. A second group of comedies, written in the mid-1780s, was directed against Freemasonry. These comedies (suggestively entitled *The Deceiver, The Deluded,* and *The Siberian Shaman*) presented Freemasonry as a dangerous superstition and Freemasons as malicious seducers of innocent souls. By the late 1780s, Catherine had begun experimenting with dramatic conventions and produced several comic operas, based on Russian fairy tales, and historical dramas, in which she attempted to imitate Shakespeare, whose work she knew in German translation. Her plays were staged mostly in her court theater, but also in private houses; some were lavish productions that involved hundreds of actors.

Among the most successful cultural enterprises that Catherine sponsored was the Society Striving for the Translation of Foreign Books; headed by Kozitskii, it lasted from 1768 to 1783. The empress's interest in translating works that she considered useful for Russians can be traced to her 1767 voyage along the Volga River, during which she, together with her courtiers, translated Jean Marmontel's *Belisarius* (published in 1768) and a selection of articles from the *Encyclopedia* (three volumes of these selections were published in 1767). The society was apparently founded to continue the work begun during the empress's voyage. In its five years of existence, the group published 112 translations and finished or began yet another 129, which were later published by the Russian Academy. The society's translations included Petr Ekimov's prose translation of the *Iliad* as well as works by Cicero, Livy, and Tacitus. Modern writers were represented by Pierre Corneille, Voltaire, Henry Fielding, Daniel Defoe, and Jonathan Swift. The society also translated numerous works by the *philosophes*, including Montesquieu, Voltaire, Gabriel Mably, and Rousseau.

Yet another of Catherine's enterprises aimed at encouraging the adoption in Russia of European literary models was her effort, between 1769 and 1774, to introduce satirical and moralistic journalism following the example of Joseph Addison and Richard Steele. Sixteen magazines—some short-lived, others more enduring—were published in those years, and all of them engaged in lively exchanges with each other on a variety of topics, such as morals, education, the conditions of the serfs, foppery, bribery, and the supposed corruption of the Russian language by French

РОССІЙСКІЙ
ѲЕАТРЪ

или

Полное собраніе

всѣхъ

россійскихъ Ѳеатральныхъ

сочиненій.

Часть III.

ВЪ САНКТПЕТЕРБУРГѢ,

при Императорской Академіи Наукъ,
1786 года.

[36]
RUSSIAN THEATER

Rossiiskii featr
St. Petersburg, 1786

Catherine was a patroness of the theater and of playwrights throughout her reign. Performances were regularly offered at her court theater in the Winter Palace. She also encouraged the public companies, both Russian and foreign, that operated in the capitals and in the provinces. Russian dramatic arts flourished, and the journal *Russian Theater,* published by the Academy of Sciences between 1786 and 1794, printed about two hundred plays.

usage. The exchanges were launched by the first weekly to appear, *All Sorts of Things*. While the degree of Catherine's personal participation in *All Sorts of Things* remains debatable, the initiative seems to have come from the circle of literati close to the court. Contemporary opinion held that Kozitskii was the editor of the publication; Novikov, in his literary dictionary, wrote in the entry on Kozitskii: "[S]ome conclude that *All Sorts of Things*, the weekly of 1769 that acquired so much praise, is the fruit of his pen."[5] Furthermore, in 1863, Petr Pekarskii, a historian of the eighteenth century, "found proof of Catherine's participation" in the magazine: "he found portions of articles in her handwriting addressed" to *All Sorts of Things*.[6]

All Sorts of Things immediately spawned a number of imitators: *The Drone*, edited by Novikov; *The Devilish Post*, edited by the novelist Fedor Emin; *Both This and That*, edited by the prose writer Mikhail Chulkov; *Neither This Nor That in Prose and Verse*, edited by the poet Vasilii Ruban; *Miscellany*, whose editor is unknown; and others. Most of the journals lasted only a few issues, but Catherine continued to encourage their publication, providing some with financial support. For instance, she subsidized Novikov's *The Painter*, giving the editor 200 rubles for its publication.

However short-lived, the episode had lasting consequences, since it established the genre of satiric and didactic journalism in Russia. Not only were several of the publications (including *All Sorts of Things*, *The Drone*, and *The Painter*) later issued in book form, even going through several editions, but similar journals continued to appear. Novikov's growing interest in Freemasonry took him away from satire but not from journalism: he was undoubtedly the most active publisher of periodicals from 1769 until 1792, when he was arrested and imprisoned. In this period, in addition to four satirical journals and *Russian Antiquities*, he published the monthly *Morning Light*; its short-lived continuation *Evening Glow*; *City and Country Library*; *The Moscow Monthly*; *The Reposing Worker*; *A Fashionable Monthly, or A Library for Lady's Dress* (fig. 33); the biweekly newspaper *The Moscow News*; and the first Russian magazine for children, *Children's Reading for Heart and Mind*.

Catherine's own interest in journalism did not end with *All Sorts of Things*; she also participated in *The Partner of Lovers of the Russian Word*, a journal published in 1783–1809 by the Russian Academy. Her involvement in this publication was even more extensive. Catherine co-edited *The Partner* with Princess Ekaterina Dashkova, whom the empress appointed president of the Russian Academy when it was established. She also was a prolific contributor. Among other things, Catherine published in *The Partner* her *Notes on Russian History*, an apologia for Russian monarchy intended for the education of her grandsons. Catherine's other contributions included *Facts and Fancies*, a moralizing work, written in question-and-answer format, with some barbs directed at Fonvizin, who had criticized her *Notes on Russian History*.

Catherine's "free press" law of 1783, which permitted individuals to own and operate private presses, greatly helped bring book culture to Russia. While Catherine's motives for this legislation remain unclear (scholars cite both political and commercial considerations), its enormous positive impact is indisputable. In his study of eighteenth-century publishing, Marker examined the explosive growth of the printing business in Russia between 1783 and the end of the century: "To appreciate the full significance of [the growth] figures, we must realize that nearly 8,000 titles were produced in Russia in the last quarter of the century—over three times what had been produced in the previous two centuries."[7] Although sales of highbrow publications still remained relatively small and were greatly outnumbered by sales of *lubok* chapbooks, the Russian equivalent of "Grub Street" fare, it could be said that Russian readership was born in the late eighteenth century, largely thanks to the "free press" law.

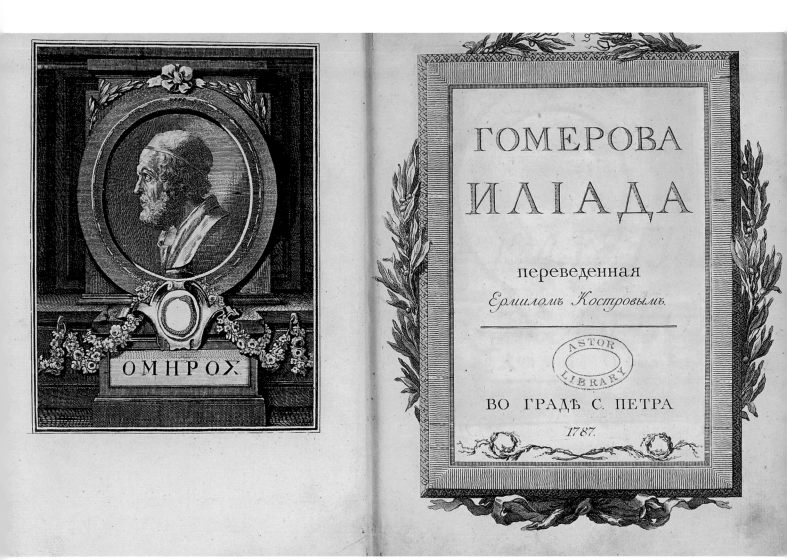

[37]

A CLASSIC IN RUSSIAN

Homer
Gomerova Iliada
Translated by Ermil Ivanovich Kostrov
St. Petersburg, 1787

In the eighteenth century, many classics were rendered into Russian. The first verse translation of the *Iliad* (cantos 1–6 only) into Russian was by Ermil Kostrov, who rendered the great epic in iambics. Subsequent cantos appeared in the journal *The Herald of Europe* [*Vestnik Evropy*] in 1811, but Kostrov did not finish his project. A full verse version, in hexameters, by the poet Nikolai Gnedich, finally appeared in 1829.

Божіею поспѣшествующею млтію
МЫ ЕКАТЕРИНА ВТОРАЯ,
ИМПЕРАТРИЦА И САМОДЕРЖИЦА
ВСЕРОССІЙСКАЯ,

Московская, Кіевская, Владимірская, Нов-
городская, Царица Казанская, Царица Астрахан-
ская, Царица Сібірская, Государыня Псковская,
и Великая Княгиня Смоленская; Княгиня Эст-
ляндская, Лифляндская, Корельская, Тверская,
Югорская, Пермская, Вятская, Болгарская и
иныхъ Государыня, и Великая Княгиня Нова
города Низовскія земли, Черниговская, Рязан-
ская, Ростовская, Ярославская, Бѣлоезерская,
Удорская, Обдорская, Кондійская и всея Сѣвер-
ныя страны Повелительница, и Государыня
Иверскія земли, Карталинскихъ и Грузинскихъ
Царей, и Кабардинскія земли, Черкаскихъ и

Along with her large-scale public cultural enterprises, Catherine also cultivated personal relationships with able individuals. In the courtly tradition, from the early days of her reign she looked for a writer whom she could consider her own panegyrist. Lomonosov, the most talented producer of panegyric poetry of his time, was not a suitable candidate, in view of his reputation as Empress Elizabeth's "singer." In any case, he died in 1765.

Sumarokov seemed a natural choice because of his support for Catherine since her days as Grand Duchess; he not only dedicated *The Industrious Bee* to Catherine but also wrote a dedication in verse for a manuscript collection prepared for her, entitled *Diversity and Pleasure* (fig. 34). Sumarokov, however, proved difficult to control. He vexed Catherine the very first time he attempted to serve her as empress with verses he wrote for her coronation festivities, a three-day celebration entitled "Minerva Triumphant." Sumarokov's contribution, "Chorus to a Perverted World," a satire of contemporary Russian life, was cut from the published version of the celebration's scenario. Later, in 1765, he published an ode dedicated to Catherine's former lover, now the Polish King Stanislas Augustus; Catherine ordered all copies of the work burned. Finally, Sumarokov's political opinions proved more conservative than those of the young empress, who was seeking to impress the world with her progressive views. His entry in an essay contest on the question of granting peasants property rights, held in 1766 on Catherine's suggestion by the Free Economic Society, defended serfdom so ardently that Catherine remarked: "Mr. Sumarokov is a good poet but … he does not have sufficient clarity of mind to be a good lawgiver."[8] It became clear that Sumarokov was not suitable court poet material.

At some point, Ruban, an able and prolific writer, seemed to be the right man. Unfortunately, his boundless passion for occasional panegyric poetry earned him a bad reputation among his contemporaries (he was particularly derided for his ode on the inoculation of Catherine against smallpox), and he was ruled out as well. Eventually, Catherine's personal charm and tact helped her succeed in her efforts to attract talent and put it to work for her policies; two truly gifted poets, Petrov and Derzhavin, became her "singers."

Petrov, born in 1736 into a poor clergy family, received his education at the Slavonic-Greek-Latin Academy in Moscow, which was the first Russian institution of higher education and the alma mater of Kantemir, Trediakovskii, and Lomonosov. The poet gained Catherine's attention with his 1766 ode "To the Magnificent Carousel" on the occasion of a jousting tournament organized by Catherine and modeled after the celebrated *Le Grand Carrousel* staged in 1662 by Louis XIV. Catherine appreciated Petrov's keen understanding of the tournament's symbolism, which aimed at establishing the right genealogy for the young empress. She rewarded the poet with the right to carry a sword (a nobleman's prerogative) and a snuffbox containing 200 rubles. The next year, Petrov followed with an ode praising Catherine for calling together the Legislative Commission. Soon thereafter he was summoned to St. Petersburg and made Catherine's personal translator and reader. In the mid-1770s, he was appointed a court librarian.

[38]
AN ILLUMINATED CHARTER

Catherine II, Empress of Russia
Imperial Charter
St. Petersburg, August 10, 1775

Catherine II, an avid reader, a versatile author, and a great patron of the arts throughout her long reign, was also known for her generosity in rewarding her servitors. This signed document grants land to the recipient as compensation for state service. It is a handsomely illuminated manuscript on vellum, with the border culminating in the monarch's portrait surmounting a double-headed eagle, the symbol of the Russian Empire.

Petrov was most famous (or, among his many literary adversaries, notorious) for his odes celebrating Russia's victories in the First Turkish War (1768–1774). The outbreak of hostilities caught the empress by surprise, and her early public documents explaining the war to her subjects fell back on the traditional rhetoric of the Christian Orthodox Empire making war with the infidels, a tradition going back at least to Lomonosov's 1739 "Ode on the Capture of Khotin." Catherine's subsequent correspondence with Voltaire helped her fine-tune this rhetoric. Voltaire ardently advised Catherine to use the war for the noble purpose of chasing the Turks out of Europe. His prime concern, of course, was not for the old Orthodox Byzantine Empire, but for classical Greece, and in his view Catherine was supposed to become its liberator. In his poem on the Russian capture of the Turkish fortress Khotyn in 1769 (the very same fortress whose capture Lomonosov had celebrated in 1739), Voltaire invites Catherine to join him "on the fields of Marathon":

O Minerva of the North, O you sister of Apollo,
You will avenge Greece by chasing out those reprobates,
Those enemies of the arts and jailors of women:
I depart; I will await you on the fields of Marathon.[9]

In yet another of his poems on the Turkish war, Voltaire compares it to the Persian war and makes Pallas promise to liberate Athens with Catherine's help:

It is I who leads Catherine,
When this astonishing heroine,
Treading the turban under foot,
Reunites Themis and Bellona
And laughs with me, sitting on her throne,
At the Bible and the Koran.[10]

While less enthusiastic about liberating Athens than about liberating Constantinople and certainly not ready to laugh at the Bible with Pallas, Catherine nonetheless incorporated the ancient Greek aspect into her ideological scheme; her choice of names for her two older grandsons, Alexander (born in 1777) and Constantine (born in 1779), testifies to her enthusiasm for the Greek Project, as the enterprise came to be called. Whereas the project's precise diplomatic and geopolitical details are debatable, its symbolic dimension, as the historian Andrei Zorin argues, is clear: by defeating the Ottoman Empire, Russia would become not only the liberator of the Second Rome, Constantinople, the birthplace of Orthodox Christianity, but also heir to classical Greece, the cradle of European civilization. Russia's position vis-à-vis Europe would drastically change: directly connected to the primary source of the Enlightenment, it would no longer need Europe as an intermediary. Instead of being Europe's disciple, Russia would become if not its superior then at least its equal.[11]

Petrov was the first Russian poet writing about the First Turkish War to incorporate ancient Greek motifs. While not abandoning biblical imagery altogether, he nonetheless concludes his own "Ode on the Capture of Khotin" with the following address to Catherine:

Your eagles will reach Athens
And will restore the freedom of Greece,

A new Pindar will thunderously laud there
The gift of Russia's victory:
Countless peoples will laud you,
The cause of their freedom.[12]

In Petrov's subsequent Turkish odes, the Greek motifs became even more pronounced. In his ode celebrating the Russian Mediterranean fleet, he portrays Catherine as Athena (Pallas) returning the rule of law to Greece:

And You who subdues the fury of the tyrant,
The lawgiver crowned by victories,
Take the scroll and announce judgment to the South:
To the region where Lycurguses and Solons flourished
 Send Your laws;
 They will be honored forever.[13]

Catherine the lawgiver and liberator of both the Orthodox Christians and the descendants of the ancient Greeks was an image the empress could appreciate and enjoy. Most importantly, it dovetailed with her grandiose, and never-to-be-fulfilled, geopolitical project.

 Derzhavin, perhaps the most gifted of all eighteenth-century Russian poets, was indebted to Catherine for his service career as well as, at least partly, for his literary fame. In turn, in his poetry he portrayed Catherine as a wise and formidable yet humane and accessible ruler, which pleased Catherine very much. Born in 1743 into a provincial gentry family and poorly educated, Derzhavin began his service as an enlisted man in the Preobrazhenskii guards shortly before the regiment helped Catherine overthrow Peter III (December 1761–June 1762). Nonetheless, as a biographer notes of Derzhavin: "[I]t took almost two decades for his career, both in the service and as a poet, to begin to rise."[14] The decisive moment came in 1782, when he wrote his ode "Felitsa," which evoked Catherine's own allegorical and didactic *Tale of Prince Khlor*, written for her grandson Alexander and published in 1781 (fig. 40). In this tale, Princess Felitsa helps Khlor in his quest for wisdom and virtue. Connecting himself with the Oriental trappings of the tale through his family's alleged Tatar origins, Derzhavin contrasts the virtuous yet humane Felitsa with her courtiers and his own poetic persona ("the murza"), all of whom are portrayed as good-for-nothing drunkards, card-players, womanizers, and idlers. In her wise kindness, however, Felitsa forgives her imperfect subjects. Derzhavin's mixing of satire and panegyric ode was highly innovative and spelled the beginning of a new era for—and ultimately the demise of—the latter genre.

 Derzhavin used Felitsa and "the murza" in several of his subsequent panegyric poems. The best of them was "The Vision of the Murza" (1783), in which he presented a striking and most flattering portrait of Catherine. Alone in his study and awake at a time when everybody else is asleep, the poetic speaker has a vision of Felitsa descending from the heavens like a goddess. Her image is modeled on the famous painting by Dmitrii Levitskii, *Catherine II as Legislatrix in the Temple of the Goddess of Justice*. In the dialogue that follows, Derzhavin's persona outlines his artistic principles, and Felitsa endorses them, commanding her murza to be honest and direct in his poetry, thus approving both his satire of the courtiers and her own flattering portrayal.

 The Felitsa cycle brought Derzhavin into direct contact with Catherine and eventually, in 1791, gained him a position as her private secretary. By this time, however, his enthusiasm for Felitsa had cooled considerably, and even Catherine's direct requests could not induce him to

АНАКРЕОНТИЧЕСКІЯ
Пѣсни.

Въ Петроградѣ
1804. Года.

Я сердцами бью челомъ.

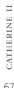

До временъ Кія Князя Кіевскаго, жилъ да былъ въ Россіи Царь добрый человѣкъ, который любилъ правду и желалъ всѣмъ людямъ добра; онъ часто объѣзжалъ свои области, чтобъ видѣть каково жить было людямъ, и вездѣ навѣдывался, дѣлаютъ ли правду.

У Царя была Царица. Царь и Царица жили согласно, Царица ѣзжала съ Царемъ и не любила быть съ нимъ въ разлукѣ.

Пріѣхалъ Царь съ Царицею въ одинъ городъ построенной на высокой горѣ посреди лѣса, тутъ родился Царю сынъ дивныя красоты, ему дали имя Хлоръ; но посреди сей радости и придневнаго празднества, Царь получилъ непріятное извѣстіе, что сосѣди его неспокойно живутъ, въѣзжаютъ въ его земли и разныя обиды творятъ пограничнымъ жителямъ. Царь взялъ войски, кои въ близости въ лагерѣ стояли и пошелъ съ полками для защиты границы. Ца-
а рица

[39, *opposite*]
LOVE POEMS

Gavriil Romanovich Derzhavin
Anakreonticheskiia pesni
St. Petersburg, 1804

Gavriil Derzhavin not only transfigured the Russian panegyric ode, eventually causing its demise, but also transformed the Anacreontic ode—a light poem about love and the enjoyment of life named for Anacreon, a semi-legendary lyric poet of Greece who supposedly lived in the fifth century B.C.E. Derzhavin gave back to Anacreontics, which had acquired a somewhat moralistic tone in Russian mid-eighteenth-century practice, their original eroticism and Epicurean character. This volume of his *Anacreontic Songs* was illustrated with engravings done after drawings by Salvator (Nikolai Ivanovich) Tonci.

[40, *above*]
A CHILDREN'S TALE BY CATHERINE THE GREAT

Catherine II, Empress of Russia
Skazka o tsareviche Khlore
St. Petersburg, 1782

In the allegorical *A Tale of Prince Khlor*, written for Grand Duke Alexander and first published in 1781, Catherine instructs her grandson in achieving virtue. The "Kirgiz-Kaisak" Princess Felitsa (Catherine) guides Prince Khlor (Alexander) to a mountain where he finds the symbol of virtue: a rose without thorns. The leading eighteenth-century poet, Gavriil Derzhavin, used the name Felitsa in a panegyric ode addressed to the empress. Catherine's *Tale* was the first literary work in Russian written specifically for children.

write more odes to her. Furthermore, he got into trouble with the empress over an attempt, in 1795, to include his 1780 poem "To the Rulers and the Judges" in his collected works. The poem, a transposition of the 82nd Psalm, had been published several times before, but the events of the French Revolution, the execution of Louis XVI in particular, altered the poem's meaning, and its further publication was prohibited, despite Derzhavin's protests that "King David was no Jacobin."

Derzhavin's disagreements with Catherine never put him in any real danger. At the same time, Catherine could be quite brutal in her attacks against perceived dissent, particularly in the years following the French Revolution. She began punishing dissenters with exile and imprisonment and all but abandoned her role as the Semiramis of the North. In 1790, Aleksandr Radishchev was arrested and tried for the publication of his *Journey from Petersburg to Moscow*, a book critical of the idea of absolute monarchy in general and Russia's social ills in particular. He was sentenced to death, and the sentence was clearly prompted by Catherine's many angry remarks in the margins of her personal copy of the book, which she made available to the criminal court. Catherine commuted the death sentence, which was replaced by a ten-year Siberian exile; after Catherine's death, Paul permitted Radishchev to return to live on his estates; and in 1801 Alexander completely restored his freedom. In 1792, Novikov, Catherine's collaborator in the 1770s in the field of journalism and book publishing, was arrested, charged with producing and harboring illegal books, mostly Masonic, and sentenced to a fifteen-year imprisonment in the Schlüsselberg Fortress in St. Petersburg (Paul released him in 1796).

Catherine's repressive mind-set in the 1790s culminated in the Censorship Act of October 1796. In Marker's words, it "revoked the right of individuals to operate their own presses" and thus "drastically constricted the ability of writers to get their works into print."[15] With private presses, censorship was haphazard and almost voluntary; the Act, however, *de facto* introduced universal censorship, since it forced writers to publish with official presses where their books underwent obligatory formal review.

Rumors of Catherine's brutality toward dissent were far worse than her actual repressions. Popular opinion accused her of ordering (or at least not preventing) the corporal punishment and torture of several writers (Fonvizin, Novikov, and Radishchev) and blamed her for the dramatist Iakov Kniazhnin's alleged death under the rod. Catherine's supposed agent in this repression was Semen Sheshkovskii, the head of the Secret Chancery. Aleksandr Pushkin's view, expressed in his so-called "Notes on Russian History of the Eighteenth Century" (1822), was typical:

Catherine abolished torture, but the Secret Chancery flourished under her patriarchal rule; Catherine loved enlightenment, but Novikov, who spread its first rays, went from Sheshkovskii's hands to prison where he remained right up until her death. Radishchev was exiled to Siberia; Kniazhnin died

[41]
A RUSSIAN TRAVELER IN EUROPE

Nikolai Mikhailovich Karamzin
Travels from Moscow, through Prussia, Germany, Switzerland, France, and England
London, 1803

- -

Nikolai Karamzin traveled around Europe from May 1789 to July 1790, visiting places and people of cultural and intellectual interest, including Immanuel Kant, Johann Gottfried Herder, and Johann Lavater; this map illustrates his itinerary (see dotted line). In 1791, he began to publish in his magazine *Moscow Journal* [*Moskovskii zhurnal*] a serialized version of his *Letters of a Russian Traveler* [*Pisma Russkogo puteshestvennika*], a fictionalized account of his grand tour. A six-volume complete edition was published in 1797–1801. A. A. Feldborg translated *Letters*, as *Travels from Moscow*, for the three-volume English edition of 1803.

under the lash, and Fonvizin, whom she feared, could not have avoided the same fate if he had not been so famous.[16]

In fact, Fonvizin was never in any physical danger; Novikov's torture is not documented; and, although Catherine did order Kniazhnin's tragedy *Vadim of Novgorod* (written in 1789, published in 1793) burned after its publication two years after the playwright's death, it is highly unlikely that she had anything to do with the death itself.[17] It is ironic that the empress, who largely succeeded as a philosopher on the throne and who, furthermore, introduced legislation forbidding corporal punishment and torture for nobles, nonetheless earned a reputation as a persecutor of writers.

By the end of the century, however, following European models, the literature of Sentimentalism developed outside the monarch's influence, as a private activity of independent individuals, bringing to an end the era of direct imperial control of the cultural sphere. Nikolai Karamzin was the first to publicly insist on his independence, both as a writer and as an individual. In his *Letters of a Russian Traveler* (1797–1801; see fig. 41 for a later edition), he created the character of a young traveler who goes to Europe not on some state business but of his own volition, as a private person—but who, nonetheless, takes it upon himself to represent Russian culture to European intellectuals. Upon his return to Russia in 1791, Karamzin demonstratively behaved as a private and independent person, entitled to his own opinions, regardless of how they might be judged by the powers that be. In 1795, after Novikov's arrest, when the majority of Novikov's associates tried to distance themselves from him, Karamzin did not hesitate to address the empress with a poem, "To Mercy," and implored her to spare Novikov his punishment.

At the same time, literature was more and more becoming a private pursuit. In 1793, Karamzin "removed himself from the 'official world' to the 'small world' of domesticity and close friendships, which was a productive environment for him as a writer."[18] Derzhavin largely separated his service life from his life as a poet and turned from panegyric poetry to apolitical genres, such as Anacreontic verse (fig. 39). In his 1807 poem "To Evgenii. Life at Zvanka," he celebrates an ordinary day on his estate away from both the rigors and the honors of state service, and claims to have achieved immortality through poetry alone.[19]

In another development, Karamzin and, later, Aleksandr Pushkin promoted the ideas of literary activity as a professional occupation and of the writer's financial independence based on his or her ability to publish. It is true that despite their efforts to live on their honoraria, Karamzin and especially Pushkin continued to depend on subsidies given by the court. In fact, no real measure of financial independence came to Russian writers until at least the second half of the nineteenth century. Nonetheless, it can be said that by 1825 Russian literature had largely completed its passage to modernity and had caught up with its counterparts in the west in virtually all areas of literary production, and this was due in no small part to the efforts of Catherine the Great.

Notes

1 Gary Marker, "N. I. Novikov," in *Dictionary of Literary Biography*, vol. 150: *Early Modern Russian Writers, Late Seventeenth and Eighteenth Centuries*, ed. Marcus C. Levitt (Detroit: Gale Research, Inc., 1995), p. 252.

2 Isabel de Madariaga, "Catherine and the Philosophes," in *Russia and the West in the Eighteenth Century*, ed. A. G. Cross (Newtonville, Mass.: Oriental Research Partners, 1983), p. 30.

3 Isabel de Madariaga, *Russia in the Age of Catherine the Great* (New Haven, Conn.: Yale University Press, 1981), p. 337.

4 Ibid.

5 Nikolai Novikov, *Opyt istoricheskago slovaria o rossiiskikh pisateliakh* (St. Petersburg, 1772; facsimile rpt. Moscow: Kniga, 1987), p. 102.

6 Michael Von Herzen, "Catherine II—Editor of *Vsiakaia Vsiachina*: A Reappraisal," *The Russian Review*, 38 (1979): 289, with a reference to Petr Pekarskii, "Materialy dlia istorii zhurnal'noi i literaturnoi deiatel'nosti Ekateriny II," *Zapiski Akademii Nauk*, 3 (1863): appendix 6, pp. 1–87.

7 Gary Marker, *Publishing, Printing, and the Origins of Intellectual Life in Russia, 1700–1800* (Princeton, N.J.: Princeton University Press, 1985), p. 105.

8 Quoted in Marcus C. Levitt, "Aleksandr Petrovich Sumarokov," in *Dictionary of Literary Biography*, 150: 377.

9 "O Minerve du Nord, ô toi, soeur d'Apollon, / Tu vengeras la Grèce en chassant ces infâmes, / Ces ennemis des arts et ses geôliers de femmes: / Je pars; je vais t'attendre au champs de Marathon." Voltaire, *Oeuvres complètes. Epitres et stances*. Vol. 11 (Paris, 1819), p. 330.

10 "C'est moi qui conduis Catherine / Quand cette étonnante héroïne, / Foulant à ses pieds le turban, / Réunite Thémis et Bellone, / Et rit avec moi, sur son trône, / De la Bible et de l'Alcoran." Voltaire, "Ode Pindarique à propos de la guerre présente en Grèce," in his *Oeuvres diverses: contes, satires, épitres …* (Paris, 1850), p. 419.

11 For an excellent treatment of Catherine's Greek Project and its cultural symbolism, see Andrei Zorin, "Russkie kak greki," in his *Kormia dvuglavogo orla … Literatura i gosudarstvennaia ideologiia v Rossii v poslednei treti XVIII–pervoi treti XIX veka* (Moscow: Novoe Literaturnoe Obozrenie, 2001), pp. 33–64. I am indebted to Zorin for my presentation of the subject.

12 Vasilii Petrov, "Oda na vziatie Khotina," in his *Sochineniia*, vol. 1 (St. Petersburg, 1782), p. 49.

13 Petrov, "Na pobedy v Moree," in his *Sochineniia*, I: 77.

14 Alexander Levitsky, "Gavriil Romanovich Derzhavin," in *Dictionary of Literary Biography*, 150: 73.

15 Marker, *Publishing*, p. 227.

16 Pushkin, *Polnoe sobranie sochinenii* (Leningrad: Akademiia Nauk SSSR, 1937–1959), 11: 16.

17 See E. D. Kukushkina, "Iakov Borisovich Kniazhnin," in *Dictionary of Literary Biography*, 150: 180.

18 Gitta Hammarberg, "Nikolai Mikhailovich Karamzin," in *Dictionary of Literary Biography*, 150: 142.

19 On Derzhavin's gradual gaining of his poetic independence, see Anna Lisa Crone, *The Daring of Deržavin: The Moral and Aesthetic Independence of the Poet in Russia* (Bloomington, Ind.: Slavica, 2001), pp. 130–135.

Visual Russia

Catherine II's Russia
Through the Eyes of
Foreign Graphic Artists

by Elena V. Barkhatova

I n 1744, when the young German princess Sophie Friederike Auguste von Anhalt-Zerbst took the long, cold journey to Moscow to become affianced, she looked at the cities and villages of Russia through the eyes of a foreigner, amazed by the boundless vistas and the dress and behavior of the people. Many years later as empress, Catherine II in her frequent travels would survey with an owner's eye the landscapes and population of the enormous domain entrusted to her care. During her thirty-four-year reign, an essentially new nation appeared on the historical stage. Russia's territory extended to Europe, Asia, and North America; its interests became an important factor in world politics; and its influence helped resolve a variety of national, cultural, and religious issues. These large-scale transformations attracted many foreigners to Russia in the second half of the eighteenth century, including merchants and craftsmen, soldiers and scholars, diplomats and spies, adventurers, and fortune-seekers. In their notes, reminiscences, diaries, and secret reports, they documented Russia's politics, culture, economics, lifestyle, and mores for the audience back home.

In addition, a phalanx of foreign artists captured the visual image of Catherine's Russia through portraits of statesmen and ethnic inhabitants, views of cities and villages, and landscapes. During this era, Italians, Germans, Danes, and Frenchmen created a kind of graphic Russica. Some of these artists arrived at the invitation of the empress, whose patronage of the arts played an important role in asserting both her own and Russia's fame in the world. Foreigners also came to teach at the invitation of the St. Petersburg Academy of Fine Arts. A third type of artist came to distant Russia by chance, often without recommendations and nearly penniless, hoping to find success in a country where, it was said, talent was generously rewarded. Many of them pictured "that theology student (Andrei Osterman), who was thrown out of Vienna and subsequently became a Russian state chancellor."[1]

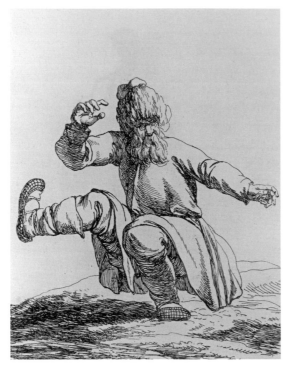

Augustin Dahlstein
Russische Trachten und Ausrufer in St-Petersburg.
Habillemens moscovites et crieurs à St. Pétersbourg
Cassel, 1750

This plate, "A Dancing Peasant," is from a series by the German artist and engraver Augustin Dahlstein, who lived and worked in Russia from the late 1740s to the early 1750s. He was one of the first European artists to develop Russian themes, creating accurate representations of folk amusements, including dances and antique musical instruments.

"In pursuit of his artistic calling," a German, Augustin Dahlstein, arrived in Russia in 1749.[2] He lived in St. Petersburg, Kronstadt, and Riga, working primarily as a painter and obtaining commissions from private individuals for canvases of landscapes, marine views, *dessus-de-porte*, and other secular scenes, all of which were then in vogue. He achieved fame with a series of lithographs, *Russian Costumes and Public Criers of St. Petersburg*, which he executed upon his return to Germany. While the "costume" genre was popular in Europe, Dahlstein was the first to apply it in Russia; twenty sheets of drawings portray peasants, men and women, young and old, in winter and summer dress. Dahlstein's compositions are simple, depicting single, static figures, who are clearly posed to provide the best view of the costume. All the characters are presented full-length, with a low horizon line, and without any background. Eighteen lithographs were devoted to the colorful peddlers of St. Petersburg, who are shown, always in free and casual poses, hawking pies, flax oil, or old clothes. Eight drawings depicted members of the clergy and demonstrated the natural interest of foreigners in Russian Orthodoxy; Dahlstein featured a monk, a deacon reading psalms, and a village priest with walking stick making the rounds of his parish. His series also included drawings of a carpenter, a sailor, a soldier in winter uniform, and ragged convicts begging for handouts. In addition, the artist devoted a number of detailed works to folk amusements and dances, for instance, peasants playing traditional instruments or dancing the *trepak* (fig. 42). Dahlstein's engravings, distinguished by their rich and confident strokes, introduced Russian themes to eighteenth-century European art.

In the late 1760s, the French artist Jean-Baptiste Le Prince made *russerie* truly fashionable (adding to the already popular *turquerie* and *chinoiserie*) with his publication in Paris of a series of exotic compositions that he had made in Russia. Le Prince, a student of François Boucher, was raised in Normandy in an artistic family. He came to St. Petersburg in early 1757, responding to a call from his older brother, François, who was a gold master and cabinetmaker in the Winter Palace, then under construction. Jean-Baptiste also worked on the ornamentation of the palace, decorating ceilings and working for Catherine herself; the roughly fifty paintings he made while

in Russia included historical compositions and tympana. He was presented to the empress by the French ambassador, Marquis de l'Hôpital, who, like the Polish ambassador, Stanislaus Poniatowski, became his patron. Le Prince soon earned Catherine's trust. At her request, he purchased works by foreign artists for her so that she could acquaint herself, and the St. Petersburg nobility who imitated her, with the best examples of European paintings.

As his next undertaking, the artist suggested that Catherine grant him 5,000 rubles annually to travel to all the most famous coasts and harbors of Russia in order to create paintings and drawings for engraving.[3] Whether in Moscow, the Baltic provinces, or Siberia, Le Prince sketched fairs, festivals, amusements, and church rituals. He substantially expanded the costume and ethnographic genres of Dahlstein and, even more important, achieved greater artistic effect in them. Like those of Boucher, his engravings—of Muscovites, peasant women, fishmongers, and egg sellers—are full of grace and lively observation (fig. 44). The compositions are complex and reminiscent of the Dutch masters, for instance in his landscapes of St. Petersburg's environs, his studies of old women, imbued with meaning and inner strength, and his dynamic and expressive sketches of horse-drawn wagons racing through the snow. From these drawings, Le Prince created a series of engravings when he returned to France (fifteen appeared before he died in 1781): *Various Modes of Dress and Customs of Russia, Costumes of Various Nationalities, Costumes of the Women of Muscovy*, plus three series depicting such subjects as merchants and peddlers. These engravings influenced both European artists, who began depicting scenes from Russian life, and Russian artists, who were only starting to develop genre painting.

Le Prince was also among the first foreign artists to portray the darker sides of Russian life, for example, the widespread practice of punishing peasants by beating them with sticks and the knout—but he did so with a light touch. These compositions became part of *A Journey into Siberia* (1768) by Abbé Chappe d'Auteroche, who traveled to Tobolsk to make astronomical observations of the 1761 transit of Venus across the sun.[4] Chappe d'Auteroche was highly critical of everything he had seen in Siberia and painted a grim picture of national poverty, but Le Prince's engravings, delicate in line and frivolous in content, contrasted sharply with the tone of the book. The artist created a highly whimsical, semi-fantastical series of Russians dancing, drinking in taverns, taking steam baths (complete with naked beauties), and examining wedding-night sheets; he also depicted such creatures as fish and ducks. In the engraving *Interior of a Russian Izba at Night*, the country kitchen of a hovel is shown as a large, high-ceilinged hall; the young mother and naked children playing on the floor seem to have been transported from a composition by Boucher or Jean-Honoré Fragonard.[5] Catherine II's *Antidote* (1770), in which she tried to persuade European public opinion that Chappe d'Auteroche was prejudiced against Russia, also criticized the lack of truth and accuracy in some of Le Prince's engravings but laughed that "in our times all bad writing [seems to be] ornamented by really marvelous engravings."[6] At any rate, she continued to appreciate the artistry of Le Prince, whose Russian engravings were also very popular in Europe. He continued to prosper and in 1765 in Paris exhibited another series, including *Russian Christening*, which was praised by Catherine's French friends Friedrich Grimm and Denis Diderot.

Another French artist, Jean Louis de Veilly, came to Russia in 1759 to teach painting for one year at the Academy of Fine Arts but then decided to remain. Soon after Catherine seized the throne, he joined the staff of the cabinet, where he was assigned to create a series of drawings for the empress's coronation, supervising a group of artists that included two of Russia's best native talents, Mikhail Makhaev and Aleksei Antropov. De Veilly was to capture the main episodes of the coronation and then use the drawings to prepare a commemorative album (fig. 43). Through the

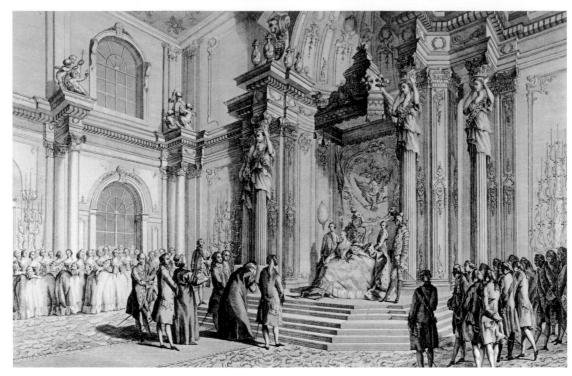

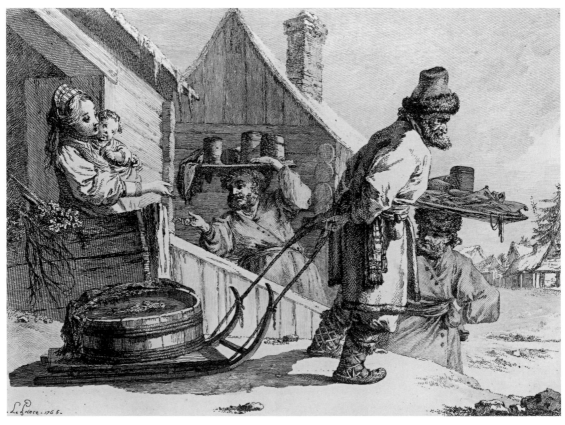

artist's drawings, contemporaries could visualize the majestic coronation, with its ritualistic and mystical elements. De Veilly's mastery took his compositions far beyond a simple representation of an event to convey the unique poetic embodiment of the ceremony, which evoked legitimacy and stability and served to counteract the scandalous story of Catherine's coup d'état and the subsequent death of her husband, Peter III.

In his *Publication of the Manifesto on Ivanovskaia Square in Moscow*, the artist represented all strata of society, endowing simple folk and nobles alike with refined and lively features. He also managed to convey the outburst of national feeling and atmosphere of enthusiasm that accompanied Catherine's ascent. Other drawings—*Procession of Catherine from the Kremlin Palace to the Cathedral of the Assumption* and *The Empress Reciting the Creed of the Orthodox Faith*—are endowed with monumentality because of the mastery of composition and space, as well as the rendering of the power of architecture. The colorful appearance of the ancient capital and the customs of the Muscovites enchanted de Veilly. And so, along with the coronation drawings, he devoted four pages to folk scenes depicting peddlers in Red Square, fishermen on the Moscow River, a view of the Iverskii Gates, and a winter sleigh scene. De Veilly's drawings do not have the grotesque expressiveness or pastoral grace of Le Prince's drawings, nor their exoticism and exaggerated character; instead, his poetic compositions of the unhurried daily life of the capital organically combine the elements of genre scene and view. This sensitivity possibly results from the fact that de Veilly was more than a visiting foreign traveler; he was a longtime resident of Russia and was friendly with some of its leading cultural figures, for instance the engravers Makhaev (fig. 45) and Evgraf Chemesov and the actor Fedor Volkov.

Another French artist who spent many years in Russia, Guerard de la Barthe, owes his European fame to his engravings of Russian life. The artist spent over twenty years in Russia—from 1787 to 1810—and created a vivid and expressive visual record of Catherine's Moscow in a

[43, *opposite, above*]
RECEIVING THE SULTAN'S EMISSARIES

Jean Louis de Veilly
Engraving depicting the reception of the Ottoman Turkish embassy
St. Petersburg, ca. 1764 (published for the first time in 1857)

This engraving, after a drawing by Jean de Veilly, depicts Catherine II receiving the emissaries of Sultan Mustafa III in October 1764, two years into her reign. The embassy to Catherine brought her the felicitations and good wishes of their sultan. This event took place during a rare period of relative calm between the two competing empires. The image was included, along with other original engravings after de Veilly, in the album commemorating Catherine's coronation, which was not published until nearly a century later, in 1857.

[44, *opposite, below*]
A FISHMONGER AND A CAVIAR MERCHANT

Jean-Baptiste Le Prince
Divers ajustements et usages de Russie
Paris, ca. 1775

From 1757 to 1762, the French artist and engraver Jean-Baptiste Le Prince lived in Russia, where he traveled widely through cities and villages making drawings depicting the life of the common people, including a fishmonger and a caviar merchant, shown here. Although Le Prince's compositions combine refined drawing with accuracy of detail, his pictures of everyday life betray a strong sentimentality.

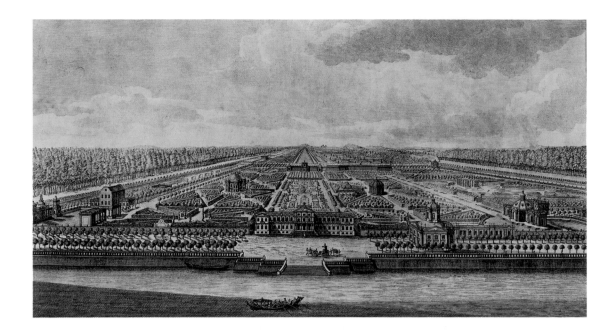

wealth of drawings, watercolors, and paintings. His chief fame came from the series of engravings, made from his drawings, that included *View of the Kremlin from Kamennyi Bridge* and *View of the Ice Hills in Moscow During Shrovetide*; both were dedicated to Catherine II. When the empress died in November 1796, work on the series was halted in Russia but German engravers resumed the task. By 1799, the series of Moscow views by de la Barthe was completed and immediately won recognition from contemporaries.[7] His panoramas recreated with great accuracy the architectural view of the capital's center—the Kremlin (fig. 46), Kitai-gorod, Zamoskvorech'e—successfully combining a broad grasp of locale with a meticulous appreciation for details.

The main feature of de la Barthe's drawings was his depiction of a crowd of figures. In one view he captured the lively and variegated life of Red Square, where children play, soldiers march, auctions are conducted, icons are carried, and people drink tea from a samovar. Another view shows celebrations during Holy Week; the composition is filled with carefully drawn tents, stalls, swings, carousels, and festively dressed crowds. An engraving that proved especially popular depicted Russian beauties, both nude and dressed in national costumes, enjoying steam baths on an embankment of the Yauza River. *View of the Ice Hills in Moscow During Shrovetide* gave a detailed account of pre-Lenten activities, and *View of Mokhovaia and the Pashkov House* recreated one of the region's most famous buildings, which boasted a garden that contemporaries called a "glimpse of Eden." In great detail, de la Barthe captured the life of Moscow in a way that corresponded to foreigners' perceptions of the ancient Russian capital, which, as a French diplomat noted, "stunned us with its exoticism."[8] For this reason, the engravings were issued repeatedly in France, Germany, and England.

During Catherine's reign, Moscow underwent a transformation. The elaboration and gradual execution of plans, based on the principles of classical urban planning, called for a general reconstruction of the city, which, at the same time, began to regain its role as the historical center of the country. These changes were due, in great part, to the policies of the empress, who did much to bring about the renaissance of the ancient city and to give it a more modern look. Catherine visited Moscow only eight times, and she saw much need for improvement: "Never did people have before their eyes more objects of fanaticism than the miraculous icons at every

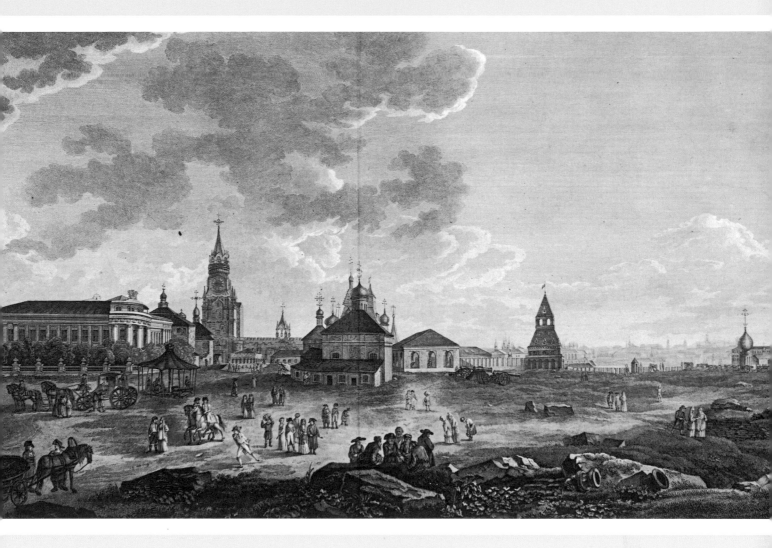

[45, *opposite*]
COUNT SHEREMETEV'S ESTATE AT KUSKOVO

Mikhail Ivanovich Makhaev
*Réprésentation exacte des edifices et du jardin, qui se
trouvent dans une des maisons de plaisance nommée
Sailo Kouskowa*
Paris, 1778–1779

The suburban estate of Kuskovo belonged to the
wealthiest aristocrat of Catherine's time, Count
Peter Sheremetev, who was famous for his luxurious
lifestyle and love of art. This plate, one of fourteen
in an engraved edition, depicts the estate's palace,
church, Italian house, Dutch house, theater, hermi-
tage, grotto, *orangerie*, and enormous French park.

[46, *above*]
A VIEW FROM INSIDE THE KREMLIN

Guerard de la Barthe
Vid Spasskikh vorot i okruzhnostei ikh v Moskve
N.p., 1799

The tallest structure in this picture is the Savior
(Spasskii) Gates of the Kremlin, to the right of which
stands a small stone church with a battery tower at
its right. The house to the left behind the trees was
built for Metropolitan Platon (Levshin), who became
Metropolitan of Moscow. To its left is the dome of
the Miracles (Chudov) Monastery and to its right the
Assumption (Voznesenskii) Monastery. In the fore-
ground, the remains of the pre-Petrine government
offices (demolished in the 1770s) surround a Kremlin
square. De la Barthe lived in St. Petersburg and
Moscow from 1787 to 1810.

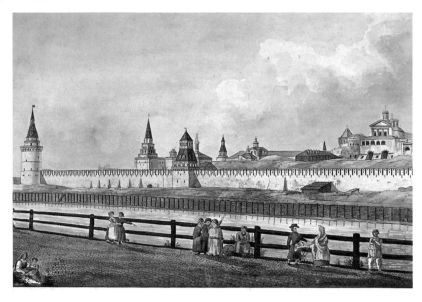

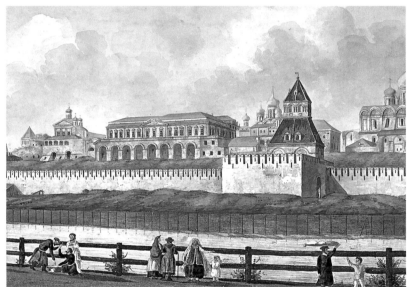

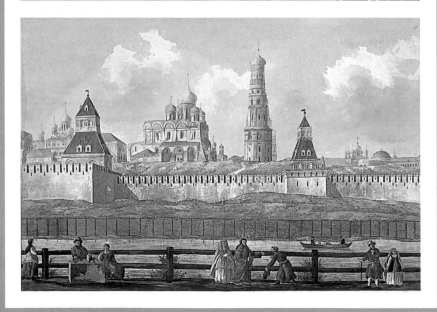

step, churches, priests, monasteries, pilgrims, beggars, thieves, useless servants in houses—and what houses—what filth in the houses, their city squares are enormous, but their courtyards are filthy swamps."[9] In 1771, the empress approved a plan for the reconstruction of the Kremlin palace, and in 1774 founded a special "Department for Creating a General Plan and Project for Improving Construction in Moscow." She also attended to trade, hospitals, sanitary conditions, homes for the poor, and postal services and moved some government offices from St. Petersburg to Moscow.

The changes impressed foreigners. Diderot even advised Catherine to give Moscow a chance at becoming the capital once again: "Spend two months a year at first in Moscow, then three, then six, and you'll end up settling there for good....You will found Moscow yet again."[10] Others also sincerely delighted in the old city. The French artist Elisabeth Vigée-Lebrun wrote: "A truly astonishing sight is created by those numerous palaces, public monuments of brilliant architecture, monasteries and churches intermingled with village views and country buildings. This mixture of luxury with country simplicity creates a magical impression."[11]

The city had a similar impact on the Italian artist Francesco Camporesi, who created a series of twelve engravings from his own drawings. Four views captured the panorama of the Kremlin from various angles; they amply document the beauty and majesty of Moscow's architectural ensembles and are distinguished by meticulous attention to detail (fig. 47). Other drawings provide views principally of churches and monasteries. While they include genre scenes, they are not detailed and peopled like the compositions of de la Barthe, but their attention to ornamental detail served to show the scale of the majestic buildings. Indeed, the style of the engravings is explained by the fact that Camporesi originally came to Russia in the 1780s as an architect and took part in Catherine's ambitious construction program in Moscow, while also building houses for the Russian nobility.

Camporesi's countryman Giacomo Quarenghi traveled with him from Italy but chose to settle in St. Petersburg. He became a favorite architect of the empress, and his buildings helped complete the majestic aspect of the northern capital: the Academy of Sciences, the Currency Bank, the Hermitage Theater, the Catherine and Smolny institutes, and the Horse Guards' Riding Hall. Quarenghi's monumental constructions feature the solemn colonnades and clear and precise proportions characteristic of classicism, the architectural style that predominated in Catherine's Northern Palmyra. Unfortunately, this productive artist did not leave engraved views of Petersburg, as Camporesi did of Moscow, but his drawings, done "for himself," are more intimate than his countryman's.[12] They capture the soul of the city, organically combining fine depictions of buildings with genre scenes and elements of urban landscape as well as catching the swift transformations taking place in the city before the very eyes of its contemporaries, native and foreign alike.

William Coxe, the English traveler who first visited the city on the Neva in 1778, noted that the new capital had an unfinished look; he marveled that stone buildings were interspersed with wooden ones and some of the streets were laid with planks.[13] St. Petersburg was under intensive construction, especially since Catherine

[47]

VIEWS OF THE KREMLIN

Francesco Camporesi
Three colored etchings of the Moscow Kremlin
Moscow, ca. 1790

This series (from a group of four etchings) by the Bolognese master Francesco Camporesi shows three parts of the Kremlin from the opposite bank of the Moscow River. The artist executed many views of the old capital and in 1808 built a special rotunda on the Tverskoi Boulevard to exhibit them.

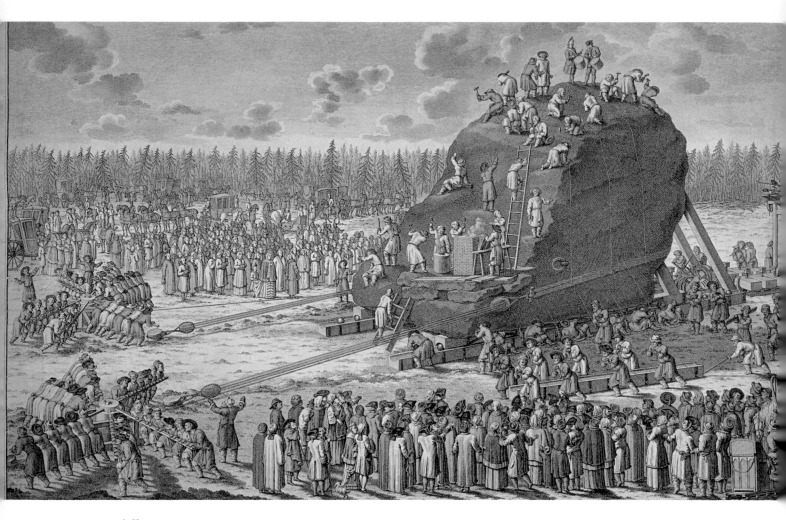

[48]

CATHERINE II's "THUNDER STONE" FOR PETER THE GREAT

Jacobus van der Schley
Engraving depicting the delivery of the "Thunder Stone"
for the base of the statue of Peter the Great
St. Petersburg, ca. 1770

This plate is one of a series of three that depicted the
moving of the stone that would serve as the base for
the equestrian statue of Peter the Great, the Bronze
Horseman. In the autumn of 1768, the more than 2,000-
ton stone was found near Lakhta on the Gulf of Finland
not far from St. Petersburg. It was lifted onto special rails
and carried to the shore with the help of a system of
rollers, winches, and levers designed by a French engineer.
Workers then transported it on a barge flanked by two
sailing ships to Senate Square in St. Petersburg, where it
was offloaded and carved. All this attracted crowds of
people. The plate shows Catherine II in elegant ermine-
trimmed travel clothes standing amidst her courtiers.

understood that the capital was the face of the empire. She also found herself captivated by building projects and confessed in a letter to Grimm: "My building passion is stronger than ever, and no earthquake has destroyed as many buildings as we are erecting. Construction is a magical thing; it consumes money and the more you build, the more you want to build."[14] In his *Travels*, Coxe described such notable examples of architecture as the Peter-Paul fortress, the Winter Palace, the Marble Palace, and the houses of the elite located along the three main roads leading to the Admiralty.

Coxe also witnessed the erection of the magnificent monument to Peter the Great, the Bronze Horseman. Sculpted by Étienne-Maurice Falconet (the head done by Falconet's talented student Marie-Anne Collot), the famous statue presented Peter as transformer and creator. Astride a bronze horse on a cliff that serves as a pedestal—symbolic of the obstacles he had to overcome—the reforming tsar with an assertive gesture extends his hand over Russia. Poetic, passionate, vivid, and flawless in its grace, the Bronze Horseman is skillfully placed in space facing the Neva River. Coxe related with awe how quickly—in just six months—the empress solved the problem of delivering the huge, heavy stone intended for the pedestal. At the same time Coxe reproached Falconet for overly finishing the pedestal, being "too lavish of the chissel," since, in his opinion, the cliff as it was originally delivered was incomparably more effective.[15]

The delivery of the stone for the Bronze Horseman in the autumn of 1768 has often been captured in engravings. The architect Iurii Fel'ten, who designed the placement of the sculpture and pedestal, made three drawings of the transportation of the huge "Thunder Stone" from Lakhta to St. Petersburg, a five-mile trek that required almost four hundred people. From Fel'ten's drawings, Jacobus van der Schley, a Dutch artist working in St. Petersburg, made engravings that depicted the complex process of installing the stone, along with the attendant crowds

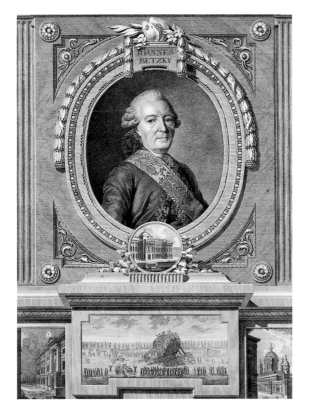

[49]
A PERIPATETIC COURTIER

Antoine Radigues
Portrait (copper engraving) of Ivan Ivanovich Betskoi
St. Petersburg, 1794

Ivan Betskoi was a long-lived courtier perhaps best known for his works on the theory and praxis of education, and for his involvement in the establishment of educational institutions throughout the empire. The small illustrations below his portrait depict other public institutions, such as the Academy of Fine Arts, with which Betskoi was involved, and the moving of the vast stone for the base of the Bronze Horseman statue.

of workers and residents (fig. 48). The story of the "Thunder Stone" even figured in one of the best engraved portraits of the period, that of Ivan Betskoi (fig. 49), a prominent figure in the Russian Enlightenment. The artist, Antoine Radigues—who worked in St. Petersburg from 1764 as head of the department of engraving at the Academy of Sciences and of the engraving department of the Academy of Fine Arts—created a complex composition. The oval frame contains images of the Academy of Fine Arts (over which Betskoi presided for thirty years) and of the foundling hospitals in the two capitals (which Betskoi had helped establish). But the bottom center of the composition is the famous scene of the transport of the "Thunder Stone."

Catherine turned the unveiling of the Bronze Horseman in August 1782 into a solemn ceremony. Surrounded by her entourage, honored guests, and foreign ambassadors, the empress surveyed the scene from the balcony of the Senate building, while the guards of the Preobrazhenskii, Semenovskii, and other elite regiments stood at attention around the monument, with thousands of spectators looking on. A brilliant diplomat, Catherine the Great showed the world her adherence to the ideas of Peter the Great, who had dreamed of seeing Russia a powerful and influential state and St. Petersburg a glittering European city. Catherine did much to make this a reality, and one French diplomat noted rightly that "before her, St. Petersburg—built in the land of cold and ice—was almost unnoticed and might as well have been in Asia. In her reign, Russia became a European state. St. Petersburg took a prominent place among the capitals of the educated world."[16]

Coxe's *Travels* provides vivid testimony to Russia's belonging to the "educated world" (fig.

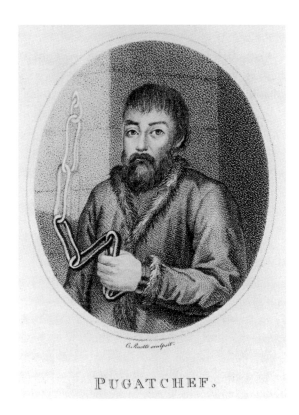

PUGATCHEF.

[50] A Rebel in Fetters

William Coxe
Travels into Poland, Russia, Sweden, and Denmark
London, 1784

William Coxe visited Russia in 1778, 1784, and 1805 and described what he saw in an interesting and sympathetic manner. Nonetheless, he reacted negatively to the Russian form of government and could not accept the institution of serfdom. He included in his book this engraving of Emel'ian Pugachev, an illiterate peasant who in 1773 and 1774 fomented a series of rebellions against tsarist authority in Siberia and the Ural Mountains, and succeeded in capturing and sacking a number of major provincial cities and military garrisons before his capture and public beheading in Moscow. Pugachev's revolt underlined some of the elements behind the deep-seated hostility between noble and serf, and between the central authorities and the provincial peasantry. Because of this depiction of Pugachev in fetters, Coxe's book was forbidden in Russia, while going through six editions in England and translation into five European languages.

50). The inquisitive Englishman described in detail a range of institutions, including a school for military cadets; the special school of the Academy of Fine Arts for talented children; and the Smolny Institute, founded by Catherine II at Betskoi's initiative for the education of young women (who rather surprised Coxe with their excellent French). The Englishman was also delighted with the Free Economic Society, to which he was elected. Catherine was its patron, and she gave the group its emblem—a beehive with the motto "Useful"—and aim: to investigate agrarian issues so that educated noblemen could be more productive in the management of their estates after being freed from compulsory military service in 1762. Coxe reserved his greatest enthusiasm for the St. Petersburg Academy of Sciences. Established by Peter the Great in 1724, the academy held a central place in the fostering of Russian economic and technological research.

Among its most significant contributions, the Academy of Sciences organized—along with the senate and naval office—various geographical expeditions that led to the exploration of such regions as Kamchatka, the Kurile and Aleutian islands, and the coast of North America. The Academy set great store by these explorations of the vast Russian Empire. Outfitted by Catherine II, they were intended to describe its regions and document their unique and significant qualities. Coxe noted that "In consequence of these expeditions, perhaps no country can boast, within the space of so few years, such a number of excellent publications on its internal state, on its natural productions, on its topography, geography, and history; on the manners, customs, and languages of the different people."[17] In the 1760s and 1770s there were five major "academic expeditions," whose work attracted great interest throughout the world. On one of them, led by Ivan Lepekhin, director of the Botanical Gardens of the Academy of Sciences, the members of the expedition traveled the Volga to the Astrakhan and Orenburg provinces and crossed the Ural Mountains.[18]

The German naturalist Peter Simon Pallas headed one of the most important and successful expeditions in 1768–1774. Its members explored the middle and lower Volga region, the Urals, the Altai Mountains, parts of Siberia, and the area around Lake Baikal; some members of the expedition reached the shore of the northern Arctic Ocean. The results of their observations and research on geography, botany, and zoology were published in Latin, German, and Russian in St. Petersburg and Leipzig, while a rich collection on flora, fauna, paleontology, and ethnography went to the Academy's *Kunstkamera*. In the 1770s, Pallas published a three-volume work in St. Petersburg entitled *Travels Through Various Provinces of the Russian Empire* and, in the 1780s, his *Flora Rossica* brought him world fame. In these works, Pallas documented his discovery of many new forms of mammals, birds, fish, insects, and plants. In addition, he studied the remains of extinct species, expressing new ideas on the evolution of the organic world.

In 1793–1794, Pallas made yet another voyage to the Crimea and Russia's southern provinces. The Academy's expeditions generally included a professional artist, who set down everything that scientists thought interesting and necessary. Pallas in this instance was accompanied by the German engraver and graphic artist Christian Gottfried Heinrich Geissler, who worked in Russia in the 1790s. In 1799–1801, Pallas's two-volume work detailing the trip, *Journey Through the Southern Regions of the Russian Empire in 1793 and 1794* was published in German in Leipzig with Geissler's illustrations. Some colored engravings are keyed to the text and illustrate parts of Pallas's scientific account. Other engravings, included as fold-outs at the end of each volume, create an amazing visual effect when opened. The drawings seem to burst out of the books, and the reader sees, as if through a camera obscura, the vast expanses of Russia: landscapes of the Volga, views of amazing cities like Astrakhan and Saratov, the nomadic Kalmyks on the steppes, the houses of the Tatars, and Cossacks on galloping horses. Geissler's illustrations escape the dark captivity of the tome and seem to increase in size, turning into impressive colorful panoramas depicting mighty

Crimean mountains, the Caspian Sea, Inkerman Bay, and ships harbored in Sebastopol. Some images elucidate the text precisely, conscientiously reproducing the clothing and household goods of the various ethnic groups. Geissler scrupulously drew sheep, camels, coins, geographical maps, and monuments of antiquity near the coast of the Black Sea. But in his landscapes, Geissler proved to be not merely an accurate recorder but a true artist—his views are valuable not only for their documentary information but especially because of their poetic character and acute rendering of the enormous scale of the Russian vistas. Geissler's impressions of Russia inspired the many books, popular among European audiences, that he produced in Germany after his return.

Geissler's work was published in five more albums. These engravings, accompanied by explanatory text, were perceived as valuable ethnographic aids and reproduce interesting details of the costumes and ethnic traits of various peoples. The illustrations for the 1803 album *Description and Depiction of Tribes and Peoples* show small figures, without background, in brightly colored dress and with captions in German, French, and Russian: "Estonian woman en face," "Ostiak hunting ermine," "Shaman woman in Krasnoiarsk District," and "Yakut in hunting gear from the back." Another album published beginning in 1803, *Mores, Customs, and Costumes of Russians in St. Petersburg*, is printed in German and French and includes forty drawings, while *Customs, Habits, and Attire of Lower-class Russians* (fig. 106, p. 179) was published only in German in 1805 and contains twenty-eight engravings. Ethnographic accuracy, and attention to costumes and vocational practices, distinguish these rather dry compositions, which depict peddlers, craftsmen, and everyday life in Russia—washing clothes at the river and processions on holidays—and which were accompanied by explanatory texts. Yet another publication of Geissler's colored engravings, *Games and Amusements of Russians of the Lower Classes*, published in German and French in 1805, featured lively and interesting themes, with the usual accompanying explanatory text.

In a fifth album, published in German and French in 1805, *Punishments Used in Russia*, Geissler tried to vary his stylistic methods through more complex compositions and color schemes. The artist created ten engravings for this edition, accompanying them with the obligatory text. These pictures depicting the ugly side of Russian life—beatings with bats, knouts, and sticks—are framed in graceful ovals that look handsome centered on a book page. The horrible scenes of violence were turned into entertaining sketches of life: an unfaithful wife is whipped; a Russian gentleman uses prisoners in wooden shackles to work around the house. With impartial accuracy, Geissler drew bloodied backs and showed the unpleasant details of torture, but for all that, his compositions resemble charming miniatures. This German artist filled the pictures with crowds of people and filled in the backgrounds with attention to detail, introducing elements of landscape and architecture, but he did not convey a feeling for Russian life, which apparently still seemed strange to him.

Another artist—the English painter and engraver John Augustus Atkinson—did, however, manage to reflect vividly and emotionally those features of Russian life that both fright-

[51]
VIEWS OF ST. PETERSBURG

John Augustus Atkinson
Three views (etching and aquatint, with hand-coloring) from the portfolio *Panoramic Views of St. Petersburg*
London, [1805–1807]

Atkinson's panoramic views of St. Petersburg were published in London with a dedication to Catherine the Great's beloved grandson, Emperor Alexander I. The portfolio included four views along with a frontispiece depicting the Bronze Horseman (see fig. 15 on page 29). Atkinson drew these views in the 1790s from the cupola of the Academy of Sciences, one of the highest points in the city.

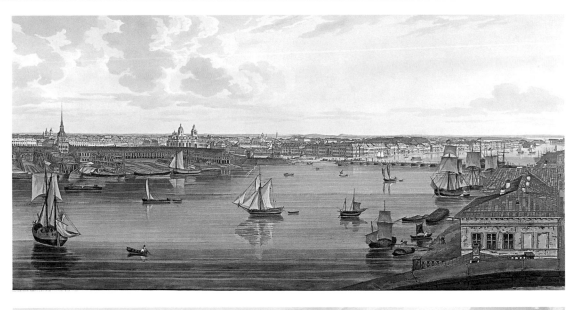

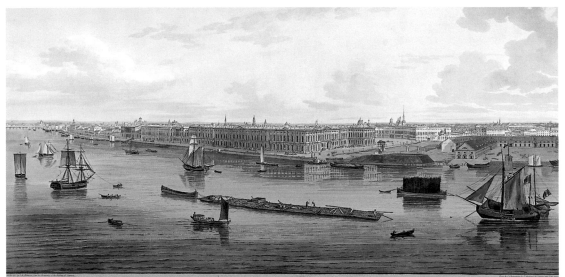

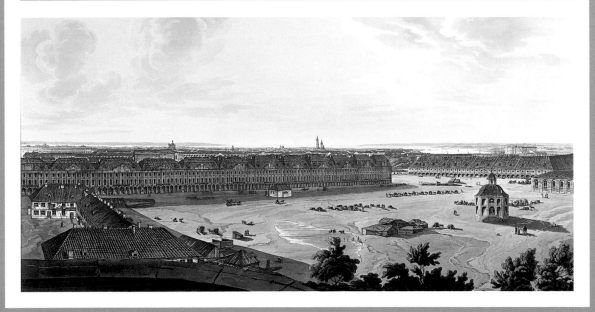

ened and delighted foreigners. Atkinson came to St. Petersburg in 1787 as a boy of twelve—with his uncle and future father-in-law, the engraver James Walker—and lived on the banks of the Neva for eighteen years. His output included several paintings on themes from Russian history (*Mamaiev's Slaughter*, the *Baptism of Rus'*), a series of portraits (Emperor Paul I on horseback, General Aleksandr Suvorov, Count Nikolai Sheremetev), and a large number of landscape and genre sketches. Upon his return to England, Atkinson published several albums devoted to Russia. Of particular interest is the three-volume *A Picturesque Representation of the Manners, Customs, and Amusements of the Russians*, prepared with Walker in the early 1800s. The work contains 100 sheets engraved in soft lacquer with aquatint and very finely colored by hand; as in the Geissler albums, there are brief explanatory notes in English and French. Atkinson's engravings are quite varied in theme, albeit traditional; they depict Russian rituals, urban and village types, games and amusements, and people at work. However, unlike many other foreign artists, Atkinson behaved first as a talented and poetic artist and only secondarily as an ethnographer and documentary artist; these are highly artistic works, distinguished by dynamic composition and unique painterly qualities. The Atkinson engravings feature the entire and rather traditional range of Russian scenes, for instance, winter dress and steam baths. But, in addition, he creates unusually lyrical and warm engravings such as those depicting the washing down of horses, a Ukrainian herd, and a well on a village street; he also renders complex scenes, for instance, of a lively winter bazaar where frozen food is sold, of sledding down enormous ice hills, and of the feast of blessing water on the Neva embankment. Published in folio, the Atkinson-Walker album possesses a monumental character that is reflected in the style of the preface: "The Russian, always a great and powerful nation, but little known to the rest of Europe, till drawn into notice by the creative mind and genius of their great law-giver, Peter the first, have at the present day assumed a weight and importance in its scale, that must necessarily give an interest to anything that may tend to elucidate or make better acquainted with their customs and manners."[19] The album was dedicated to Alexander I, Catherine the Great's favorite grandson, who ascended the Russian throne in March 1801, but the artists nonetheless portray the faces, mores, and lifestyle of the inhabitants of Catherine's day.

Published in London in 1805–1807 but still depicting Catherine's Russia, Atkinson's other famous work consists of engraved sheets that comprise a panorama of St. Petersburg (fig. 51). The landscape drawings, from which Atkinson made aquatints with watercolor, were made from the observatory of the Academy of Sciences. From that height, amazing views opened up to him—of the Admiralty, the English and Court embankments, Vasil'evskii Island, and the Peter-Paul fortress. The broad and smooth water of the Neva with ships ruffling its surface, the numerous canals, the extended perspectives of the streets, and the endless space of the squares were a vivid demonstration of the beauty of the Northern Palmyra, the city founded by Peter I and lovingly embellished by Catherine II. These enlightened monarchs did everything possible to promote the Europeanization of Russia and turned St. Petersburg into the country's most open city, with unlimited possibilities for creative work, fruitful activity, and opportunities for all kinds of talent.

With the flourishing of St. Petersburg came the beginning of a new Russia, no longer isolated from the rest of the world and indeed relentlessly becoming a part of that world. That historically inevitable process was aided by the visual Russica created throughout the eighteenth century by painters and graphic artists, assiduously "translating" into foreign languages the poetry and prose of Russian life.

Translated by Antonina W. Bouis

Notes

1 Aleksandra Müller, *Byt inostrannykh khudozhnikov v Rossii* (Leningrad: Academiia, 1927), p. 59.

2 From a report, "About People of Various Ranks Arriving and Departing Across the Border," in E. I. Itkina, "Russkaia seriia gravur A. Dal'shteina," *Pamiatniki kul'tury. Novye otkrytiia. Ezhegodnik 1981* (Leningrad: Academiia Nauka SSSR, 1983), p. 271.

3 K. B. Malinovskii, "Iakob fon Shtelin i ego zapiski po istorii russkoi zhivopisi," in *Russkoe iskusstvo barokko. Materialy i issledovaniia*, ed. T. V. Alekseeva (Moscow: Nauka, 1977), p. 194.

4 *Voyage en Sibérie fait par ordre du roi en 1761 ... par M. Abbé Chappe d'Auteroche*. 2 vols. (Paris, 1768).

5 Ia. V. Bruk, *U istokov russkogo zhanra* (Moscow: "Iskusstvo," 1990), p. 67.

6 "Antidot (Protivoiadie). Polemicheskoe sochinenie gosudaryni imperatritsy Ekateriny Vtoroi," in *Vosemnadtsatyi vek. Istoricheskii sbornik, izdavaemyi Petrom Bartenevym* (Moscow, 1869), 4: 227.

7 The further story of these works can be found in N. N. Skorniakova, *Staraia Moskva. Graviury i litografii XVI–XIX vekov iz sobraniia Gosudarstvennogo istoricheskogo muzeia* (Moscow: Galart, 1996), p. 105.

8 *Zapiski grafa Segiura o prebyvanii ego v Rossii v tsarstvovanie Ekateriny II (1754–1789)* (St. Petersburg, 1865), pp. 83–84.

9 *Ekaterina Velikaia i Moskva. Katalog vystavki* (Moscow: Gosudarstvennaia Tretiakovskaia galereia, 1997), p. 10.

10 Ibid., pp. 10–11.

11 *Russkii byt po vospominaniiam sovremennikov. XVIII vek* (Moscow: Zadruga, 1922), part 2, issue 2, p. 23.

12 Some of them, located in the Venice Academy of Arts, are reproduced in *Gorod glazami khudozhnikov = The Artist and the City: Peterburg-Petrograd-Leningrad v proizvedeniiakh zhivopisi i grafiki* (Leningrad: Khudozhnik RSFSR, 1978), illustrations nos. 41–45.

13 William Coxe, *Travels into Poland, Russia, Sweden and Denmark*. 2 vols. (London, 1784).

14 *Ekaterina II v perepiske s Grimmom*, ed. Ia. K. Groota (St. Petersburg, 1884), p. 82.

15 Coxe, *Travels*, I: 427.

16 L. F. Séguier, "Zapiski o prebyvanii v Rossii v tsarstvovanie Ekateriny II," in *Rossiia XVIII v. glazami inostrantsev*, ed. Iu. A. Limonova (Leningrad: Lenizdat, 1989), p. 324.

17 Coxe, *Travels*, 2: 111.

18 *Dnevnye zapiski puteshetviia doktora i Akademii nauk ad"iunkta Ivana Lepekhina po raznym provintsiiam Rossiiskago gosudarstva*, Parts 1–4 (St. Petersburg, 1771–1805).

19 "Preface," in John Augustus Atkinson and James Walker, *A Picturesque Representation of the Manners, Customs, and Amusements of the Russians*, vol. 1 (London, 1803).

Texts of Exploration

and Russia's European Identity

by Richard Wortman

In 1721, at the celebration of the Treaty of Nystad ending the Northern War with Sweden, Peter the Great accepted the title of emperor (*imperator*). Chancellor Gavriil Golovkin made clear the symbolic meaning of the change in a speech delivered to the Senate. Peter, he intoned, had taken Russia "from the darkness of ignorance into the Theater of the World, so to speak from nothingness into being, into [numbering among] the political peoples of the world."[1] The adoption of a western, Roman image of secular rule was expressed in the language of emergence, showing movement from ignorance and superstition to the promotion of science, which was cultivated by the "political peoples of the world," those who had embarked on explorations and extended their realms as they ventured into the unknown.

In other words, a sign of Russia's emergence into the "theater of the world" was its engagement in the European project of world exploration and in its scientific pursuits. In the late seventeenth century, Siberia had become the focal point of interest for western scholars and explorers interested in pathways to China, and Dutch and German scholars began to publish descriptions of the region (fig. 52). During Peter's time in power, from 1696 to 1725, Russia too participated in this effort. An expedition of Cossacks led by Vladimir Atlasov explored Kamchatka, while Danilo Antsyforov and Ivan Kozyrevskii conducted explorations of the Kurile Islands.[2] Peter also sought to bring Russia into the European scientific endeavor. In Leibniz's correspondence with Peter, the famed German philosopher wondered whether Asia was joined by land to North America, and the emperor determined to find the answer. He instructed two surveyors, Ivan Evreinov and Fedor Luzhin: "Go to Tobolsk, and from Tobolsk, with guides travel to Kamchatka and beyond, wherever you are shown, and describe these areas to find out whether America is joined to Asia. This is to be done with great carefulness."[3] The surveyors provided

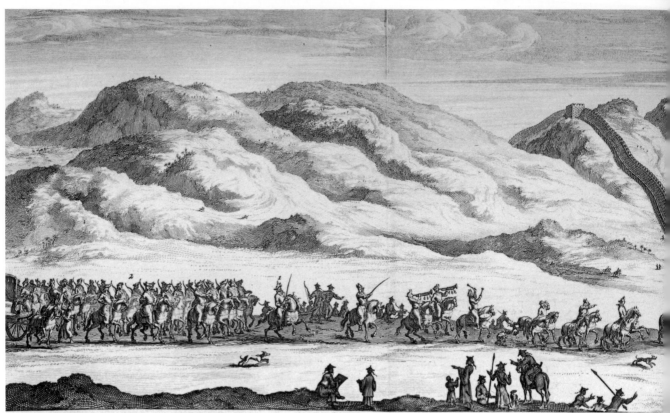

THE EMBASSADORS ENTRY THROUGH THE [

[52]

PROCESSION BEFORE THE GREAT WALL OF CHINA

Evert Ysbrants Ides (also known as Adam Brand)
Three Years Travels from Moscow Over-land
to China
London, 1706

A native of Holstein, Evert Ysbrants Ides resided in Russia from 1677. Peter the Great sent him to China in 1692 to establish commercial relationships and to gauge Chinese satisfaction with the Treaty of Nerchinsk, signed in 1689. His mission, which lasted until 1695, proved successful, and his writings were translated into a number of languages. In this illustration, the ambassador, his retinue, and their caravan approach the Great Wall.

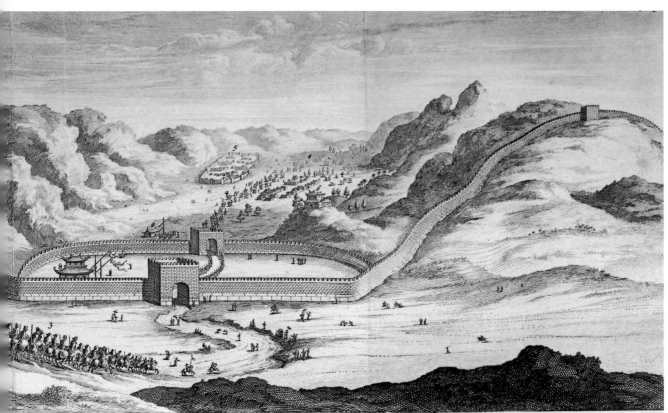

NESE WALL. WHICH IS 1200 MILES LONG.
OTON 6. An Idol Temple. 7 the Chinese Guard and watch Tower. 8 Idol Temple on ye wall. 9 second Chinese Guard

Peter only with a map of the Kurile Islands. Disappointed and on his deathbed, Peter entrusted the undertaking to a Dane in Russian service, Vitus Bering. It took the explorer three years just to reach the Pacific by land. Once there at Okhotsk, Bering built his ship, the *St. Gabriel*, but the results of this first expedition proved unsatisfactory, as he failed to reach America.

The Academy of Sciences, established by Peter in 1724, sponsored Bering's second journey, from 1733 to 1743. One part consisted of a sea expedition to the coast of America; another, on land, was charged with providing a multifaceted description of Siberia. The sea expedition was grandiose and arduous. Moving the equipment and supplies from Tobolsk to Okhotsk, where the ships were built, took hundreds of sledges and lasted eight years. Bering finally discovered the coast of North America but died in a sea accident on the return voyage. The land expedition was led by a group of scholars under the direction of the historian Gerhard Friedrich Müller and the naturalist Johann-Georg Gmelin. The team conducted a vast survey of Siberia, including its geography, flora, and fauna, and its peoples and their languages. Müller brought back copies of hundreds of documents from local archives, which provided the basis for his classic *History of Siberia* (1750; fig. 53). Gmelin's four-volume *Voyage Through Siberia* (1751–1752) also focused on flora and fauna but included extensive descriptions of the region's peoples. Other naturalists, Stepan Krasheninnikov and Georg Wilhelm Steller, wrote accounts of an encyclopedic character on Kamchatka. All in all, the expedition's maps as well as collections of materials provided the basis for future ethnographical, historical, botanical, and zoological studies of the regions.[4]

The scholarly texts of this "Great Northern Expedition," as it was often called, were

potent symbols of Russia's European character. Written or quickly translated into European languages and accompanied by elaborate illustrations, they showed Russians sponsoring European explorations of Russia. The paradoxical character of this relationship was concealed by defining Siberia as a colony, similar to those of the west. In the 1730s, the historian and geographer Vasilii Tatishchev drew a line between Europe and Asia at the Urals, and this division soon gained general acceptance. As one scholar, Mark Bassin, wrote: "In one stroke, Siberia was transformed into an Asiatic realm cleanly set off from a newly identified 'European Russia.'"[5] The relationship was also concealed by defining the expeditions as Russian, regardless of the nationality of the leaders or the authors of the texts (fig. 54). For instance, Müller spoke of a "summary of the voyages made by Russians on the Frozen Sea, in search of a north east passage," and Bering came to be known as the "first Russian sea-farer."[6] The designation "Russian" clearly came to be applied to anyone serving the westernized Russian state.

Another sign of Russia's European identity was the production of maps. Following the example of western monarchies, Peter used maps to define his state as a discrete territory, initiating what James Cracraft has called the "visual conquest of Russia." The tsar founded a cartography department, where the French astronomer Joseph Nicolas De L'Isle collaborated with the Russian mapmaker Ivan Kirilov. Although Kirilov's *Atlas vserossiiskoi* and the Academy of Sciences' *Rossiiskoi atlas* (fig. 56) did not attain the accuracy of contemporary European atlases, they represented the first efforts of the state to mark the extent, boundaries, and features of the country.[7] Russians were developing what Willard Sunderland describes as a "territorial consciousness" that identified "Russia" with the land belonging to the empire as well as with the westernized monarchy that created it.[8]

In 1767, Catherine II's *Instruction* to the Legislative Commission, assigned to codify Russian laws, announced the European character of the Russian state as an apodictic truth, given

A DESCRIPTION OF THE SIBERIAN KINGDOM

Gerhard Friedrich Müller
Opisanie Sibirskago tsarstva
St. Petersburg, 1750

Gerhard Friedrich Müller drew on his travels and research during Vitus Bering's second expedition to compose a description of Siberia that offered a groundbreaking history of the region as well as his own ethnographic and geographical observations. Despite Müller's scholarly rigor, the work is very much a first-person account that conveys the passion for discovery and learning of the Enlightenment. The vignette on this title page shows a figure representing knowledge holding a lamp over a globe unveiled to reveal Siberia and Kamchatka. Two natives in the lower corner offer goods in trade.

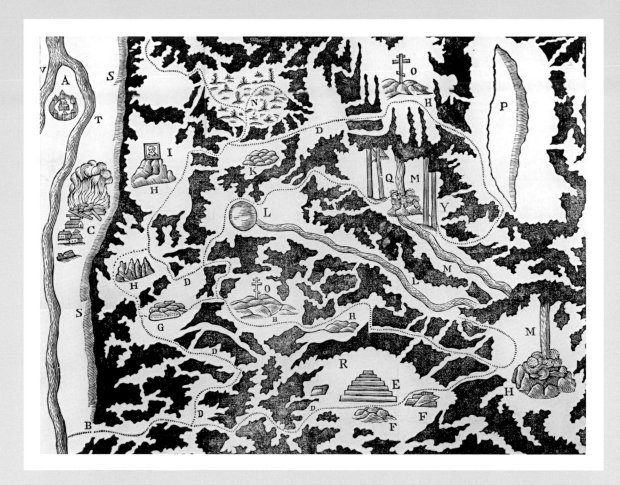

[54]
MAP OF SIBERIAN CAVES

Philipp Johann von Strahlenberg
*An Historico-geographical Description of the North and
Eastern Parts of Europe and Asia, but more particularly
of Russia, Siberia, and Great Tartary*
London, 1738

Some of the more important early descriptions and
maps of the eastern regions of the Russian Empire,
most notably Siberia, were prepared in exile by Philipp
Johann von Strahlenberg, one of the most renowned
of the Swedish officers and men of rank who were
captured and exiled eastward after Sweden's defeat
by Russia at the Battle of Poltava. Upon his return
to his homeland, Strahlenberg's writings and maps
were published, first in a German version in 1730
and then in an English translation, from which this
map is taken.

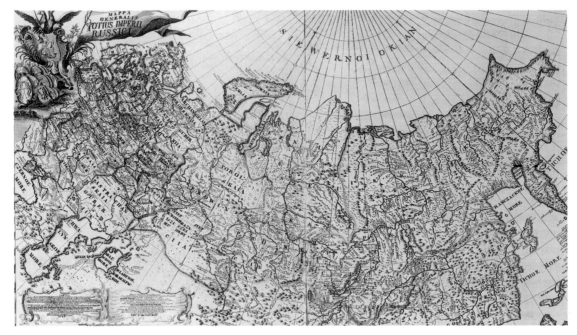

the success of Peter's reforms. The rapid expansion of the empire during the reign of Catherine the Great later afforded another indication of the success of the westernized Russian state. The empire grew in the south and the west to encompass the littoral of the Caspian and Black seas, as well as the provinces that came to Russia with the partitions of Poland. The state now seemed not only to equal but also to excel its western rivals: the most imperial of any nations, comprising more peoples than any other. By 1797, the economist Heinrich Storch could write: "[N]o other state contains such a mixed and diverse population. Russians and Tatars, Germans and Mongols, Finns and members of the Tungusic tribes live here separated by vast distances and in the most varied regions as citizens of a single state, joined together by their political order...." He went on to conclude that to see so many different people united in one state "is a most rare occurrence, a second example of which we look for in vain in the history of the world."[9]

In 1768, in part to answer Chappe d'Auteroche's derogatory account of Russia, Catherine directed the Academy of Sciences to launch a massive survey of the regions of her realm.[10] This "Academy Expedition" assembled an impressive array of German scholars, who for six years undertook detailed and extensive studies of various parts of the empire and produced works that described the economic and geographical characteristics of particular regions as well as the variety of its human subjects. Perhaps the most important contribution was made by Peter Simon Pallas. He traveled through the Ural and Altai mountains and the Transcaucasian region, and his work was published in German, English, French, and Russian editions. Pallas's three-part account included observations of flora, fauna, and mining resources as well as of the manners and traditions of the peoples he encountered.[11] His exquisitely illustrated study of Russian plants represents a landmark of eighteenth-century botany (fig. 57).

Another member of the expedition, Johann Georgi, in the late 1770s published in German, French, and Russian editions his monumental four-volume *Description of All the Nationalities of the Russian Empire, Their Way of Life, Religion, Customs, Dwellings, Clothing and Other*

[55, *opposite, above*]
MAP OF AN EXPANDING EMPIRE

Atlas Russicus
St. Petersburg, 1745

The *Atlas Russicus*, prepared under the direction of Joseph Nicolas De L'Isle in the Geographical Department of the Academy of Sciences, included thirteen maps of European Russia ornamented with decorative cartouches. With its use of new techniques of surveying and geodesy, this atlas showed that Russian cartography was approaching European levels of accuracy and detail. Due to the authors' haste in publication, the work failed to incorporate geographical materials on Siberia and the Urals gathered during Bering's second expedition. But as the most complete representation of Russia to date, the atlas gave the European public a knowledge of the vastness and complexity of the Russian Empire.

[56, *opposite, below*]
MAP OF THE SIBERIAN IRKUTSK REGION

Aleksandr Mikhailovich Wildbrecht
Rossiiskoi atlas
[St. Petersburg, 1792]

This map, from an atlas showing the forty-six provinces of Russia as they were delineated by Catherine's local government reform of 1775, shows the western part of the Siberian province of Irkutsk. Prepared in the Cartography Department of the Academy of Sciences, it includes topographical features, towns, and churches. Each map in the atlas contained a cartouche illustrating a scene emblematic of the region. Here a fur merchant deals with two Chinese men who have brought chests of valuables to exchange for the pelts at his side. The maps were engraved after the designs of Aleksandr Wildbrecht.

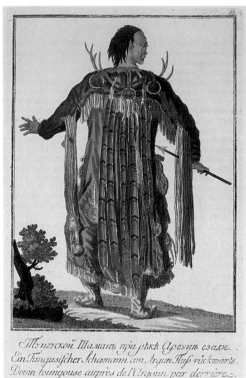

Тунгуской Шаманъ при рѣкѣ Аргунъ сзади.
Ein Tungusischer Schæmann am Argun Fluß rückwærts.
Devin toungouse auprès de l'Argoun par derrière.

[57]

RUSSIAN FLORA

Karl Friedrich Knappe
Drawing (pencil, ink, and wash), ca. 1780s
For: Peter Simon Pallas, *Flora Rossica*
St. Petersburg, 1784–1788

--

The German naturalist Peter Simon Pallas based his
Flora Rossica on his observations in western Siberia
during Catherine's "Academy Expedition." It was a
pioneering work of Russian botany, but it remained
unfinished, comprising only flowers found east of
the Urals. This illustration by Karl Friedrich Knappe is
one of 104 original drawings from which the plates
for the *Flora* were made.

[58]

PEOPLES OF THE RUSSIAN EMPIRE

Johann Gottlieb Georgi
Description de toutes les nations de l'empire de Russie
St. Petersburg, 1776–1777

--

Johann Gottlieb Georgi's *Description of All the
Nationalities of the Russian Empire*, another product
of Catherine's "Academy Expedition," was the first
ethnographic survey of the Russian Empire. It showed
the world the great number and diversity of peoples
inhabiting the empire and gave brief descriptions
of their customs, economic life, religion, and dress.
The numerous colored engraved plates presented the
dress characteristic of national types. This shaman of
the Tungus, a Siberian people of reindeer herders,
wears reindeer antlers, indicative of the Tungus'
animistic religion.

Characteristics (fig. 58). The study was based on his own observations as well as on the works of Müller, Gmelin, Krasheninnikov, and Pallas. Georgi applied the methodology of natural science, as formulated by Linnaeus, to create a taxonomy of the nationalities of the empire, with language the principal determinant of classification. The text Georgi produced confirmed that the Russian Empire was more diverse than any other: "Hardly any other state in the world possesses such a great variety of different nations, survivals of peoples, and colonies as the Russian state."[12] Georgi and other scholars of the Academy Expedition, as well as Empress Catherine, shared an Enlightenment faith that human nature was uniform and that all peoples possessed reason; however, that reason developed only through education, which would be imposed from above and eventually bring about the elimination of national traits. Those peoples at earlier stages, for instance the Tungus and the Chukchi, were ignorant, simple, and possessed a beguiling innocence, but "the uniformity of State organization" could transform all nationalities, including ethnic Russians, into educated, Europeanized Russians. The state, Georgi concluded, was "leading our rude Peoples by giant steps toward the common goal of general enlightenment in Russia, of a wonderful fusion of all into a single body and soul, and of creating, as it were, an unshakable Giant that will stand for hundreds of centuries."[13]

The great Russian polymath and academician Mikhail Lomonosov insisted on a different measure of Russia's European identity. The Russian state could achieve glory equal to that of other states only if it developed sea power and extensive commerce with foreign nations, particularly in Asia. His poem of 1761, "Peter the Great," put his own hopes for future "Russian Christopher Columbuses" in the emperor's mouth.[14]

> Russian Christopher Columbuses, scorning dismal fate,
> > Will open a new route through the ice to the East,
> And our Mighty Power shall reach America,
> > But now wars urge another glory.

In 1762, Lomonosov's memorandum, composed for Tsarevich Paul, "A Brief Description of Various Voyages in Northern Seas and an Indication of a Possible Passage Through the Siberian Ocean to East India," asserted that Russia lagged behind other states in the development of foreign trade because they had greater access to sea routes and therefore "from ancient times had learned sea-faring and the art of building ships for long voyages." As a result, Russia had enjoyed little success in trading with eastern peoples. Lomonosov looked forward to the appearance of Russian seamen and shipbuilders. His immediate concern, however, was to discover and open a northeast passage that would make it possible for Russian ships to sail across the Arctic Sea into the Pacific. He argued that such a voyage was feasible and set forth a scientific analysis of the waters and the ice floes of the Arctic Sea, leading to the conclusion that "according to natural laws and information concordant with them" such a voyage would fare well.[15] Lomonosov succeeded in convincing the Admiralty College to launch two expeditions under Vasilii Chichagov, in 1765 and 1766, but his ships could not find their way through the ice and heavy fog and turned back less than one-third of the way from the port of Kola to the Bering straits.

In the last decades of the eighteenth century, Catherine began to follow Lomonosov's suggestions and took measures to enhance Russia's sea power and presence in the North Pacific. She was inspired by James Cook's third voyage of exploration in the late 1770s, which uncovered an abundance of fur-bearing animals in the region and spurred British merchants to develop an extensive trade, particularly with China. Cook's example was important in another respect.

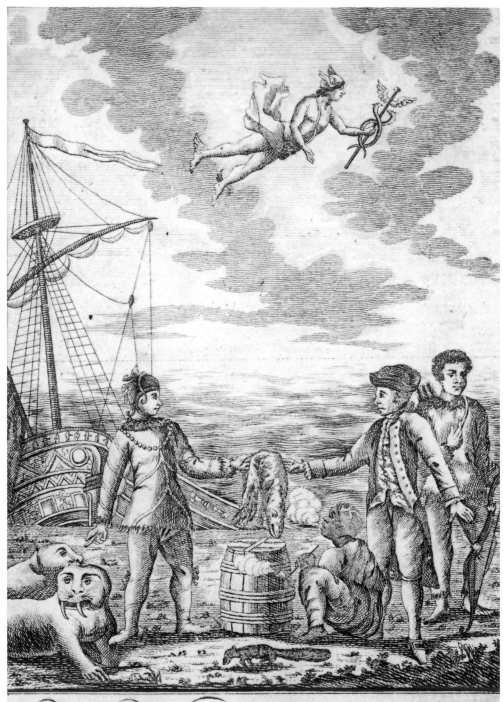

Колумбы Росскіе презрѣвъ угрюмый рокъ
Межъ льдами новый путь отворятъ на Востокъ,
И наша досягнетъ въ Америку Держава,
И во всѣ концы досягнетъ Россовъ слава.

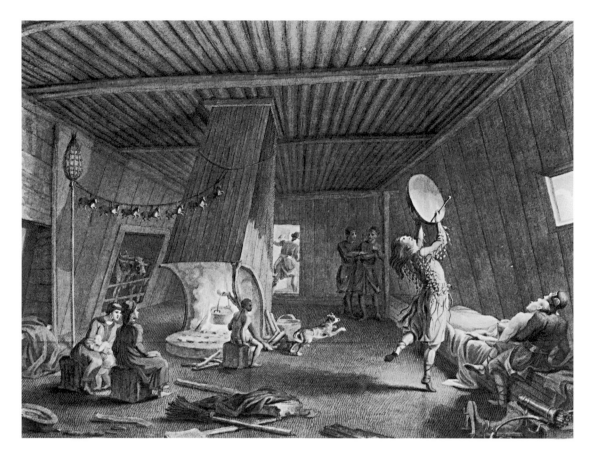

[59, *opposite*]

A RUSSIAN COLUMBUS

====

Grigorii Ivanovich Shelekhov

*Rossiiskago kuptsa Grigor'ia Shelekhova stranstvovanie v
1783 godu iz Okhotska po Vostochnomu Okeanu k
Amerikanskim beregam*

St. Petersburg, 1791–1792

--

In 1783, Grigorii Shelekhov, a merchant based in
Okhotsk, traveled to Kodiak Island off the southern
coast of Alaska, where he established the first perma-
nent Russian settlement in the New World as a base
for his fur-trading enterprise. Shelekhov's official
report gives a vivid if highly embellished account of
his exploits. The frontispiece engraving glorifies his
accomplishment in the contemporary idiom of classi-
cal allegory. Shelekhov was often called "the Russian
Christopher Columbus," and the verse in the caption
is an adaptation of lines published in 1761 by Mikhail
Lomonosov prophesying the appearance of "Russian
Christopher Columbuses."

[60, *above*]

INDIGENOUS SIBERIAN PEOPLES

====

Gavriil Andreevich Sarychev

*Puteshestvie Flota kapitana Sarycheva po severovostochnoi
chasti Sibiri, Ledovitomu moriu i Vostochnomu okeanu*

St. Petersburg, 1802

--

Gavriil Sarychev captained the second ship, the *Glory
of Russia*, on Captain Joseph Billings's expedition of
1785 to explore Russian holdings in the North Pacific.
His ship journal, published in 1802, detailed his
efforts to chart the Siberian coastland and described
the native Siberian peoples, their customs and beliefs.
He was particularly critical of the shamans' exploita-
tion of the superstitious Yakuts. In this illustration, a
shaman exorcises an evil spirit, takes it into himself,
and, by his frenzy, tries to cure an ailing Yakut.

Unlike previous explorers, he published his journals, which served both as scientific documents and cultural statements.[16] His accounts appeared in Russian translation and wielded considerable influence.

Following Cook's example, the imperial government promoted the publication of two Russian accounts of sea explorations: Grigorii Shelekhov's description of his colonization of Kodiak Island and Gavriil Sarychev's study of the Siberian coastline. Shelekhov, often called "the Russian Christopher Columbus," was a merchant who came from Ukraine to make his way in the rough-and-tumble Siberian frontier. In Okhotsk, he organized a group of merchants and hunters to mount an expedition to the shore of Kodiak Island, off the southern coast of Alaska. With the support of the government and mine owners and after a year's journey, Shelekhov's three ships in 1784 reached Kodiak Island, where he built the first Russian settlement in America. Kodiak Island would become the center of the empire's fur trade in Alaska.[17]

Shelekhov's account of his achievements, published in 1791, was not a seaman's journal but an official report submitted to the governor-general of Siberia.[18] Unlike Cook, the Russian voyager made little effort to record the truth. He cast himself as a benevolent conquistador: subduing the natives with minimal force and winning their admiration and obedience; instructing them in the rudiments of Christianity; and providing them with education and habitation. The frontispiece of the publication (fig. 59) set Shelekhov's supposed achievements in the frame of myth. This rather crude illustration depicted a merchant, presumably Shelekhov, standing on a shoreline, receiving a sealskin from a native; the merchant's wife looks on from behind her husband. The figure of Mercury hovers in the clouds, announcing the benevolence of the gods. An otter, sea lions, and various other animals sit quietly and gaze out innocently. The caption below repeats the first three lines of Lomonosov's verse. Lomonosov's fourth line was replaced with the

[61, *opposite, above*]

A RUSSIAN ARTIST IN CHINA

Andrei Efimovich Martynov
Zhivopisnoe puteshestvie ot Moskvy do kitaiskoi granitsy
St. Petersburg, 1819

In 1805, the artist Andrei Martynov accompanied the embassy of Count Iurii Golovkin to the Chinese court. During the course of his lengthy trip, traveling from Moscow to present-day Ulan Bator in Mongolia, Martynov made many watercolor and gouache sketches of places throughout Russia, Siberia, and the frontier with China. This hand-colored engraving depicts a meeting place in the inner recesses of the trading stalls in the town of Kiakhta (also known as Troitskosavsk).

[62, *opposite, below*]

SITE OF IMPORTANT CHINESE-RUSSIAN ENCOUNTERS

William Coxe
Les nouvelles découvertes des Russes, entre l'Asie et l'Amérique, avec l'histoire de la conquête de la Sibérie, & du commerce des Russes & des Chinois
Paris, 1781

English divine, educator, and historian William Coxe traveled widely throughout Europe in the late eighteenth century and was especially well-connected to the English community of St. Petersburg. While respected as a historian of his native England, Coxe is perhaps best known as a memoirist and writer of travelogues dealing with the Russian Empire and its neighbors. His works were widely translated and often republished. Shown here, from the French edition of his *Russian Discoveries* (1780), is a view of the Chinese-Russian border town of Maimachin.

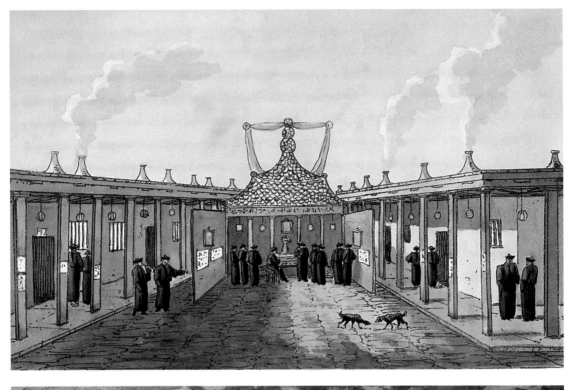

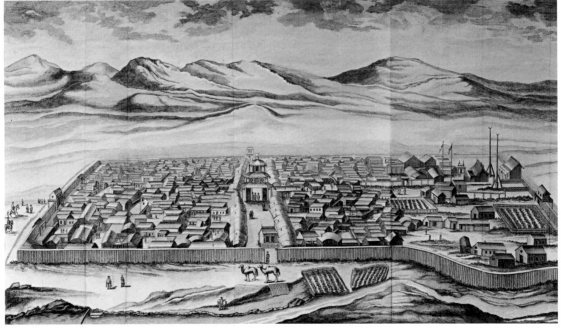

words, "And glory comes to Russians everywhere." In reality, like earlier conquistadors, Shelekhov massacred hundreds, treated those who survived brutally, and greatly exaggerated his successes in providing the natives with education, dwellings, and the rudiments of the Christian faith. Indeed, his abuses became notorious and were perpetuated in the practices of the Russian-American Company, which was founded in 1799 through his encouragement.[19]

In 1785, Catherine the Great sponsored another voyage to explore Russian holdings in the North Pacific and to take possession of areas not formally incorporated into the Russian Empire. She appointed Joseph Billings to lead the expedition; the captain had accompanied Cook on his third voyage and entered Russian service in 1783. The expedition sailed from Okhotsk in 1787, with Billings piloting the *Pallas* and a Russian naval officer, Gavriil Sarychev, the second ship, the *Glory of Russia*. It is clear that the Russian took the tasks of the expedition far more seriously than did the Englishman.[20] Sarychev carefully mapped the shorelines of the Sea of Okhotsk and the Aleutian Islands. He also kept a journal, without intention to publish, but was prevailed upon to put his entries in order and "compose a connected narrative from them." The explorer became convinced that such a publication would benefit both seafaring and the reading public.[21]

Sarychev's 1802 account was the first Russian explorer's journal in the Cook tradition, but the least sophisticated and comprehensive. The text is written in a simple, conversational style, and the author took care to apologize for his unpolished writing: "I have not tried like some explorers to embellish my tale with attractive, extraordinary and diverting, but invented adventures, but have followed the exact truth, describing real events, and in places, made my own remarks." Another purpose of his voyage, he understood, was to assert the sovereignty of the Russian empress in Siberia—to give "an effusive expression of [Her Majesty's] benevolence and to announce Her protection to the savage people in the countries subject to Her."[22] His descriptions of the native peoples, particularly the Yakuts, are sympathetic but extremely critical of their superstitions, particularly the way the shamans exploited the natives' credulity. For instance, Sarychev provides a lengthy, astonished description of a shaman, who screams and writhes as he evokes the evil spirits that presumably had inflicted illness on a Yakut. A print shows the shaman's presumed loss of control as he takes the spirit into himself (fig. 60).[23]

The descriptions of sea expeditions during the reign of Alexander I were more sophisticated than those of Shelekhov and Sarychev. Later authors viewed their achievements as events in the history of world exploration. Educated in elite naval institutions, they had familiarized themselves with western thought and literature and, as Ilia Vinkovetskii has shown, "considered themselves engaged in active dialogue with general European culture."[24] Indeed, the four captains of major sea explorations of the Alexandrine epoch—Adam Johann von Krusenstern, Iurii Lisianskii, Vasilii Golovnin, and Mikhail Lazarev—served as officers and saw combat with the British navy, an interchange Catherine II had initiated. They came to believe that Russia would show its European character by extending its sea power, like Britain, into the Pacific and developing trade and colonies (figs. 61, 62). They had little interest in Siberia, which had come to be regarded as a barren, forbidding land, a bleak place of exile that was, for better or worse, a part of Russia.[25]

For the explorers of Alexander's day, the model was not Christopher Columbus but James Cook, and the composition of a journal was the demonstration of both their achievement and their European character. They aspired to Cook's professional competence and integrity, as well as his determination to combine exploration, the expansion of trade, and the advancement of science. Like Cook, they took naturalists, astronomers, and artists on board, leaving a scientific and artistic as well as verbal record of the journey. They adopted Cook's sympathetic and inquisi-

[63]

THE ISLAND OF ST. HELENA

Ivan Fedorovich Kruzenshtern (also known as
Adam Johann von Krusenstern)
Puteshestvie vokrug sveta v 1803, 4, 5 i 1806 godakh
St. Petersburg, 1809–1813

Adam Johann von Krusenstern organized the first
Russian circumnavigation of the globe in 1803.
His ship, the *Hope* (*Nadezhda*), reached the Pacific
by sailing southward on the Atlantic and around
Cape Horn, and returned across the Indian Ocean
and around the Cape of Good Hope to the Atlantic.
For his Russian readers, he described his principal
ports of call, among them St. Helena, where he
stopped on his return. He found the island a safe
port where he could easily obtain supplies: "Every
kind of provision may be obtained here, particularly
the best kinds of garden-stuffs…. Porter and wine,
especially madeira, were in great abundance, as well
as all sorts of ship provisions, such as salt meat, peas,
butter, and even naval stores." Ironically, in 1815
St. Helena became the island of exile for Russia's
arch-enemy, Napoleon Bonaparte.

[64]

THE KALOSHES OF ALASKA

Count Fedor Petrovich Litke
Voyage autour du monde … dans les années 1826, 1827, 1828 et 1829
Paris, 1835–1836

Litke's circumnavigation of the globe on the sloop *Seniavin* was notable for its scientific and geographical discoveries, as well as the captain's subsequent perceptive description of native peoples and their ways of life. The Kaloshes of Sitka Island were of particular interest to Litke, as well as to the naturalists Aleksandr Postels and Baron Friedrich Kittlitz, who provided the illustrations. Litke found that the women of Sitka were "much less handsome than the men, but would not be quite so repulsive if they did not disfigure themselves often with pieces of wood pierced into their lips," a practice that the artists did not reproduce in their renderings.

tive manner toward native peoples. Their journals revealed a new conception of themselves both as seamen and as Russian Europeans, to use Marc Raeff's term, full partners in the project of world exploration.

Cook had shown the possibilities of extended sea voyages. Taking up an idea of Empress Catherine, these explorers reached the Pacific by sea, thus avoiding the overland trek to Okhotsk. They now embarked on "round-the-world" voyages, beginning at Kronstadt, crossing the Atlantic with stops in the Canary Islands and Brazil, rounding Cape Horn to the west coast of South America, and exploring the myriad islands of the Pacific before heading north to Siberia and Alaska. The sea voyages returned via the China Sea, the Indian Ocean, and the Cape of Good Hope. They sailed in modern ships built in London or the Baltic ports, rather than the ramshackle vessels put together in Okhotsk. The first to embark on this route was von Krusenstern, a Baltic German nobleman from Estland educated at the Naval Cadets Corps; he took part in naval battles against Sweden in 1789–1790 and served in the British navy from 1793 to 1799, when he saw combat against French warships and witnessed the vigorous British trade in the Far East. He returned with a determination to reform the Russian navy and to extend its reach in the Pacific.

Krusenstern's journal, published in four volumes (1809–1811), opened with a virtual manifesto about the future of Russian naval exploration. He recalled his chagrin when he observed an English trading vessel in Canton, which, after being fitted out in Macao, had reached the northwest coast of America in less than five months. Russians customarily brought their furs to Okhotsk, then to Kiakhta, and then to Canton—a two-year trek. He reasoned that if Russia had good ships and sailors, the journey could be made directly and the return trip could bring Russia goods from Canton and other ports along the way (fig. 63). The empire could then also avoid the payments to England, Sweden, and Denmark for East Asian and Chinese goods and could even undersell these nations in the north German market. He proposed to augment the Naval Cadets Corps with six hundred young noblemen and one hundred commoners; the latter—a "most useful body of men"—were to be trained for the merchant service "on the same liberal footing as the nobles."[26]

Krusenstern envisioned a sweeping governmental program that would extend Russian sea power and establish a merchant marine, and an assertive and enterprising merchantry in the Far East. Alexander I was sympathetic to these efforts, and two high-ranking officials in the beginning of his reign—Count Nikolai Mordvinov and Count Nikolai Rumiantsev—promoted the project; both remained forceful proponents of sea explorations throughout the epoch. In addition, resources provided by the Russian-American Company made it possible to purchase the latest ships and equipment in London. Krusenstern captained the *Hope* and his protégé, Iurii Lisianskii, the *Neva*, which followed a somewhat different route. Two naturalists, Georg Heinrich von Langsdorff and Wilhelm Gottlieb Tilesius von Tilenau, traveled on the trip along with an astronomer, Johann Caspar Horner. Krusenstern also had to make room on the *Hope*, though reluctantly, for a special embassy to Japan, headed by the ambassador, Nikolai Rezanov.

Alexander I brought Pacific explorations into his scenario of friendship, kindness, and sympathy, making them an expression of his image as a wise and enlightened monarch.[27] Krusenstern described how the emperor carefully inspected the two ships: "He noticed everything with the greatest attention and expressed his satisfaction" with the vessels and new equipment acquired in England.

Krusenstern intended his journal as a sign of Russia's advancement and sophistication, as was also the case for the others who left accounts of this voyage: Lisianskii, Langsdorff, Rezanov, and the clerk of the Russian-American Company, Fedor Shemelin. Krusenstern's journal

[65]

PACIFIC NATIVES

Ivan Fedorovich Kruzenshtern (also known as
Adam Johann von Krusenstern)
Puteshestvie vokrug sveta v 1803, 4, 5 i 1806 godakh
St. Petersburg, 1809–1813

- -

The voyages of Krusenstern and others brought
Russia into the project of Pacific exploration
initiated by English Captain James Cook. Like Cook,
Krusenstern visited many islands; his journals describe
the natives he encountered. He wrote that the Ainos
of Jesso, one of whom is shown here, resembled
the inhabitants of Kamchatka, and he found their
women "sufficiently ugly." But he thought that "the
characteristic quality of an Aino is his goodness of
heart, which is expressed in the strongest manner
in his countenance." The Ainos' actions as well as
their looks "evinced something simple but noble."

[66]

A TATTOOED MAN

Georg Heinrich von Langsdorff
Voyages and Travels in Various Parts of the World,
During the Years 1803, 1804, 1805, 1806, and 1807
London, 1813–1814

- -

The physician and naturalist Georg Heinrich von
Langsdorff left the University of Göttingen to join
Krusenstern's expedition. Like other explorers, he
was struck by the practice of tattooing, which,
he noted, was widespread in the South Sea islands.
He regarded tattooing as a substitute for clothing,
and the complex symmetrical tattoos as the natives'
counterpart to expensive clothing in Europe. His
journal contains a detailed description of the
techniques of tattooing, the taboos surrounding it,
and its function as an expression of conspicuous
consumption.

appeared almost simultaneously in Russian, German, and English, Lisianskii's in Russian and his own English translation, and Langsdorff's in German and English. The volumes included maps of discoveries, scientific reports, illustrations of landscapes and plant and animal life, and portraits of the native peoples the authors met and described (figs. 65, 66). They announced to the world Russian seafarers' active involvement in the exploration of the Pacific.

In the Alexandrine era, Russia's American settlements replaced Siberia as the colonies indicating imperial status and prestige. The explorers' descriptions of their encounters with native peoples reflected the sympathetic, inquiring attitude of those striving to understand human beings remote from their own experience. While the eighteenth-century faith in education and progress persisted, it receded into the background at the sight of individuals bizarre in appearance, dress, and conduct. The evidence of the corruption and abuses of the Russian-American Company belied the easy identification of civilization and progress, while the Rousseauist image of primal innocence lingered to produce feelings of guilt and uncertainty in the confrontation with human beings who did not conform to their notions of humanity.

The accounts of native people on Krusenstern's circumnavigation were varied and reflected the authors' efforts to make sense of their perceptions while maintaining the posture of detached scientific observers. They were particularly nonplussed by the inhabitants of Nukahiwa, an island in the Marquesan chain in the South Pacific. On the surface, the Nukahiwers fit the conception of the innocent savage: handsome, friendly, peaceful, and honest. The men were large and striking, and many covered their bodies with tattoos, a frequent subject of illustrations in all the journals, showing the distance of these natives from European society. But Krusenstern and his comrades learned of the dark side of the Nukahiwers from a runaway British seaman, Edward Roberts, who told them of their brutality, and of frequent episodes of cannibalism.

Krusenstern was struck by the absence of institutions and morality in their midst. The king possessed no power, and as a result there was no justice; theft was regarded as "a particular merit in those who evince adroitness." Men took connubial vows, but adultery was general, and he had heard of husbands consuming their wives and children during famines. He held their religion in particular contempt. There were priests among them, but from Nukahiwers' "moral character," he concluded that religion had done nothing to ameliorate it. The Nukahiwers had all the marks of children of nature, but of a nature that was violent, brutish, and profligate.[28]

Lisianskii was somewhat more sympathetic. He believed that the Nukahiwers regarded their marital vows as sacred. Following the logic of eighteenth-century ethnographers, he attributed their violence and brutality to instinct and ignorance, which led them to believe in superstitions and magic.[29] Langsdorff expressed a Hobbesian conception of human nature. Everything he saw in Nukahiwa seemed to support his notion that "there is no creature on earth in all zones and climates that rages against its own species as much as man.... Among savages as well as civilized peoples, man eternally seeks to destroy his species."[30]

The Aleutians and the inhabitants of Kodiak Island off the south coast of Alaska evoked the same feelings of offense and disapproval from Lisianskii and Langsdorff. Lisianskii was contemptuous of their lengthy mourning rites and their fantastic origin myths. He found the Toyons' practice of keeping male concubines especially repulsive and the inhabitants of Kodiak Island incapable of conversation: "A stupid silence reigns amongst them.... I am persuaded that the simplicity of their character exceeds that of any other people, and that a long time must elapse before it will undergo any very perceptible change." On occasion they did not fear to appear before him in the nude, though they considered him "the greatest personage on the island." But he was most disgusted by their filth: "They have not the least sense of cleanliness. They will not go a step out

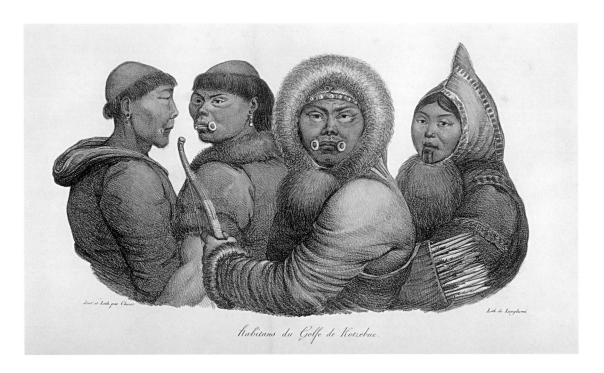

Habitans du Golfe de Kotzebue.

[67, *above*]
ABORIGINES OF ALASKA

[68, *opposite*]
AN ABORIGINE CHIEF

Ludovik Andreevich Choris
Voyage pittoresque autour du monde, avec des portraits
de sauvages d'Amérique, d'Asie, d'Afrique, et des îles
du Grand océan
Paris, 1822

Ludovik Andreevich Choris
Voyage pittoresque autour du monde, avec des portraits
de sauvages d'Amérique, d'Asie, d'Afrique, et des îles
du Grand océan
Paris, 1822

Ludovik (or Louis) Choris, an artist of German-Russian parentage born in Kharkov (Kharkiv), accompanied Otto von Kotzebue, son of the playwright August von Kotzebue, on his first voyage around the world, from 1815 to 1818. Shown here are the natives of an island in the gulf off the northwest coast of Alaska that came to bear Kotzebue's name; they had never seen Europeans before. Kotzebue describes how he endured their welcome—rubbing noses with him, wiping his face with their spittle, and offering him a meal of whale fat—with great patience and aplomb. "Little by little, the savages began to laugh, joke, and to embrace us." They joined the explorers in "a friendly alliance."

Here Choris affectingly portrays a native chief, called Rarik in Kotzebue's text, who lived on Romanov Island. Kotzebue describes Rarik's childlike enthusiasm and astonishment at the Europeans and their pots and pans. As chief, Rarik wore many ornaments, flowers, and beads, and his tattoos covered the greater part of his body, giving him "the look of a person wearing armor."

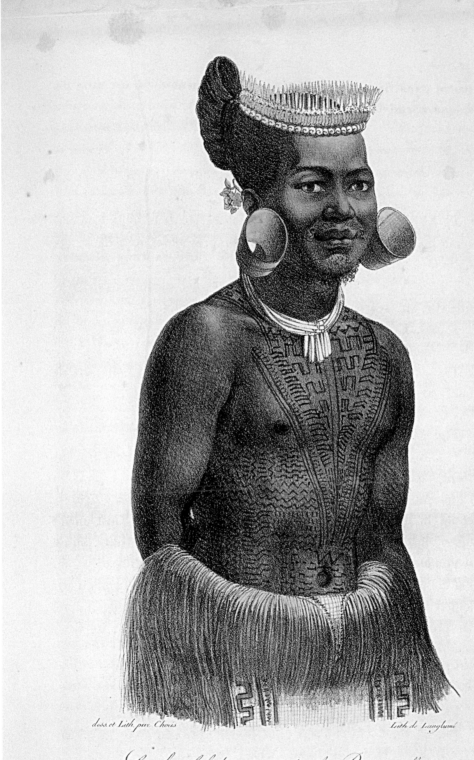

Larik Chef du groupe des îles Romanzoff

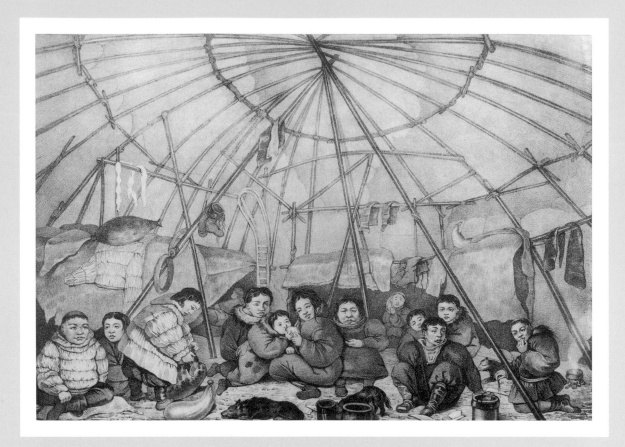

[69]

AN ELEGANT YURT DWELLING

Count Fedor Petrovich Litke
*Voyage autour du monde … dans les années 1826, 1827,
1828 et 1829*
Paris, 1835–1836

Litke commented on the Kaloshes' love of children,
who are shown in this interior scene. In his caption,
Baron Kittlitz explains that the "solidity and elegance"
of the yurt dwelling was owed to the influence of
the nearby Russian colony. He adds, "It is easy to see
that a love of cleanliness is not the main virtue of the
Kaloshes and often their children will eat from the
same dish as their dogs." The illustrations also convey
the Kaloshes' phlegmatic, placid temperament. Litke
writes, "Sometimes one will see the same figure sit-
ting there for hours on end … gaping at the passers
by in an almost perfect immobility."

of their way for the most necessary purposes of nature." They used urine to launder their clothing and even to wash themselves. But both Lisianskii and Langsdorff were critical of the Russian-American Company for its cruel and irresponsible treatment of the natives subject to its authority, and their accounts bear what Vinkovetskii describes as "the mark of condescending paternalism." Its agents, Langsdorff wrote, "have tortured those defenseless creatures to death in the cruelest manner and gone unpunished. That is why the natives hate the Russians, including their wives and children, and kill them whenever the opportunity presents itself."[31]

Krusenstern's expedition was the first of thirty-three sea voyages to the North Pacific from 1803 to 1833, many of which were described in journals. Two notable expeditions were led by Otto von Kotzebue, who as a boy had sailed with Krusenstern. The first of these was financed by Count Rumiantsev and received the sympathetic attention of Alexander I, who allowed the ship, the *Riurik*, to fly the Russian military flag, along with the commercial flag, in order to protect it from international incidents. Kotzebue reached Kamchatka and the Bering Strait and claimed to have discovered over three hundred islands. His account of his voyage appeared in German, English, and Russian.[32] Remarkable illustrations by Ludovik Choris, an artist of Russian-German parentage, were published in a separate volume in Paris in 1822 (figs. 67, 68).[33] Kotzebue's second voyage around the world, from 1823 to 1826, also resulted in a multivolume publication in Russian and English.

Another notable explorer, Vasilii Golovnin, authored *Around the World on the Kamchatka, 1817–1819*, a volume that expresses the viewpoint of a talented and educated naval officer who was determined to defend and extend Russia's possessions in the Pacific. Golovnin was educated at the Naval Military Academy at Kronstadt and read extensively in the history of sea exploration and philosophy as well as the works of the *philosophes*. From 1802 to 1805, he served in the British navy and saw action under Admiral Nelson. In 1807, he undertook a voyage on the *Diana* to conduct a survey of the northern Pacific. Despite numerous mishaps—among them being taken into captivity in South America and Japan—he completed a survey of Russian possessions along the coast of Alaska. Upon his return, he wrote an account of Japan that enjoyed great popularity and became a classic text on the subject. Golovnin served as the model for the cosmopolitan, professionally trained naval officer for future generations. Three future explorers—Fedor Litke, Ferdinand Wrangel, and Fedor Matiushkin—served under him on the *Kamchatka* and praised the strict and rigorous training they received in the "Golovnin School."

The objectives of Golovnin's trip were several: to deliver supplies to Kamchatka; to survey islands in Russian possession not already surveyed as well as a stretch of the northwest coast not approached by Cook; and to inquire into the treatment of natives by the Russian-American Company.[34] He confined most of his criticisms of the company to a confidential report he wrote for the government. He approached the natives without the sense of righteous superiority displayed by his predecessors. Describing the Kodiak Islanders, Golovnin observed the survivals of idolatry; although they professed Orthodoxy, the natives refused to talk about religion "because the first Russian settlers … made fun of and expressed scorn at the various myths which they heard about the creation of the world and man." The Sandwich or Hawaiian Islanders stole, but "at least along with all the other European 'arts' they have learned to steal like civilized people"— that is, they did not take things they did not need. He believed that introducing Christianity and the art of writing to the Sandwich Islanders would enable them to reach a stage of development "unparalleled in history.[35]

In general, Golovnin shared Krusenstern's vision for an expansion of Russian initiatives in the Pacific and demanded a rebuff to merchants from the United States who had been encroach-

ing on the Russian fur trade in Alaska. He inspected the small Russian settlement at Fort Ross in California, which had been established in 1812; he found that it was thriving and enjoyed the friendship of the local tribes, and gave an eloquent defense of Russia's rights to the fort and the adjacent land.[36] But in the last years of his reign, Alexander I abandoned his aims in the Pacific. The triumphalist mood that set in after the victory over Napoleon was sufficient to display Russia's parity with or even moral superiority to Europe. The development of Russian naval power was no longer necessary to elevate Russia's prestige, and Golovnin watched in dismay as the attention to the fleet began to wane.[37]

The final text of this rich period of naval explorations was Captain Litke's *A Voyage Around the World, 1826–1829*. Litke, a product of the Golovnin School, joined the navy in 1812, and in 1817 gained a place on Golovnin's Kamchatka expedition. From 1821 to 1824 he led his own expedition to study the island of Novaia Zemlia in the Arctic Ocean. Litke understood his role to be more that of a scientist than a representative of Russian sea power. He contemplated the difficulties awaiting him on the voyage of the *Kamchatka* but was inspired by the determination "to see much that is new, to learn much that cannot be learned in the depths of the fatherland, and the hope that our voyage will not be without benefit for the enlightened world and will not remain without reward from the monarch."[38]

In the introduction to his account, Litke emphasized that the principal goals of his expedition were scientific, unlike the expeditions of the previous fifteen years, which "were destined to carry cargoes to Okhotsk and Kamchatka, and to cruise around the colonies of the Russian-American companies." Thus, in addition to surveying the shores of the Bering Sea and the Pacific islands, Litke undertook scientific investigations: with the pendulum on the curvature of the earth; with a magnetic needle on the theory of gravity; and with a barometer on climatic phenomena. The naturalists on the voyage, Aleksandr Postels and Karl Heinrich Mertens, collected hundreds of specimens of flora and fauna. Postels also collected ethnographic materials, costumes, arms, utensils, and ornaments. The two naturalists and Friedrich Heinrich von Kittlitz, the accompanying artist, compiled a portfolio of 1,250 sketches, some of which were published as illustrations to Litke's text (figs. 64, 69).[39] Litke's scientific work gained him world renown: his survey of the Bering Sea revealed unknown shorelines and islands; his conclusions about the curvature of the earth were considered major scientific contributions; and his findings with the magnetic needle provided material for important works of other scholars.

Litke's *Voyage Around the World*, written in Russian and published simultaneously in Russian and French, marked a new stage in the evolution of the genre of texts of exploration. The effacing mode of the humble ship captain, not given to verbal expression, disappears. Litke does not contain his authorial voice and shapes his material to express his own personal feelings and views, for instance, describing the beauty of a sunset or the problems of perception when the last port of call remains in the sailor's mind. The confidence and authority in his writing and his eloquence of expression give his journal the flow and evocative power of a literary text. A review of the first two parts of his study greeted *Voyage* as a "European book …, an event like the appearance of a comet." The reviewer perceived that the European persona of the author was expressed in the quality of his writing, the vividness of his perceptions, and the nobility of his attitude to native peoples.[40]

Concerning the last encomium, Litke describes the peoples he encountered with ease and confidence; there is no sense of discomfort with the crude customs and squalor of native life. He respects the myths of origin and notes that they resembled those of other peoples including the ancients: "The childhood dreams of the human spirit are the same under the beautiful sky of

Greece as in the wild forests of America." For instance, the Kaloshes' sacrifice of slaves and their brutal warfare evince "the same bloodthirsty vengeance that we find with the Bedouins and our own mountain people." "The customs of the Kaloches," he concluded, "differ very little from those of other peoples who live in wild independence. They are cruel to their enemies, and all strangers are enemies. They are suspicious and cunning." Litke went on to describe their positive qualities: their love for their children, who were obedient; the absence of poverty in their midst; their attention to their physical condition; and their love for life, proven by the absence among them of suicide.[41]

Litke found that the administration of the Russian-American Company had greatly improved. The company had reached a fair arrangement with the Aleutians, who were exempted from paying tribute so long as they agreed to supply half their manpower for hunting sea animals when the company demanded it. He concluded that the condition of the Aleutians on the island of Unalaska had changed for the better, since they had adopted the Russian way of life and dress. They had become true converts to Orthodoxy: they had begun to adopt Christian beliefs; attended church diligently; made the sign of the cross when boarding ship; and sent their children to the schools founded for them.[42]

Litke's text expresses the confidence of a seaman born and educated in Russia who serves the Russian emperor and who expresses his western identity in his scientific contributions and literary sophistication. But Russia's Pacific empire was losing its political significance, and the new emperor, Nicholas I, boasted of Russia's superiority to the west because of its defense of monarchy and religion, proclaiming the distinctiveness of Russian institutions and the national character of the westernized monarchy. In this setting, exploration took new directions. Litke remained a respected and influential figure in Russian government and cultural life—he was a founder and first vice-president of the Russian Geographical Society, which organized geographical and ethnographic expeditions in the last decade of Nicholas's reign. But further expeditions focused on Russia itself. They sought not so much an engagement with the world and creating Russian Europeans but answers to the question of Russia's distinctive national identity.[43]

Notes

1 Sergei Solov'ev, *Istoriia Rossii* (Moscow: Izdatel'stvo sotsialno-ekonomicheskoi literatury, 1963), 9: 321.

2 Erich Donnert, *Russia in the Age of the Enlightenment*, trans. Alison and Alistair Wightman (Leipzig: Edition Leipzig, 1986), pp. 95–96.

3 Solov'ev, *Istoriia Rossii*, 9: 532.

4 Donnert, *Russia in the Age of the Enlightenment*, pp. 99–100; S. A. Tokarev, *Istoriia russkoi etnografii* (Moscow: Nauka, 1966), pp. 82–85, 87–93; Gert Robel, "German Travel Reports on Russia and Their Function in the Eighteenth Century," in Conrad Grau, Sergueï Karp, and Jürgen Voss, eds., *Deutsch-Russische Beziehungen im 18. Jahrhundert: Kultur, Wissenschaft und Diplomatie* (Wiesbaden: Harrassowitz Verlag, 1997), pp. 276–278.

5 Mark Bassin, "Inventing Siberia: Visions of the Russian East in the Early Nineteenth Century," *American Historical Review*, 6, no. 3 (June 1991): 767–770.

6 Müller's book was translated into French as well as English: *Voyages from Asia to America, for Completing the Discoveries of the North West Coast of America* (London, 1761). See the entry on Bering in *Entsiklopedicheskii slovar'* (St. Petersburg, 1892), 6: 534.

7 See James Cracraft, *The Petrine Revolution in Russian Imagery* (Chicago: University of Chicago Press, 1997), pp. 272–281; Larry Wolff, *Inventing Eastern Europe: The Map of Civilization in the Mind of the Enlightenment* (Stanford, Calif.: Stanford University Press, 1994), pp. 144–146; Mark Bassin, "Russia Between Europe and Asia," *Slavic Review*, 50, no. 1 (Spring 1991): 7–9.

8 See the innovative article by Willard Sunderland, "Becoming Territorial: Ideas and Practices of Territory in 18th-century Russia," forthcoming.

9 Quoted in Andreas Kappeler, *The Russian Empire: A Multiethnic History*, trans. Alfred Clayton (Harlow, England: Pearson Education, 2001), p. 141.

10 On Chappe d'Auteroche, see the essay by Irina Reyfman in this volume.

11 Robel, "German Travel Reports," pp. 278–279; Donnert, *Russia in the Age of the Enlightenment*, pp. 110–111.

12 Tokarev, *Istoriia russkoi etnografii*, pp. 103–106.

13 Nathaniel Knight, "Constructing the Science of Nationality: Ethnography in Mid-Nineteenth Century Russia," Doctoral Dissertation, Columbia University, 1995, pp. 32–40; Yury Slezkine, "Naturalists Versus Nations: Eighteenth-century Russian Scholars Confront Ethnic Diversity," in Daniel R. Brower and Edward J. Lazzerini, eds., *Russia's Orient: Imperial Borderlands and Peoples, 1700–1917* (Bloomington: Indiana University Press, 1997), pp. 38–39.

14 M. V. Lomonosov, *Polnoe sobranie sochinenii* (Moscow-Leningrad: Izdatel'tsvo Akademii Nauk, 1959), 8: 703.

15 Ibid., 6: 422–425.

16 Bernard Smith, *Imagining the Pacific: In the Wake of the Cook Voyages* (New Haven, Conn.: Yale University Press, 1992), p. 231.

17 See the Introduction by Richard A. Pierce to Grigorii I. Shelekhov, *A Voyage to America, 1783–1786*, trans. Marina Ramsay (Kingston, Ontario: Limestone Press, 1981), pp. 1–15.

18 For a list of the subsequent editions, see Avrahm Yarmolinsky, *Shelekhov's Voyage to Alaska: A Bibliographical Note* (New York: The New York Public Library, 1932), pp. 5–8.

19 *Puteshestvie G. Shelekhova s 1783 po 1790 god iz Okhotska po Vostochnomu Okeanu k amerikanskim beregam, i vozvrashenie ego v Rossiiu* (St. Petersburg, 1812), pp. 15–21, 29–36; Pierce, introduction to *A Voyage to America*, pp. 8, 10, 12–13.

20 A. J. von Krusenstern, *Voyage Round the World, in the Years 1803, 1804, 1805, & 1806*. 2 vols. in one; trans. Richard Belgrave Hoppner (London, 1813), p. xviii.

21 Donnert, *Russia in the Age of the Enlightenment*, pp. 112–114; Gavriil Sarychev, *Puteshestvie Flota kapitana Sarycheva po severovostochnoi chasti Sibiri, Ledovitomu moriu i Vostochnomu okeanu* (St. Petersburg, 1802), p. viii; the volume was translated into English in 1806.

22 Sarychev, *Puteshestvie G. Shelekhova*, pp. iv–vi, xii.

23 Ibid., pp. 29–31; Smith, *Imagining the Pacific*, pp. 1–4, 20–28, 36–37.

24 Ilia Vinkovetskii, "Circumnavigation, Empire, Modernity, Race: The Impact of Round-the-World Voyages on Russia's Imperial Consciousness," *Ab Imperio*, 1–2 (2001): 198–201.

25 Bassin, "Inventing Siberia," pp. 770–775.

26 Krusenstern, *Voyage Round the World*, 1: xxiv–xxv.

27 Richard S. Wortman, *Scenarios of Power; Myth and Ceremony in Russian Monarchy, Vol. 1, From Peter the Great to the Death of Nicholas I* (Princeton, N.J.: Princeton University Press, 1995), 1: 195–201.

28 Krusenstern, *Voyage Round the World*, 1: 152–184.

29 Iurii Lisianskii, *A Voyage Round the World in the Years 1803, 1804, 1805, 1806* (London, 1814), pp. 79–90.

30 Georg Heinrich Langsdorff, *Voyages and Travels in Various Parts of the World, During the Years 1803, 1804, 1805, 1806, and 1807* (London, 1813–1814), 1: 91. Langsdorff's work was first published in German, in 1812.

31 Lisianskii, *Voyage*, pp. 179, 182–183, 214–215; Langsdorff, *Voyages and Travels*, 2: 21–22, 36–38; Vinkovetskii, "Circumnavigation, Empire, Modernity, Race," p. 199.

32 Flot-kapitan Kotzebue, *Puteshestvie v iuzhnyi okean ... 1815–1818* (St. Petersburg, 1821), pp. iii–v.

33 Louis Choris, *Voyage pittoresque autour du monde* (Paris, 1822).

34 V. M. Golovnin, *Around the World on the Kamchatka, 1817–1819*, trans. Ella Lury Wiswell; foreword by John J. Stephen (Honolulu: Hawaiian Historical Society, 1979), p. 7; L. A. Shur, *K beregam novogo sveta* (Moscow: Nauka, 1971), pp. 89–90.

35 Golovnin, *Around the World*, pp. xxviii–xxx, 116, 122–123, 202, 206–207.

36 Ibid., pp. 127–131, 162–166.

37 See the Foreword to Golovnin, by John J. Stephen, pp. xiiii–xiv.

38 Shur, *K beregam*, p. 89.

39 Frederic Litke, *A Voyage Around the World, 1826–1829* (Kingston, Ontario: Limestone Press, 1987), pp. i, viii–xi.

40 "Puteshestvie vokrug sveta," *Biblioteka dlia chteniia*, 9 (1835): Part 5, 1–32.

41 Litke, *Voyage*, pp. 83–84, 88–89.

42 Ibid., pp. 72–78, 101–102.

43 On Litke and the Geographical Society, see Nathaniel Knight, "Science, Empire and Nationality: Ethnography in the Russian Geographical Society, 1845–1855" in Jane Burbank and David L. Ransel, eds., *Imperial Russia: New Histories for the Empire* (Bloomington: Indiana University Press, 1998), pp. 108–147.

The Emergence of the Russian European

Russia as a Full Partner of Europe

by Marc Raeff

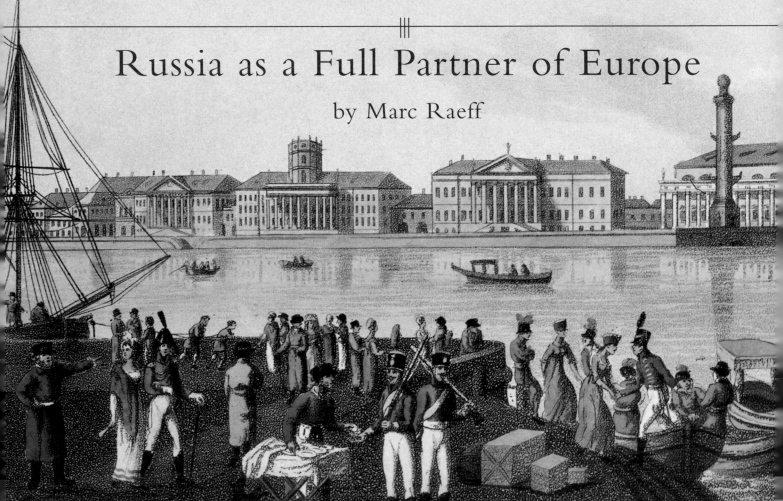

Peter the Great, by opening "a window onto Europe" during his time in power from 1696 to 1725, put into motion the complex process of bringing about a nation of "Russian Europeans." This meant, first, the formation of a europeanized elite class, drawn mainly from the service nobility, with the expectation of eventually drawing the entire population into that development.

Although any study of europeanization naturally focuses on the culture of the educated, upper social layers of the population, the overwhelmingly peasant common people also participated, vicariously, in Russia's engagement with the outside world. Little is known about this aspect of cultural development because of lack of documentation and efficacious conceptual tools; however, for the eighteenth and early nineteenth centuries, indirect evidence yields some insights. Since members of the church and state were drawn into the process of europeanization and underwent transformation in their behavior and concerns, they, willy-nilly, affected the lives and manners of those under their control and on whose labors they depended. Thus, the peasants (close to 95 percent of the population) were forced into new occupations, whether in domestic service or in mining and manufacturing.

Changes in the elite's traditional ways of dress and lifestyle, in the long run, affected how they were perceived by servants and serfs. For example, indirect negative evidence indicates that during uprisings and revolts, serfs often willfully destroyed objects symbolic of foreign innovation, such as glass panes, mirrors, imported furniture, musical instruments, books, and paintings. More positively, peasants became directly involved in servicing the daily needs and tastes of their europeanized masters in a variety of ways: in the kitchen and nursery; in travels; as builders and decorators of western-style mansions and churches; and through participation in new types of amusements, for instance as performers in musical and theatrical events.

A. Paris, chez Martinet, Libraire, rue du Coq, N.º 15.

Déposé

Galerie Militaire.

Army service also played a europeanizing role. Harsh as it was, it directly involved recruits and ordinary soldiers (drawn from the peasantry) with new weapons, and new ways of living and fighting; in addition, some soldiers gained direct experience of the European world on campaigns abroad, for example, during the Seven Years War of the mid-eighteenth century and the anti-Napoleonic campaigns from 1813 to 1815. In addition, Peter the Great's creation of a navy sent Russian sailors to all parts of the world (fig. 70).

In order to create Russian Europeans in the eighteenth century, a variety of tools were acquired to move the process forward. When speaking of cultural innovations, naturally, language shows the first effects, because it becomes transformed through new concerns, interests, material objects, and experiences. Modern Russian integrated foreign concepts and words and developed greater flexibility and simplicity of syntax and morphology, thus increasing the language's efficacy and aesthetic appeal. Peter introduced a new typography, "civil script," which greatly facilitated the teaching and handling of the written and printed word. The creative success of the young secular literature in the eighteenth century paved the way for modern Russian's glorious triumph in the works of Aleksandr Pushkin and his contemporaries in the early nineteenth century. Along with the evolution of Russian came the spread of knowledge of other European languages, principally of German and French but also of Italian, English, and ancient Greek and Latin. Knowledge of foreign tongues gave members of the Russian elites access to the full range of European letters and thought, which, in turn, opened up a broad horizon onto western science and philosophy.

Education provided a second tool for europeanization. Muscovy had no regular, secular schooling; whatever schools there were focused exclusively on religious subjects. Tsar Peter was an enthusiast for most branches of contemporary technology and established regular technical training for the children of the service nobility; he also made primary education compulsory for them. The reign of Peter's daughter, Empress Elizabeth, witnessed another milestone: a university on the European model was founded in Moscow in 1754. Next, Catherine II expanded the network of primary and secondary schools, including some for girls. Along with these educational institutions, opportunities existed for receiving western schooling informally from tutors at home and in private boarding schools. Moreover, cadets corps prepared young men for military and naval careers while giving instruction in the liberal arts and sciences; these schools also sponsored literary efforts and translations by cadets, as well as encouraging the publication of magazines and the staging of plays.

As had been the case earlier in Europe, introduction of the printed book stimulated the expansion of education, which, in turn, increased the demand for printed material. While printing had come to Muscovy in the sixteenth century, it did not flourish there as it had in the west. Even in the last quarter of the seventeenth century, only one printing press existed; it operated under the patriarch's supervision and published works of religious devotion or official legislative documents. Slowly but surely this changed in the course of the eighteenth century; Catherine II's decree allowing private printing presses and publishing houses confirmed that Russia had finally joined the "Gutenberg galaxy." Nikolai Novikov

[70]
THE ARMORY OF THE VICTORS

The Costume of the Allied Armies in Paris in the Year 1815
[Paris, 1816]

The international alliance of former foes that coalesced to break France's short-lived dominance of Western Europe is represented in this hand-colored vignette, representing a gallery of military weapons and escutcheons of the conquerors.

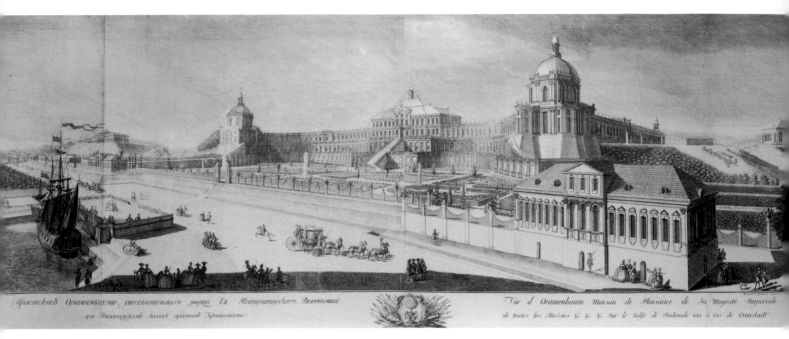

Проспект Оранienбаума увеселительнаго дворца Ея Императорскаго Величества при Финляндскомъ Заливъ противъ Кронштата

Vue d Oranienbaum Maison de Plaisance de Sa Majesté Imperiale de toutes les Russies &c &c &c Sur le Golfe de Finlande vis à vis de Cronstadt

[71]

VIEW OF THE ORANIENBAUM PALACE,
ON THE GULF OF FINLAND

[*Vidy S.-Petersburgskikh okrestnostei*]
St. Petersburg, 1761

During the eighteenth and nineteenth centuries,
Russia's imperial family constructed a large number
of palaces both within the capital of St. Petersburg,
and in the countryside on its periphery. The complex
at Oranienbaum, depicted here in its heyday in *Views
of the Environs of St. Petersburg*, reflected both the
grand scale of these palaces, and their architectural
eclecticism. Oranienbaum's "Chinese Pavilion," for
example, was considered one of the finest examples
of the chinoiserie style in Europe. During World War II,
the buildings and gardens of Oranienbaum were,
like many Russian palaces, devastated by the Nazis.
Although some of the buildings and pavilions have
been restored, much remains in ruins.

became the first "publishing tycoon," and his presses produced everything from moralistic literature, translations of foreign classics, and textbooks and manuals to journals for children and agriculturalists. These books found wide distribution and helped to create an ever-growing reading public in the Russian Empire.

Government service, too, played its part in Russia's engagement with the rest of Europe. The new Petrine army and navy were trained and equipped on the western model, introducing its rationalist, scientific, and technological notions and practices to Russian officers as well as to soldiers and sailors. The civilian administration was modernized along the principles of German cameralist doctrine and the practices of "the well-ordered police state." Although their implementation in Russia left much to be desired, they did help bring about an intellectual climate and institutional setting that prepared members of the imperial state service to be receptive to new ideas, among which were a critical stance toward the ways of bureaucracy and proposals for corrective reforms. The needs of state service also afforded opportunities for foreign travel, since young men were sent abroad to study and undergo technical training. In addition, with the intensification of europeanization among the elites, travel abroad became popular as a way to satisfy curiosity and to obtain personal cultural enhancement. In fact, tourism threatened to degenerate into a mania and soon became the object of satire and angry denunciation in late eighteenth-century literature, for instance in Denis Fonvizin's play *The Brigadier*.

On the other hand, exposure to Europe's artistic treasures stimulated the collection of *objets d'art*. Catherine II acquired a splendid collection, which she housed in the Hermitage of the Winter Palace in St. Petersburg. In imitation, wealthy aristocrats like the Stroganovs, Golitsyns, and Elagins turned their mansions into galleries of art. The country estates of the wealthier members of the service nobility and, to a lesser extent, of country squires became another stage on which to display acquisitions from abroad, including a europeanized style of life and its assimilation by Russian society. In fact, for the lowlier ranks of the service and provincial nobility, country estates proved to be, in the long run, the most effective agents in shaping Russian Europeans. Catherine II's legislation guaranteeing noblemen individual autonomy and a modicum of participation in public life in the provinces facilitated and accelerated the process in a most significant manner.

Last but not least, foreigners residing in Russia played a major role in moving europeanization forward. They came in increasing numbers as traders, as experts and professors or teachers, as artisans and manufacturers, as tourists, and after 1789 also as émigrés. Many took up government service—for instance, John Paul Jones, Samuel Bentham, and a plethora of German princelings in the army and navy—while others settled down in private occupations. Often they formed small "sub-societies" in the capitals, preserving their languages, religion, and customs while at the same time enlarging the range of cultural offerings for the Russian public; foreigners sponsored musical societies and concerts, theatrical presentations, art exhibitions, and even—in the reign of Alexander I—public scholarly and scientific lectures.

Europeanization also spread to Russia's newly conquered territories. The military proved particularly significant as a middleman; it not only applied its new style, forms, values, and leadership to "reeducate" its own members, but also—and even more importantly, albeit with mixed success—introduced western organization and ways in the areas it had brought into the Russian Empire. In this manner, the europeanized military assisted the integration of the new conquests by imposing a uniform pattern of administrative structure, economic development, and promotion of cultural (mostly linguistic) russification. The most prominent of the imperial military and administrative leaders who promoted such policies included Vasilii Tatishchev in the southeastern steppes,

Grigorii Potemkin in the south along the Black Sea, Petr Rumiantsev in Ukraine, General Dmitrii Mertvago in the Crimea, and Ivan Selifontov and Mikhail Speranskii in Siberia.

By the same token, territorial expansion brought the empire into direct physical contact with states like the Ottoman Empire, Persia, and China and with nonwestern peoples such as the Kalmyks, Bashkirs, Siberian natives, and the plethora of Caucasian peoples and tribes. The enhanced knowledge and integration of "oriental" civilization into the dynamics of Russia's cultural development were evidenced in literature, music, and scholarship in the first decades of the nineteenth century. Major contributors to this movement included Aleksandr Vostokov, Aleksandr Griboedov, the monk Iakinf (Nikita Bichurin), and Sergei Uvarov. Of course, these facts in no way imply a value judgment on the costs involved and the results obtained in territorial expansion. Similarly, the increase of mining and manufacturing and of trade with the outside world served to promote the drive for the material europeanization of the Russian Empire. Economic needs fostered the importation and creation of new technologies that required innovation in schooling, as well as the sponsorship of the exploration and exploitation of newly discovered resources, especially in Asia.

When embracing a foreign culture—whether in part or in its entirety—a society picks and chooses among those elements that seem most attractive and useful. While importing and assimilating the aspects chosen, the recipient simplifies and distorts the cultural items received. This adaptive dynamic works in ascending order of accommodation from instruments of utility (tools, engines) to objects of luxury and beauty (fashions in clothes, adornments, architecture, painting, literary forms) and then the incorporation of values and conceptual systems. This is precisely the course taken by eighteenth-century Russian society as it implemented Peter I's "project" of becoming European. Technology was imported, put to use, and duplicated. Artistic principles and models, as shown by Professor James Cracraft in his magisterial study of the Petrine cultural revolution, were adapted to local traditions, materials, and social needs, and were often adorned with native decorative elements. In the intellectual and spiritual realms, selectivity and reinterpretation had much wider scope. Adoption of modern European scientific theory and speculation lagged behind the importation and application of techniques and instruments, even though the ideal of the rational pursuit of and objective knowledge about natural features and resources stimulated scientific expeditions into the remote and new regions of the empire.

From the perspective of book culture in the eighteenth century, the process of europeanization was perforce dominated by the Enlightenment. Recent research and historiography have not only sharpened our vision of the complexities of the Enlightenment's conceptual content but have also brought out the impact that the social and historic context had on the understanding and receptive dynamics of specific "enlightened" ideas. In the case of Russia, for example, Voltaire's work attracted the richer nobility principally for its entertainment value. The social and political radicalism of the later French Enlightenment was received in Russia with

[72]
A MANUSCRIPT IMPERIAL CHARTER

Paul I, Emperor of Russia
Imperial Charter
[St. Petersburg], October 24, 1797

This illuminated Russian imperial charter, signed by Paul I, bestowed on a servitor the title of Grand Marshall of Poland and Counselor, and granted him lands in Podillia and Volyn Province. Such charters included the full titles of the reigning sovereign and hand-drawn and colored armorials of Russia's dominions. This particular charter was issued from one of Paul's favorite residences, the fortress-like Gatchina Palace, during the first year of his reign.

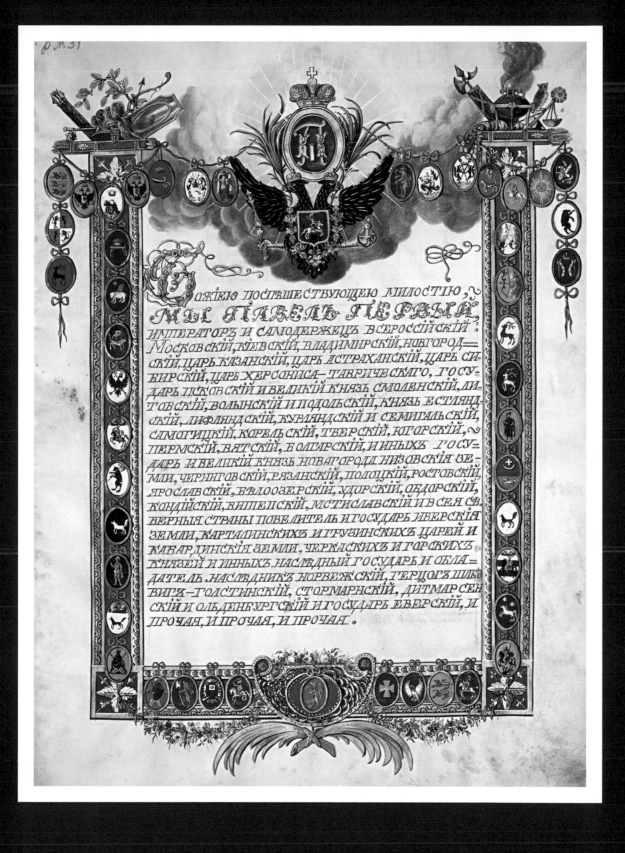

much delay and in the postrevolutionary context of the 1790s; it thus had an impact upon Russian public discourse only at the very end of the reign of Alexander I.

The German *Aufklärung*, on the other hand, was received with enthusiasm starting from the middle of the eighteenth century. The *Aufklärung* was a syncretic mixture of enlightened, secular concepts with a Christian religious, spiritualistic view of man and the world. This fusion resulted in a philosophic syncretism consisting of a rational search for "scientific laws of nature" in tandem with a deepening of the individual's spiritual and mystical experience of God. The ultimate achievement was to be sought in the individual's synergetic identification with God and His universe. The melding of an "enlightenment of the heart" with a knowledge of the laws of nature—obtained through scientific experimentation and hermetic speculation—was the essence of the Rosicrucian Enlightenment, which originated in England and Central Europe in the seventeenth century and was disseminated by Masonic lodges.

The role of Freemasonry in promoting a European, modern style of civility and in supporting socially useful private initiatives and associations has been the focus of recent historical research. The studies of Raffaella Faggionato and Douglas Smith have demonstrated that Masonic lodges played the same role in eighteenth-century Russia. Nor should we forget, or underestimate, the religious dimension of Masonic beliefs and activities. Novikov, in particular, expended enormous energy in promoting translations and popular education and engaging in famine relief; he firmly embedded the ideas and goals of the Rosicrucian Enlightenment in the spiritual, intellectual, and social enterprises of prominent Masons active in the fields of literature, administration, and education. Their pupils and followers would constitute the center of a network that was to encompass the most energetic reformers of Russian public life in the early decades of the nineteenth century.

The short and chaotic rule of Catherine II's son, Emperor Paul I, proved to be the catalyst for eighteenth-century trends and set the stage for the crystallization of a truly European-style political and cultural establishment during the reign of Catherine II's oldest grandson, Alexander I. In the first decade of his rule, he introduced liberal censorship regulations, which spurred the rapid expansion of publishing in all fields. At the same time, he greatly enlarged the network of public schools. The curriculum was modernized at the four new imperial universities of Kazan, Kharkov [Kharkiv], Iurev [Dorpat], and Wilno [Vilnius] and at the secondary schools, which were established in every provincial capital. The reorganization of a comprehensive system of ecclesiastical schools accompanied reform of the secular schools: primary schools were built in each large parish, though the implementation here proceeded rather slowly; seminaries on the secondary level accommodated each diocesan see; and four theological academies were set up to provide a university-level education for the clerical hierarchy. Moreover, the curricula of the ecclesiastical schools were much modernized with the inclusion of modern languages, natural sciences, church history, and theology. Within two generations, the ecclesiastical school system became the major source of students preparing themselves for secular careers in law, scholarship, science, and higher education.

The reinvigorated press and schools provided the context and audience for a massive influx of contemporary European cultural products in literature, fashions, and aesthetic and philosophic interests as well as in technology and science. While continuing eighteenth-century trends—albeit with greater dynamic impact and less fettered by state censorship—a notable new feature was the appearance on Russia's intellectual scene of private initiative and financial support. The imperial government no longer retained exclusive control of and a monopoly on the promotion and development of cultural institutions, even though it maintained a supervisory role, as was

the case on the rest of the European continent. For the first time, private institutions of higher learning emerged in Russia, like the *lycées* of Aleksandr Bezborodko in Nezhin and of Pavel Demidov in Iaroslavl. Rumiantsev's library in St. Petersburg and philanthropic work in hospitals, schools for commoners, and prisons provided other signs of individuals initiating and supporting public endeavors.

Energetic practitioners in various fields also launched a number of scholarly and scientific organizations with the financial support of individual Maecenases and led to the appearance of oriental, archaeographic, historic, geographic, and other societies. Not only did these associations keep track of European progress in their respective areas of interest, they likewise promoted the creative efforts of their members and made the results known through correspondence and exchanges with similar groups abroad, for instance, the American Philosophical Society and the German, French, and Italian academies. In short, Russia was joining the international project of scientific and scholarly progress on well-nigh equal footing. The haphazard amateur efforts of the eighteenth century at carrying out scientific experiments were gradually giving place to the systematic activities of an international community of professionals. The same trend existed in the collecting of art.

These activities found favor with educated society, as illustrated in, for instance, the high attendance at public lectures. Serious discussions were also increasingly the focus of more intimate gatherings in aristocratic salons. Literary, aesthetic, and philosophic topics were actively debated in circles of young students and *littérateurs*, each with its own preferences and concerns: Andrei Turgenev's group met in the first years of the nineteenth century in Moscow; the Arzamas Circle gathered the best of the defenders of "modern" literary and linguistic ideas; the Symposium, under the leadership of the conservative Admiral Aleksandr Shishkov, proclaimed traditional Slavic values and linguistic forms; the Free Society of Amateurs of Letters, Sciences, and Arts promoted the ideals of romanticism; while Mnemosyne, with its journal of the same name, disseminated German idealist philosophy. A major topic raised in all of these groups was the nature of Russia's national identity and the tasks of social betterment. They foreshadowed the open controversy between "Westernizers" and "Slavophiles" in the 1830s and 1840s and subsequent polar dissensions among the intelligentsia.

The spiritualist tendencies in eighteenth-century Europe, as represented by German pietism, the quietism of Mme. Jeanne Guyon, and Rosicrucianism, continued to pervade Russian culture in the early nineteenth century; their ideals now found practical expression in public affairs, as illustrated by the leading part played by such government dignitaries as Speranskii and Aleksandr Golitsyn. The outlook of these men on reforming state institutions had been shaped not only by the innovations wrought in France and Prussia but also by their readings of and meditations on the writings of western mystics and illuminates, whose ranks included Guyon, Jakob Boehme, Philipp Jakob Spener, Louis Claude de Saint-Martin, Johann Heinrich Jung-Stilling, and Emanuel Swedenborg. In the first decade of his reign, Emperor Alexander supported a liberal reformist orientation, but in the later years he turned more rigidly traditionalist and conservative. After 1815, his main advisers were the staunchly conservative Admiral Shishkov, Aleksandr Sturdza, and the monk Fotii (Petr Nikitich Spaskii). While reformism did not vanish completely from his mind, it now took on a distinctly religious-mystical tint.

After his visit to England in 1815, the emperor agreed to permit the opening of branches of the English Bible Society in his empire. The bible societies were to promote a greater role for religion and church in Russia's cultural life, but they were not permitted to carry on any missionary or proselytizing activities in favor of any Christian denomination. The Bible Society was, how-

ever, encouraged to translate the scriptures into many of the languages of the empire, including vernacular Russian. In so doing, the organization initiated philological research in these languages and promoted literacy among their speakers. The society's active dissemination of the Slavonic and vernacular Russian translations also helped open up the vast field of biblical and church historical scholarship in the ecclesiastical academies.

Emperor Alexander I became directly involved, of course, in the military and diplomatic events caused by Napoleon's drive for total domination over Europe (fig. 78). Russia participated in the several coalitions that eventually succeeded in defeating France, but before this happened, Napoleon invaded Russia in 1812 and succeeded in briefly occupying Moscow. Soon, he was forced to retreat ignominiously and lost most of his Grande Armée (figs. 73–77). The foiled invasion brought vast destruction to Russia as well as a surge of patriotic fervor and pride. Army service and combat experiences fostered new bonds among officers and heightened their civic awareness and commitment. These experiences triggered the hope among Russians of more active participation in public affairs and of greater involvement in improving the people's material and spiritual condition after the war.

One consequence of Russia's engagement in the anti-Napoleonic coalitions and in the subsequent occupation of France was the opportunity for thousands of Russians to see central and western Europe with their own eyes. The officers, well received by European society, had the additional advantage of observing at close quarters the political life of France under the Constitutional Charter of 1815, as well as becoming directly acquainted with the literature and lectures on political economy, philosophy, and science at leading universities. In addition, contacts with the German Tugendbund or Union for Virtue, which led the drive for Germany's national liberation and unification, resulted in its serving as the model for private associations of young intellectuals and officers in Russia.

The emperor's adamant refusal to allow the active participation of private individuals in public life brought about the organization of secret societies for the discussion of reform plans

[73, *opposite, above*]

DREAMS OF CONQUEST VANISH IN MOSCOW'S FLAMES

Carl Friedrich Wilhelm Borck (editor)
Napoleon's erster Traum in Moskwa
St. Petersburg, 1812

- -

Published in the immediate aftermath or perhaps during the time of the French retreat, this collection of commemorative poems was originally in the Great Catherine Palace Library at Tsarskoe Selo. The engraved and colored frontispiece depicts Napoleon waking from a bad dream, only to discover that his nightmare has become reality. Father Time draws back a curtain to reveal Moscow—intended as a place to comfortably billet and provision troops during the Russian winter—as an inferno, torched by its own inhabitants.

[74, *opposite, below*]

NAPOLEON'S FOES CELEBRATE WITH MUSIC

Ferdinand Charles Panormo
Moscow, or Buonaparte's Retreat, A Grand Russian Air
London, ca. 1814?

- -

Following a series of wars between 1796 and 1809, Napoleon had established control over much of Western Europe, either through conquest or by alliances that made states such as Prussia unequal partners. England remained France's principal competition, both economically and militarily. So it is not surprising that the news of the vast Grande Armée's decimation on its retreat from Russia was greeted with celebration in Britain, expressed in patriotic airs such as this composition.

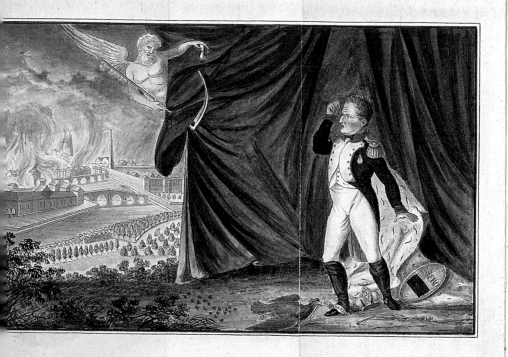

Napoleon's
Erſter Traum in Moskwa
nebſt einem Titelkupfer
gezeichnet
von Herrn Conrad Oppermann
Ruſſiſch = Kaiſerlichem Cabinets = Mahler,
geſtochen
von Herrn Friedrich Meyer
Ruſſiſch = Kaiſerl. Kupferſtecher der Akademie der Wiſſenſchaften.

Napoleon's
Unterredung mit einem Ruſſiſchen Bauer.

Nachruf der Miliz
welche
zum General von der Cavalerie Grafen Wittgenſtein
marſchirten.

Kriegs = Lied
dem Corps der deutſchen Legion
gewidmet
von
C. F. W. Borck
Ruſſiſch = Kaiſerlichem Hof = Schauſpieler.

Nebſt einem
Original = Briefe
eines Bewohners von Moskwa.

St. Petersburg.
Gedruckt in der Buchdruckerey bey Jwan Glaſunow 1812.

MOSCOW,
or
BUONAPARTE'S RETREAT,
A
Grand Russian Air,
With Characteristic
Variations,
Composed & Dedicated to
GOVERNOR ROSTOPCHIN,
By
Ferdinand Charles Panormo.
Pr. 3s
LONDON,
Printed & Sold by G. Walker, Publisher of Books & Music 105, & 106, Gt Portland Str.
Just Published,
Miss Platoffs Cosaque a Pands by T. Janson,
Buonaparte's Defeat a Grand March & Cossack Quick Step by Dr. A.

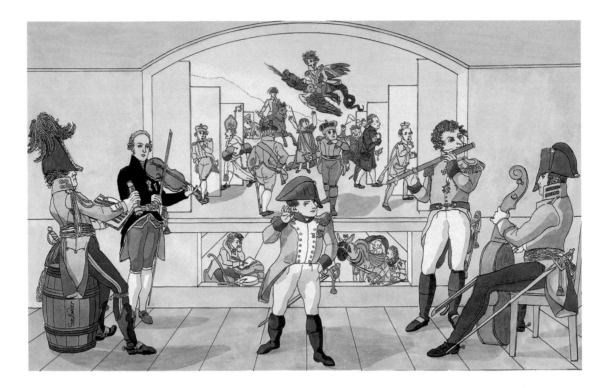

[75, *above*]
BONEY'S IMMINENT COMEUPPANCE

Ivan Ivanovich Terebenev
Karrikatury Napoleona I
[Russia], ca. 1813–1815

The magnitude of Bonaparte's defeat, as well as his
small physical stature, made him a popular subject
for ridicule. Terebenev was one of the best-known
Russian satirical artists of his day. This caricature,
captioned in French, depicts the "beginning of the
end," as a quartet of staff officers play for Napoleon,
who is oblivious to events involving his continental
"allies" in the background.

[76, *opposite*]
AN INTERNATIONAL ALLIANCE OCCUPIES PARIS

The Costume of the Allied Armies in Paris in the Year 1815
[Paris, 1816]

Of all the allied armies that marched into France,
none was as ethnically diverse as Russia's. Conscripts
from throughout Russia's vast Eurasian Empire,
many in their native dress, were a remarkable sight
on the boulevards of occupied Paris. The fierce
Kalmyk horseman shown in this hand-colored
engraving was one of many such exotic peoples,
with a pelt-adorned saddle, and his yurt home in
the background.

[77]

RUSSIA EXTENDS AN OLIVE BRANCH

Count Fedor Petrovich Tolstoi
Sobranie reznykh izobrazhenii s medalei
St. Petersburg, 1818

This design by Fedor Tolstoi for a commemorative
medal engraved by Nikolai Utkin, reproduced from
A Collection of Images Engraved from Medals,
memorializes both the triumph of Russia over
Napoleon and the victor's European "civility." Here,
the Russian conqueror, his vanquished foes littering
the field behind him, offers a symbol of peace to
the kneeling personification of the subjugated city
of Paris. The encircling caption suggests that justice
has been done, as "The Fire of Moscow will be
extinguished in the walls of Paris."

[78]

ALEXANDER I AT THE END OF AN AGE

Stepan Filippovich Galaktionov
Emperor Alexander I
[Russia], 1827

This lithograph, rich in imagery, shows Emperor
Alexander I slightly bowed by the weight of his
responsibilities, particularly the defeat of Napoleon's
armies. He walks toward the west, into the stiff
winds blowing off the Gulf of Finland. In the back-
ground rises the Peter-Paul fortress, whose spired
cathedral contains the crypts of Russia's tsars. The
artist, Galaktionov, was one of the principal Russian
artists and lithographers of the late eighteenth–
early nineteenth centuries.

and of conspiracies to introduce a constitution. Seizing upon the confusion that accompanied the succession to the throne of Alexander's brother, Nicholas, in December 1825, the conspirators fomented a military uprising in St. Petersburg and in Ukraine. The new emperor easily crushed the revolt and stifled further progress in liberalizing and diversifying Russian intellectual and public life. Throughout his reign, Nicholas I focused his energies on preserving the status quo, although he encouraged preparatory work in secret for what were to become the "Great Reforms" under his successor, Alexander II.

In another result of the engagement with Europe at the end of the Napoleonic era, Russia, following the lead of central and western Europe, experienced the full impact of romanticism and German idealist philosophy just after the wars ended. These movements generated a new wave of literary creativity that culminated with the work of Aleksandr Pushkin, Russia's greatest poet, and was accompanied by a lively flowering of artistic, musical, and dramatic talent, which in turn stimulated a spirit of criticism and new forms of sociability. Individuals were encouraged to cultivate a "beautiful soul," in Friedrich Schiller's sense, and to suffuse all acts and emotions with a moral commitment to civic service. These injunctions gave dynamic impetus to the intelligentsia's fashioning of their identity and social role as leaders of society's moral liberation and regeneration.

Moreover, romanticism reveled in memories (real or imagined) of the past and extolled each people's historical uniqueness and sense of national pride. Eloquent histories of individual nations were avidly read by a public whom they inspired with aggressive national enthusiasm. This was the case of Russia as well; Nikolai Karamzin's *History of the Russian State* began to appear in 1816, and its many volumes were snatched up as soon as they left the presses (fig. 79). The historian turned out to be, in Pushkin's apt words, the Christopher Columbus who had discovered for his compatriots "the America of their past." For the next half century, Karamzin's work remained the most popular source of historical knowledge about Russia. At the same time, history as a recognized and popular discipline, which helped shape the cultural identity and national consciousness of educated Russians, had secured a permanent cultural niche.

The trends and happenings that have been sketched were not limited to the two capitals of Moscow and St. Petersburg. Starting in the eighteenth century, europeanized country estates had become the conduit for cultural trends, and this continued in the first quarter of the nineteenth century. In addition, the new universities, all located in the provinces, gave a mighty boost to the creative energies of the local population. In consequence, publishing houses, professional associations, and societies for the discovery and study of the province's past through the examination of archaeological material, old chronicles, and documents sprang up all over the empire, often with the encouragement and financial support of individual amateurs and wealthy patrons.

The intensification of local and provincial life brought to the fore the topic of administrative autonomy and of the political integrity of the empire. Suggestions arose for administrative regionalization and even for total regional autonomy in matters of economic life, education, and culture. Unavoidably, this line of discussion raised the question of the treatment and administration of non-Russian peoples: their rights, and their linguistic, religious, and social separateness. Pragmatic considerations and Romantic notions of the basic uniqueness and individuality of every people led to the acknowledgment of special requirements for the non-Russians of the empire. In some cases, these needs could be met, more or less adequately, by granting political and administrative status to a region like Siberia or to a country like Poland or Finland. Proposals were also drafted, but rarely implemented, for awarding special arrangements and legal status to individual peoples or members of religious groups such as Jews, Armenians, Muslims, and "pagan" nomads.

The continuing expansion of the empire exacerbated the nationality problem. The acqui-

Karamsin

Historiograph des Rußischen Reiches.

Nikolai Mikhailovich Karamzin
Geschichte des russischen Reiches
Riga, 1820–1833

Littérateur par excellence, traveler, and historian, Nikolai Karamzin was appointed Historiographer of the Russian Empire in 1803. He was a strong believer in the educational and moral value of historical writing, and his elegantly written *History of the Russian State* (1816–1826; *Istoriia rossiiskogo gosudarstva*) was among the most widely read and influential works of the first half of the nineteenth century. Shown here, from the German translation of the 1820s, is the author himself—sporting formal dress and the Order of St. George.

sitions, conquests, and efforts at integrating the multiethnic, multireligious, and linguistic jumble of the empire, especially in Transcaucasia, gave rise to the conundrum of "orientalism," in the now popular, albeit questionable, definition of Edward Said. In the mountain peoples of the Caucasus, the educated service nobleman could discover (or imagine) his "other"; the natural consequence of ambivalence toward these peoples' place in the empire became a problem that later generations had to confront in full. Meanwhile, ethnographic and geographic curiosity had been stirred. Explorations and linguistic studies—the latter stimulated by the philological infatuation with Sanskrit—were undertaken, and their results found enthusiastic reception in learned circles, both in Russia and in Europe.

Besides the cultural and political impact of europeanization after 1815, the economic problems of reconstruction and further industrial and agricultural development demanded attention. In England, Russians had seen the first stages of industrialization and modern capitalism, and their reaction was mixed. A few were willing to follow the English model and the economic teachings of Adam Smith, Thomas Malthus, and Frédéric LePlay. Others, on the contrary, were shocked by the social consequences of poverty and urban crowding and argued the need to avoid the English example, with Russia's own traditions and social organization offering a more solid foundation for the future. Obviously serfdom was the one socioeconomic feature that made the success of genuine industrial capitalism in Russia highly unlikely. Discussions took place in private circles and in secret government committees during the reign of Alexander I, to be continued more aggressively under Nicholas I. But the practical tackling of the "serf question" had to wait for the second half of the nineteenth century for a solution. Hastening this greater awareness of peasant problems—as well as of many other aspects of Russian reality—was the presence of an ever-growing number of foreign travelers and observers whose descriptions of conditions in the

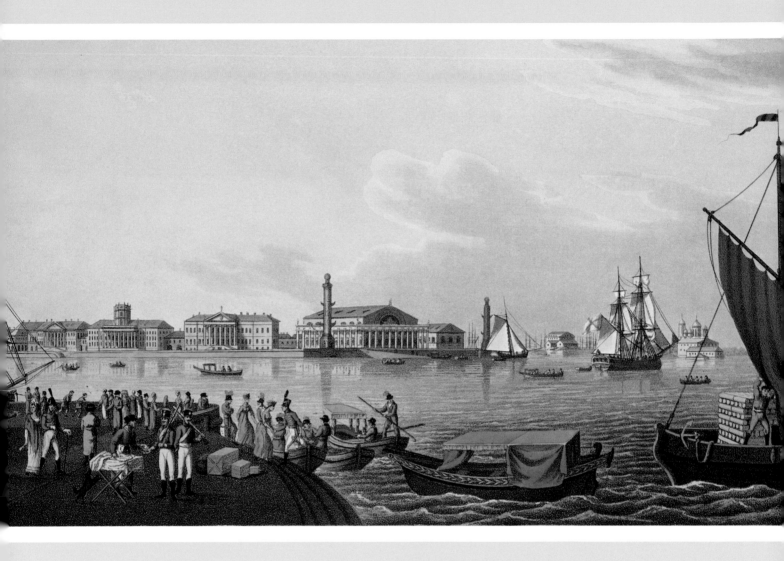

[80]

RUSSIA'S EUROPEAN CAPITAL

A Picture of St. Petersburgh
London, 1815

After its key role in Napoleon's defeat, Russia held enormous interest for other European peoples, both victors and vanquished. Publications such as the collection of views in which this image appeared served to further underline Russia's European character. Here, ships and smaller barges ply the waters at the confluence of the "Greater" and "Lesser" Neva River, from a quay near the Winter Palace. In the distance is the Academy of Sciences building on Vasil'evskii Island, and the Bourse, designed by the French-born architect Tomas de Thomon. The gondola-like craft navigating its canals emphasize the romantic notion of St. Petersburg as the "Northern Venice."

empire were widely disseminated, both in Russia and abroad. These accounts served as the basis for travel guidebooks, which were read by both tourists and Russians themselves.

The issue of Russia's self-image and national consciousness, or identity, moved to center stage in the elites' thinking as they discussed the empire's present condition and its needs for the future. In this respect, the Russians again did only what most European intellectuals were doing: they were spurred on by Romantic ideas about history, language, and nation; and they acted against the backdrop of the increasing preeminence of industry and capitalism in the life of western society.

Yet the Russian case was a bit different from that of continental Europe. Over the preceding two centuries, both the imperial government and elite culture had acquired a European cast. An educated member of the upper ranks of Russian society could truly call himself a "Russian European" and be seen as such by his counterparts abroad. And the Russian Empire itself was a powerful factor in the political destinies of Europe and the world at large (fig. 80). The stability and power achieved under Alexander I seemed to have justified the travails and crises of the past. But, applying the very categories of contemporary European thought, members of the elite could not fail to realize that the success of Russia's europeanization did not organically grow out of the medieval past of Kievan Rus' and Muscovy. Unlike most European cultural leaders, the Russians could not so easily tap their own roots, for they had broken with much of their early culture to take on foreign models and inspiration. This created for many a sense of the irreality, or rather artificiality, of modern Russian culture—hence the energetic and open disagreements and debates over the nature and history of Russia's path from the past into the future. Despite the increasingly active and constructive participation of Russian science, scholarship, and artistic creation in the ongoing progress of western civilization, the nagging question remained: are we truly part of that civilization? There also lingered the hopeful wish that the very differences that defined Russia would contribute to the total renewal of world civilization, of which Russians would serve as both the prophets and architects.

The outside world, primarily Europe, was asking in turn whether the energetic newcomer in the east presented a threat or a promise for its own civilization and its preeminence. The ambiguous and hesitant responses shaped the ambivalent, indeed contradictory, image of Russia abroad and at times led to political disagreements or conflicts. Today, following the downfall of the Soviet Union, the situation is not too dissimilar, and it gives rise to the old, fundamental debate: is Russia's future in the west? Or does its renewed engagement with the world harbor an agonal, at best a Eurasian, response?

References

Bawden, C. R. *Shamans, Lamas and Evangelicals: The English Missionaries in Siberia*. London: Routledge & Kegan Paul, 1985.

Cracraft, James. *The Petrine Revolution in Russian Imagery*. Chicago: University of Chicago Press, 1997.

Cross, Anthony Glenn. *By the Banks of the Neva: Chapters from the Lives and Careers of the British in Eighteenth-century Russia*. Cambridge, England: Cambridge University Press, 1997.

De Madariaga, Isabel. *Russia in the Age of Catherine the Great*. New Haven, Conn.: Yale University Press, 1981.

Faggionato, Raffaella. "From a Society of the Enlightened to the Enlightenment of Society: The Russian Bible Society and Rosicrucianism in the Age of Alexander I." *Slavonic and East European Review*, 79 (2001): 461–487.

Hughes, Lindsey. *Russia in the Age of Peter the Great*. New Haven, Conn.: Yale University Press, 1998.

Keep, John L. H. *Soldiers of the Tsar: Army and Society in Russia, 1462–1874*. Oxford: Oxford University Press, 1985.

Lincoln, W. Bruce. *Sunlight at Midnight: St. Petersburg and the Rise of Modern Russia*. New York: Basic Books, 2000.

Marker, Gary. *Publishing, Printing, and the Origins of Intellectual Life in Russia, 1700–1800*. Princeton, N.J.: Princeton University Press, 1985.

Martin, Alexander M. *Romantics, Reformers, Reactionaries: Russian Conservative Thought and Politics in the Reign of Alexander I*. Dekalb: Northern Illinois University Press, 1997.

McConnell, Allen. *Tsar Alexander I: Paternalistic Reformer*. New York: Crowell, 1970.

Roosevelt, P. R. *Life on the Russian Country Estate: A Social and Cultural History*. New Haven, Conn.: Yale University Press, 1995.

Saunders, David. *Russia in the Age of Reaction and Reform 1801–1881*. New York: Longman, 1992.

Smith, Douglas. *Working the Rough Stone: Freemasonry and Society in Eighteenth-century Russia*. Dekalb: Northern Illinois University Press, 1999.

Wirtschafter, Elise Kimerling. *From Serf to Russian Soldier*. Princeton, N.J.: Princeton University Press, 1990.

Yates, Frances Amelia. *The Rosicrucian Enlightenment*. London and Boston: Routledge & Kegan Paul, 1972.

RUSSIA'S EASTERN ORIENTATION

Ambivalence Toward West Asia

by Edward A. Allworth

Russia's reputation as an eastern,
rather than western, land has some basis in its actual legacy. Great migrations of Turkic and other
nomads gradually began moving west at least as early as the eighth century C.E. In the process,
they seeded the space from Mongolia to the Volga River, and beyond, with people later known
as "Asians."[1] Much more emphatically, from about 1220 until the middle of the same century,
Mongol commanders invaded Russia's plains with their many nomadic Turkic horsemen and
devastated settled communities. Soon enough, the relentless cavalrymen probably affected the
genetic makeup of the population as the Mongols held Russia under tribute for more than two
centuries and ruled an Asian expanse reaching from the Black Sea's northern shores to the Sea
of Japan. This invasion simultaneously initiated a lengthy process of forming among Russians,
both high and low, impressions of, opinions about, and attitudes toward West Asia and its people.[2]

At the same time, while Asians migrated westward, unlettered populations such as those
of old Russia composed oral poems, songs, and tales that created an Asian realm of fantasy only
distantly related to the influx of real nomads. This invention of vivid images hints that, certainly
as early as the thirteenth century, Russians grew up with notions of a mysterious east, really the
land of West Asia. Strange giants having six heads or arms, and animals combining parts from
dogs, serpents, and humans, along with many other monsters, inhabited Russians' visions. They
absorbed many of these preposterous concepts through hearing fanciful legendary accounts. Popular
favorites included "Deeds of the Apostle Thomas in India," "The Tale of Varlaam and Iosaf," "Kalilah
and Dimna," a collection of moral, comic, and erotic fables going back to Sanskrit origins, and
"Aleksandriia," a fanciful rendering of Alexander the Great's campaign across Persia into Central
Asia in 330 B.C.E.[3] Several of those same ancient narratives also formed a substratum of Islamic
culture, thus very early aligning Russian popular cultural history closely with that of West Asia.

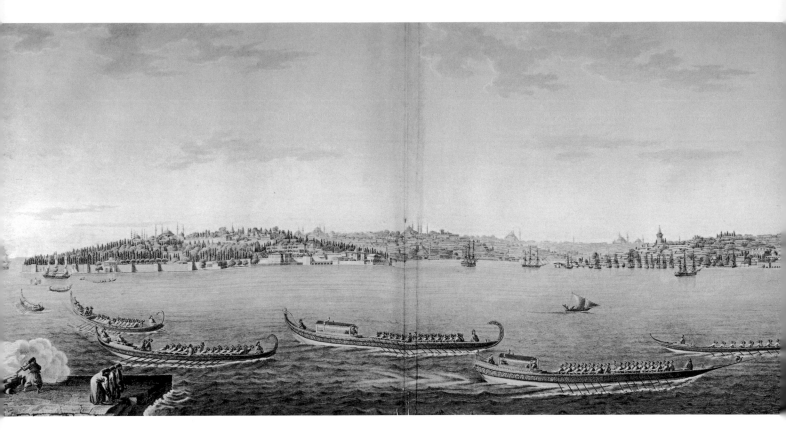

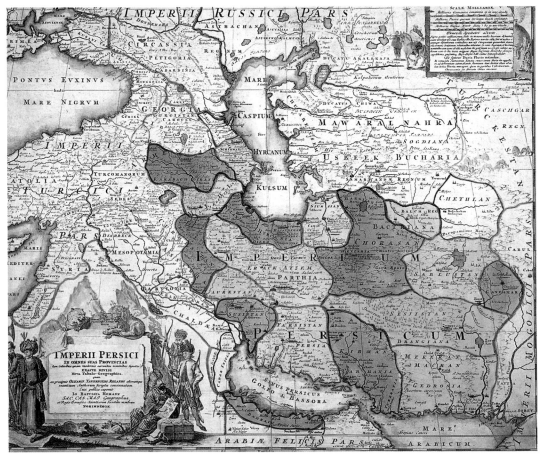

In a later era, the exotic imaginings of Muscovite Russians persistently focused upon the people and fauna of that part of West Asia most remote and different from themselves, those of Hindustan (later, India). In the late 1470s, just as Mongol domination was ending, a Russian merchant, Afanasii Nikitin, wrote an account of his lengthy journey from his home in Tver south to the Caspian Sea and on to Persia, the Straits of Hormuz, and over the Arabian Sea. His diary records the strong impression that West Asia made upon him once he reached Gujarat in Hindustan: "This is an Indian country. People go about all naked, with their heads uncovered and bare breasts; the hair tressed into one tail; and pregnant. They bring forth children every year ...; and men and women are all black. Wherever I would go, many people would follow me, marveling at the white man."[4] In this scene, he describes no grandeur or wealth and bluntly portrays the opposite of elaborate costume; he focuses instead upon the very dark skin of half-naked inhabitants. That pigmentation attracts his comparisons several times in the diary, usually in favor of his whiteness.

Regarding the Muslims, Nikitin notes that while he was in Junnir, its khan tried to force or bribe him to convert from Christianity to Islam and declares in his diary: "Now, Christian Brethren of Russia, whoever of you wishes to go to the Indian country may leave his faith in Russia, confess Mahomet, and then proceed to the land of Hindostan. Those Mussulman dogs have lied to me, saying I should find here plenty of our goods; but there is nothing for our country."[5] Nevertheless, Nikitin demonstrates his pragmatism when he reveals to Hindus at Bidar (or Beder) that he employs what he calls "a Mahommedan name for himself: Khoja Yussuf Khorossani," when dealing in the Islamic world.[6] Also verifying his contrived duality, numerous passages among his Russian diary entries contain phrases or whole paragraphs written in a mixed Turkic-Persian jargon then used by traders in West Asia and almost incomprehensible to others. Experience in that region quickly taught him to adjust not only to requirements of verbal communication but also to the practicality of adopting an eastern identity when among Asians.

Increasing this sense of dual identity among Russians like Nikitin, events in Byzantium in the fifteenth century had begun to reshape the contours and makeup of the westernmost portion

[81, *opposite, above*]
OTTOMAN SPLENDORS

Antoine Ignace Melling
Voyage pittoresque de Constantinople et des rives du Bosphore
Paris, 1819

Both Orthodox Russia and the Christian West retained Constantinople (Tsargrad) as the traditional name of the great city at the crossroads of Europe and Asia, but by the time Russia had become dominant in the north, the city's name had changed to Istanbul, the capital of Russia's neighbor to the south, the Ottoman Empire. Antoine Ignace Melling, who worked in the late eighteenth and early nineteenth centuries, was one of the many European visitor-artists who sketched engaging portraits of the city.

[82, *opposite, below*]
WEST ASIA AND RUSSIA IN THE MIDDLE AGES

Johann Baptist Homann
Imperii Persici in omnes suas Provincias
Nuremberg, early 18th century

This early modern map shows portions of West Asia to the south and Russia to the north. Scanning from west to east, the map demonstrates contemporary geographic knowledge about the locations of parts of the Ottoman Turkish, Central Asian, Persian, and Mughal (here, *Mogolici*) empires. Cartographers based their knowledge upon printed reports made by other seventeenth-century travelers such as Adam Olearius and Jean-Baptiste Tavernier.

of Asia. In 1453, Turkic invaders largely dislodged Christianity and Greek Orthodoxy from Constantinople and converted that once great Christian political and religious center into Islamic Istanbul (fig. 81). This change also affected Russia when it prompted Ivan III, son-in-law of the defeated Byzantine emperor, to claim that Muscovy had inherited the mantle of Orthodox Christianity. The conquest of Constantinople would redefine the proximity of West Asia to Russia as well as Russia's posture toward the new Ottoman Turkic Empire.

Since then, some foreigners, rightly or not, have regarded Orthodox Christian Russia as an east/west combination, neither completely eastern nor wholly western. Certain modern Russians have agreed. Fedor Dostoevskii, in the 1870s, wrote in his diary: "Russia is ... not like Europe at all." A Russian historian, a contemporary of the great novelist, went even further, characterizing his country as an "Asiatic-Turanian" land.[7] A very recent study analyzes the fervent arguments that have consigned Russia to the east, rather than to Europe.[8] This debate aside, perhaps owing to a prolonged, organic infusion of easternness, Russia acquired a certain susceptibility to Asian cultural influences (fig. 83).

Indeed, until the eighteenth century and the creation of the Russian European, Russians felt rooted in the east. In that respect, they contrasted strikingly with other inhabitants of the continent, who showed little doubt about their European identity. Most Europeans saw the east, including Russia, as a mysterious, faraway area, little known and vaguely defined (fig. 82).[9] That mystery would add to the confusion about the Russian orientation by contributing to its complex image a contagious romanticism—both in Europe about Russia and in Russia regarding the surrounding east. Nonetheless, by the mid-eighteenth century, Russia had begun to act more like a western land.

In the meantime, from the fifteenth century, Russians' attitude toward West Asia, in considerable part, seemed to derive not so clearly from external relations as from the inconstant self-esteem of Russia itself. Toward neighboring Asia, Russians felt a strong and growing superiority in religious and cultural matters as early as the sixteenth century. This condescension probably owed its origin as much to misinformation and ignorance as to evidence of Asia's presumed inferiority.[10] In regard to the empires of West Asia, however, Russian attitudes toward their grandeur and arts remained quite deferential until at least the beginning of the eighteenth century. For these reasons, and others, the evolution in Russia's own aesthetic and genetic easternness up to the nineteenth century subtly complicates the problem of clearly understanding its attitudes toward West Asia.

Russia's easternness during the centuries between 1453 and the 1700s, it seems plain, depended on more than the prowess of military commanders or the influence of geographic location. That orientation carried with it a kind of reverie about the true nature of the neighboring cultures. The Turkic Golden Horde (*Altin Orda*), successor to the Mongol conquerors of the early thirteenth century, gained its popular name in Russia from the color and magnificence displayed by the array of splendid tents erected along the Volga River by armies of the "Tatars"—as the Russians called the Qipchaq troops and their Mongol commanders—long

[83]

ORIENTAL RUSSIA

Joan Blaeu
Grooten atlas, oft Werelt beschryving
Amsterdam, 1648–1664

Joan Blaeu was the most important cartographer and publisher of world maps in the seventeenth century. This map of the Asian continent shows, among other regions, the oriental parts of the Russian and Ottoman empires.

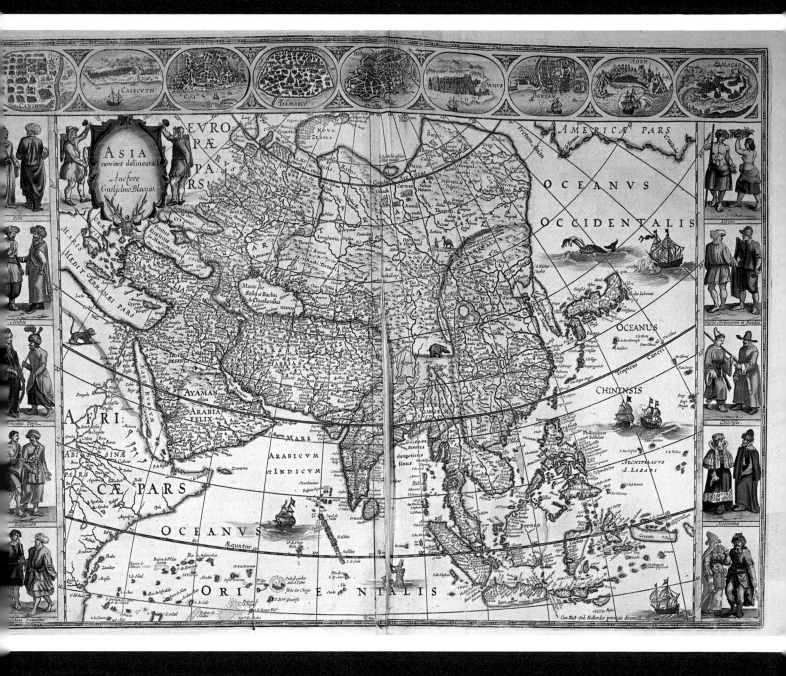

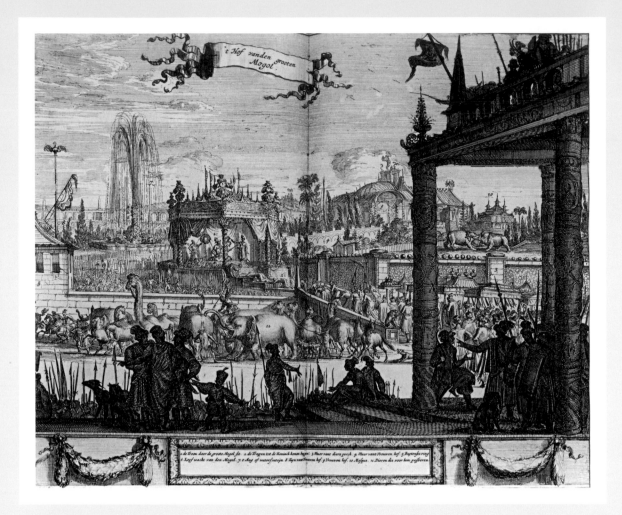

[84]

A MUGHAL EXTRAVAGANZA

John Ogilby
*Asia, the first part. Being an accurate description of Persia,
and … the vast empire of the Great Mogol*
London, 1673

This scene represents the magnificence of the
Mughal court in India, with the display of fountains,
gardens, palaces, and pavilions. The background
portrays contesting behemoths entertaining royalty
and shows visiting diplomats or governors prostrating
themselves before the emperor, seated on his throne.
A menagerie of animals, exotic to Russians and most
Europeans, heads along an avenue fronting Delhi,
the capital city. John Ogilby borrowed this etching
for part one of his book.

encamped there. The Mongols' tax collectors likewise helped to convey a vague familiarity with eastern costumes, manners, and cultural preferences. The Mongol and Turkic outsiders also loaned the Slavs some practical terminology, for example, the word for money (*den'ga* < *tenga* Turkish) and the term for prized Damascus steel (*bulat* < *pulad* Persian/Turkish < *fulaz* Arabic), thus adding vocabulary linked with wealth and power.

A central Russian image of West Asia is that of a land of opulence. Indeed, the lure of the east in medieval and early modern times stemmed from the popular old myths of fabulous quantities of accessible precious metals in West Asia. At least since the era of the Great Silk Route, starting around 1000 B.C.E., a place and a river in the heart of southern Central Asia bore the striking name Zarafshon ("sparkling like gold" or "gold bearing"). Nikitin's diary provides an account of his journey that is quite realistic until he begins to depict luxury, when he exhibits a propensity for the vogue of statistical extravagance with large round numbers. For these scenes, he relied upon his store of legends and myths about Asia rather than on firsthand experience. For instance, while in Bidar, the Russian traveler notes that its sultan went out on campaigns with 300,000 men and, when hunting, took along only a few royal women, but "10,000 men on horseback, 50,000 on foot; 200 elephants adorned in gilded armour, and in front, 100 horn-men, 100 dancers, and 300 common horses in golden clothing, 100 monkeys, and 100 concubines, all foreign." The nobles, he observes, "delight in luxury."[11]

According to Nikitin, on Muslim religious occasions, royal parades demanded innumerable aides, not only many elephants in steel armor but "100 camels with torchbearers" plus even more than the usual number of trumpeters, dancers, and others. In such a pageant, the sultan sat on a golden saddle, and wore sapphire-embroidered clothes and a peaked headdress decorated with a large diamond. He had a suit of sapphire-inlaid gold armor and three gold-mounted swords. Preceded by a Muslim musician and a huge elephant covered in silk and holding a large chain in its mouth to help hold back people and horses from the sultan, crowds of attendants followed him.

In Asia, elements of visible or imagined splendor at the time thus included many elements: great numbers of attendants surrounding royalty; possession and display of numerous exotic animals, some ferocious, plus birds; and extravagant dress and costume. At the royal site, servants arranged to provide lavish offerings of many varieties of food and drink, rich gifts for visitors, attractive entertainments, and splendid hospitality in and around the large, elaborate palaces, residences, architectural monuments, and vast gardens and grounds occupied by the very rich nobility (fig. 84).

Various of these elements figure in the accounts of travelers besides Nikitin (fig. 85). The sober English merchant Anthony Jenkinson, who visited Asia around the middle of the sixteenth century, left a striking portrait of Asiatic splendor and also of Asian influences among Muscovites. He carefully described the contemporary dress—owing much to Asian fabrics and styles—of the well-placed Russe, or noble Russian: "[O]n his head he weareth a white kolpak [< *qalpaq*; Turkish/Persian for a tall conical hat] with buttons of silver, gold, pearl, or stone, and under it a black fox cap turned up very broad." When on horseback, he continued, the Russe "hath a sword of the Turkish fashion and his bow and arrows of the same manner."[12]

Soon after Jenkinson's visit, Giles Fletcher, an English scholar and diplomat, arrived at the Muscovite court of Tsar Fedor. The emissary's account pictured the same style of dress as Jenkinson but added interpretive details regarding its Asian aspects: he names the skullcap [< *taf'ia* < *taqya* Persian/Turkish] worn under "a wide cap of black fox … with a tiara or long bonnet put within it standing up like a Persian or Babylonian hat"; over his shirt, the nobleman "puts a *zipun*

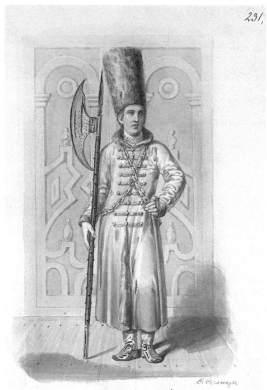

ОДЕЖДА БОЯРСКАЯ XVII СТ: (ИЗЪ ОЛЕАРІЯ.)

ИЗЪ ОЛЕАРІЯ РУССКОЙ ЦАРСКОЙ СТОЛЬНИКЪ.

[85]

COSTUME OF THE SIXTEENTH-CENTURY RUSSE NOBILITY

Fedor Grigor'evich Solntsev
Odezhdy Russkogo gosudarstva
St. Petersburg, ca. 1820–1869

These unique watercolors are drawn from a set of
324 images of historical and ethnic costume of the
Russian Empire, initially prepared at the behest of
Emperor Nicholas I and later in the collection of his
great-grandson, Nicholas II. The ones shown here are
of the type described in sixteenth-century accounts
of the "Russe" nobility in Moscow, such as those by
the Englishmen Anthony Jenkinson and Giles Fletcher,
who briefly served the Russian crown abroad during
the period. In 1558, Jenkinson became the emissary
of Ivan IV to the Bukharan court of 'Abdullah Khan II,
the most formidable ruler of the Uzbek Shaybanids.
Later, the Russian ruler also converted Fletcher into
his own ambassador to England's Queen Elizabeth I.

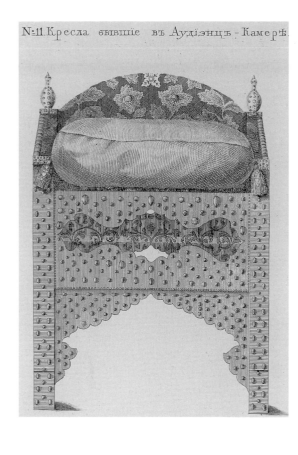

№ 11. Кресла бывшіе въ Аудіэнцъ - Камеръ.

Obstoiatel'noe opisanie … koronovaniia … Imperatritsy Elisavety Petrovny
St. Petersburg, 1744

The renowned Safavid ruler, Shah 'Abbas I of Persia, gave the costly throne pictured here to Tsar Boris Godunov around 1596. Artisans in Persia had encased the base and legs of the throne with figured gold sheets encrusted with turquoise, tourmalines, and pearls, and they bejeweled the finials on the corners of the throne. For a while, this colorful royal seat, with cushion added, stood in Russia's royal audience chamber. Curators continue to display it in the Kremlin Armory. This engraving appears in a volume specially prepared for the coronation of the Russian Empress Elizabeth, which took place on April 25, 1742.

[< *zabun* Arabic], a light garment of silk made down to the knees"; then he dons a *kaftan* [< *khaftun* Persian]; over all this, he wears a collarless garment fabricated from camel's hair or other fine cloth; the nobleman's "buskins … are made of a Persian leather [Moroccan goatskin of high quality tanned with sumac] called *saffian* [< *saf'ian* Russian < *säkhtiyän* Persian], embroidered with pearl."[13] Nikitin had shown a century earlier in his Russian diary that Asian costume impressed him as well.

Russians particularly admired and imitated the extravagant luxury of the Safavids in Persia. Compared with the roughness of life in the towns and villages of agrarian Russia, the larger cities of adjoining West Asia, especially Isfahan/Esfahan, could not help but amaze (fig. 87).[14] Under Shah 'Abbas I, "the Great" (r. 1587–1628), the city of Isfahan impressed not just Russia but the world with its beautiful mosques, gardens, palaces, decorative architecture, and its 600,000 inhabitants. At the time, the city surpassed any settled place in Russia, or in many other countries. Shah 'Abbas I contributed directly to Muscovy's awe when he sent rich presents to the tsar.

One gift—sometimes known as "The Throne of Tsar Boris Godunov" and still preserved in the State Armory of the Moscow Kremlin—came to Moscow in the late sixteenth century when Tsar Boris and Shah 'Abbas I entered into political negotiations. Jewelers and artificers had designed the lavishly adorned gift with innumerable closely placed turquoise, tourmaline, and black and white pearls imbedded over the plating of gold, itself embellished with floral ornamentation, to cover the entire wooden frame. The back of the seat was upholstered with colorful fabric elegantly figured with flowers and leaves. Precious stones of various hues also decorate the short finials at the front of the armrests and at the upper back corners of the throne (fig. 86).[15] Persia in that period exerted such a cultural impact upon Russian nobility that nobles affected Persian styles and built and decorated their residences in imitation of Isfahan's models (fig. 88). "The Muscovite court … was strongly influenced by Safavid style … particularly in … clothing,

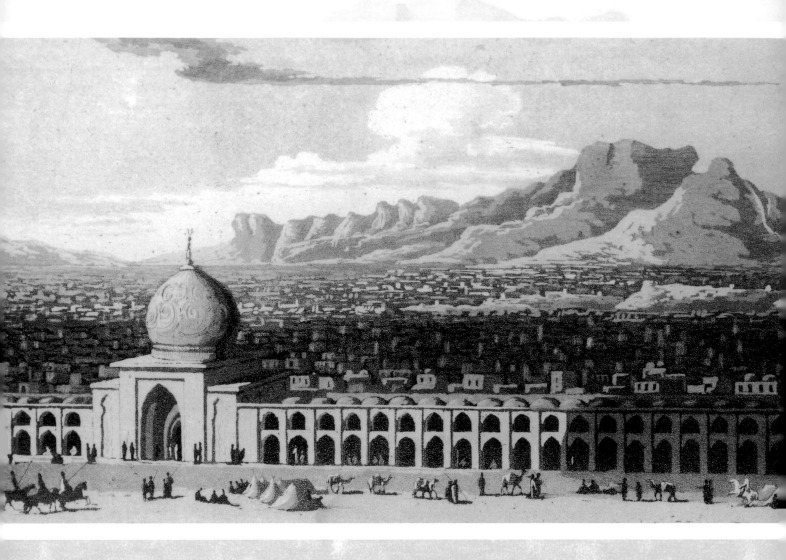

[87]

The Arc of Islamic Glory

James Justinian Morier
*A Journey Through Persia, Armenia, and Asia Minor, to
Constantinople, in the Years 1808 and 1809*
Philadelphia, 1816

This frontispiece etching shows the renowned
Lutfullah Mosque in the foreground, with the large
city of Isfahan, Persia, and the mountains beyond.
Symbolizing the huge stretch of Islam reaching across
Russia's southern horizon, this specimen of monumen-
tal architecture also helped to spread the grandeur
and fame of the Persian emperors far beyond their
realm, to Russia and Europe.

interior decoration ..., tapestries and rugs, the design of furniture and utensils ..., cavalry gear, sabers, saddles, and equestrian accoutrements. This vogue continued [from the late sixteenth] well into the seventeenth century."[16]

In the eyes of Russians, however, Persia, although physically close and accessible to Muscovy, lacked the allure of the distant Indian bazaars and architectural wonders. Nikitin, for instance, refers to the sultan's palace in Bidar as "very wonderful, everything in it ... carved or gilded, and, even to the smallest stone ..., cut and ornamented with gold most wonderfully."[17] The allure of India became especially strong during the period of the Mughals, who were known for gorgeous excess.

Zahiriddin Muhammad Babur (r. Central Asia, including Qabul, intermittently 1494–1525; Delhi 1526–1530), born into a noble Timurid family in Central Asia, founded the Mughal dynasty immediately after the Battle of Panipat in 1526 and the taking of Delhi and the future site of Agra. Accompanied by architects, administrators, armies, and librarians, Babur introduced the splendid arts of elegant capitals; as he frequently records in his memoirs, he admired, designed, and ordered the landscaping of beautiful royal gardens in a number of different locations.[18] Babur and his dynasty, therefore, earned credit for generating specimens of the elegance and opulence characterizing West Asia that would dazzle Russian sensibilities throughout much of the sixteenth and seventeenth centuries (fig. 89). In 1566 the Mughal ruler, Akbar I, "the Great" (r. 1556–1605)— a contemporary of Ivan IV and his successors—established Agra, which soon became his capital and eventually the site of Akbar's great fort, constructed of red sandstone, and the impressive Imperial Mosque situated within it. Although Akbar could neither read nor write, Agra and Delhi distinguished themselves as centers of learning and the arts, and Europeans frequented his courts.

During the same era, the Ottomans, too, showed off their might visibly in great monuments and other structures. Süleyman I, "the Magnificent" (r. 1520–1566), likewise a contemporary of Ivan IV of Muscovy, enlarged the Ottoman Empire to its widest reaches (fig. 90). His engineers erected the walls, still standing, around the old city of Jerusalem. His chief architect, Sinan, in 1557 completed in Istanbul the great Süleymaniye Mosque complex, likewise still actively in use (fig. 91). These and other structures gave sure signs of the huge wealth and strength then commanded by the Ottomans.

Ottoman Turkey anchored the westernmost segment of the Islamic empires, which reached from one end of West Asia to the other. That great Arc of Islam, rising in the east from the Uyghur region in northwest China, passed through the populous Muslim sections of India. It continued westward via the realm of Persia. Then the arc stretched on across the Middle East, reaching as far north as the Balkans and westward to the Atlantic coast of North Africa. With the persistent early migrations from the east, not only had Asia moved near and into Russia's heartland, so to speak, but Islam, officially adopted by the Golden Horde in the fourteenth century, closely gripped the southeastern area neighboring Russia as well. That perspective inevitably put Russians in contact with Muslims, in addition to some others. However, Russia's diplomatic activity only sporadically reached out to Islamic potentates in West Asia; nonetheless, Russia's diplomatic protocol closely copied that of the Tatars.[19] It was only much later that Russian foreign relations took on the forms of stable embassies and regular posting of diplomats abroad. Even so, when less engaged elsewhere, the Russian court gave attention to forwarding contacts with West Asia, almost always aiming for Hindustan.

Tsar Aleksei, promptly after his investiture, took action to establish direct contact with the Mughal ruler of India. The tsar had a number of motives, but one particularly engrossed him. His contemporary, Mughal Emperor Shah Jahan (r. 1628–1658), had already gained world fame as

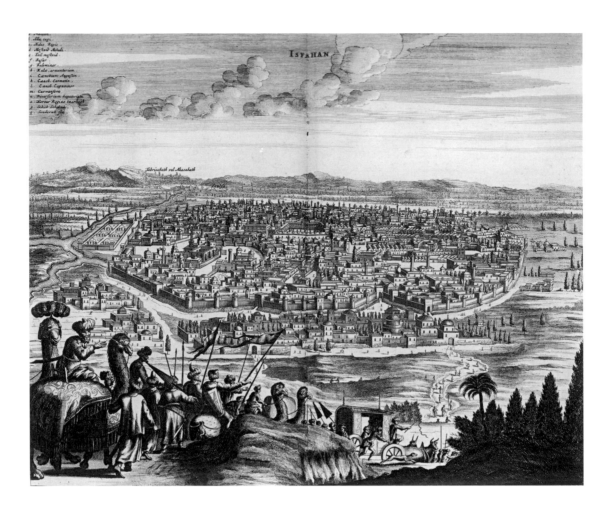

[88, *above*]
ISFAHAN

John Ogilby
*Asia, the first part. Being an accurate description of Persia,
and … the vast empire of the Great Mogol*
London, 1673

In this scene, the walled city of Isfahan, Persia, is
approached by a procession of camels, horses, oxen,
riders, and pedestrians. In the distance appear its
numerous gardens, mosques, minarets, and palaces.

[89, *opposite*]
THE BOOK OF KINGS

Firdawsi
Shahnamah
Shiraz?, 1614 (miniatures after 1825)

This miniature, illustrating the famed "Shahnamah"
by the tenth-century poet Firdawsi, shows the leg-
endary figures Kay Khusraw, his mother Farangis,
and the paladin Giv crossing the Oxus River (Amu
Darya) in Central Asia. A painter copied this picture
no earlier than 1825 from an original rendered previ-
ously. Someone fraudulently placed the imitation in
a genuine early text that had been copied in 1614
for the Persian Shah 'Abbas I, a patron of the arts.
The manuscript also offers a treasury of genuine
Shirazi calligraphy.

a builder of great architectural monuments, especially the Taj Mahal at Agra and the Red Fort in Delhi. Evidently, some word, and perhaps even sketches, of these and other grand Mughal structures had reached Moscow and stimulated lively curiosity. Aleksei's official letter to his emissaries ordered them to collect information about the religions of the Mughal rulers and about their buildings:

And how, under Shah Jahan, according to religious faith, are prayer places constructed and with what, stone or wood, and the city where the Shah himself is, of what magnitude and with stone or wood ...? And how are the houses of those close to Shah Jahan and any ranking people built ...; thus, observe any building and of those that cannot be observed, really find out everything about them.[20]

These Russian emissaries, like a number of others preceding and following them, failed to bring back the desired information. Despite further efforts, Tsar Aleksei was frustrated in all his diplomatic attempts to draw Mughal India and its splendid arts, culture, and economy closer to Russia.

In Muscovy's continuing efforts to establish links with the powers of West Asia, intermediaries played an important role. Though isolated from the great Muslim empires by deserts, mountain chains, and thousands of kilometers, late medieval Russian rulers in Moscow, and their successors in St. Petersburg, listened carefully to merchant-traders and emissaries going to and coming from those territories. Rudimentary maps became accessible to the Muscovite court as early as the sixteenth and seventeenth centuries.[21] Whole eastern societies and khanates—Armenians, Azerbaijanians, Caucasians, Georgians, Kalmyks, Nogais, and Tatars—lived between Russia and the foreign empires of Central Asia, India, Persia, and Turkey, and, sometimes grudgingly, acted as intermediaries between Russia and West Asia. Persia at times likewise obliged Russia by acting as an intermediary with Hindustan. In other periods, the intermediaries could form obstacles to such contacts.

To reach as far as the outer circle of foreign lands in West Asia that attracted the interest of Russia's rulers for specific purposes, the tsars had long depended upon the assistance of individ-

[90, *opposite, above*]
THE GREAT SIEGE OF VIENNA

Engraving of the Ottoman Siege of Vienna
N.p., after 1683

From their capital in Istanbul, the Ottoman sultans made massive and repeated efforts to extend their empire and the religion of Islam. Twice they pushed all the way to the gates of Vienna (in 1529 and 1683). This engraving by an anonymous German depicts the almost successful second attempt.

[91, *opposite, below*]
SÜLEYMAN THE MAGNIFICENT

Prospero Bonarelli
Il Solimano
Florence, 1620

Süleyman the Magnificent, the great Ottoman Turkish emperor, a contemporary of Russia's Ivan IV, "the Terrible," caused many splendid structures to rise in his realm, including the grand Süleymaniye complex in Istanbul, completed by the architect Sinan in 1557. Süleyman impressed Russia's court as well as the people of Europe. The drama *Il Solimano* well reflects Süleyman's renown outside the vast Ottoman Empire. This fanciful scene depicts the end of the third act of the tragedy, with Solimano/Süleyman downstage center.

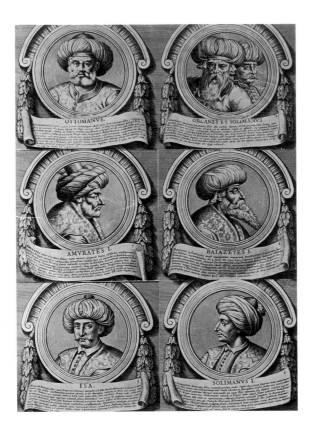

[92]

THE OTTOMAN SULTANS

Julius Mandosius
Ottomanorum principum effigies ab Ottomano ad regnantem Mustapham II
Rome, 1698

These portraits by Julius Mandosius, engraved by Nicolas Dorigny, attest to a time when Europe was fascinated by the sultans of the Ottoman Empire.

ual foreigners to carry out some missions effectively. A renowned instance of this strategy of employing single go-betweens occurred during the reign of Ivan IV. A London merchant firm sent one of its agents, Anthony Jenkinson, mentioned above, via Russia to the Caspian Sea and the state of Bukhara. While in Muscovy conducting his company's business, Jenkinson received a summons from the tsar to a personal audience, and this led to his performing important diplomatic functions for the Russian government. Among other things, in 1559 he brought to the Russian court several ambassadors from the Central Asian states. With them came two dozen Russian slaves; they had been previously held in captivity in Bukhara, Khiva, and elsewhere in the region and, after payment of ransom, released to Jenkinson.[22]

Another competent foreign emissary, the Italian Florio Beneveni, served Peter I during a prolonged mission to Persia and Central Asia. Before that, Beneveni aided Russian diplomacy in Ottoman Istanbul, where, because of his association with Russian officials, he also suffered imprisonment for a year and a half, along with the Russian ambassador, Petr Tolstoi. Later, in Persia, Bukhara, and Khiva, Beneveni compiled valuable information and somehow sent many memorandums via messengers out of these dangerous kingdoms to the Russian capital. He kept his detailed records in Italian in order to protect his intelligence from interception by Russian slaves held in Asia.[23]

Beneveni came on the scene at a propitious moment. Russia's rather passive stance in respect to the lands immediately south and east of it had begun to shift, and in the eighteenth century, weak leaders succeeded the powerful rulers who had formerly dominated West Asia. This change afforded new opportunities for Peter I, "the Great," who, more than most of his predecessors, looked aggressively southward toward West Asia from the seat of Russia's government. The usual vague but tantalizing reports of gold, silver, rubies, and lapis lazuli in Central Asia focused

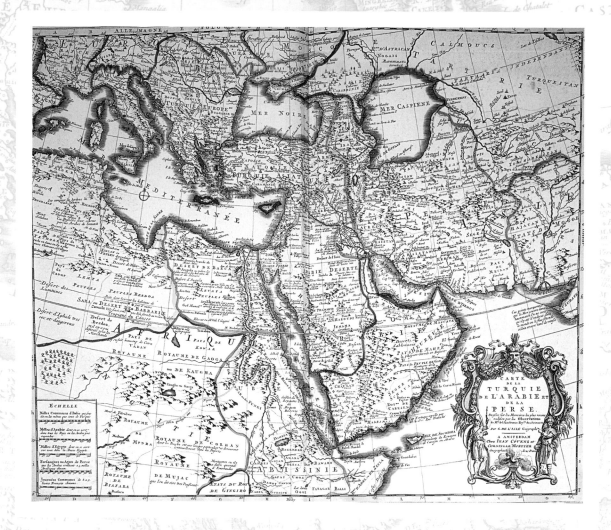

[93]

RIVERS OF GOLD

Guillaume de L'Isle

"Carte de la Turquie, de l'Arabie et de la Perse"

In: *Atlas nouveau*

Amsterdam, 1733

The Caspian Sea figured prominently in Russian calculations about expanding trade, extending influence abroad, and finding gold and other wealth in West Asia. Just east of the Caspian, the Aral Sea and rivers flowing into it from the southeast drew Russian attention. Tales about the supposed abundance of gold lying in the beds of Central Asian rivers such as the Amu Darya and Zarafshon notably captured the imagination of Peter the Great.

دخى اول رضده

سابع اقلیمده

هندایجون هرنه

نقدراکمرایسه ها

شهوت نفسید

حکما بویده آنی ب

کرم اولو رآبی ز

اعتدال اوزره ه

او سببه لبری ه

چشم و ابروی ک

رخم و چهده ا

his attention on that area's natural resources (fig. 93). His forces invaded the Central Asian Khanate of Khiva in a quest for gold supposedly lying abundantly in the beds of the Amu Darya River. But Central Asia had formidable natural defenses: endless arid deserts, intense heat and cold, a region inured to perpetual combat in that environment, and old societies skilled in traditional military strategies and ambushes. In 1717, Peter suffered a catastrophic defeat at the hands of the Khivans and turned to Beneveni about the possibilities for extracting gold in Central Asia. The emissary provided many details for locating the gold deposits that so obsessed his master. He found that up and down the Amu Darya the sands held flakes of gold dust and forwarded samples with the report. He discovered that the Amu Darya did not originate, as hoped, in a gold-bearing source, but the sands of a tributary, the Kuram, bore some gold flakes and did spring from such a source in the Samarkand Mountains. However, no one could prospect for gold and silver in the mountains, for guards posted by the region's rulers prevented it. Local inhabitants found their own curious way to search for gold in the streams: "When they shear their sheep, they put the wool pelts in the water, and cover them with dirt and sand. Then they pull them out on the bank, and as the pelts dry, they shake out of them the purest gold."[24]

Peter I may have received this enticing report. At any rate, the emperor planned a military invasion, which was disguised as a friendly, large-scale embassy across Central Asia into India. He also launched attacks against Ottoman strongholds and invaded Persian outposts in the Caucasus. None of these combative approaches earned lasting rewards for Russia during his lifetime, but they gave momentum to a thrust that eventually would bring tsarist troops to the borders of the former powers of West Asia.

During the reign of Catherine II, "the Great," Russia emerged triumphant in the two Turkish Wars of 1768–1774 and 1787–1792. Even in victory over Ottoman Turkey, Russian royalty seemed possessed with an aesthetic need to emulate the conquered Asians' tastes. After Russian sailors defeated the Ottoman fleet at Chesme Bay on the Aegean Sea in 1770, the empress felt compelled to commemorate it by constructing Chesme Palace, completed in 1777, a structure "whose pseudo-gothic style of the exterior ... symbolized the exoticism of Turkish architecture." Earlier, in 1773, she had given in to this urge by commissioning the building of "a ruin," fashionable in the period, that related to what Russia saw as "the colorful and 'barbaric' culture of the Ottoman Empire." In 1775, Catherine made an extravagant investment in putting up a temporary field model that imitated a supposedly Crimean scene, complete with a body of water and miniature ships. Built on Khodinka Field in Moscow and directed by architect Vasilii Bazhenov, it celebrated the conclusion of the First Turkish War. In the words of a historian of architecture: "[Workers] contoured a large, open space filled with pavilions and theaters whose eclectic styles represented the exotic varieties of architecture in the Ottoman Empire."[25]

These displays mirrored official attitudes regarding the Asian empires and indoctrinated the public as well. Well-grounded information remained scarce, and the court still nourished narrow views regarding the realities of West Asia. In the palace of

[94]
PORTRAIT OF A RUSSIAN YOUTH

Fazil Tahir Omerzade
Khubannamah
Istanbul, copied 1797–1798

The Ottomans called Russia "Mosko," long after the small principality of Muscovy had become the Russian Empire, the immense neighbor to the north and east of the Ottomans. This portrait of a young Russian by Fazil Tahir Omerzade is in a convolute of curiosities produced in Istanbul in 1797–1798.

Catherine II, the diaries of the tutor to Tsarevich Paul record how the tutor and his young charge often heard discussions, usually pejorative, of West Asians and their lands. For instance, in the diary entry for September 23, 1764, the notes speak of exchanges between Grigorii Orlov and Nikolai Panin when they recalled the "outrage and violence" created as Turkish and Persian missions passed through Russia during the reign of Empress Anna.[26]

In the literary arts, some renowned Russian authors prolonged the Russian tendency to find mystery and allure in the Crimea and Caucasus. One prominent *littérateur*, Gavriil Derzhavin, sounded the tones of a poet laureate in works such as a panegyric celebrating the Russian capture of Derbent on the Caspian Sea; he wrote of an approaching caravan: "Elephants, loaded with riches / Sheathed in carpets from India!"[27] In that phrase, the poet projected the happy expectation of Russian officials that dominance of the Caspian Sea would open the way for beneficial interaction with the rulers of Hindustan. The reality disappointed them.

By the eighteenth century, Russia's familiarity with West Asia had bred contempt and taken on larger meaning. Peter I had made a step in that direction when he decisively categorized neighboring eastern peoples, including Caucasians and Tatars, as unequal to Russia but continued to address most West Asians, excluding those in Central Asia, as equals. As the limits of the tsarist realm drew closer and the empire involved itself in more dealings with West Asians, Russian officials, as well as heads of government, repeatedly abandoned diplomatic language and expressed contempt toward the people of those more distant Asian regions. This change occurred as the potence of the West Asian dynasties declined. The court in St. Petersburg gained greater confidence in its power and an accompanying rise in self-esteem fed by the tsar's faith in Russian superiority. That attitude rested on a notion that enlightened rule characterized Russia's government, in contrast to the policies followed by West Asian empires.[28]

Contempt for the West Asian empires led to disturbing excesses among tsarist officials. A russianized general, Pavel Tsitsianov, the hand-picked governor-general of Georgia, harbored the aim in his regime of disparaging West Asians. Descended from Georgian nobles who had languished under the harsh controls of Persian domination, he used his position to denigrate everything Persian. Under the rule of Emperor Alexander I, the general saw himself extending European civilization into a scene of "Asian depravity." His correspondence repeatedly used expressions such as "Persian scum" and "Asian treachery." While Tsitsianov strove to equate "Persian" and "Asian" with barbarism, cunning, immorality, and faithlessness, his superiors did not seem to find this open hostility mistaken or reprehensible.[29]

Russian expressions of contempt seemed not to be targeted at India. In fact, the interest of seventeenth- and eighteenth-century tsars in establishing good relations with Agra and Delhi continued into the early nineteenth century, and the activities of an eccentric Russian traveler to India helped draw the attention of Emperor Alexander in that direction once more. Gerasim Lebedev, a cellist, had left England for India in 1785 and spent two years in Madras presenting musical concerts and learning the languages of the country. Moving on to Calcutta, Lebedev continued his work with languages and translated two English-language comedies, *The Disguise* and *Love Is the Best Doctor*, into Bengali. His choice of plays said something pertinent about his view of the aesthetic taste of the Indian public: "Indians prefer mimicry and Drollery to plain, grave solid Sense, however purely expressed." The characters in these plays included thieves, watchmen, lawyers, petty clerks, and court officials, all engaged in "daily plunder and other Diabolical outrages," according to Lebedev.[30]

After an extended residence in Calcutta, where he had built a theater and staged dramas in Bengali, Lebedev returned home to Russia via England in 1801. En route, he faced many finan-

cial difficulties and, upon arriving in St. Petersburg, wrote a long letter addressed to Alexander; he explained his personal troubles, requesting approval to publish the works on Bengali and Sanskrit that he had prepared in India.[31] Lebedev's estimate for type fonts, printing, purchasing paper, and binding his books came to 15,522 rubles, a large sum of money in those times.[32] Three months later, Lebedev wrote the emperor again, this time requesting appointment to the diplomatic service and again raising the matter of the publication of his works about Asia. Alexander then appointed Lebedev a professor of eastern languages and a member of the Academy of Sciences, with pay of 1,800 rubles annually.[33] A year later, Alexander appointed Lebedev to serve also in the Asian department of the foreign ministry, specifically because of his knowledge of East Indian languages.[34] Alexander's receptiveness to Lebedev verified increased imperial concern with the Indian subcontinent and with systematic interpretation of Asian realities.

Russia's creative artists and writers into the early 1820s continued to visualize the wonderful, imaginary Asia of old. Ambivalent, they noticed the reality of the widespread decline, during their own era, among the Islamic states. Nonetheless, some authors showed a reluctance to adopt the attitudes of contempt that often projected from the throne in St. Petersburg. In 1822, Aleksandr Pushkin, the leading poet in Russia, published *Prisoner of the Caucasus*, one of whose verses reads: "So the muse, gentle friend of a dream / flew to the ends of Asia / And plucked wild flowers of the Caucasus as a crown for herself." Two years later, another poem, *Bakhchisarai Fountain*, contained the distich: "How charming the dark beauties / Of the nights of the sumptuous East!"[35] Each of these long poems conveys a degree of fascination with the aura of the east, though the poet also shades these expressions in them with his subtle sense of irony toward his themes. Some later Russian authors felt less sure about the enigmas of neighboring Asia.[36]

Reality did eventually temper Russian daydreams about a rich, gorgeous Asia. In the mid-1830s, for the time being, disillusion selectively overcame fantasy in St. Petersburg. Pushkin would conclude from personal observation in Erzurum ("Arzrum"), a provincial Turkish capital at the edge of the Ottoman Empire: "I do not know an expression more senseless than the words 'Asiatic splendor.' " It would make more sense, he thought, to speak of "Asiatic squallor, Asiatic beastliness." Even so, his travelogue a little further on records a contradiction. Upon hearing the clear voice of a veiled young woman standing at the entrance of the women's quarters of the Turkish pasha in Erzurum, the poet felt impelled to write: "Here you have the basis for an Eastern romance."[37]

Notes

1 Karl H. Menges, "People, Languages and Migrations," in *Central Asia, 130 Years of Russian Dominance: A Historical Overview*, 3rd ed. (Durham, N.C.: Duke University Press, 1994), pp. 85–87.

2 The territory of West Asia before 1825 consisted of Hindustan (or India), the northwest part of which later became Pakistan, Ceylon (now Sri Lanka), Afghanistan, the states of Bukhara and Khiva (lands now mainly part of Uzbekistan and Tajikistan), Persia (now called Iran), and Turkey (Türkiye). In this article, the terminology "neighboring Asians" distinguishes the groups adjoining Russia—especially Crimean Tatars, Caucasus groups, Tatars of Kazan, Bashkirs, Nogais, and Kalmyks—from the above-listed people and lands of West Asia.

3 P. M. Shastitko, et al., *Russia and India: Ancient Links Between India and Central Asia* (Calcutta and Moscow: Vostok, 1991), pp. 27–32; Annemarie Schimmel, "Die islamische Kultur," in Albert Schaefer, ed., *Die Kulturen der asiatischen Grossreiche und Russlands* (Stuttgart: W. Kohlhammer, 1963), p. 74.

4 "Put' Afanasiia Nikitina za tri moria (1466–1472 gg.)," folding route map inside back cover of *Khozhenie za tri moria Afanasiia Nikitina, 1466–1472 gg.* (Moscow and Leningrad: "Nauka," 1958). In English translation: "The Travels of Athanasius Nikitin, of Twer: Voyage to India," in R. H. Major, ed., *India in the Fifteenth Century. Being a Collection of Narratives of Voyages to India in the Century Preceding the Portuguese Discovery of the Cape of Good Hope; from Latin, Persian, Russian, and Italian Sources* (London, 1857), no. 22, pp. 5–15. Athanasius Nikitin, p. 9. The author of this article has made some revisions in the English translation on the basis of the revised Russian edition of 1958.

5 Nikitin, "Travels," pp. 10–15.

6 Ibid., p. 15.

7 K. Leont'ev, *Vostok, Rossiia i Slavianstvo: Sbornik statei.* 2 vols. (Moscow, 1885–1886), I: 285; F. M. Dostoevskii, "Dnevnik pisatelia za 1876 g.," *Polnoe sobranie sochinenii*, 6th ed. (St. Petersburg: P. F. Pantelieeva, 1905), 11: 203, 206–207, 276–277.

8 For a discussion of Russian orientalism, see Martin Malia, *Russia Under Western Eyes: From the Bronze Horseman to the Lenin Mausoleum* (Cambridge, Mass.: Belknap Press of Harvard University Press, 2000), pp. 4–7; see especially pp. 437–439, where the author offers a selected bibliography of works devoted to the contentions, forwarded by various authors, that intellectuals should or should not consider Russia as part of the east.

9 Edward A. Allworth, "The Rediscovery of Central Asia: The Region Reflected in Two Collections of The New York Public Library," *Biblion: The Bulletin of The New York Public Library*, 4, no. 2 (Spring 1996): 95–99.

10 Marc Raeff, "Patterns of Russian Imperial Policy Toward the Nationalities," in *Soviet Nationality Problems* (New York: Columbia University Press, 1971), pp. 33–34; Sergei V. Soplenkov, *Doroga v Arzrum: Rossiiskaia obshchestvennaia mysl' o vostoke* (Moscow: "Vostochnaia literatura," 2000), pp. 14–24.

11 Nikitin, "Travels," pp. 23–24.

12 "The Voyage of Anthony Jenkinson," excerpted in *Rude & Barbarous Kingdom: Russia in the Accounts of Sixteenth-century English Voyagers*, ed. Lloyd E. Berry and Robert O. Crummey (Madison: University of Wisconsin Press, 1968), p. 57.

13 Giles Fletcher, "Of the Russe Commonwealth," first published in 1591, excerpted in *Rude & Barbarous Kingdom*, p. 243.

14 Edward Keenan, "Royal Russian Behavior, Style and Self-Image," in *Ethnic Russia in the USSR: The Dilemma of Dominance* (New York: Pergamon Press, 1980), pp. 7, 9–10.

15 "Tron Tsaria Borisa Godunova," V. Pochaev and Iu. Pankov, photographers for the collection issued by Izdatel'stvo "Izobrazitel'noe Iskusstvo" (n.p., 1976).

16 Keenan, "Royal Russian Behavior," p. 9.

17 Nikitin, "Travels," pp. 14–15.

18 *The Baburnama: Memoirs of Babur, Prince and Emperor*, trans. Wheeler M. Thackston (Washington, D.C.: Freer Gallery of Art, Smithsonian Institution; New York: Oxford University Press, 1996), folio 132, pp. 173–174; folios 339–343b, pp. 403–406.

19 *Poslannik Petra I na Vostoke. Posol'stvo Florio Beneveni v Persiiu i Bukharu v 1718–1725 godakh* (Moscow: Vostochnoi Literatury, 1986), p. 149 n. 62.

20 Document no. 29, "1646 g. iiunia 24.—Gramota iz Posol'skogo prikaza N. Syroezhinu i V. Tushkanovu o sbore svedenii ob Indii," *Russko-indiiskie otnosheniia v XVII v. Sbornik dokumentov* (Moscow: Vostochnoi Literatury, 1958), pp. 69–70.

21 Edward Allworth, "The Controversial Status of Soviet Asia," *Soviet Asia, Bibliographies: A Compilation of Social Science and Humanities Sources on the Iranian, Mongolian and Turkic Nationalities* (New York: Praeger, 1975), pp. xx–xxiii.

22 "The Voyage of Master Anthony Jenkinson made from the citie of Mosco in Russia, to the citie of Boghar in Bactria, in the yeere 1558: written by himselfe to the Merchants of London of the Muscovie companie," in E. D. Morgan, ed., *Early Voyages and Travels to Russia and Persia …* (London, 1886), pp. 87–88.

23 *Poslannik Petra I na Vostoke*, pp. 13–15.

24 "Kopiia s tsifirnoi reliatsii poslannika Floriia Beneveni, kotoraia pisana na stolbtsakh po obeim storonam. Iz Bukhar, 10–go marta 1722–go g.," *Poslannik Petra I na Vostoke*, pp. 73, 74–75.

25 William Craft Brumfield, *A History of Russian Architecture* (Cambridge, England: Cambridge University Press, 1993), pp. 266, 269, 578 n. 65.

26 Semen A. Poroshin, *Zapiski, sluzhashchie k istorii Ego Vysochestva, blagovernago Gosudaria Tsesarevicha i Velikago Kniazia Pavla Petrovicha*, 2nd ed. (St. Petersburg, 1881), cited in Soplenkov, *Doroga v Arzrum*, pp. 9, 199.

27 Gavriil R. Derzhavin, "Na pokorenie Derbenta," *Stikhotvoreniia* (Leningrad: Sovetskii Pisatel', 1957), pp. 238–239; also quoted in Muriel Atkin, *Russia and Iran, 1780–1828* (Minneapolis: University of Minnesota Press, 1980), p. 32.

28 Atkin, *Russia and Iran*, p. 64.

29 Ibid., pp. 74–75, 101.

30 Document no. 225, "1797 g. ne ranee fevralia.— Zapiska G. S. Lebedeva o ego zhizni i deiatel'nosti v Indii," in *Russko-indiiskie otnosheniia v XVIII v. Sbornik dokumentov* (Moscow: "Nauka," 1965), pp. 432–433. The text of this letter appears in the document in the original English, followed by a Russian translation.

31 Document no. 253, "1801 g. oktiabria 24.—Proshenie G. S. Lebedeva imperatoru Aleksandru I s opisaniem ego stranstvii po Evrope, Afrike i Indii i s pros'boi izdat' na kazennyi schet ego trudy ob indiiskikh iazykakh," in *Russko-indiiskie otnosheniia v XVIII v. Sbornik dokumentov*, pp. 492–495.

32 Document no. 258, "1801 g. dekabria 2.—Smeta, sostavlennaia G. S. Lebedevym na tipografskie raskhody po pechataniiu ego trudov," in *Russko-indiiskie otnosheniia v XVIII v. Sbornik dokumentov*, pp. 498–499.

33 Document no. 264, "1802 g. ranee ianvaria 29.— Imennoi ukaz imperatora Aleksandra I Glavnomu pochtovomu pravleniiu o naznachenii G. S. Lebedevu Professorskogo zhalovaniia iz pochtovykh dokhodov," in *Russko-indiiskie otnosheniia v XVIII v. Sbornik dokumentov*, p. 506.

34 Document no. 267, "1802 g. fevralia 4.—Imennoi ukaz imperatora Aleksandra I Kollegii inostrannykh diel ob opredelenii G. S. Lebedeva na sluzhbu v Aziatskii departament Kollegii s chinom kollezhskago asessora," in *Russko-indiiskie otnosheniia v XVIII v. Sbornik dokumentov*, pp. 507–508.

35 Aleksandr Pushkin, *Poemy, 1821–1824*, ed. Boris Tomashevskii and K. Khalabaev (Moscow-Leningrad: Gosudarstvennoe Isdatel'stvo, 1923), pp. 43, 75. Printed according to the publication *Poemy i povesti Aleksandra Pushkina* (St. Petersburg, 1835).

36 See especially *Circassian Boy* (1833) and *Hero of Our Time* (1840) by Mikhail Lermontov, who suffered banishment to the Caucasus in 1837 for composing a controversial ode to Pushkin on his death. Curiosity and energy carried young Leo Tolstoy actively into the Crimean War as well as Russia's conflicts in the Caucasus. These experiences have affected various writings by him, including *The Cossacks* (1863) and *Hadji Murad* (1896–1904).

37 Aleksandr Pushkin, "Puteshestvie v Arzrum," *Sovremennik*, no. 1 (1836): 75, 81.

Afterword

Collecting Slavica at The New York Public Library

by Edward Kasinec and Robert H. Davis, Jr.

Readers may wonder how the manuscripts, books, and works on paper reproduced in this volume—and representing only a small selection from among thousands of items—were acquired by The New York Public Library. This essay attempts to address this question by tracing the development of the Library's Slavic and East European collections, along the way suggesting the fundamental importance of the resources assembled by generations of librarians and administrators.[1]

During the late 1830s, the German-born merchant John Jacob Astor, America's richest citizen, determined to leave a lasting benefaction to the people of his adopted city and country. Ultimately, he bequeathed the startling sum of $400,000 for the purpose of establishing a privately funded public library that would be "universally free to foreigners as well as citizens."[2] This money and its future accumulation of interest were for bricks and mortar but, most especially, for books, with the aim of establishing "a well digested, systematic library."[3] The goal, however, was not to create a "popular" public library, but rather one that could support advanced research on a wide variety of humanistic, scientific, and practical topics based on materials gathered from around the world.[4] The energetic Joseph Green Cogswell, appointed the Astor Library's first superintendent when it opened in 1848, was the ideal choice for the job as he brought a lifetime of experience and international contacts to his position. Cogswell had served as the librarian of Harvard College, his alma mater, and spent some four years abroad, traveling throughout Europe, the Mediterranean, and India. He studied at Göttingen at a time when it had the greatest university library in the world. In many ways, the library he sought to build reflected what he had encountered in Europe. His successors continued to promote Cogswell's vision. Contrasting the characteristics of the Astor with those of the Library of Congress, public libraries, and academic libraries, one superintendent, Robbins Little, in 1880 wrote:

But Astor Library records make it clear that few readers were interested in Russia or the Slavic countries generally. In all of 1868, only two books from the combined holdings of Russian, Hungarian, and Polish literature circulated; in the same year there were requests for 5,094 volumes of British literature. Books on the history of Russia, Hungary, and Poland fared better, with 224 volumes circulated—versus 3,172 on American history.[6] Nevertheless, from the beginning the Astor Library collected titles on Russian and Slavic philology, science, history, cartography, ethnology, literature, mythology, and religion. These materials were largely limited to retrospective and current Rossica, that is, works in either Latin or western European languages printed about, or in, Russia. Cogswell wrote that while more than half the books in the Astor Library were in English, "in collecting books … the proper question is, what is the merit of the work, and not in what language it was written." Nevertheless, there were precious few books in Slavic vernacular languages in the Astor, the oldest being Captain Gavriil Sarychev's Russian-language account of an expedition to Siberia and Alaska in the late eighteenth century (fig. 60, page 101).

Cogswell, in his compilation *Alphabetical Index to the Astor Library, or Catalogue, with Short Titles, of the Books Collected and of the Proposed Accessions … Jan. 1851*, identified as desiderata a number of Rossica titles, in a diverse array of fields: the publications of the Russian Academy of Sciences (in Latin), extending back to 1726; numerous western European histories of Russia (such as Nicolas-Gabriel LeClerc's); travel accounts (such as Adam Olearius's; fig. 11, page 18); and publications depicting Russian cities and attractions. Folio plate books depicting the flora, fauna, and native peoples of the Russian Empire, the Americas, and the northern and southern Pacific, and documenting discoveries by Russian-sponsored expeditions of the late eighteenth and early nineteenth centuries were purchased by the Astor Library; selections from many of these are included in this volume. Such heavily illustrated antiquarian volumes were usually produced in small quantities and priced well beyond the means of most American libraries. The Astor Library intended to make such rarities available to American researchers. In addition, Russian treatises in Latin and other western European languages on subjects such as navigation, calculus, and electricity were frequently acquired by the Astor.

The second institution that was to form part of the future New York Public Library, the Lenox Library, was incorporated in 1870, during the lifetime of its principal benefactor. The son of a successful New York merchant, James Lenox was educated at Columbia and Princeton and retired from his family's business at the age of forty to indulge his passion for collecting books, manuscripts, paintings, and *objets d'art*. Characterized by at least one bookseller as "original and peculiar," Lenox and the narrowly focused, idiosyncratic research library he established complemented, and to a very limited degree duplicated, materials in the Astor Library.[7] Whereas the Astor sought to become a diversified collection serving many areas of knowledge, Mr. Lenox collected what caught his fancy, with little thought to breadth or comprehensiveness. Travel accounts represented a principal collecting interest, and, among his purchases, Lenox acquired early foreign travel accounts of Muscovy, including those of Giles Fletcher (fig. 10, page 16), Sigmund von Herberstein (fig. 7, page 13), and Jacob Ulfeldt (fig. 9, page 16). The Lenox Library contributed most significantly to the Slavic and East European collections of the future New York Public Library in the area of western Slavic vernacular Bibles and liturgical works. Lenox secured a number of examples of early Polish, Czech, and Croatian book culture with the acquisition of

imprints from the fifteenth to the seventeenth centuries. In the aggregate, however, the Lenox Library's contribution to the Slavic and East European holdings was minor.

In 1895, the separate boards of the Astor and Lenox libraries and the Tilden Trust (which administered the substantial bequest to the city left by former Governor of New York Samuel J. Tilden for a free public library) agreed to merge their collections and endowments for the public good. The new institution, incorporated as The New York Public Library, was a hybrid, with a world-class, noncirculating research collection, on the one hand, and a more "popular" circulating library and neighborhood branch network on the other.[8] The result was, and still is, a unique private/public partnership serving advanced researchers and general readers alike.

In 1899, a separate Russian section was created in the noncirculating reference department, and the distinguished writer and Jewish social activist Herman Rosenthal became chief of what soon became known as the Slavonic Division—today's Slavic and Baltic Division.[9] Rosenthal immediately expanded the scope of the collection through the acquisition of volumes in the vernacular languages of the Russian Empire, in part as a response to the needs of a diverse and rapidly expanding Slavic-speaking community in greater New York. Backed by Dr. John Shaw Billings, the visionary first director of The New York Public Library, Rosenthal embarked on a campaign to establish formal exchange relations with many of the learned societies in Eastern Europe and to call upon the resources of the increasing number of Slavic-language booksellers in New York as well as to attract gifts from individuals interested in the region. For example, in 1901 the division acquired almost 500 volumes from the private library of Eugene Schuyler, a nineteenth-century

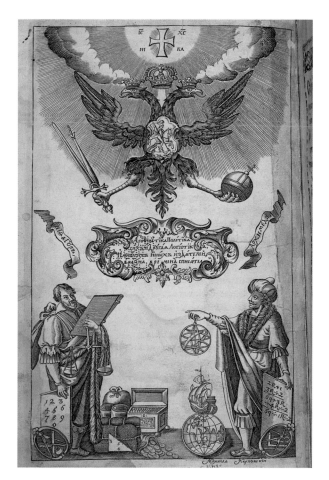

[95]

THE FIRST ARITHMETICAL TEXTBOOK PRINTED IN RUSSIA

Leontii Filippovich Magnitskii
Arifmetika
Moscow, 1703

One of the most famous books of Peter the Great's time, *Arithmetic* was prepared by a professor of mathematics at Moscow's Graeco-Roman-Slavonic Academy, which opened in 1687. It remained a standard text for many years. This frontispiece, engraved by Mikhail Karnovskii, is rich in allegorical imagery, with the imperial eagle soaring above figures symbolizing Pythagoras and Archimedes. In recognition of western and Islamic achievements in mathematics and geometry, the work includes Latin, Greek, and Arabic typefaces.

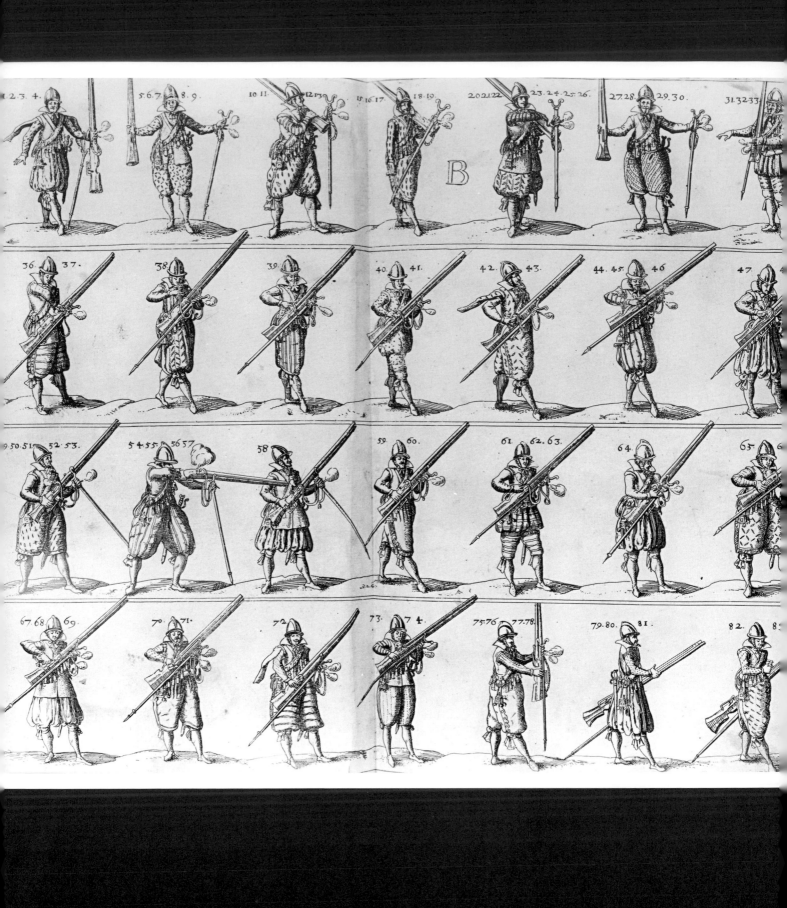

diplomat and the first American-born biographer of Peter the Great. One of Leo Tolstoy's American translators, Isabel Florence Hapgood, donated contemporary Russian illustrated books and children's literature as well as manuscript letters from noted Russian authors, while, at the same time, mediating the donation of 500 volumes of theological materials from Platon (Rozhdestvenskii), the former archbishop of the Aleutian Islands and North America.

Rosenthal's ambition was to collect both current and retrospective materials. The Library's annual report for 1911 mentions the acquisition of Ivan Reikhel's eighteenth-century description of Japan and another edition of Herberstein's description of Muscovy. The report for the following year notes the acquisition of the first edition of Mikhail Lomonosov's *Grammar*, and in 1913 of Petrine and Church Slavonic texts, for instance Leontii Magnitskii's *Arithmetic* (fig. 95) and two seventeenth-century Ruthenian Slavonic imprints. Building upon its fine Rossica holdings, the Library acquired such important and unusual items as Angelo Nonni's depiction of Tsarevich Paul I's visit to Venice in January 1782 (fig. 97) and an account of a reception in London for Emperor Alexander I in June 1814 (fig. 98).

In 1911, the Library moved from the cramped confines of the Astor Library into a grand new Beaux-Arts building at the "crossroads of the world," Fifth Avenue and 42nd Street. The Library now had the venue and vastly enhanced visibility to further expand its collecting reach. By the time of Rosenthal's death in 1917, the underpinnings for the creation of a broadly based and expansive research collection for the study of the Slavic, Baltic, East European, and Eurasian areas were solidly in place.

World War I and the revolutions and civil war in Russia disrupted—and in many cases, completely swept away—the network for acquisitions developed by Rosenthal. The challenge facing the Library's administrators and curators was to renew a flow of current materials, while continuing to build the holdings of older materials in a climate of governmental and popular discomfort with the new regime in Russia.[10]

[96]

A Manual of Arms for Pikemen and Infantry

Johann Jacobi von Wallhausen
Uchenie i khitrost' ratnago stroeniia pekhotnykh liudei
Moscow, 1647

This Russian translation of a German-language work on military training and tactics was the first secular book printed in the Muscovite Tsardom. Well before Peter, Muscovy perceived the need to modernize Russia's military according to western European models. The text is illustrated with copper engravings by Theodor de Bry, reproduced from the German edition; the title page was drawn by the Kremlin master Grigorii Blagushin, and engraved in Holland.

The principal figures involved in collection development during this period were Harry Miller Lydenberg, director of the Library's research division, and the chief of the Slavonic Division, Avrahm Yarmolinsky, who attained this position in early 1918. They achieved their objective in part by capitalizing on contacts such as Liubov Khavkina, a pioneer in library education in Russia, who had visited the Library in 1914 and again in 1926. She was enormously helpful before, during, and after an extended book-buying trip to Russia and eastern Europe by Yarmolinsky and Lydenberg in 1923/24.[11] Their journey was the first by American librarians expressly for the purpose of buying books, and it allowed them to establish personal contacts with representatives of the Soviet Union, the book world, academia, and many of the leading lights of Russian literary and artistic culture. Khavkina provided advice on securing a visa, and urged them to emphasize the Library's past

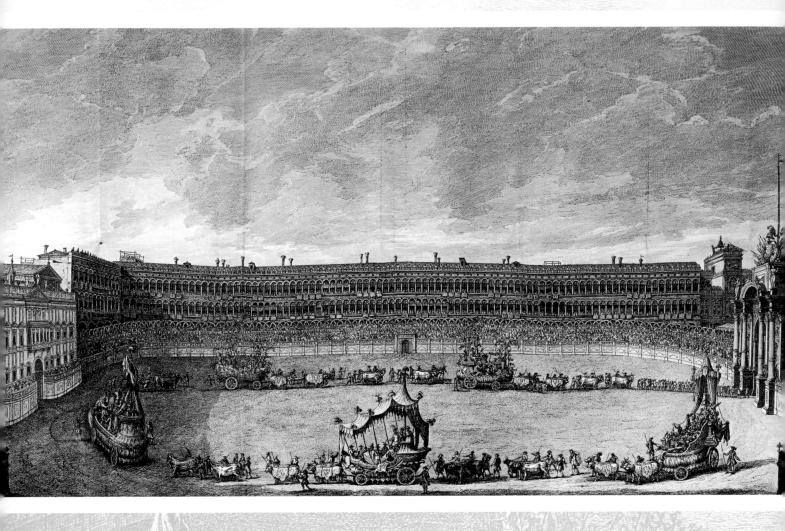

[97, *above*]

A PAGEANT IN VENICE'S PIAZZA SAN MARCO

Angelo Nonni
Descrizione degli spettacoli, e feste datesi in Venezia
Venice, 1782

In an attempt to allay her Prussophile son's anger over Russia's broken alliance with Prussia, Catherine the Great sent the Grand Duke Paul and his wife to tour France and the lands controlled by Russia's new ally, the Habsburgs. In January of 1782, the visitors—traveling anonymously as the "Count and Countess of the North"—were honored with a grand spectacle in Venice's Piazza San Marco, complete with festival carriages. Although the journey failed to heal the rift between Paul and Catherine, it provided the tsarevich an opportunity to acquire many fine and decorative art objects for his palaces.

[98, *opposite*]

EMPEROR ALEXANDER I VISITS LONDON

An Account of the Visit of His Royal Highness, the Prince Regent, and Their Imperial and Royal Majesties the Emperor of All the Russias and the King of Prussia, to the Corporation of London, in June 1814
London, [1815]

Alexander I's defeat of Napoleon and triumphant entry into Paris at the head of a multinational army was one of the high water marks of Russian influence on the Continent. In June of 1814, Emperor Alexander I, the acclaimed "Savior of Europe," visited England along with the Prussian king, Frederick William III. The reigning English monarch, George III, had been declared mentally incompetent in 1811, so Alexander was feted by the Prince Regent (the future George IV) at London's historic Guild Hall.

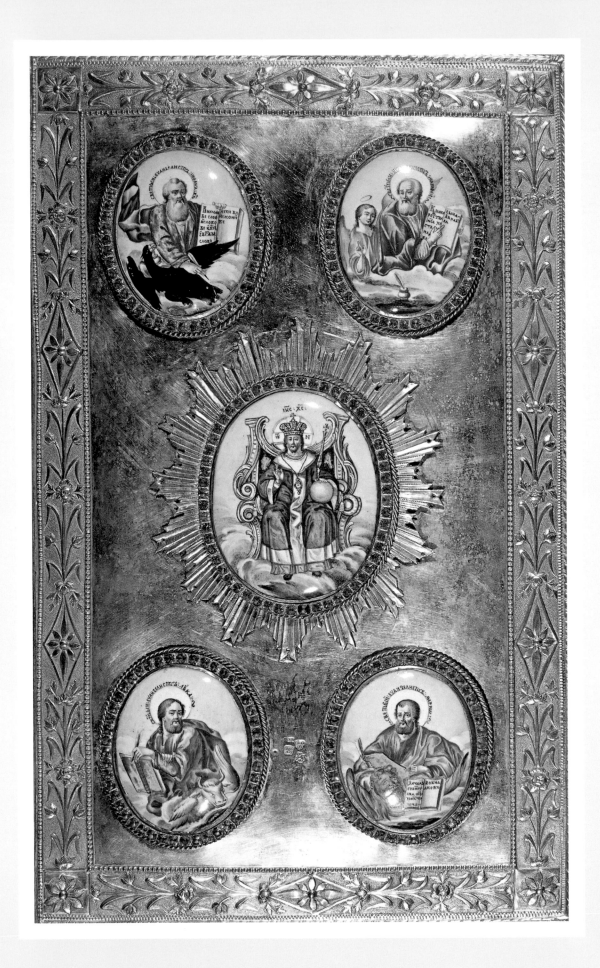

and present collecting of social democratic literature and the long-standing patronage of Russian revolutionaries (such as Lev Deich and David Shub) in New York exile.[12] On September 30, 1923, the national executive secretary treasurer of the Workers Party of America, Charles Emil Ruthenberg, wrote the Soviet ambassador in Berlin:

[T]heir admission to Soviet Russia will be of service both in making available in the United States the literature of Soviet Russia and in reestablishing contact with American publications and the libraries of this country, and therefore [the Workers Party] recommends that permission to enter Soviet Russia be granted to them.[13]

Permission for their journey was finally granted, with the direct participation of Anatolii Lunacharskii, the minister of education. Lunacharskii wrote enthusiastically, in English, that "I should be happy if the arrival of your authorized representatives could settle a constant bond with America and give her a true representation of … the government of Workers & Rustics [i.e., peasants]…."[14]

Lydenberg and Yarmolinsky were abroad for six months, stopping in Riga, Moscow, St. Petersburg, and—in the case of Lydenberg—Kiev and Warsaw. In addition to knitting anew a skein of commercial, institutional, and individual connections, they acquired upwards of 10,000 volumes, *à bon prix*. Lydenberg wrote to the Library's director, Edwin Hatfield Anderson, that "Moscow offered such a wealth of opportunities we soon saw that we could spend the whole $5,000 I had allotted to Russia and never leave the town."[15] Yarmolinsky's annual report for 1925 takes special notice of several eighteenth-century titles acquired during the previous year, among them the forty-two-volume collection of *Russian Theater* (fig. 36, page 59).

This visit in 1923/24 to the Soviet Union was Yarmolinsky's last. Yet for the next three decades he built upon his many institutional and personal contacts to enhance both current and, significantly, older collections. His efforts received the full support and encouragement of the Library's administration, characterized by Anderson's terse cablegram to Lydenberg in Europe: "Don't hurry home if the book market is tempting."[16]

During the interwar period, the Library's holdings expanded tremendously, due in large measure to the efforts of Israel Perlstein, America's premier dealer of Russian antiquarian books, manuscripts, and works on paper.[17] It is not hyperbole to say that this volume and the exhibition it complements would have been impossible without the energetic efforts of Perlstein, and the enlightened administration of Lydenberg and Anderson. Beginning in 1925, Perlstein made the first of many regular buying trips to Russia, obtaining

[99]

AN ORNAMENTAL EIGHTEENTH-CENTURY BINDING

Evangelie naprestol'noe
Moscow, 1791; 1795 (binding)

In the aftermath of the Bolshevik Revolution, countless objects like this finely bound Altar Gospels—held aloft during the liturgy, and therefore intended to be seen by the entire congregation—were stripped of their jewels and metal ornamentation, which were melted down into ingots. This is a rare survivor of the turbulent revolutionary period, the gift of New York antiquarian book dealer Gabriel Wells. The hall-marked gilded silver binding includes enamel medallions (*drobnitsy*) of Christ, dressed in the saccos and mitre of a bishop, and the evangelists, surrounded by green stones. In general, the "Latinized" rendering of the binding suggests the influence of western European (in this case, French) craftsmen in eighteenth-century Russia.

in quantity often remarkable materials confiscated by the Soviet government from institutional, church, and private (including imperial palace) libraries.[18] Along with the sale of fine and decorative artworks, the Soviet authorities sought to market antiquarian books on the European and American markets for hard currency. During his 1924 trip to Russia, Lydenberg noted that "we went over so much of the mass as they have arranged, but it will be five years and more before the whole mass is in condition for examination."[19] In addition to the sale of book materials in large lots to dealers, the Soviet trade organization, International Books, formed an antiquarian book section that issued printed and mimeographed catalogues of individual rarities, organized by subject and priced in dollars.[20]

Evidence of the riches offered to Perlstein and other western booksellers is found today in the collections of The New York Public Library and of his other major institutional customers, the Library of Congress and Harvard University. Between 1927 and 1934 Perlstein sold more than 9,000 volumes to the Library of Congress, from various sources.

The New York Public Library made numerous significant purchases directly from Perlstein during the decade from 1925 until 1935. The largest of these, in 1931, consisted of 2,200 volumes from the library of Grand Duke Vladimir, brother of Emperor Alexander III and uncle to the last emperor, Nicholas II. After the Soviets ceased exporting antiquarian books, the Library continued to buy from Perlstein's extensive stock. Even items acquired at auction often turned out to have been sold by Perlstein to private buyers years before. Further documentation as to the wealth and diversity of book materials on the market is provided by booksellers' accounts. In his memoirs, the British bookseller Percy Muir wrote that during a visit to Russia in 1928 he was shown

a Russian Imperial Library containing many books that had belonged to Catherine the Great, and also a fantastic collection formed by her son Paul and his second wife Maria Feodorovna. It was housed in the

[100]

A TRANSLATION OF A FRENCH TREATISE ON FORTIFYING CITIES

François Blondel
Novaia manera, ukrepleniiu gorodov
Moscow, 1711

The modernization of Russia's military under Peter I required the translation of the latest foreign treatises on all aspects of warfare. This copper-engraved frontispiece, for a text originally published in France, depicts Pallas Athena, surrounded by the accoutrements of careful military planning and modern warfare—calipers, a T square, maps, etc.—with a classical encampment in the background.

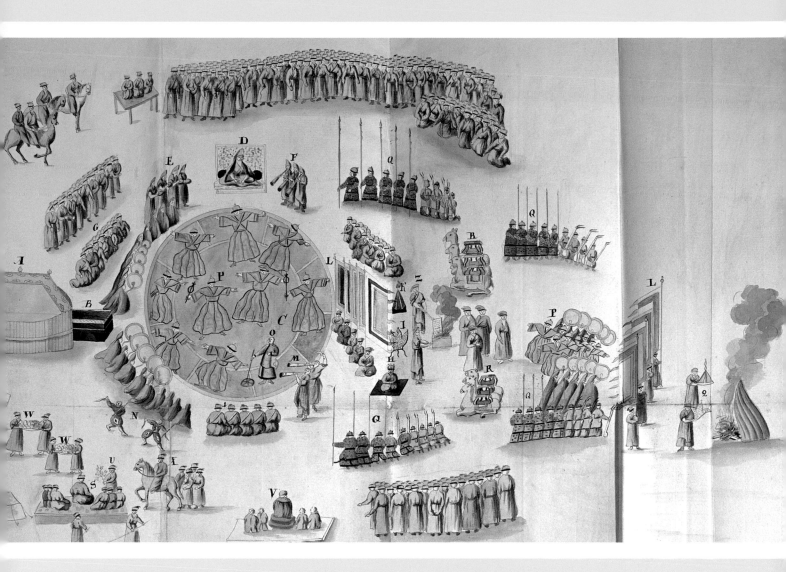

AN ENCAMPMENT AND CEREMONY OF NATIVE
SIBERIAN PEOPLES

Georg Wilhelm de Hennin
*Opisanie sibirskikh kazennykh i partikuliarnykh gornykh
zavodov*
N.p., 1735

This remarkable and little-known manuscript is one
of only five extant copies. Written and illustrated by
a Dutchman who served the Russian state for more
than half a century, the manuscript describes Ural
and Siberian natural resources mining operations,
as well as the customs and rituals of indigenous
peoples, such as the Kalmyks, likely depicted here.

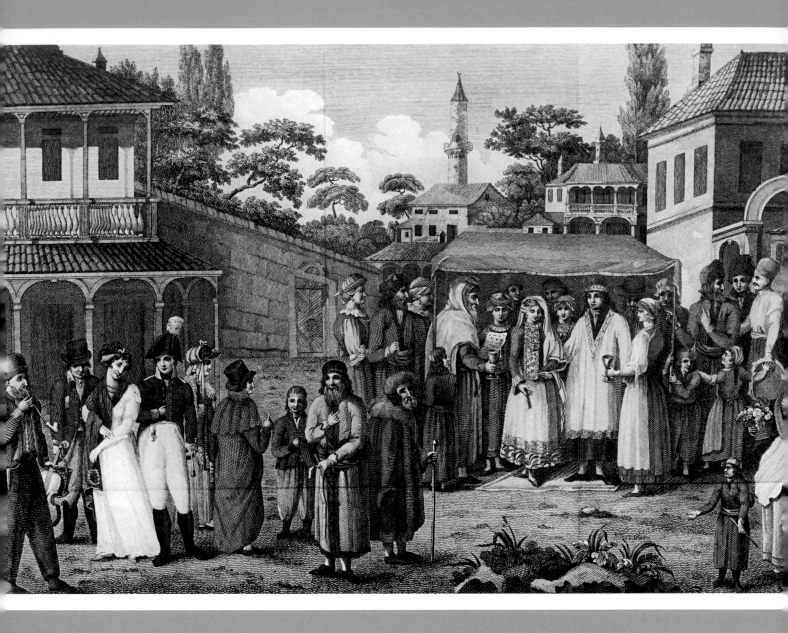

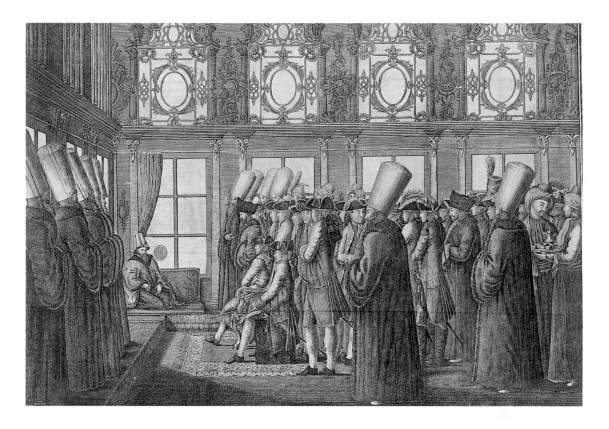

[102, *opposite*]

A JEWISH WEDDING IN CRIMEA

Pavel Ivanovich Sumarokov
Dosugi krymskago sud'i, ili Vtoroe puteshestvie v Tavridu
St. Petersburg, 1803–1805

Sumarokov left a rich textual and pictorial account of his travels through the Crimea. This illustration suggests the natural beauty of the region, and its polycultural character. Here he depicts a Jewish wedding, attended by Russians in European dress, with the minarets of a mosque in the distance. The Library's copy was originally in the Great Catherine Palace Library at Tsarskoe Selo near St. Petersburg.

[103, *above*]

A RUSSIAN EMBASSY TO THE SUBLIME PORTE

Rossiiskoe posol'stvo v Konstantinopol', 1776 goda
St. Petersburg, 1777

Competing expansionist intentions and the mutual subjugation of co-religionists in conquered lands ensured the fragility of Russian-Ottoman relations during the fifteenth through the nineteenth centuries. In 1776, Catherine dispatched Count Nikolai Repnin to lead an embassy to Istanbul for ratification of a peace treaty. Depicted here is the delegation's formal reception in the throne room of the Topkapi Palace by the sultan, surrounded by his elite guards, the Janissaries, who were themselves drawn from the ranks of Christian converts.

[104]
A ROYAL REWARD

Peter I, Emperor of Russia, and Ivan V, Tsar of Russia
Royal Property Charter granted to the State Clerk
Iuda Davydov Protasov
Moscow, 1686

It was common for the tsars of Muscovy and the
emperors of Russia to reward servitors with grants
of land, serfs, or titles. This particular charter is
for service in a war against the Turkish Sultan and
the Crimean Khan, suggesting the enmity between
Russia on the one hand and, on the other, its
southern neighbor, the Ottoman Empire, and the
indigenous Turkic population of the Crimea. This
charter (above, left) was issued by the young co-
tsars Peter and Ivan during the regency of Sophia,
which lasted from 1682 until 1689, when Peter
and his supporters forcibly deposed her. Ivan died in
1696. The document is protected by a seventeenth-
century Persian textile (above, right).

palace of Pavlovsk ... and some of the books were at Gatchina.... The riches of the Pavlovsk collection were incredible not less in their variety than in their splendour.... Every French illustrated book of the 18th century of any importance was there.... One cupboard was full of illuminated manuscripts....[21]

The more than four decades of Yarmolinsky's and Lydenberg's tenure at The New York Public Library were marked by unparalleled growth in the collections of both Slavic, and particularly Russian, vernacular, and Rossica collections. The items at the core of both the exhibition *Russia Engages the World, 1453–1825* and this volume were acquired during this fruitful period.

Church Slavonic collections grew significantly during the 1930s and 1940s. In 1931 alone the Library purchased seven printed Cyrillic books of the sixteenth and seventeenth centuries, including Johann Jacobi von Wallhausen's engraved military manual (fig. 96). A Cyrillic paleotype produced by Szwajpolt Fiol in the late fifteenth century was purchased in 1935; a fourteenth-century Novgorodian manuscript was acquired in 1936; and in 1945 the Library purchased the only known copy of the 1630 *Horologion*. The largest cluster of illuminated manuscripts was purchased in 1948/49 from an anonymous Connecticut dealer. Other important acquisitions during this period include a sumptuously hand-colored and illuminated printed book, the 1606 *Gospels* by Anisim Radishevskii, quite possibly a personal copy of Patriarch (later Saint) Germogen, who was a central figure during Russia's Time of Troubles in the early seventeenth century (fig. 3, page 7). The Library also owns an altar *Gospels* commissioned by Catherine II; the volume is a rare survivor of the Soviet campaign to strip such bindings of their finery, melt down the metal, and sell their enamels and precious and semi-precious stones for hard cash (fig. 99).[22]

From the Petrine era, the Library's Spencer Collection acquired extensively illustrated books in the civil script as examples of fine printing, such as François Blondel's work on fortification (fig. 100). As early as 1925, the Library had obtained the account of the sea voyages of Grigorii Shelekhov (fig. 59, page 100) and the Russian edition of the coronation album of Empress Elizabeth (fig. 43, page 76). Acquisitions from 1934 suggest the heterogeneity of collection development interests: the first edition of the *Bakhchisarai Fountain* by Aleksandr Pushkin, published in 1824; the journal of Iurii Lisianskii's circumnavigation of the globe; and a copy of one of the five surviving manuscripts of Georg Wilhelm de Hennin's illustrated description of mining techniques in Ekaterinburg (fig. 101).[23]

Other important items acquired from International Books and Perlstein during the 1930s included the Library's extraordinary suite of Mikhail Makhaev's engravings of St. Petersburg and its environs (fig. 14, page 28 and fig. 23, page 27), Antonio Spada's *Ephemerides* of Russia, and several imprints from the reign of Peter the Great. These years saw the acquisition of some of the most important items represented in this volume, among them the Cornelius Cruys cartographic folio of the Don River (fig. 13, page 26); Pavel Sumarokov's depictions of the Crimea (fig. 102); an account of the Russian mission to the Ottoman sultan (fig. 103); the Makhaev engravings of the Sheremetev estate of Kuskovo (fig. 45, page 78); and an eighteenth-century copper folk engraving of Aesop (fig. 105). Concluding his annual report for 1945, Yarmolinsky noted, with his usual understatement, that "all things considered, the growth of the resources of the Division during the period under review may be regarded not without satisfaction."

Beginning in the early 1920s, the Library began to acquire yet another category of publication that has substantially enhanced the beauty of the exhibition and its website, namely, triple-oversize or elephant folio plate books—principally Russian—produced during the nineteenth and early twentieth centuries (fig. 109). A number of such volumes were purchased between 1923 and 1930. The more than 500 volumes of Russian and Rossica folio plate books in the collections of

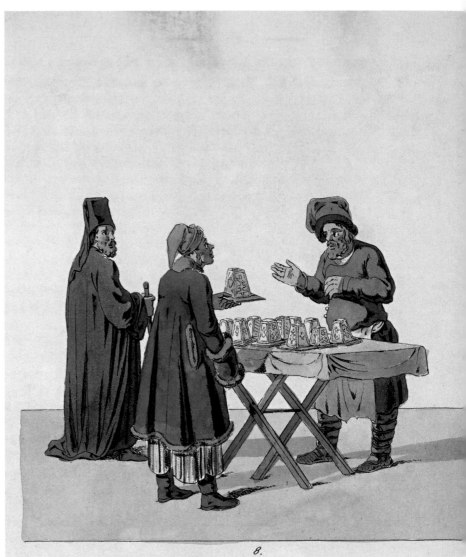

8.

The New York Public Library rival those held in other major depositories in the western world.

Yarmolinsky retired in early 1955; he was succeeded by John Leo Mish, a remarkable polyglot, as comfortable with Asian languages as with Slavic. Widely traveled, Mish was largely responsible for reconnecting the Library with institutions in East Central Europe. By the early 1960s, however, the Library had begun to enter a protracted period of fiscal austerity, culminating with New York City's crisis of the mid-1970s. Public service divisions were compelled to concentrate on current materials only, rather than rarities or examples of the book arts. Mish's successor, the late Estonian-born classicist and philologist Viktor Koressaar, assumed the leadership of the division when the city teetered on the edge of bankruptcy. He wrote in his 1978/79 report that "the policy of considering any title published in Europe before 1975 as an antiquarian item makes the task of filling gaps … very difficult." Only in the mid-1980s, some three decades after Yarmolinsky's retirement, would the division again have the support to make antiquarian purchases and to provide improved care and security for the collections.[24]

Since 1984, under the curatorship of Edward Kasinec, the division has initiated the process of identifying rare Slavica in a number of other curatorial and public service units. In addition, rarities from the stack collections and annex were relocated to secure areas of the Humanities and Social Sciences Library. The division has also been able to raise additional federal and state funding for the physical conservation of materials from the sixteenth to the early nineteenth centuries. The Library is able once again to support antiquarian acquisitions; for instance, the division has recently acquired a Petrine charter (fig. 104), an autograph of Peter the Great, an early travelogue of the Holy Land, early maps of St. Petersburg, colored engravings of Moscow by Francesco Camporesi (fig. 47, page 80), and erotica (fig. 107) and popular prints (fig. 108) from the eighteenth century.

[105, *opposite, left*]
THE FABULIST AESOP

Planudes Maximus
Zhitie ostroumnago Esopa
N.p., ca. 1750

Although western and Classical aesthetics appealed to Russia's elites during the eighteenth century, popular tastes remained broad and sometimes coarse. This fanciful, crudely executed illustration of Aesop is from a rare copper-engraved block book featuring an earlier Russian translation of the *Life of Aesop* (translated literally from the Russian: *The Life of the Clever Aesop*).

[106, *opposite, right*]
A MAN SELLING EASTER CAKES

Johann Gustaf Richter and Christian Gottfried Heinrich Geissler
Sitten, Gebräuche, and Kleidung der Russen aus dem niedern Ständen
Leipzig, 1805

In this drawing by the German artist and engraver Christian Gottfried Heinrich Geissler, a man sells *paskhi*, or Easter cakes. *Paskhi* are made of eggs and curds in special wooden molds and decorated with candied fruit rinds and nuts; these and other foods are blessed in an Eastern Christian church ceremony and then eaten at the end of the long Lenten fast. Geissler, who lived in Russia from 1790 to 1798, made many drawings of St. Petersburg artisans and merchants, a well-known European genre, as well as of the various nationalities that inhabit the Russian Empire.

[107]

IMPERIAL LOVERS BEHIND CLOSED DOORS

Erotic watercolor
Russia, ca. 1790s

This drawing of Catherine the Great and Prince Grigorii Potemkin is from a set of five unique watercolors, each on a single sheet of paper, depicting eighteenth-century Russian emperors and empresses *in flagrante delicto*. Each couple is concealed behind folding "doors" guarded by a soldier in period uniform (left) and, with one exception, the image is accompanied by a bit of bawdy verse in a late eighteenth-century hand. The accuracy of the guard's uniform (particularly its coloration), and of the representations of the royal couples, suggests that these drawings were prepared by someone with knowledge of, and perhaps entrée to, court circles.

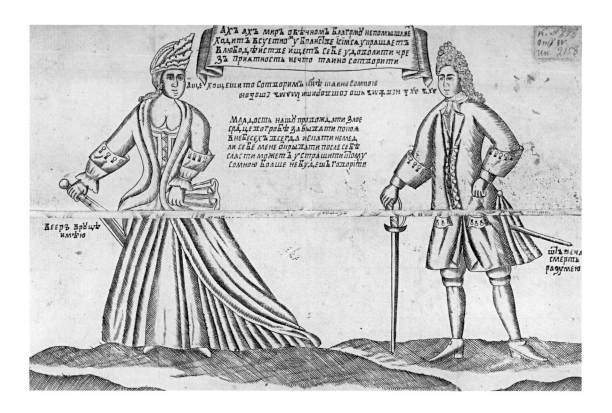

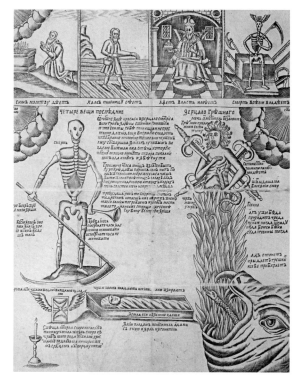

[108]

A MIRROR FOR THE SINNER, ILLUSTRATED

after Jan Tessing

Zertsalo greshnago

Russia, late 18th–early 19th century

This woodblock print, based on an earlier original by the Dutch engraver and printer Jan Tessing (known in Russia as Ivan Andreevich Tessing), suggests the cultural divide between Russia's europeanized elites and the broader society. On one side of the print (above) are figures in luxurious European dress representing Adam and Eve and original sin. On the reverse (right) are images from the life of man, depicting good and evil, death, the brevity of life, and the suffering of the sinner. Printed on a single sheet of cheap paper and folded into a small book, such edificatory graphics were distributed far and wide in the provinces and cities by itinerant peddlers.

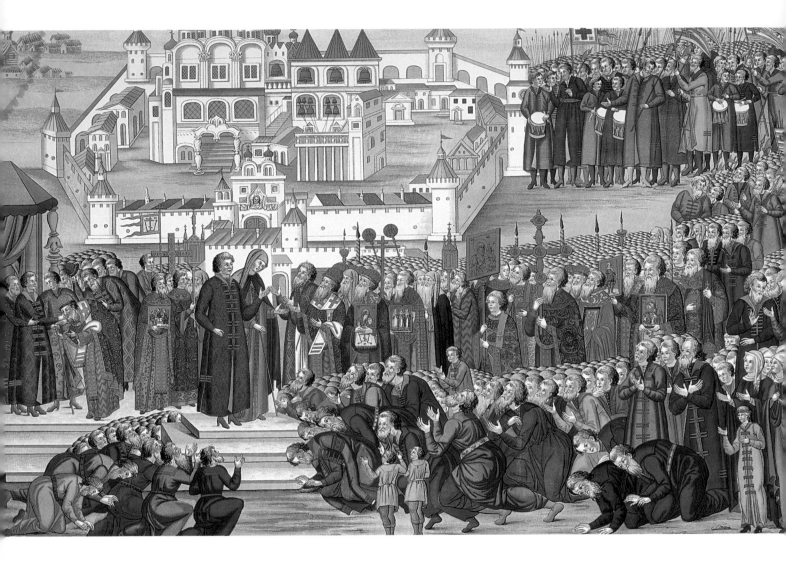

[109]

Tsar Mikhail Romanov and His Father,
the Patriarch, Distribute Alms

Artamon Sergeevich Matveev
Kniga ob izbranii na tsarstvo Velikago Gosudaria, Tsaria i
Velikago kniazia Mikhaila Fedorovicha
Moscow, 1613 [printed 1856]

A number of significant manuscripts of the Muscovite
period emerged from the archives only during the
nineteenth century, and were then published in very
limited facsimile editions. The image reproduced here
is from a facsimile of a contemporary 1613 illustrated
account of the first Romanov coronation, *The Book
Concerning the Election of the Great Sovereign, Tsar
and Grand Prince Mikhail Fedorovich*. At the time of
its production in 1856, this volume was one of the
most expensive ever produced in Russia.

Private donors have responded to these initiatives as well, creating endowed book funds, and donating works on paper that range from a fourteenth-century illuminated liturgical manuscript to a hand-colored eighteenth-century engraving of St. Petersburg. Especially significant was the donation in 1998 of some 4,000 volumes of antiquarian material from the library of Paul M. Fekula, Perlstein's largest private customer.

This afterword has suggested the manner by which the Library came to acquire some of its most spectacular antiquarian pieces. However, it is important to emphasize that the Slavic and East European collections that exist today are not purely treasure collections. Quite the opposite. The Library has steadfastly adhered to Cogswell's vision of a broadly based collection serving the research needs of scholars. The librarians of the Astor Library and of The New York Public Library should be applauded both for the great rarities they secured and for their perseverance in acquiring and processing the millions of ordinary volumes that provide the basis for research. Writing in 1881, a *New York Times* reporter speculated on popular reaction to the materials obtained by the Astor:

If the public were allowed to roam freely among the alcoves and to examine the books, how often would they exclaim: "Oh, what dry things these are! Who ever reads them, and who could have the patience to write them."[25]

And so today, this work among the living, growing corpus of "dry things" allows researchers to gain new insights into mankind's past, present, and future. Certainly, we delight at the historically significant, often magnificent works on paper included in this volume. Yet we should never lose sight of the fundamental importance of that gray, ever-expanding mass of research material that makes their contents, and their story, come to life.

Notes

1 This essay is based on the manuscript and printed annual reports of the Slavic and Baltic Division of The New York Public Library and of the two book collections that served as the basis for the Library's early holdings, the Astor and Lenox libraries. The authors wish to thank Kenneth E. Carpenter, retired from the Harvard University libraries, for his insightful commentary and guidance. Any errors are the responsibility of the authors alone.

2 [Third] Annual Report of the Trustees of the Astor Library for the year 1851, in *Documents of the Assembly of the State of New York* (Albany, 1852), 1: 20, p. 4.

3 Joseph Green Cogswell to George Ticknor, May 27, 1840, as cited in Harry Miller Lydenberg, *History of The New York Public Library Astor, Lenox and Tilden Foundations* (New York: The New York Public Library, 1923), p. 7.

4 It is remarkable that by 1854 the Astor Library was able to prepare *Catalogue of Books … Relating to the Languages and Literatures of Asia, Africa, and the Oceanic Islands* (New York, 1854), containing 370 pages of entries to works of philology and literature, with an average of five per page. Coverage included Arabic, Bengali, Ethiopian, Hebrew, and Sanskrit, as well as Persian, Gypsy (Romany), Tatar, and Chinese. Even works on the Amer-Indian languages and the "languages of Russian America" were included.

5 Annual Report of the Trustees of the Astor Library for the year 1880, in *Documents of the Assembly of the State of New York* (Albany, 1881), 1: 8, p. 9.

6 Annual Report of the Trustees of the Astor Library for the year 1868, in *Documents of the Assembly of the State of New York* (Albany, 1869) 3: 24, p. 7.

7 Henry Stevens, *Recollections of Mr. James Lenox of New York and the Formation of His Library* (London, 1886), as cited in Lydenberg, *History of The New York Public Library*, p. 96.

8 For a history of this period, see Phyllis Dain's *The New York Public Library: A History of Its Founding and Early Years* (New York: The New York Public Library, 1972).

9 See Robert H. Davis, Jr., *Slavic and Baltic Library Resources at The New York Public Library* (New York: The New York Public Library, 1994). For a broader perspective on the development of collections and academic programs in America before the revolutions of 1917, see Marc Raeff's "Russian and Slavic Studies in Europe and America Before the 'Great War,'" *Biblion: The Bulletin of The New York Public Library*, 8, no. 2 (Spring 2000): 81–113.

10 The NYPL Archives contain a number of documents, including police requests for lists of "non-native-born staff," denunciatory letters inveighing against the perceived absence of "anti-Communist" periodicals, and *ad hominem* attacks directed at staff members of the Slavonic Division. See Record Group [hereafter, RG] 6, Director's Office: E. H. Anderson, RO—Employees—Enemy Aliens; and RG 6, Director's Office: E. H. Anderson, Correspondence 1929–33, "Ben-Ber."

11 On this trip, see Robert A. Karlowich, "Stranger in a Far Land," *Bulletin of Research in the Humanities*, 87, no. 2/3 (1986–1987): 182–224, which publishes excerpts from Lydenberg's letters home, and Avrahm Yarmolinsky, "The Slavonic Division: Recent Growth," *Bulletin of The New York Public Library*, 30, no. 2 (February 1926): 71–79. Yarmolinsky was accompanied by his wife, the poet Babette Deutsch (1895–1982). A selection of their correspondence was published as "Something Truly Revolutionary," *Biblion: The Bulletin of The New York Public Library*, 2, no. 1 (Fall 1993): 140–176.

12 Robert A. Karlowich drew heavily upon the Library's holdings of exile and émigré newspapers in his *We Fall and Rise: Russian-language Newspapers in New York City, 1889–1914* (Metuchen, N.J.: Scarecrow Press, 1991).

13 RG 6, Director's Office: E. H. Anderson, Box 10, Correspondence 1915–28, folder H. M. Lydenberg—Trips Abroad—Letters of Introduction.

14 RG 6, Director's Office: E. H. Anderson, Box 10, Correspondence 1915–28.

15 Written in Warsaw on January 6, 1924. RG 6, Director's Office: E. H. Anderson, Box 10, Correspondence 1915–28, folder H. M. Lydenberg—Trips Abroad—Correspondence, Jan.–March 1924.

16 Cablegram, Anderson to Lydenberg, January 3, 1924. RG 6, Director's Office: E. H. Anderson, Box 10, Correspondence 1915–28, folder H. M. Lydenberg—Trips Abroad—Correspondence, Jan.–March 1924.

17 The bindings of many of the books shown in the exhibition are marked in pencil with the name of the source, and the date of acquisition. Israel Perlstein's name is encountered frequently.

18 On the book sales, see Robert H. Davis, Jr., comp., *A Dark Mirror: Romanov and Imperial Palace Library Materials in the Holdings of The New York Public Library: A Checklist and Agenda for Research* (New York: Norman Ross Publishing, 1999).

19 Lydenberg to Anderson, January 6, 1924. Ibid.

20 NYPL holds two catalog series produced by Mezhdunarodnaia Kniga: *Antikvarnyi knizhnyi otdel, Katalog* [*Antiquarian Book Section, Catalog*] (Moscow, 1924–1936, 7 vols., nos. 1–78), and *Russkie knizhnye novosti* [*Russian Book News*] (Moscow, nos. 1–7, June–November 1927), 1(8)–5(12) (January–May 1928), 7(14)–12(19) (July–December 1928), 1(20)–7(26) (January–May 15, 1929), 10(29)–11(30) (July–August 1929), and 3/4(35/36)–11/12(43/44) (March/April–November/December 1930). These catalogs are also available at the Library on microfilm.

21 Percy Muir, "Further Reminiscences," *The Book Collector*, 13 (1964): 48–49.

22 The donor was New York antiquarian book dealer Gabriel Wells (1862–1946). On Monday, May 30, 1938, *The New York Times* carried a nine-paragraph announcement of its donation.

23 The Library's copy of the de Hennin manuscript is the subject of a forthcoming article by Elena Kogan.

24 One positive achievement of this otherwise dire period was an exhibition of the Library's Russian Civil Script books in 1969–1970, and publication of a checklist by Edward Kasinec (at that time a graduate student at Columbia University): "Eighteenth-century Russian Publications in The New York Public Library: A Preliminary Catalogue," *Bulletin of The New York Public Library*, 73, no. 9 (November 1969): 599–614, and its "Part II: The Westernization of Russia," *Bulletin of The New York Public Library*, 75, no. 9 (November 1971): 474–494. The continuation of such checklists has occurred in recent years. See, for example, *Church Slavonic, Glagolitic, and Petrine Civil Script Printed Books in The New York Public Library: A Preliminary Catalog* (Marina del Rey, Calif.: Charles Schlacks, 1996) and T. N. Zhukovskaia's *Izdaniia epokhi Aleksandra I v Niu-Iorskoi publichnoi biblioteke* [Publications from the Epoch of Alexander I in The New York Public Library] (Moscow: Institut politicheskogo i voennogo analiza, 2000).

25 "John Jacob Astor's Gift: Some Account of the Great Library," *The New York Times*, October 30, 1881, p. 6.

Checklist of the Exhibition
Russia Engages the World, 1453–1825

Compiled by Robert H. Davis, Jr.

This checklist for the exhibition *Russia Engages the World, 1453–1825*, on view at The New York Public Library's Humanities and Social Sciences Library, Fifth Avenue and 42nd Street, from October 3, 2003 to January 31, 2004, includes materials relating to Russia from the fifteenth through the late seventeenth centuries (presented in the intimate Sue and Edgar Wachenheim III Gallery) and (in the grand D. Samuel and Jeane H. Gottesman Exhibition Hall) sections devoted to Russia during the eighteenth and the first quarter of the nineteenth centuries (the core of the exhibition) and smaller groupings on world regions and cultures particularly engaged with Russia during this period—Asia, northern and western Europe, and the Ottoman and Safavid empires. The exhibition was curated by Edward Kasinec and Robert H. Davis, Jr., with Cynthia Hyla Whittaker.

Unless otherwise indicated, New York Public Library divisions are located within the Humanities and Social Sciences Library. Please note that none of the old Slavonic manuscripts in the Library's collections have been fully described and cataloged. Items reproduced in this volume are indicated by an asterisk (*).

1. A Distant World
(Marshall Poe, Consultant)

A. HOLY RUS'

Evangelie [The Gospels]. Manuscript. Russia, 15th century. NYPL, SPENCER COLLECTION

Evangelie [The Gospels]. [Moscow], ca. 1564. NYPL, SLAVIC AND BALTIC DIVISION

Apostol [Acts of the Apostles]. Moscow: Ivan Fedorov and Petr Mstislavets, 1564. NYPL, SLAVIC AND BALTIC DIVISION

*Saint John Climacus (ca. 525–600). *Lestnitsa* [The Ladder of Divine Ascent]. Manuscript. Russia, 16th century. NYPL, SPENCER COLLECTION [Fig. 2, p. 7]

**Evangelie* [The Gospels]. Moscow: [A. M. Radishevskii], 1606. NYPL, SPENCER COLLECTION [Fig. 3, p. 7]

*Artamon Sergeevich Matveev (1625–1682). *Kniga ob izbranii na tsarstvo Velikago Gosudaria, Tsaria i Velikago kniazia Mikhaila Fedorovicha* [The Book Concerning the Election to the Tsardom of the Great Sovereign, Tsar and Grand Prince Mikhail Fedorovich]. Moscow, 1613 [printed in a limited edition by the Sinodal'naia Tipografiia only in 1856, from the manuscript originals]. NYPL, SLAVIC AND BALTIC DIVISION [Fig. 109, p. 182]

*Willem Janszoon Blaeu (1571–1638). *Tabula Russiae* [A Map of Russia]. Map. Amsterdam: Hessel Gerritz, 1614. NYPL, SLAVIC AND BALTIC DIVISION [Fig. 5, p. 9]

Chasoslov [Book of Hours]. Moscow: Pechatnyi Dvor, 1630. NYPL, SLAVIC AND BALTIC DIVISION

*Johann Jacobi von Wallhausen (fl. 17th century). *Uchenie i khitrost' ratnago stroeniia pekhotnykh liudei* [The Teaching and Art of the Deployment of Infantry]. Moscow: [Pechatnyi Dvor, 1647]. NYPL, SLAVIC AND BALTIC DIVISION [Fig. 96, p. 166]

Disk from a *Panagiarion* with the Virgin and Child and Three Church Fathers. Ivory. Russia, ca. 1500 or later. THE METROPOLITAN MUSEUM OF ART, THE DEPARTMENT OF MEDIEVAL ART AND THE CLOISTERS, GIFT OF J. PIERPONT MORGAN, 1917 (17.190.129)

Palitsa [Eastern Christian ecclesiastical vestment worn at the hip of a Bishop]. Embroidery, pearls. Russia, 17th century. THE METROPOLITAN MUSEUM OF ART, THE DEPARTMENT OF EUROPEAN SCULPTURE AND DECORATIVE ARTS, PURCHASE, FRIENDS OF EUROPEAN SCULPTURE AND DECORATIVE ARTS GIFTS, 1991 (1991–289)

Plashchanitsa [ceremonial shroud of Christ]. Silk and metallic thread embroidery. Russia, 17th century. THE METROPOLITAN MUSEUM OF ART, THE DEPARTMENT OF EUROPEAN SCULPTURE AND DECORATIVE ARTS, GIFT OF MRS. STEPHAN ROSENAK, 1946 (46.191)

Icon of Our Lady of Vladimir. Egg tempera on panel, with gold, enamel, niello, and jeweled cover (*oklad*). Moscow, the Kremlin Armory Workshop, ca. 1650. A LA VIEILLE RUSSIE

Icon of Saints Boris and Gleb. Egg tempera and gold on panel with jeweled cover (*oklad*). Russia, 17th century. THE METROPOLITAN MUSEUM OF ART, THE DEPARTMENT OF EUROPEAN PAINTINGS, GIFT OF GEORGE D. PRATT, 1933

B. THE FIRST EUROPEAN ACCOUNTS

Ambrogio Contarini (fl. 15th century). *Il Viazo … Ambasciator della Illustrissima Signoria di Venetia al Signor Uxuncassan Re de Persia* [The Journey of … the Ambassador of the Most Illustrious Council of Venice to Lord Uzun Hasan, King of Persia]. Venice, 1543. NYPL, RARE BOOKS DIVISION

*Freiherr Sigmund von Herberstein (1486–1566). *Comentari della Moscovia* [Commentaries on Muscovy]. Venice: Giovanni Battista Pedrezzano, 1550. NYPL, RARE BOOKS DIVISION [Fig. 7, p. 13]

Paul Oderborn (d. 1604). *Ioannis Basilidis … vita* [The Life of Ivan Vasil'evich (i.e., Ivan IV, "the Terrible")]. Wittenberg: Heirs of Johann Crato, 1585. NYPL, RARE BOOKS DIVISION

*Antonio Possevino (1533 or 1534–1611). *Moscovia* [Muscovy]. Antwerp: Christophe Plantin, 1587. NYPL, RARE BOOKS DIVISION [Fig. 6, p. 11]

*Giles Fletcher (1549?–1611). *Of the Russe Common Wealth*. London: Printed by T[homas] D[awson] for Thomas Charde, 1591. NYPL, RARE BOOKS DIVISION [Fig. 10, p. 16]

*William Russell (fl. 1600). *The Reporte of a Bloudie and Terrible Massacre in the Citty of Mosco*. London: Val. Sims, for Samuel Macham, and Mathew Cooke, 1607. NYPL, RARE BOOKS DIVISION [Fig. 8, p. 15]

*Jacob Ulfeldt (d. 1593). *Hodoeporicon Ruthenicum* [A Ruthenian (i.e., Muscovite) Journey]. Frankfurt: M. Becker, imprensis I. T. & I. I. de Bry, 1608. NYPL, RARE BOOKS DIVISION [Fig. 9, p. 16]

Beschryvinghe van der Samoyeden Landt [A Description of the Land of the Samoyeds]. Amsterdam: Hessel Gerritsz, 1612. NYPL, RARE BOOKS DIVISION

Russia seu Moscovia itemque Tartaria [Russia or Muscovy, and the Tatar Territories]. Leiden: Elzevir, 1630. NYPL, SLAVIC AND BALTIC DIVISION

Gerhard Mercator (1512–1594). *Atlas novus* [New Atlas]. Amsterdam: Henricus Hondius & Johannes Janssonius, 1638. NYPL, MAP DIVISION

*Adam Olearius (d. 1671). *Viaggi di Moscovia de gli anni 1633, 1634, 1635, e 1636* [Voyages to Muscovy in the Years 1633, 1634, 1635 and 1636]. Viterbo, 1658. NYPL, SLAVIC AND BALTIC DIVISION [Fig. 11, p. 18]

Pieter Goos (ca. 1616–1675). *De zee-atlas ofte water-wereld* [The Sea Atlas, or, The Water World]. Amsterdam: P. Goos, 1668. NYPL, MAP DIVISION

Pieter Goos (ca. 1616–1675). [*Perevod s"knigi imenuema Vodny mir*] [A Translation of the Book "The Water World"]. Manuscript. N.p., 1667. NYPL, MANUSCRIPTS AND ARCHIVES DIVISION

*Samuel Collins (1619–1670). *The Present State of Russia, in a letter to a friend at London; written by an eminent person residing at the Tzars court at Mosco for the space of nine years*. London: Printed by J. Winter, for D. Newman, 1671. NYPL, RARE BOOKS DIVISION [Fig. 12, p. 18]

John Milton (1608–1674). *A Brief History of Moscovia: and of other less-known countries lying eastward of Russia as far as Cathay. Gather'd from the writings of several eye-witnesses*. London: Printed by M. Flesher, for Brabazon Aylmer, 1682. NYPL, RARE BOOKS DIVISION

"Wire" kopek. Silver. Russia, ca. 1689. THE AMERICAN NUMISMATIC SOCIETY (1914.265.47)

Kovsh [ceremonial drinking cup]. Silver. Russia, Kremlin Armory Workshop, 1693. A LA VIEILLE RUSSIE

2. Asia
(John Ma, Consultant)

A. CHINA

A list of Imperial edicts issued by Emperors Shunzhi (1638–1661) and Kangxi (1654–1722) of China. Manuscript scroll and woven textile. [Beijing], 1642–1689. NYPL, MANUSCRIPTS AND ARCHIVES DIVISION

*Evert Ysbrants Ides (1657–1708/09), also known as Adam Brand. *Three Years Travels from Moscow Over-land to China*. London: W. Freeman et al., 1706. NYPL, GENERAL RESEARCH DIVISION [Fig. 52, pp. 92–93]

Georg Johann Unverzagt (fl. 1719–1725). *Die Gesandschafft Ihro Käyserl. Majest. von Gross-Russland an den sinesischen Käyser* [The Embassy of His Imperial Majesty of Great Russia to the Chinese Emperor]. Lübeck: Johann Christian Schmidt, 1725. NYPL, GENERAL RESEARCH DIVISION

Theophilus Siegfried Bayer (1694–1738). *De horis sinicis* [Concerning Chinese Calendars]. St. Petersburg: Academia Scientiarum, 1735. NYPL, ASIAN AND MIDDLE EASTERN DIVISION

Fuheng (d. 1770). *Huang Qing zhi gong tu* [A Collection of Foreigners (portraits) of Different Nations Who Had Presented Gifts to the Emperors of the Early Qing Dynasty]. [Beijing: Nei fu, Qing, between 1761 and 1805]. NYPL, SPENCER COLLECTION

*William Coxe (1747–1828). *Les nouvelles découvertes des Russes, entre l'Asie et l'Amérique, avec l'histoire de la conquête de la Sibérie & du commerce des Russes & des Chinois* [The New Russian Discoveries Between Asia and America, with the History of the Conquest of Siberia and of Russian and Chinese Commerce]. Paris: Hôtel de Thou, 1781. NYPL, RARE BOOKS DIVISION [Fig. 62, p. 103]

Porcelain jars. China, Kangxi Period (1662–1722). NYPL, HENRY W. AND ALBERT A. BERG COLLECTION OF ENGLISH AND AMERICAN LITERATURE

Porcelain plate decorated in underglaze blue. China, Kangxi Period (1662–1722). THE METROPOLITAN MUSEUM OF ART, THE DEPARTMENT OF ASIAN ART, RODGERS FUND, 1925 (25.64.5)

B. JAPAN

*Ivan Fedorovich Kruzenshtern (1770–1846). *Puteshestvie vokrug sveta v 1803, 4, 5 i 1806 godakh* [Voyage Around the World in 1803, 1804, 1805 & 1806]. St. Petersburg: Morskaia Tipografiia, 1809–1813. NYPL, SLAVIC AND BALTIC DIVISION [Fig. 63, p. 105; Fig. 65, p. 108]

Ivan Fedorovich Kruzenshtern (1770–1846). *Voyage Around the World in the Years 1803, 1804, 1805 & 1806*. London: Printed by C. Roworth for J. Murray, 1813. NYPL, GENERAL RESEARCH DIVISION

Petr Ivanovich Rikord (1776–1855). *Zapiski flota kapitana Rikorda o plavanii ego k Iaponskim beregam v 1812 i 1813 godakh, i o snosheniiakh s Iapontsami* [Notes of Fleet Captain Rikord concerning his sailing to Japan's shores in 1812 and 1813, and about his relations with the Japanese]. St. Petersburg: Morskaia Tipografiia, 1816. NYPL, SLAVIC AND BALTIC DIVISION

Roshia Zokkoku Jinbutsu Zu [Picture Book of People in the Territories of Russia. Sketches of people in Siberia and Kamchatka, made during the later years of the Edo Period]. Edo, 1845. NYPL, SPENCER COLLECTION

3. Peter the Great
(James Cracraft, Consultant)

A. EUROPEAN AND RUSSIAN PUBLICATIONS

*Leontii Filippovich Magnitskii (1669–1739). *Arifmetika* [Arithmetic]. Moscow, 1703. NYPL, SLAVIC AND BALTIC DIVISION [Fig. 95, p. 165]

*Cornelius Cruys (1657–1727). *Nieuw pas-kaart boek* [A New Book of Charts]. Amsterdam: Hendrick Doncker, [1703–1704]. NYPL, MAP DIVISION [Fig. 13, p. 26]

Fedor Polikarpovich Polikarpov-Orlov (ca. 1660–1731). *Leksikon treiazychnyi, sirech' Rechenii slavenskikh, ellino-grecheskiikh i latinskikh sokrovishche* [A Trilingual Dictionary, that is, A Treasury of Slavonic, Greek, and Latin Words]. Moscow: [Pechatnyi Dvor], 1704. NYPL, SLAVIC AND BALTIC DIVISION

Letter signed by Peter the Great, giving safe conduct to the nobles Petr Baranov and Ignat Kutashev to travel to the northern Russian city of Novgorod the Great. Manuscript. [Russia?], 1707. NYPL, SLAVIC AND BALTIC DIVISION

Politikolepnaia Apotheosis dostokhvalnyia khrabrosti vserossiiskago Gerkulesa ... nashego tsaria i velikago kniazia Petra Alekseevich ... Po preslavnoi viktorii ... Na generalnoi batalii ... pod Poltavoiu [A Glorious Apotheosis of the Laudable Bravery of the All-Russian Hercules ... Our Tsar and Grand Prince Peter Alekseevich ... on the Most Glorious Victory ... at the Great Battle ... near Poltava]. [Moscow], 1709. NYPL, SLAVIC AND BALTIC DIVISION

Baron Menno van Coehoorn (1634–1704). *Novoe krepostnoe stroenie na mokrom ili nizkom gorizonte* [The New Fortification on Wet or Low-lying Land]. Moscow: [Pechatnyi Dvor], 1710. NYPL, SLAVIC AND BALTIC DIVISION

*François Blondel (1618–1686). *Novaia manera, ukrepleniiu gorodov* [The New Manner of Fortifying Cities]. Moscow: [Pechatnyi Dvor], 1711. NYPL, SLAVIC AND BALTIC DIVISION [Fig. 100, p. 172]

Quintus Curtius Rufus. *Kniga Kvinta Kurtsia o delakh sodeianykh Aleksandra velikago tsaria Makedonskago* [The Book of Quintus Curtius on the Deeds Achieved by Alexander the Great, King of Macedon]. Moscow: [Pechatnyi Dvor], 1711. NYPL, SLAVIC AND BALTIC DIVISION

*Aleksei Fedorovich Zubov (1682–1751). Etching depicting the Russian naval victory over Sweden at Hangö (Gangut) Head, July 27, 1714. St. Petersburg, 1717. NYPL, SLAVIC AND BALTIC DIVISION [Fig. 20, p. 34]

Count Iakov Vilimovich Brius' (Bruce) (1670–1735). *Kniga leksikon ili Sobranie rechei po Alfavitu s Rossiiskogo na Gollandskii iazyk* [A Lexicon Book (Dictionary), or, Collection of Phrases in Alphabetical Order (translated) from Russian into the Dutch Language]. St. Petersburg, 1717. NYPL, SLAVIC AND BALTIC DIVISION

Baron Petr Pavlovich Shafirov (1669–1739). *Razsuzhdenie kakie zakonnye prichiny ego tsarskoe velichestvo Petr Pervyi ... k nachatiiu voiny protiv Korola Karolia 12 Shvedskogo [v] 1700 godu imel* [A Discourse Concerning the Just Causes Which His Tsarist Majesty Peter the First ... Had for Beginning the War Against the Swedish King Charles XII in the Year 1700]. St. Petersburg, 1717. NYPL, SLAVIC AND BALTIC DIVISION

*Johann Baptist Homann (1663–1724). *Topographische Vorstellung der neuen russischen Haupt-Residenz und See-Stadt St. Petersburg* [Topographic Presentation of the New Russian Royal Residence and Seaport of St. Petersburg]. Map. Nuremberg: Ioh. Baptist Homann, [1718]. NYPL, MAP DIVISION [Fig. 16, p. 30]

Kniga ustav morskoi [The Book of Naval Statutes]. St. Petersburg: Sanktpiterburgskaia Tipografiia, [1720]. NYPL, SLAVIC AND BALTIC DIVISION

General'nyi reglament ili ustav [The General Regulation or Statute]. [Moscow: Sinodal'naia Tipografiia, 1725]. NYPL, SLAVIC AND BALTIC DIVISION

Pravda voli monarshei vo opredelenii naslednika derzhavy svoei [The Right of the Monarch's Will in Designating the Successor to His Realm]. Moscow: Moskovskaia Tipografiia, 1726. NYPL, SLAVIC AND BALTIC DIVISION

*After Cosmas Indicopleustes (fl. 6th century). *Kniga glagolemaia Kosmografiia* [The Book Termed the Cosmography]. Russia, first third of the 18th century. NYPL, MAP DIVISION [Fig. 1, p. 4]

*Guillaume de L'Isle (1675–1726), engraved by Matthaeus Seutter (1678–1756). *Mappae Imperii Moscovitici* [Maps of the Muscovite Empire]. Augsburg?, 18th century. NYPL, SLAVIC AND BALTIC DIVISION [Fig. 4, p. 9]

Medal commemorating Peter the Great's visit to France. By Jean Du Vivier (1687–1761). Bronze. France, 1717. THE AMERICAN NUMISMATIC SOCIETY (1951.109.1)

B. ST. PETERSBURG ACADEMY OF SCIENCES

Commentarii Academiae Scientiarum Imperialis Petropolitanae ... ad annum 1726 [Commentaries of the Imperial Academy of Sciences at St. Petersburg ... for the Year 1726]. St. Petersburg: Imperatorskaia Akademiia Nauk, 1728. NYPL, SLAVIC AND BALTIC DIVISION [Fig. 25, p. 40]

Theophilus Siegfried Bayer (1694–1738). *Historia regni Graecorum bactriani* [A History of the Kingdom of the Bactrian Greeks]. St. Petersburg: Academia Scientiarum, 1738. NYPL, SLAVIC AND BALTIC DIVISION

Leonhard Euler (1707–1783). *Tentamen novae theoriae musicae* [An Investigation of New Music Theory]. St. Petersburg: Academia Scientiarum, 1739. NYPL, SCIENCE, INDUSTRY AND BUSINESS LIBRARY

*Gerhard Friedrich Müller (1705–1783). *Opisanie Sibirskago tsarstva* [A Description of the Siberian Kingdom]. St. Petersburg: Imperatorskaia Akademiia Nauk, 1750. NYPL, SLAVIC AND BALTIC DIVISION [Fig. 53, p. 94]

C. POPULAR CULTURE

*Planudes Maximus ("Aesop") (ca. 1260–ca. 1310). *Zhitie ostroumnogo Esopa* [The Life of the Clever Aesop]. N.p., ca. 1750. NYPL, SPENCER COLLECTION [Fig. 105, p. 178]

Kniga imenuemaia Briusovskoi Kalendar [The Book Known as the Brius' (Bruce) Calendar]. [Moscow, ca. 1783]. NYPL, SLAVIC AND BALTIC DIVISION

*Francesco Camporesi (1747–1831). Three colored etchings of the Moscow Kremlin. N.p., ca. 1790. NYPL, SLAVIC AND BALTIC DIVISION [Fig. 47, p. 80]

Opisanie ... gradov Vserossiiskoi Imperii i ischislenie verst ot ... Moskve [A Description of the Cities of the Russian Empire and a Calculation of Their Distance from Moscow]. [Russia, 18th century]. NYPL, MAP DIVISION

*After Ivan Andreevich Tessing (Jan Tessing) (d. 1701). *Zertsalo greshnago* [A Mirror for the Sinner]. [Russia, late 18th–early 19th century]. NYPL, SLAVIC AND BALTIC DIVISION [Fig. 108, p. 181]

Beard-tax coin. Bronze. Russia, 1705. THE AMERICAN NUMISMATIC SOCIETY (1914.265.55)

D. THE CULT OF PETER THE GREAT

Fedor Ivanovich Dmitriev-Mamonov (1727–1805). *Slava Rossii, ili Sobranie medalei del Petra Velikago* [The Glory of Russia, or, A Collection of Medals of Peter the Great]. [Moscow], 1770. NYPL, SLAVIC AND BALTIC DIVISION

Archbishop of Novgorod Feofan (Prokopovich) (1681–1736). *Istoriia Imperatora Petra Velikago ot rozhdeniia ego do Poltavskoi batalii* [A History of Emperor Peter the Great from His Birth to the Battle of Poltava]. Moscow: Kompaniia Tipograficheskaia, 1788. NYPL, SLAVIC AND BALTIC DIVISION

Two rouble. Gold. Russia, ca. 1721. THE AMERICAN NUMISMATIC SOCIETY (1893.14.1099)

E. PETERSBURG AFTER PETER

Ingermanlandiae seu Ingriae Novissima Tabula [The Most Up-to-date Record of Ingermanland or Ingria]. Map. Nuremberg: Heirs of Johann Baptist Homann, 1734. NYPL, SLAVIC AND BALTIC DIVISION [Fig. 17, p. 30]

*Tobias Conrad Lotter (1717–1777). *Topographia sedis Imperatoriae Moscovitarum Petropolis anno 1744* [Topographical Description of Petropolis, the Seat of the Muscovite Empire]. Map. Augsburg?, 1744. NYPL, SLAVIC AND BALTIC DIVISION [Fig. 21, p. 34]

*Mikhail Ivanovich Makhaev (1716–1770). *Plan stolichnago goroda Sanktpeterburga* [Plan of the Capital City of St. Petersburg]. Engravings. St. Petersburg: Imperatorskaia Akademiia Nauk, 1753. NYPL, SLAVIC AND BALTIC DIVISION [Fig. 14, pp. 28–29; Fig. 23, p. 37]

*Prokofii Artem'ev (1736–1803), Nikita Chelnakov (b. 1734), and Filipp Vnukov, (d. 1765). [*Vidy S.-Peterburgskikh okrestnostei*] [Views of the Environs of St. Petersburg]. Engravings. [St. Petersburg: Imperatorskaia Akademiia Nauk, 1761]. NYPL, SLAVIC AND BALTIC DIVISION [Fig. 27, pp. 44–45; Fig. 71, p. 122]

*Christian Gotthelf Schönberg (b. 1760) and Christian Gottfried Heinrich Geissler (1770–1844). *St. Petersburgische Hausierer: Crieurs publics de St. Pétersbourg* [St. Petersburg's Street Peddlers]. St. Petersburg: Carl Lissner, 1794. NYPL, SPENCER COLLECTION [Fig. 24, p. 39]

*John Augustus Atkinson (1775–ca. 1833). *Panoramic View of St. Petersburg*. London: J. A. Atkinson, [1805–1807]. NYPL, MIRIAM AND IRA D. WALLACH DIVISION OF ART, PRINTS AND PHOTOGRAPHS, PRINT COLLECTION [Fig. 15, p. 29; Fig. 51, p. 87]

Andrei Grigorevich Ukhtomskii (1771–1852). *Sobranie fasadov, Ego Imperatorskim Velichestvom vysochaishe aprobovannykh dlia chastnykh stroenii v gorodakh Rossiiskoi imperii* [A Collection of Facades approved by His Imperial Majesty (Alexander I) for private buildings in the towns of the Russian Empire]. St. Petersburg, 1809. NYPL, SLAVIC AND BALTIC DIVISION

*Luigi Rusca (1758–1822). *Recueil des Dessins de différens bâtiments, construits à Saint-Pétersbourg et dans l'intérieur de l'Empire Russie* [A Collection of Drawings of Various Buildings Constructed in St. Petersburg and in the Interior of the Russian Empire]. St. Petersburg, 1810. NYPL, MIRIAM AND IRA D. WALLACH DIVISION OF ART, PRINTS AND PHOTOGRAPHS, ART AND ARCHITECTURE COLLECTION [Fig. 28, p. 47]

*Hand-colored lithograph depicting the St. Petersburg Exchange. N.p., ca. 1825. NYPL, SLAVIC AND BALTIC DIVISION [Fig. 22, p. 36]

4. The Eighteenth-century Romanov Court and Western Europe
(Robert H. Davis, Jr. and Cynthia H. Whittaker, Curators)

A. ROYAL PAGEANTRY

Opisanie koronatsii … Anny Ioannovny [Description of the Coronation of … Anna Ioannovna]. [Moscow]: Senatskaia Tipografiia, 1730. NYPL, Slavic and Baltic Division

Georg Wolfgang Krafft (1701–1754). *Description et réprésentation exacte de la maison de glace, construite à St. Pétersbourg au mois de janvier 1740* [A Description and Exact Representation of the House of Ice, Constructed in St. Petersburg in the Month of January 1740]. St. Petersburg: L'Académie des Sciences, 1741. NYPL, MIRIAM AND IRA D. WALLACH DIVISION OF ART, PRINTS AND PHOTOGRAPHS, ART AND ARCHITECTURE COLLECTION

Obstoiatel'noe opisanie … koronovaniia …Imperatritsy Elisavety Petrovny [Detailed Description of the Coronation of … Empress Elizabeth Petrovna]. St. Petersburg: Imperatorskaia Akademiia Nauk, 1744. NYPL, SLAVIC AND BALTIC DIVISION [Fig. 86, p. 147]

Mappe monde [World Map]. Amsterdam: Jean Covens et Corneille Mortier, 1770. NYPL, MAP DIVISION

Jean Louis de Veilly (fl. 1759–1763). Engraving depicting the coronation banquet of Catherine II. [St. Petersburg], ca. 1762; printed 1857. NYPL, SLAVIC AND BALTIC DIVISION

*Mikhail Ivanovich Makhaev (1716–1770). *Répresentation exacte des edifices et du jardin, qui se trouvent dans une des maisons de plaisance nommée Sailo Kouskowa* [An Exact Depiction of the Buildings and Garden in the Country Residence Named Kuskovo]. [Paris: Laurent, Barabé, Denizard, engravers, 1778–1779]. NYPL, MIRIAM AND IRA D. WALLACH DIVISION OF ART, PRINTS AND PHOTOGRAPHS, ART AND ARCHITECTURE COLLECTION [Fig. 45, p. 78]

*Angelo Nonni. *Descrizione degli spettacoli, e feste datesi in Venezia* [Description of the Spectacles and Festivities Given in Venice]. Venice: V. Formaleoni, 1782. NYPL, SPENCER COLLECTION [Fig. 97, p. 168]

Giorgio Fossati (1706–1778). *Currus triumphales ad adventum clarissimorum Moschoviae principum Pauli Petrovitz et Mariae Theodorownae* [Triumphal Chariots Used for the Arrival of the Renowned Princes of Muscovy, Paul Petrovich and Maria Fedorovna (the First)]. Venice: Fossati, [1782]. NYPL, SPENCER COLLECTION

Evangelie naprestol'noe [Altar Gospels]. Moscow, 1791. NYPL, RARE BOOKS DIVISION [Fig. 99, p. 170]

*Paul I, Emperor of Russia (1754–1801). Imperial Charter issued by Emperor Paul I, granting titles and lands for service. Manuscript. [St. Petersburg], October 24, 1797. NYPL, SPENCER COLLECTION [Fig. 72, p. 125]

Honoré J. Dalmas. *Le nouveau siècle. Invocation au soleil* [The New Century. An Invocation to the Sun]. St. Petersburg: Imprimerie Impériale, 1800. NYPL, RARE BOOKS DIVISION

Istoricheskoe opisanie Drevniago rossiiskago muzeia [Historical Description of the Ancient Russian Museum]. Moscow: Imperatorskii Moskovskii Universitet, 1807. NYPL, SLAVIC AND BALTIC DIVISION

Goblet (*pokal*) made to commemorate the coronation of Empress Elizabeth Petrovna. Engraved and gilded glass. Russia, ca. 1741. A LA VIEILLE RUSSIE

Plate (St. Andrew's Service). Porcelain. Meissen, Germany, 1743. PRIVATE COLLECTION, NEW YORK

Repoussé gold box. By Jérémie Pauzié (1716–1779). Russia, ca. 1740. PRIVATE COLLECTION

Order of St. Anne, First Class, Civil Rank. Gold, enamel, jewels. Russia, ca. 1750–1850. THE AMERICAN NUMISMATIC SOCIETY (1924.206.1)

B. SCANDALS AT THE COURT

Mémoires en forme de manifeste, sur le procez criminel jugé & publié à S. Pétersbourg en Moscovie le 25. juin 1718 [A Report in the Form of a Manifesto on the Criminal Process Adjudicated and Published in St. Petersburg in the Kingdom of Muscovy on June 25, 1718]. Nancy: Jean de la Rivière, 1718. NYPL, SLAVIC AND BALTIC DIVISION

Eléazar de Mauvillon (1712–1779). *Histoire de la vie, du règne, et du détrônement d'Iwan III. [i.e., VI] empereur de Russie* [A History of the Life, Reign, and Dethronement of Ivan VI, Emperor of Russia]. London, 1766. NYPL, GENERAL RESEARCH DIVISION

Le faux Pierre III; ou, La vie et les avantures du rebelle Jemeljan Pugatschew [The False Peter III, or, The Life and Adventures of the Rebel Emel'ian Pugachev]. London: C. H. Seyffert, 1775. NYPL, GENERAL RESEARCH DIVISION

Claude Carloman de Rulhière (1734–1791). *A History, or Anecdotes, of the Revolution in Russia, in the Year 1762*. Boston: Printed by Manning & Loring, for J. Nancrede, 1798. NYPL, RARE BOOKS DIVISION

*Erotic watercolor. Russia, ca. 1790s. NYPL, SLAVIC AND BALTIC DIVISION [Fig. 107, p. 180]

Jean-Charles Laveaux (1749–1827). *Histoire de Pierre III, empereur de Russie* [A History of Peter the Third, Emperor of Russia]. Paris: La Briffe, [1799]. NYPL, GENERAL RESEARCH DIVISION

Jeanne Éleonore de Cérenville (1738–1807). *Memoirs of the Life of Prince Potemkin*. London: H. Colburn, 1812. NYPL, GENERAL RESEARCH DIVISION

5. Northern, Central, and Southern Europe
(*Janis A. Kreslins, Jr. and Janis A. Kreslins, Sr., Consultants*)

A. SWEDEN

*Erik Jönsson Dahlbergh (1625–1703). *Suecia antiqua et hodierna* [Ancient and Modern Sweden]. [Stockholm: E. J. Dahlbergh, at the expense of the King, 1667–1716]. NYPL, MIRIAM AND IRA D. WALLACH DIVISION OF ART, PRINTS AND PHOTOGRAPHS, ART AND ARCHITECTURE COLLECTION [Fig. 18, p. 32; Fig. 19, p. 33]

Frederick de Wit (1630–1706). *Novissima nec non Perfectissima Scandinaviae* [The Most Recent, Although Incomplete, Information on Scandinavia]. Map. Amsterdam: Pierre Mortier, ca. 1710. NYPL, SLAVIC AND BALTIC DIVISION

*Philipp Johann von Strahlenberg (1676–1747). *An Historico-geographical Description of the North and Eastern Parts of Europe and Asia, but more particularly of Russia, Siberia, and Great Tartary.* London: W. Innys and R. Manby, 1738. NYPL, GENERAL RESEARCH DIVISION [Fig. 54, p. 95]

Aleksei Fedorovich Zubov (1682–1751). Etching depicting the battle of Poltava, June 27, 1709. Moscow or St. Petersburg, ca. 1710. NYPL, SLAVIC AND BALTIC DIVISION Jöran Andersson Nordberg (1677–1744). *Histoire de Charles XII. roi de Suéde* [History of Charles XII, King of Sweden]. The Hague: P. De Hondt, 1748. NYPL, GENERAL RESEARCH DIVISION

Tankard. Gilded silver with niello decoration (ca. 1750). By Heming Petri. Nyköping, Sweden, ca. 1680. A LA VIEILLE RUSSIE

B. OTHER REALMS OF THE TIME

Johann Samuel Mock (1687–1737). *Engravings of a Procession held in Dresden during the visit of Frederick IV, king of Denmark, to Frederick Augustus II, elector of Saxony, in 1709.* Berlin, 1719. NYPL, SPENCER COLLECTION

David Fassmann (1683–1744). [*Des glorwürdigsten Fürsten ... Friedrich Augusti des Grossen, Königs in Pohlen und Churfürstens zu Sachsen, &c. &c. Leben*] [Life of the Glorious Prince Frederic Augustus, King of Poland and Grand Duke of Saxony, etc.]. Frankfurt: W. Deer, 1734. NYPL, GENERAL RESEARCH DIVISION

Johann Heinrich Ramhoffsky (1700–1760). [*Die Beschreibung] Des königlichen Einzugs, welchen Ihro Königliche Majestät ... Maria Theresia, zu Hungarn und Böheim Königin ... in dero königliche drey Prager-Städte gehalten* [Description of the Royal Arrival of Her Royal Majesty Maria Theresa, Queen of Hungary and Bohemia ... in the Three Royal Towns of Prague]. Prague: Carl Franz Rosenmüller, [1743]. NYPL, SPENCER COLLECTION

Estadística, ó, Descripción geográfica y política del gran imperio de Rusia [Statistics, or, Geographic and Political Description of the Great Empire of Russia]. Madrid: Hija de Ibarra, 1807. NYPL, SLAVIC AND BALTIC DIVISION

Abraham's Sacrifice of Isaac. Workshop of Rembrandt van Rijn. Dutch. Oil on canvas, ca. 1650–1675? MUSEUM OF ART AND ARCHAEOLOGY, UNIVERSITY OF MISSOURI–COLUMBIA, GIFT OF THE SAMUEL H. KRESS FOUNDATION

6. Catherine the Great
(Irina Reyfman, Consultant, and Cynthia H. Whittaker, Curator)

A. THE *PHILOSOPHES* AND THE ENLIGHTENMENT SPIRIT

Charles de Secondat, Baron de Montesquieu (1689–1755). *De l'esprit des loix* [On the Spirit of Laws]. Geneva: Barillot & fils, 1748. NYPL, RARE BOOKS DIVISION

Pierre François Tardieu (1711–1771). *St. Pétersbourg.* Map. N.p., [1753]. NYPL, SLAVIC AND BALTIC DIVISION

Widow of Josua Ottens (1704–1765). *Nova ac verissima urbis St. Petersburg* [A Recent and Most Accurate Depiction of the City of St. Petersburg]. Map. Amsterdam: I. Ottens, after 1765. NYPL, SLAVIC AND BALTIC DIVISION

Mikhail Vasil'evich Lomonosov (1711–1765). *Drevniaia rossiiskaia istoriia ot nachala rossiiskago naroda do konchiny velikago kniazia Iaroslava pervago, ili do 1054 goda* [Ancient Russian History from the Origins of the Russian People Until the Death of Grand Prince Iaroslav the First, or up to 1054]. St. Petersburg: Imperatorskaia Akademiia Nauk, 1766. NYPL, SLAVIC AND BALTIC DIVISION

Vasilii Nikitich Tatishchev (1686–1750). *Istoriia rossiiskaia s samykh drevneishikh vremen* [Russian History from Earliest Times]. [Moscow]: Imperatorskii Moskovskii Universitet, 1768–1848. NYPL, SLAVIC AND BALTIC DIVISION

*Jean Chappe d'Auteroche (1723–1769). *Voyage en Sibérie* [A Journey into Siberia]. Paris: Debure, père, 1768. NYPL, MAP DIVISION [Fig. 35, p. 56]

The Grand Instructions to the Commissioners Appointed to Frame a New Code of Laws for the Russian Empire: composed by Her Imperial Majesty Catherine II. London: T. Jefferys, 1768. NYPL, GENERAL RESEARCH DIVISION

*Jacobus van der Schley (1715–1779). Engraving depicting the delivery of the "Thunder Stone" for the base of the statue of Peter the Great. St. Petersburg, ca. 1770. NYPL, SLAVIC AND BALTIC DIVISION [Fig. 48, p. 82]

Catherine II, Empress of Russia (1729–1796). *The Antidote; or An Enquiry into the Merits of a Book, entitled: A Journey into Siberia.* London: S. Leacroft, 1772. NYPL, GENERAL RESEARCH DIVISION

Ivan Ivanovich Betskoi (1704–1795). *Les plans et les statuts, des différents établissements ordonnés par Sa Majésté Impériale Catherine II. Pour l'éducation de la jeunesse et l'utilité générale de son empire* [Plans and Regulations for the Different Establishments Decreed by Her Imperial Majesty Catherine II for the Education of Youth and for the General Utility of Her Empire]. Amsterdam: M. M. Rey, 1775. NYPL, GENERAL RESEARCH DIVISION

*Antoine Radigues (1721–1809). Portrait of Ivan Ivanovich Betskoi (1704–1795). Engraving. St. Petersburg: Imperatorskaia Akademiia Khudozhestv, 1794. NYPL, SLAVIC AND BALTIC DIVISION [Fig. 49, p. 83]

*Catherine II, Empress of Russia (1729–1796). Imperial Charter issued by Catherine II, granting privileges for service to the state. Manuscript. [St. Petersburg], August 10, 1775. NYPL, SPENCER COLLECTION [Fig. 38, p. 62]

*Christoph Melchior Roth (d. 1798). *Novoi plan stolichnago goroda i kreposti Sanktpeterburga* [A New Plan of the Capital City and Fortress of St. Petersburg]. Map. N.p., 1776. NYPL, SLAVIC AND BALTIC DIVISION [Fig. 26, p. 41]

Sanktpeterburgskii vestnik, soderzhashchii: vse ukazy Eia Imperatorskago Velichestva i Pravitel'stvuiushchago Senata [The St. Petersburg Herald, Containing: All Laws of Her Imperial's Majesty and the Governing Senate]. St. Petersburg: J. J. Weitbrecht, 1778–1781. NYPL, SLAVIC AND BALTIC DIVISION

Nicolas-Gabriel Clerc (1726–1798), called LeClerc. *Histoire physique, morale, civile et politique de la Russie moderne* [A Physical, Moral, Civil and Political History of Modern Russia]. Paris: Froullé, 1783–an II [1793]. NYPL, SLAVIC AND BALTIC DIVISION

*Ivan Nikitich Boltin (1735–1792). *Primechaniia na Istoriiu drevniia i nyneshniia Rossii g. Leklerka* [Notes on the History of Ancient and Modern Russia of Mr. LeClerc]. [St. Petersburg]: Gornoe Uchilishche, 1788. NYPL, SLAVIC AND BALTIC DIVISION [Fig. 32, p. 54]

Catherine II, Empress of Russia (1729–1796). *Perepiska rossiiskoi imperatritsy Ekateriny Vtoryia s g. Volterom, s 1763 po 1778 god* [Correspondence of the Russian Empress Catherine II with Mr. Voltaire from 1763 to 1778]. St. Petersburg: Imperatorskaia Akademii Nauk, 1802. NYPL, SLAVIC AND BALTIC DIVISION

Marchese Cesare Bonesana di Beccaria (1738–1794). *Razsuzhdenie o prestupleniiakh i nakazaniiakh* [Thoughts on Crimes and Punishments]. St. Petersburg: Gubernskoe Pravlenie, 1803. NYPL, SLAVIC AND BALTIC DIVISION

"Letter" (*paket*) box. Porcelain. Russia, Imperial Porcelain Factory, 1760. A LA VIEILLE RUSSIE

B. MODERN LITERATURE IN RUSSIA

*Nikolai Ivanovich Novikov (1744–1818). *Opyt istoricheskago slovaria o rossiiskikh pisateliakh* [Attempt at a Historical Dictionary of Russian Writers]. St. Petersburg: [Imperatorskaia Akademiia Nauk], 1772. NYPL, SLAVIC AND BALTIC DIVISION [Fig. 31, p. 54]

*Aleksandr Petrovich Sumarokov (1718–1777). *Polnoe sobranie vsekh sochinenii, v stikhakh i proze* [Complete Collection of All Works, in Verse and Prose]. Moscow: Universitetskaia Tipografiia u N. Novikova, 1781–1782. NYPL, SLAVIC AND BALTIC DIVISION [Fig. 30, p. 53]

Mikhail Matveevich Kheraskov (1733–1807). *Vladimir vozrozhdennyi, epicheskaia poema* [Vladimir Reborn, An Epic Poem]. Moscow: Universitetskaia Tipografiia u N. Novikova, 1785. NYPL, SLAVIC AND BALTIC DIVISION

Rossiiskii featr [Russian Theater]. St. Petersburg: Imperatorskaia Akademiia Nauk, 1786. NYPL, SLAVIC AND BALTIC DIVISION [Fig. 36, p. 59]

*Ermil Ivanovich Kostrov (1750?–1796), translator. *Gomerova Iliada* [The *Iliad* of Homer]. St. Petersburg: Imperatorskaia Tipografiia, 1787. NYPL, SLAVIC AND BALTIC DIVISION [Fig. 37, p. 61]

Count Vasilii Vasil'evich Kapnist (1757–1823). *Iabeda, komediia v piati deistviiakh* [Slander, A Comedy in Five Acts]. St. Petersburg: G. Krutitskii, 1798. NYPL, SLAVIC AND BALTIC DIVISION

Raznost' i priiatnost' [Diversity and Pleasure]. Manuscript. [Russia], ca. late 18th century. NYPL, MANUSCRIPTS AND ARCHIVES DIVISION [Fig. 34, p. 55]

*Platon Petrovich Beketov (1761–1836). *Panteon rossiiskikh avtorov* [Pantheon of Russian Authors]. Moscow: [Senatskaia Tipografiia u Selivanovskago], 1801. NYPL, SLAVIC AND BALTIC DIVISION [Fig. 29, p. 53]

*Nikolai Mikhailovich Karamzin (1766–1826). *Travels from Moscow, through Prussia, Germany, Switzerland, France, and England*. London: J. Badcock, 1803. NYPL, GENERAL RESEARCH DIVISION [Fig. 41, p. 69]

Rassuzhdenie o starom i novom sloge rossiiskago iazyka [Discourse on the Old and New Styles of the Russian Language]. St. Petersburg: Imperatorskaia Tipografiia, 1803. NYPL, SLAVIC AND BALTIC DIVISION

*Gavriil Romanovich Derzhavin (1743–1816). *Anakreonticheskiia pesni* [Anacreontic Songs]. St. Petersburg: [Shnor], 1804. NYPL, SLAVIC AND BALTIC DIVISION [Fig. 39, p. 66]

Anna Petrovna Bunina (1774–1829). *Neopytnaia muza* [Inexperienced Muse]. St. Petersburg: Shnor, 1809–1812. NYPL, SLAVIC AND BALTIC DIVISION

Vasilii Andreevich Zhukovskii (1783–1852). *Stikhotvoreniia Vasiliia Zhukovskago* [The Poetry of Vasilii Zhukovskii]. St. Petersburg: Meditsinskaia Tipografiia, 1815–1816. NYPL, SLAVIC AND BALTIC DIVISION

Aleksandr Sergeevich Pushkin (1799–1837). *Kavkazskii plennik. Povest'* [The Caucasian Captive. A Story]. St. Petersburg: N. Grech, 1822. NYPL, SLAVIC AND BALTIC DIVISION

C. JOURNALISM IN RUSSIA

Ezhemesiachnyia sochineniia i izvestiia o uchenykh delakh [Monthly Compositions and News of Scholarly Affairs]. St. Petersburg: Imperatorskaia Akademiia Nauk, 1755–1764. NYPL, SLAVIC AND BALTIC DIVISION

Sanktpeterburgskiia vedomosti [The St. Petersburg Gazette]. St. Petersburg, 1777–[1819]. NYPL, SLAVIC AND BALTIC DIVISION

**Modnoe ezhemesiachnoe izdanie; ili, Biblioteka dlia damskago tualeta* [A Fashionable Monthly, or A Library for Lady's Dress]. Moscow: Imperatorskii Moskovskii Universitet, 1779. NYPL, SLAVIC AND BALTIC DIVISION [Fig. 33, p. 55]

Sobesednik liubitelei Rossiiskago slova [The Partner of Lovers of the Russian Word]. St. Petersburg: Imperatorskaia Akademiia Nauk, 1783–1809. NYPL, SLAVIC AND BALTIC DIVISION

D. CULTURAL TRENDS

*Catherine II, Empress of Russia (1729–1796). *Skazka o tsareviche Khlore* [A Tale of Prince Khlor]. St. Petersburg: [Akademiia Nauk], 1782. NYPL, SLAVIC AND BALTIC DIVISION [Fig. 40, p. 67]

Catherine II, Empress of Russia (1729–1796). *Zapiski kasatel'no rossiiskoi istorii* [Notes on Russian History]. St. Petersburg: Imperatorskaia Tipografiia, 1801. NYPL, SLAVIC AND BALTIC DIVISION

"A Polish Nobleman." Tapestry after a painting by Rembrandt. Russia, Imperial Tapestry Manufactory, late 18th century. THE METROPOLITAN MUSEUM OF ART, THE DEPARTMENT OF EUROPEAN SCULPTURE AND DECORATIVE ARTS, GIFT OF JULIA A. BERWIND, 1953 (53.225.22)

E. WESTERN EUROPEAN INTEREST IN RUSSIA

*Augustin Dahlstein (fl. 18th century). *Russische Trachten und Ausrufer in St.-Petersburg* [Russian Costumes and Public Criers of St. Petersburg]. Cassel: W. C. Mayr, [1750]. NYPL, MIRIAM AND IRA D. WALLACH DIVISION OF ART, PRINTS AND PHOTOGRAPHS, ART AND ARCHITECTURE COLLECTION [Fig. 42, p. 74]

François Marie Arouet de Voltaire (1694–1778). *Histoire de l'empire de Russie sous Pierre le Grand* [History of the Russian Empire During the Reign of Peter the Great]. [Geneva: Cramer], 1765. NYPL, RARE BOOKS DIVISION

*Jean-Baptiste Le Prince (1734–1781). *Divers ajustements et usages de Russie* [Various Modes of Dress and Customs of Russia]. [Paris, 1775?]. NYPL, MIRIAM AND IRA D. WALLACH DIVISION OF ART, PRINTS AND PHOTOGRAPHS, PRINT COLLECTION [Fig. 44, p. 76]

*William Coxe (1747–1828). *Travels into Poland, Russia, Sweden, and Denmark.* London: Printed by J. Nichols, for T. Cadell, 1784. NYPL, SLAVIC AND BALTIC DIVISION [Fig. 50, p. 84]

*Guerard de la Barthe (fl. late 18th–early 19th century). *Vid Spasskikh vorot i okruzhnostei ikh v Moskve* [View of the Savior Gates and Their Environs in Moscow]. Engraving. N.p., 1799. NYPL, SLAVIC AND BALTIC DIVISION [Fig. 46, p. 79]

*Johann Gustaf Richter and Christian Gottfried Heinrich Geissler (1770–1844). *Sitten, Gebräuche und Kleidung der Russen aus den niedern Ständen* [Customs, Habits, and Attire of Lower-class Russians]. Leipzig: Industrie-Comptoir, [1805]. NYPL, MIRIAM AND IRA D. WALLACH DIVISION OF ART, PRINTS AND PHOTOGRAPHS, ART AND ARCHITECTURE COLLECTION [Fig. 106, p. 178]

F. UKRAINE AND POLAND: TRADITIONS AND PEOPLES

Joachim Pastorius (1611–1681). *Bellum Scythico-Cosacicum* [The Polish-Cossack War]. Gdansk: G. Förster, 1652. NYPL, SLAVIC AND BALTIC DIVISION

Polen, Litauen und Kurland [Poland, Lithuania, and Kurland]. Map. [Berlin: Sotzmann, 1797?]. NYPL, MAP DIVISION

Polen, zur Zeit der zwey letzten Theilungen dieses Reichs [Poland at the Time of the Last Two Partitions of This Country]. N.p., 1807. NYPL, GENERAL RESEARCH DIVISION

Dmitrii Nikolaevich Bantysh-Kamenskii (1788–1850). *Istoriia Maloi Rossii* [A History of Ukraine]. Moscow: S. Selivanovskii, 1822. NYPL, SLAVIC AND BALTIC DIVISION

Adam Mickiewicz (1798–1855). *Pan Tadeusz* [Pan Tadeusz]. Paris: Aleksander Jelowicki, 1834. NYPL, RARE BOOKS DIVISION

7. Russian Exploration
(Richard S. Wortman, Consultant)

**Atlas Russicus* [Atlas of Russia]. St. Petersburg: Academia Scientiam Imperialis, 1745. NYPL, MAP DIVISION [Fig. 55, p. 96]

Izobrazhenie obieikh polovin zemnago shara [A Representation of Both Hemispheres of the Globe]. Map. St. Petersburg, 1787. NYPL, MAP DIVISION

*Aleksandr Mikhailovich Wildbrecht (d. ca. 1820). *Rossiiskoi atlas* [A Russian Atlas]. St. Petersburg: Gornoe Uchilishche, 1792. NYPL, MAP DIVISION [Fig. 56, p. 96]

A. JOURNEYS WITHIN THE RUSSIAN EMPIRE

*Georg Wilhelm de Hennin (1676–1750). *Opisanie sibirskikh kazennykh i partikuliarnykh gornykh zavodov* [A Description of Siberian Metal Works, Both State and Private]. Manuscript. N.p., 1735. NYPL, SLAVIC AND BALTIC DIVISION [Fig. 101, p. 173]

Georg Wilhelm Steller (1709–1746). *Beschreibung von dem Lande Kamtschatka* [Description of the Land of Kamchatka]. Frankfurt: Johann Georg Fleischer, 1774. NYPL, RARE BOOKS DIVISION

*Johann Gottlieb Georgi (1738–1802). *Description de toutes les nations de l'empire de Russie* [A Description of All the Nationalities of the Russian Empire]. St. Petersburg: J. C. Shnoor (Shnor), 1776–1777. NYPL, SPENCER COLLECTION [Fig. 58, p. 98]

*Karl Friedrich Knappe. Drawings (pencil, ink, and wash), ca. 1780s, for Peter Simon Pallas, *Flora Rossica*. NYPL, MIRIAM AND IRA D. WALLACH DIVISION OF ART, PRINTS AND PHOTOGRAPHS, PRINT COLLECTION [Fig. 57, p. 98]

Peter Simon Pallas (1741–1811). *Flora Rossica* [The Flora of Russia]. St. Petersburg: J. J. Weitbrecht, 1784–1788. NYPL, SLAVIC AND BALTIC DIVISION

Vasilii Fedorovich Zuev (1754–1794). *Puteshestvennyia zapiski Vasil'ia Zueva ot S. Peterburga do Khersona v 1781 i 1782 godu* [The Travel Diary of Vasilii Zuev, from St. Petersburg to Kherson in 1781 and 1782]. St. Petersburg: Imperatorskaia Akademiia Nauk, 1787. NYPL, SLAVIC AND BALTIC DIVISION

*Pavel Ivanovich Sumarokov (d. 1846). *Dosugi krymska- go sud'i ili Vtoroe puteshestvie v Tavridu* [Idle Reflections of a Crimean Judge, or, A Second Journey to Tauride]. St. Petersburg: Imperatorskaia Tipografiia, 1803–1805. NYPL, SLAVIC AND BALTIC DIVISION [Fig. 102, p. 174]

Box with map of Siberia. Gilded silver and niello. Russia, 18th century. A LA VIEILLE RUSSIE

Figure of a Kabardian fish merchant. Porcelain. Russia, Russian Imperial Porcelain Factory, 1780–1790. A LA VIEILLE RUSSIE

B. INTEREST IN FARAWAY PLACES

Opisanie s[via]tago B[o]zhiia grada Ier[usa]lima [A Description of God's Holy City of Jerusalem]. [Moscow, ca. 1830, printed from the engraved plates, dated 1771]. NYPL, SLAVIC AND BALTIC DIVISION

Graf Boris Petrovich Sheremetev (1652–1719). *Zapiska puteshestviia … grafa Borisa Petrovicha Sheremeteva … v Krakov, v Venu, v Venetsiiu, v Rim i na Maltiiskii ostrov* [Travel Notes of … Count Boris Petrovich Sheremetev … to Cracow, Vienna, Venice, Rome, and the Island of Malta]. Moscow: Imperatorskii Universitet, 1773. NYPL, SLAVIC AND BALTIC DIVISION

Neshchastnyia prikliucheniia Vasil'ia Baranshchikova, meshchanina Nizhniago Novagoroda v … Amerike, Azii i Evrope, s 1780 po 1787 god [The Unfortunate Adventures of the Nizhnii Novgorod Merchant Vasilii Baranshchikov in America Asia and Europe from 1780 to 1787]. St. Petersburg: Vil'kovskii i Galchenkov, 1787. NYPL, SLAVIC AND BALTIC DIVISION

Count Móric Benyovsky (1741–1786). *Begebenheiten und Reisen* [Adventures and Travels]. Hamburg: Benjamin Gottlob Hoffmann, 1791. NYPL, RARE BOOKS DIVISION

*Grigorii Ivanovich Shelekhov (1748–1795). *Rossiiskago kuptsa Grigor'ia Shelekhova stranstvovanie v 1783 godu iz Okhotska po Vostochnomu Okeanu k Amerikanskim beregam* [An Account of the Journeys of the Russian Merchant Grigorii Shelekhov in 1783 from Okhotsk on the Eastern Pacific Ocean to the Shores of America]. St. Petersburg: V.S., 1791–1792. NYPL, SLAVIC AND BALTIC DIVISION [Fig. 59, p. 100]

*Gavriil Andreevich Sarychev (1763–1831). *Puteshestvie flota kapitana Sarycheva po severovostochnoi chasti Sibiri, Ledovitomu moriu i Vostochnomu okeanu* [The Journey of Fleet Captain Sarychev Through the Northeastern Regions of Siberia, the Arctic Sea, and the Eastern (Pacific) Ocean]. St. Petersburg: Shnor, 1802. NYPL, SLAVIC AND BALTIC DIVISION [Fig. 60, p. 101]

Iurii Fedorovich Lisianskii (1773–1837). *Puteshestvie vokrug sveta v 1803, 4, 5, i 1806 godakh* [A Voyage Round the World in 1803, 1804, 1805, 1806]. St. Petersburg: F. Drekhsler, 1812. NYPL, SLAVIC AND BALTIC DIVISION

Opisanie narodov, obitaiushchikh v Evrope, Azii, Afrike i Amerike [A Description of the Peoples Inhabiting Europe, Asia, Africa, and America]. St. Petersburg: Ios. Ioannesov, 1812. NYPL, SLAVIC AND BALTIC DIVISION

*Georg Heinrich von Langsdorff (1774–1852). *Voyages and Travels in Various Parts of the World, during the years 1803, 1804, 1805, 1806, and 1807*. London: H. Colburn, 1813–1814. NYPL, GENERAL RESEARCH DIVISION [Fig. 66, p. 108]

Pavel Petrovich Svin'in (1788–1839). *Opyt zhivopisnago puteshestviia po Severnoi Amerike* [An Illustrated Description of a Picturesque Journey Through North America]. St. Petersburg: F. Drekhsler, 1815. NYPL, SLAVIC AND BALTIC DIVISION

*Andrei Efimovich Martynov (1768–1826). *Zhivopisnoe puteshestvie ot Moskvy do kitaiskoi granitsy* [A Picturesque Journey from Moscow to the Chinese Border]. St. Petersburg: Aleksandr Pliushar, 1819. NYPL, SLAVIC AND BALTIC DIVISION [Fig. 61, p. 102]

*Ludovik Andreevich Choris (1795–1828). *Voyage pittoresque autour du monde, avec des portraits de sauvages d'Amérique, d'Asie, d'Afrique, et des îles du Grand océan* [A Picturesque Voyage Around the World, with Portraits of the Savages of America, Asia, Africa, and the Islands of the Pacific Ocean]. Paris: Firmin Didot, 1822. NYPL, RARE BOOKS DIVISION [Fig. 67, p. 110; Fig. 68, p. 111]

*Count Fedor Petrovich Litke (1797–1882). *Voyage autour du monde ... dans les années 1826, 1827, 1828 et 1829* [A Voyage Around the World ... in the Years 1826, 1827, 1828 and 1829]. Paris: Firmin Didot frères, 1835–1836. NYPL, SLAVIC AND BALTIC DIVISION [Fig. 64, p. 106; Fig. 69, p. 112]

8. The Ottoman Empire and the Arc of Islam
(Svatopluk V. Soucek and Edward A. Allworth, Consultants)

*Joan Blaeu (1596–1673). *Grooten atlas, oft Werelt beschryving* [The Great Atlas, or, A Description of the World]. Amsterdam, 1648–1664. NYPL, MAP DIVISION [Fig. 83, p. 143]

A. THE OTTOMAN EMPIRE

*Prospero Bonarelli (1580–1659). *Il Solimano* [Süleyman]. Florence: P. Cecconelli, 1620. NYPL, SPENCER COLLECTION [Fig. 91, p. 152]

Willem Janszoon Blaeu (1571–1638) and Joan Blaeu (1596–1673). *Taurica Chersonesus* [Taurid of Chersonese]. Map. Amsterdam: Willem Janszoon Blaeu and Joan Blaeu, 1670? NYPL, MAP DIVISION

*Anonymous German. Engraving of the Ottoman Siege of Vienna. N.p., after 1683. NYPL, MIRIAM AND IRA D. WALLACH DIVISION OF ART, PRINTS AND PHOTOGRAPHS, PRINT COLLECTION [Fig. 90, p. 152]

*Peter I, Emperor of Russia (1672–1725), and Ivan V, Tsar of Russia (1666–1696). Royal property charter granted for service in the war with the Turkish Sultan and the Crimean Khan. Printed and manuscript document, with Persian silk textile cover. Moscow, 1686. NYPL, SLAVIC AND BALTIC DIVISION [Fig. 104, p. 176]

Moscowitische Belagerung und Eroberung der Haupt Stadt Asoff in Tartarischen Königreich Nagaja am Fluss Tänais oder Don [The Muscovite Siege and Conquest of the City of Azov in the Tatar Kingdom Nogai on the Tanais or Don River]. Map. N.p., 1696. NYPL, Map Division

*Julius Mandosius. *Ottomanorum principum effigies ab Ottomano ad regnantem Mustapham II* [Portraits of Ottoman Rulers from Osman to the Present-day Ruler Mustafa II]. Rome: D. de Rubeis, Jo. Jacobi heirs, 1698. NYPL, GENERAL RESEARCH DIVISION [Fig. 92, p. 154]

Dimitrie Cantemir (Kantemir), Voivode of Moldavia (1673–1723). *Kniga sistema, ili Sostoianie mukhammedanskiia religii* [A Book Concerning the Mohammedan Religion and Political System of the Muslim People]. St. Petersburg: Sanktpiterburgskaia Tipografiia, 1722. NYPL, SLAVIC AND BALTIC DIVISION

Jean de Thévenot (1633–1667). *Voyages ... en Europe, Asie & Afrique* [Travels in Europe, Asia & Africa]. Amsterdam: Michel Charles Le Céne, 1727. NYPL, GENERAL RESEARCH DIVISION

*Guillaume de L'Isle (1675–1726). "Carte de la Turquie, de l'Arabie et de la Perse," in *Atlas nouveau* [New Atlas]. Amsterdam: Jean Covens & Corneille Mortier, 1733. NYPL, MAP DIVISION [Fig. 93, p. 155]

Nouvelle carte de la Crimée & toute La Mer Noire [A New Map of the Crimea and the Entire Black Sea]. Map. N.p., [1737]. NYPL, SLAVIC AND BALTIC DIVISION

*Jean Louis de Veilly (fl. 1759–1763). Engraving depicting the reception of the Ottoman Turkish embassy. [St. Petersburg], ca. 1764; printed 1857. NYPL, SLAVIC AND BALTIC DIVISION [Fig. 43, p. 76]

Rossiiskoe posol'stvo v Konstantinopol', 1776 goda [The Russian Embassy to Constantinople (i.e., Istanbul) in 1776]. St. Petersburg: Imperatorskaia Akademiia Nauk, 1777. NYPL, SLAVIC AND BALTIC DIVISION [Fig. 103, p. 175]

*Fazil Tahir Omerzade (d. 1810). *Khubannamah* [The Book of the Excellent Ones]. Manuscript. Istanbul, copied 1797–1798. NYPL, SPENCER COLLECTION [Fig. 94, p. 156]

Heinrich Christoph von Reimers (1768–1812). *Reise der russisch-kaiserlichen ausserordentlichen Gesandschaft an die Othomanische Pforte im Jahr 1793* [The Journey of the Extraordinary Russian Imperial Embassy to the Ottoman Porte in 1793]. St. Petersburg: [J. C. Shnoor (Shnor)], 1803. NYPL, GENERAL RESEARCH DIVISION

Konstantinopel und St. Petersburg [Constantinople and St. Petersburg]. St. Petersburg: F. Dienemann und Co., 1805–1806. NYPL, GENERAL RESEARCH DIVISION

*Antoine Ignace Melling (1763–1831). *Voyage pittoresque de Constantinople et des rives du Bosphore* [Picturesque Voyage from Constantinople and the Banks of the Bosphorus]. Paris: Treuttel et Würtz, 1819. NYPL, MIRIAM AND IRA D. WALLACH DIVISION OF ART, PRINTS AND PHOTOGRAPHS, ART AND ARCHITECTURE COLLECTION [Fig. 81, p. 140]

*Fedor Grigor'evich Solntsev (1801–1892). *Odezhdy Russkago gosudarstva* [Costume of the Russian State]. Original watercolors. [St. Petersburg?], 1820–1869. NYPL, RARE BOOKS DIVISION [Fig. 85, p. 146]

Aleksandr Sergeevich Pushkin (1799–1837). *Bakhchisaraiskii fontan* [Bakhchisarai Fountain]. Moscow: August Semen, 1824. NYPL, SLAVIC AND BALTIC DIVISION

Ecclesiastical textile. Silk brocade. Turkey, 16th century. THE METROPOLITAN MUSEUM OF ART, THE DEPARTMENT OF ISLAMIC ART, ROGERS FUND, 1917 (17.22.2)

Pair of figural cups. Porcelain, with turbaned and bejewelled covers. Russia, Gardner Porcelain Factory, 18th century. A LA VIEILLE RUSSIE

Crescent-shaped box with depiction of a mosque. Silver with niello decoration. Russia, ca. 1780. THE METROPOLITAN MUSEUM OF ART, THE DEPARTMENT OF EUROPEAN SCULPTURE AND DECORATIVE ARTS, BEQUEST OF JOHN L. CADWALADER, 1914 (14.58.190)

B. PERSIA AND THE MUGHAL EMPIRE

*Firdawsi (A. H. 329/C.E. 940–A. H. 411/C.E. 1023). *Shahnamah* [The Book of Kings]. Manuscript. Shiraz?, 1614 (miniatures after 1825, probably Teheran). NYPL, SPENCER COLLECTION [Fig. 89, p. 151]

*John Ogilby (1600–1676). *Asia, the first part. Being an accurate description of Persia. The Vast Empire of the Great Mogol.* London: the author, 1673. NYPL, GENERAL RESEARCH DIVISION [Fig. 84, p. 144; Fig. 88, p. 150]

*Johann Baptist Homann (1663–1724). *Imperii Persici in omnes suas Provincias* [The Persian Empire and All Its Territories]. Map. Nuremberg, early 18th century. NYPL, SLAVIC AND BALTIC DIVISION [Fig. 82, p. 140]

Jean Bernoulli (1744–1807). *Description historique et géographique de l'Inde* [A Historical and Geographical Description of India]. Berlin: C. S. Spener, 1786–1789. NYPL, GENERAL RESEARCH DIVISION

S. Bartholomaeo Paulinus (1748–1806). *Viaggio alle Indie orientali* [A Voyage to the East Indies]. Rome: A. Fulgoni, 1796. NYPL, GENERAL RESEARCH DIVISION

*James Justinian Morier (1780?–1849). *A Journey through Persia, Armenia, and Asia Minor, to Constantinople, in the Years 1808 and 1809.* Philadelphia: M. Carey; Boston: Wells and Lilly, 1816. NYPL, GENERAL RESEARCH DIVISION [Fig. 87, p. 148]

9. The Interaction of Russian and Western Intellectual Life
(Marc Raeff, Consultant)

A. A NEW FLOWERING OF PUBLISHING

Johann Samuel Halle (1727–1810). *Otkrytyia tainy drevnikh magikov i charodeev ili Volshebnyia sily natury* [Revealing the Secrets of Ancient Magic and Sorcerers, or, The Magical Forces of Nature]. Moscow: Universitetskaia Tipografiia u Ridigera i Klaudiia, 1798–1804. NYPL, SLAVIC AND BALTIC DIVISION

Novoe zrelishche vselennyia, predstavlennoe iz Tsarstva Prirody, iskusstva, nravov i obyknovennoi zhizni, dlia detei oboego pola [The New Spectacle of the Universe, as Presented in the Natural Kingdom, Art, Morals, the Ways of Everyday Life, for Children of Both Sexes]. Moscow: Universitetskaia Tipografiia Ridigera i Klaudiia, 1804. NYPL, SLAVIC AND BALTIC DIVISION

Mémoires de la Société impériale des naturalistes de Moscow [Reports of the Moscow Imperial Society of Naturalists]. Moscow, 1806–1817. NYPL, GENERAL RESEARCH DIVISION

Vestnik Evropy [The Herald of Europe]. Moscow, 1813–1826. NYPL, SLAVIC AND BALTIC DIVISION

Karl von Eckartshausen (1752–1803). *Nochi, ili besedy mudrago s drugom* [Nights, or Conversations of a Wise Person with a Friend]. St. Petersburg, 1817. NYPL, SLAVIC AND BALTIC DIVISION

*Nikolai Mikhailovich Karamzin (1766–1826). *Geschichte des russischen Reiches* [History of the Russian State]. Riga: C.J.G. Hartmann, 1820–1833. NYPL, SLAVIC AND BALTIC DIVISION [Fig. 79, p. 134]

Sir John Bowring (1792–1872) *Specimens of the Russian Poets*. London: the author, 1821–1823. NYPL, SLAVIC AND BALTIC DIVISION

Émile Dupré de Saint-Maure (1772–1854). *Anthologie russe, suivie de poésies originales* [A Russian Anthology, Including Original Poetry]. Paris: C. J. Trouvé, 1823. NYPL, SLAVIC AND BALTIC DIVISION

Poliarnaia zvezda [The Northern Star]. St. Petersburg: N. Grech, 1823–1825. NYPL, SLAVIC AND BALTIC DIVISION

Kniga Khvalenii, ili, Psaltir' [The Book of Praise, or, The Psalter]. St. Petersburg: Rossiiskoe Bibleiskoe Obshchestvo, 1824. NYPL, SLAVIC AND BALTIC DIVISION

Ivan Andreevich Krylov (1768–1844). *Fables russes* [Russian Fables]. Paris: Bossange, 1825. NYPL, SLAVIC AND BALTIC DIVISION

Magazin für Russland's Geschichte [A Magazine for Russia's History]. Mitau: J. F. Steffenhagen und Sohn, 1825–1826. NYPL, GENERAL RESEARCH DIVISION

Severnye tsvety [Northern Flowers]. St. Petersburg: Departament Narodnago Prosveshcheniia, [1825–1826]. NYPL, SLAVIC AND BALTIC DIVISION

Serving tray. Silver. St. Petersburg, 1801. PRIVATE COLLECTION, LONG ISLAND, NEW YORK

B. WAR

Johann Christian Hinrichs (b. 1760). *Entstehung, Fortgang und ietzige Beschaffenheit der russischen Iagdmusik* [The Origin, Development, and Present State of Russian Hunting Music]. St. Petersburg: I. K. Schnoor (Shnor), 1796. THE NEW YORK PUBLIC LIBRARY FOR THE PERFORMING ARTS, MUSIC DIVISION

*Carl Friedrich Wilhelm Borck. *Napoleon's erster Traum in Moskwa* [Napoleon's First Dream in Moscow]. St. Petersburg: I. Glasunow, 1812. NYPL, SLAVIC AND BALTIC DIVISION [Fig. 73, p. 129]

Carte de la Russie Européenne [Map of European Russia]. Map. Paris: Depôt Général de la Guerre, 1812. NYPL, MAP DIVISION

Plan de la ville et des faubourgs de Moscou, indiquant … les parties de cette Ville, que les Russes ont incendiées lors de l'entrée de S.M. l'Empereur Napoléon, le 14 septembre 1812 [Plan of the City and Suburbs of Moscow, Showing Those Parts of the City Burned by the Russians at the Time of the Entry of His Majesty Emperor Napoleon on September 14, 1812]. Map. Paris: Pierre-Grégoire Chanlaire, Charles Picquet, [1812?]. NYPL, MAP DIVISION

*Ivan Ivanovich Terebenev (1780–1815). *Karrikatury Napoleona I* [Caricatures of Napoleon I]. Lithograph. [Russia, ca. 1813–1815]. NYPL, SLAVIC AND BALTIC DIVISION [Fig. 75, p. 130]

*Ferdinand Charles Panormo. *Moscow, or Buonaparte's Retreat: A Grand Russian Air*. Printed score. London: G. Walker, [1814?]. THE NEW YORK PUBLIC LIBRARY FOR THE PERFORMING ARTS, MUSIC DIVISION [Fig. 74, p. 129]

An Account of the Visit of His Royal Highness the Prince Regent and Their Imperial and Royal Majesties the Emperor of All the Russias and King of Prussia. London: Nicholas, son, and Bentley, [1815]. NYPL, GENERAL RESEARCH DIVISION [Fig. 98, p. 169]

The Costume of the Allied Armies in Paris in the Year 1815. [Paris, 1816]. NYPL, SPENCER COLLECTION [Fig. 70, p. 120; Fig. 76, p. 131]

*Count Fedor Petrovich Tolstoi (1783–1873). *Sobranie reznykh izobrazhenii s medalei* [A Collection of Images Engraved from Medals]. St. Petersburg: V. Plavil'shchikov, 1818. NYPL, SLAVIC AND BALTIC DIVISION [Fig. 77, p. 132]

Vladimir Bogdanovich Bronevskii (1784–1835). *Zapiski morskago ofitsera … ot 1805 po 1810 g.* [Memoirs of a Naval Officer … from 1805 to 1810]. St. Petersburg: Morskaia Tipografiia, 1818–1819. NYPL, SLAVIC AND BALTIC DIVISION

*Stepan Filippovich Galaktionov (1779–1854). Lithograph of Emperor Alexander I. [Russia], 1827. NYPL, SLAVIC AND BALTIC DIVISION [Fig. 78, p. 132]

Dress sword made for General Paisii Sergeivich Kaisarov (1783–1844). Etched, gilded, and blued metal. By Ivan N. Bushuyev for the Zlatoust (city) Arms Factory, Russia, 1824. A LA VIEILLE RUSSIE

C. WESTERN EUROPEAN TRAVELERS TO RUSSIA

Plan der Kaiserlichen Residenzstadt St. Petersburg [A Plan of the Imperial Residence of St. Petersburg]. Map. Weimar: Industrie Comptoirs, 1800. NYPL, SLAVIC AND BALTIC DIVISION

St Pétersbourg et les environs [St. Petersburg and Environs]. St. Petersburg: Velten, ca. 1800. NYPL, SCIENCE, INDUSTRY AND BUSINESS LIBRARY

Aleksandr Dmitrievich Savinkov (fl. 1792–1835). *Plan stolichnago goroda St. Peterburga* [Plan of the Capital City of St. Petersburg]. Map. [St. Petersburg, 1806?]. NYPL, MAP DIVISION

A Picture of St. Petersburgh. London: Printed for E. Orme, by J. F. Dove, 1815. NYPL, GENERAL RESEARCH DIVISION [Fig. 80, p. 135]

Robert Lyall (d. 1831). *The Character of the Russians, and a Detailed History of Moscow*. London: T. Cadell, 1823. NYPL, GENERAL RESEARCH DIVISION

Suggested Reading

Barford, P. M. *The Early Slavs: Culture and Society in Early Medieval Eastern Europe*. Ithaca, N.Y.: Cornell University Press, 2001.

Cracraft, James. *The Petrine Revolution in Russian Culture*. Cambridge, Mass.: Harvard University Press, forthcoming (2004).

Cross, Anthony Glenn. *By the Banks of the Neva: Chapters from the Lives and Careers of the British in Eighteenth-century Russia*. Cambridge, England: Cambridge University Press, 1997.

De Madariaga, Isabel. *Russia in the Age of Catherine the Great*. New Haven, Conn.: Yale University Press, 1981.

Halperin, Charles. *Russia and the Golden Horde: The Mongol Impact on Russian History*. Bloomington: Indiana University Press, 1985.

Hughes, Lindsey. *Russia in the Age of Peter the Great*. New Haven, Conn.: Yale University Press, 1998.

Kamenskii, Aleksandr Borisovich. *The Russian Empire in the Eighteenth Century: Tradition and Modernization from Peter to Catherine*. Armonk, N.Y.: M. E. Sharpe, 1997.

Kappeler, Andreas. *The Russian Multiethnic Empire*. Harlow, England: Longman, 2001.

Khodarkovsky, Michael. *Russia's Steppe Frontier: The Making of a Colonial Empire, 1500–1800*. Bloomington: Indiana University Press, 2002.

Lincoln, W. Bruce. *Sunlight at Midnight: St. Petersburg and the Rise of Modern Russia*. New York: Basic Books, 2000.

Marker, Gary. *Publishing, Printing, and the Origins of Intellectual Life in Russia, 1700–1800*. Princeton, N.J.: Princeton University Press, 1985.

Poe, Marshall. *"A People Born to Slavery": Russia in Early Modern European Ethnography, 1476–1748*. Ithaca, N.Y.: Cornell University Press, 2000.

Whittaker, Cynthia Hyla. *Russian Monarchy: Eighteenth-century Rulers and Writers in Political Dialogue*. De Kalb: Northern Illinois University Press, 2003.

Wolff, Larry. *Inventing Eastern Europe: The Map of Civilization in the Mind of the Enlightenment*. Stanford, Calif.: Stanford University Press, 1994.

Wortman, Richard S. *Scenarios of Power: Myth and Ceremony in Russian Monarchy*. Vol. 1: *From Peter the Great to the Death of Nicholas I*. Vol. 2: *From Alexander II to the Abdication of Nicholas II*. Princeton, N.J.: Princeton University Press, 1995–2000.

Contributors

EDWARD A. ALLWORTH is Emeritus Professor of Turco-Soviet Studies at Columbia University, and former Director of the Center for the Study of Central Asia and Chairman of the University Seminar on Soviet Nationality Problems. He has published widely in the fields of Central Asian and nationality studies. The Institute for Advanced Studies, The Hebrew University of Jerusalem, and Sidney Sussex College, University of Cambridge, England, each named him a research fellow. His books include (with others) *Nationality Group Survival in Multi-ethnic States: Shifting Support Patterns in the Soviet Baltic Region* (Praeger, 1977); and as sole author: *Evading Reality: The Devices of 'Abdalrauf Fitrat, Modern Central Asian Reformist* (Brill, 2002) and "Devolution in Central Asia, 1990–2000," the complete issue of *Nationality Papers* no. 1 (2002).

ELENA V. BARKHATOVA is the principal curator of the Graphics Department of the Russian National Library in St. Petersburg and a leading specialist on the history of Russian prints, drawings, and photographs. She has curated many exhibitions based on these media in Russia and abroad, including the United States. Among Dr. Barkhatova's published works are *Russian Constructivist Posters* (Flammarion, 1992) and (as co-author) *Russkaia Fotografiia: Seredina XIX–Nachalo XX Veka* (Planeta, 1996).

JAMES CRACRAFT is Professor of History and University Scholar, University of Illinois at Chicago. He received his doctorate from Oxford University, and has held research fellowships from the National Endowment for the Humanities, the J. S. Guggenheim Foundation, the MacArthur Foundation, and the Russian Research (now Davis) Center at Harvard University. He has published numerous scholarly articles and ten books in the field of modern Russian political and cultural history, including, most recently, *The Revolution of Peter the Great* (Harvard University Press, 2003), which is intended for general readers.

ROBERT H. DAVIS, JR. is Senior Librarian, Slavic and Baltic Division, The New York Public Library, and a co-curator of the exhibition *Russia Engages the World, 1453–1825*. He is the author of *Slavic and Baltic Library Resources of The New York Public Library: A First History and Practical Guide* (The New York Public Library and Charles Schlacks, Jr., 1994) and *A Dark Mirror: Romanov and Imperial Palace Library Materials in The New York Public Library* (Norman Ross Publishing, 1999). He has also authored, co-authored, or edited numerous other scholarly publications.

EDWARD KASINEC is Chief Curator, Slavic and Baltic Division, The New York Public Library, and a co-curator of the exhibition *Russia Engages the World, 1453–1825*. He previously served as Reference Librarian and Archivist for the Harvard University Library and the Ukrainian Research Institute Library (1973–1980), and Librarian for Slavic Collections, University of California, Berkeley, Library (1980–1984). His numerous publications include *Slavic Books and Bookmen: Papers and Essays* (Russica Publishers, 1984) and, most recently, "The Tsars of Muscovy: Their Envoys—Their Treasures: Some Rare Printed and Illustrated Sources of the 16th through 19th Centuries," *Gifts to the Tsars, 1500–1700: Treasures from the Kremlin* (Harry N. Abrams, 2001).

MARSHALL POE is an editorial analyst at *The Atlantic Monthly*. He holds a doctorate from the University of California at Berkeley and has taught at Columbia, New York University, and Harvard. He has held fellowships from the Kennan Institute for Russian Studies, the Davis Center for Russian Studies, the Harvard Ukrainian Research Institute, the Harriman Institute for Russian Studies, and the Institute for Advanced Study (Princeton). He is the author of many articles and several books, including *Foreign Descriptions of Muscovy: An Analytic Bibliography of Primary and Secondary Sources* (Slavica Publishers, 1995), *A People Born to Slavery: Russia in Early Modern European Ethnography, 1476–1748* (Cornell University Press, 2000), *The Russian Elite in the Seventeenth Century* (2 vols.; Finnish Academy of Science, 2003), and *The Russian Moment in World History* (Princeton University Press, 2003). Dr. Poe was a founder of *Kritika: Explorations in Russian and Eurasian History* and currently serves as editor.

MARC RAEFF is Boris Bakhmeteff Professor of Russian Studies Emeritus, Columbia University. He is an internationally known expert in the cultural and administrative history of the Russian Empire in the eighteenth and nineteenth centuries. He has been involved in the exhibition *Russia Engages the World, 1453–1825* from its conception, and has been a reader at The New York Public Library for more than fifty years. His works include *Origins of the Russian Intelligentsia: The Eighteenth-century Nobility* (Harcourt, Brace & World, 1966), *Comprendre l'ancien régime russe: Etat et société en Russie impériale* (Seuil, 1982), *The Well-ordered Police State: Social and Institutional Change through Law in the Germanies and Russia, 1600–1800* (Yale University Press, 1983), and *Russia Abroad: A Cultural History of the Russian Emigration, 1919–1939* (Oxford University Press, 1990).

IRINA REYFMAN is Professor and Chair of Russian Languages and Literatures at Columbia University. She received her M.A. degree equivalent in 1973 at Tartu University in Estonia and her Ph.D. in 1986 at Stanford. Her main field is Russian literature and culture in the eighteenth century. She is the author of *Vasilii Trediakovsky: The Fool of the "New" Russian Literature* (Stanford University Press, 1991) and *Ritualized Violence Russian Style: The Duel in Russian Culture and Literature* (Stanford University Press, 1999).

CYNTHIA HYLA WHITTAKER is Professor of History at Baruch College and the Graduate Center of the City University of New York; she also serves as the chair of Baruch's history department. She received her doctorate and master's degrees in both Russian history and literature at Indiana University. Her research has been funded, among others, by the National Endowment for the Humanities, the Rockefeller Foundation, Fulbright-Hays, the International Research and Exchanges Board, and the Slavic Research Center at Hokkaido University, Japan. She is the author of many articles and books on Imperial *Russian political culture, most recently of Russian Monarchy: Eighteenth-century Rulers and Writers in Political Dialogue* (Northern Illinois University Press, 2003). She is a co-curator of the exhibition *Russia Engages the World, 1453–1825*.

RICHARD WORTMAN is Bryce Professor of History, Columbia University. An internationally recognized specialist on prerevolutionary Russia, he has taught and written on cultural history for more than thirty years. His books include *The Crisis of Russian Populism* (Cambridge University Press, 1967) and *The Development of a Russian Legal Consciousness* (University of Chicago Press, 1976). His current scholarly project, the multivolume *Scenarios of Power: Myth and Ceremony in Russian Monarchy* (Princeton University Press; Volume I, 1995; Volume II, 2000), deals with the imperial government's use of political symbols and visual imagery—a subject reflected in many examples in the exhibition *Russia Engages the World, 1453–1825*.

Acknowledgments

Major underwriting support for the exhibition has been provided by a generous gift from The Boris Jordan Family.

Additional support has been provided by the Samuel H. Kress Foundation and the National Endowment for the Humanities.

Special thanks to Mrs. Charles Wrightsman, the Trust for Mutual Understanding, Jacqueline and John P. Rosenthal, Grace Allen, Mrs. Daniel P. Davison, and The Harriman Institute at Columbia University in the City of New York, for generous gifts in support of this exhibition.

Support for The New York Public Library's Exhibitions Program has been provided by Pinewood Foundation and by Sue and Edgar Wachenheim III.

EDWARD KASINEC and ROBERT H. DAVIS, JR., NYPL curators of the exhibition *Russia Engages the World, 1453–1825*, would like to extend their gratitude to the staff, docents, and volunteers of the Slavic, Baltic, and East European collections, past and present, especially librarian Hee Gwone Yoo, for his indispensable assistance and forbearance; Svatopluk Soucek and John Ma of the Asian and Middle Eastern Division; Alice C. Hudson, Chief of the Library's Map Division, who lent her expertise to the selection and description of all cartographic materials; the staffs of the offices of Development, Exhibitions, Public Relations, Publications, Graphics, Public Education, and Special Events; and the curators and staffs of The Research Libraries, most especially those from the more than a dozen divisions loaning to this exhibition.

Beyond the Library, we would like to thank the director, curators, and staff of the Russian National Library; and colleagues at the American Friends of the State Hermitage Museum, CEC International Partners, the Indianapolis Museum of Fine Arts, the Metropolitan Museum of Art, the American Numismatic Society, and the Office of Research Programs and the Publications Office of the National Endowment for the Humanities. Individuals who merit our special thanks include David Cronin, formerly Manager of Exhibitions at NYPL's Humanities and Social Sciences Library and now Executive Director of the New York Council for the Humanities; Janis Kreslins, Jr., of the Royal Library of Sweden at Stockholm; Alexander Rabinovich of Alexander Rabinovich Rare Books; James Risk, a specialist in New York on Russian coins, medals, and decorations; and most especially Scott Ruby, Assistant Curator at the Jewish Museum in New York, who selected the decorative and fine arts items in the exhibition.

Index